Toward Fewer Images

OCTOBER Books

George Baker, Yve-Alain Bois, Benjamin H. D. Buchloh, Leah Dickerman, Devin Fore, Hal Foster, Denis Hollier, David Joselit, Rosalind Krauss, Carrie Lambert-Beatty, Annette Michelson, Mignon Nixon, and Malcolm Turvey, editors

Broodthaers: Writings, Interviews, Photographs, edited by Benjamin H. D. Buchloh

AIDS: Cultural Analysis / Cultural Activism, edited by Douglas Crimp

Aberrations: An Essay on the Legend of Forms, by Jurgis Baltrušaitis

Against Architecture: The Writings of Georges Bataille, by Denis Hollier

Painting as Model, by Yve-Alain Bois

The Destruction of Tilted Arc: Documents, edited by Clara Weyergraf-Serra and Martha Buskirk

The Woman in Question, edited by Parveen Adams and Elizabeth Cowie

Techniques of the Observer: On Vision and Modernity in the Nineteenth Century, by Jonathan Crary

The Subjectivity Effect in Western Literary Tradition: Essays toward the Release of Shakespeare's Will, by Joel Fineman

Looking Awry: An Introduction to Jacques Lacan through Popular Culture, by Slavoj Žižek

Cinema, Censorship, and the State: The Writings of Nagisa Oshima, by Nagisa Oshima

The Optical Unconscious, by Rosalind E. Krauss

Gesture and Speech, by André Leroi-Gourhan

Compulsive Beauty, by Hal Foster

Continuous Project Altered Daily: The Writings of Robert Morris, by Robert Morris

Read My Desire: Lacan against the Historicists, by Joan Copjec

Fast Cars, Clean Bodies: Decolonization and the Reordering of French Culture, by Kristin Ross

Kant after Duchamp, by Thierry de Duve

The Duchamp Effect, edited by Martha Buskirk and Mignon Nixon

The Return of the Real: The Avant-Garde at the End of the Century, by Hal Foster

October: The Second Decade, 1986–1996, edited by Rosalind Krauss, Annette Michelson, Yve-Alain Bois, Benjamin H. D. Buchloh, Hal Foster, Denis Hollier, and Silvia Kolbowski

Infinite Regress: Marcel Duchamp 1910–1941, by David Joselit

Caravaggio's Secrets, by Leo Bersani and Ulysse Dutoit

Scenes in a Library: Reading the Photograph in the Book, 1843–1875, by Carol Armstrong

Toward Fewer Images

The Work of Alexander Kluge

Philipp Ekardt

An OCTOBER Book

The MIT Press
Cambridge, Massachusetts
London, England

This book was set in Bembo by the MIT Press. Printed and bound in the United States of America.

Library of Congress Cataloging-in-Publication Data is available.
ISBN: 978-0-262-03797-6

10 9 8 7 6 5 4 3 2 1

Contents

ACKNOWLEDGMENTS

Starting with the dissertation chapters from which it developed, this book was written in the cities of Berlin, New Haven, Paris, and London, between which I moved, following the various steps of a graduate student's, a junior academic's, also a critic's and an editor's trajectory. When I began work on *Toward Fewer Images*, these places marked out a zone of intellectual, scholarly, and artistic exchange, a public sphere, which lay isomorphic to a shared political terrain. Somewhere Alexander Kluge has said: "I am from Germany. A country that no longer exists." Taking in the situation as I am completing the book, I cannot help but wonder whether, while the intellectual community holds strong, that political sphere does still exist, and what the consequences may be.

In one of his stories, Kluge poses the question of whether there is a line that separates the ages, eras, periods. Have we crossed one such line recently? And how wide is the chasm? Just as Kluge's work produces historical knowledge across disjunctions and temporal caesuras, such as the one that separates, but also connects, the digital and the analog, the one that divided the moment before and after cinema, fractures within power, the beginnings and ends of states, empires too, we will have to measure and navigate these fault lines. If there is anything to be trusted in the

following chapters, it is that images will be one medium, and certainly the product, of this probing of chasms.

Unbroken, by contrast, has been the support, encouragement, sympathy, and critique which I have been fortunate to experience from a number of teachers, colleagues, and friends who have accompanied this work for more than a good while. I thank Carol Jacobs, David Joselit, and Christopher Wood, who were part of the team that was there when the dissertation chapters came into being. And I thank Winfried Menninghaus, who welcomed my work back to Berlin. Most recently, I cannot thank the editors of *October* enough for their endorsement. I am honored that they should have accepted *Toward Fewer Images* among the ranks of October Books. Devin Fore was a kind shepherd in the process, after David had given me directions more than once, while Adam Lehner kept an eye on the execution throughout. As at earlier points with his questions, David gave the project a new and important point of navigation when he included an essay and a conversation which I conducted with Kluge in a special issue of *October* on the implications of digitization. Frederic Schwartz and Devin were kind enough to invite me to participate in a workshop dedicated to Kluge's work at University College London: a well-timed invitation, since I was just about to move into the academic vicinity; and Fred offered encouragement. Christine Mehring, Noa Steimatsky, and Katie Trumpener were involved in my earlier chartings of Richter, film, and the dissertation. Later on, in Berlin, I thank Gertrud Koch and Joseph Vogl for dialogue, exchanges, comments, and encouragement. Along the way, Mike Jennings always had an open ear and good advice. My thanks also to Isabelle Graw and Andreas Beyer, who both trusted in me and my work, and who each gave me wonderful jobs.

As a scholar, writer, and former editor, I can say that I have had the privilege of working with a superb team at the MIT Press: in a veritable *tour de force* Victoria Hindley opened the editing process, and made sure that this book could still appear on time; with great meticulousness and a

strong vision, Roger Conover watched over the entire production; while Matthew Abbate and Gillian Beaumont were wonderfully empathic, yet exact and exacting editors—as careful, supportive, and understanding as an author could wish for. It was such joy to work with all of them. Finally, I have to thank Yasuyo Iguchi for listening so attentively to my thoughts about the visual aspects of Kluge's work, and then delivering such a forceful cover design.

Alexander Kluge himself has been extraordinarily patient and generous with his time and his answers. I am so grateful that he lent me his ear, responded to my inquiries, and gave his permission to reproduce the many images in this book. And I do thank his *Mitarbeiterinnen* and *Mitarbeiter* at dctp—first of all Beata Wiggen, who cheerfully facilitates so much. I also thank Gerhard Richter for very kindly agreeing to have his works featured in *Toward Fewer Images*, and the staff at his *atelier*, in particular Konstanze Ell, for smoothly handling these communications. Finally, I thank Tom Tykwer, Christoph Hochhäusler, and Christian Petzold for allowing me to print stills from their contributions to Kluge's DVD works. All three did so in the most uncomplicated and friendly manner—practically overnight.

Jess Atwood Gibson has for many years been a close friend, and a trusted and trusting, patient and discerning reader who understands where one's writing and thinking—in this case mine—needs to be left as it is, but also when, where, and how it should be different. She saw the book first, and her comments, critique, corrections, and questions throughout all its stages have made it infinitely better. I owe her so much more than better English—or a better book, for that matter. Armen Avanessian and Florian Klinger have both read chapter drafts, offered feedback and encouragement, and—unwaveringly—never quit asking when the book would finally come out. Now that it's here, I can relax and so can they: I thank them for their persistence, along our diverging and shared intellectual paths, within the institution of the university and beyond. Among the friends and intellectual companions who have shared

the work's and my own ways are, finally, Heike-Karin Foell, Irene Small, and Maria Zinfert, as well as Prajna Desai and Alena Williams.

Kluge's last works for the classical cinema, dating from the late 1970s and early 1980s, contain a number of scenes filmed in Frankfurt am Main. When I see these images I sometimes recognize the city, the buildings, the light that I first lived in as a child—give or take a few years. Ever since that moment my parents, and my family, have been there for me. And then there is the one person without whom this and many other things quite simply wouldn't have been possible. I know he's now happy, proud—and relieved. And so am I—happiest of all, however, not because the book is here, but because he is: Jan.

The Question of Work

For the critic and scholar, addressing the work of Alexander Kluge poses a challenge, primarily due to a difficulty in determining what the concept of "work," as pertaining to all sorts of (artistic) production, might in this case precisely refer to. When we speak of somebody's "work," do we mean her or his activity of producing something, as a synonym for their labor? Do we mean the outcome of that person's production or labor, the more or less finished product, i.e., one of multiple individual works—*a* work among many? Or, do we mean the sum of all of these individual instantiations, also referred to as an artist's "work," her or his *œuvre*? While asking such questions may under different conditions amount to little more than parsing semantic minutiae, in case of Kluge's work one is confronted with them in all acuteness and in actuality.

Kluge is a filmmaker and a literary author, a television producer and a theorist, as well as a digital entrepreneur. Since 1960 he has made fourteen feature films and twenty short films; authored around thirty volumes of literary texts, a number of interview books and conversation transcripts; and co-published—with Marxist philosopher Oskar Negt—three

volumes of theoretical writings. As of the late 1980s, when Kluge first worked in television, his production company dctp has turned out over 3,000 features, for most of which Kluge converses with real or fictional experts, or in which he arranges visual material into thematically organized montages. In recent years, he has also engaged the digital realm: by maintaining a website on which he reassembles segments from his filmic and television productions, as well as by publishing three DVD films, two of which are comprised of three discs, all of which also contain booklets or pdf files with even more literary stories. To say that Kluge is "prolific" would amount to an understatement of sorts.

In the face of the sheer numerical magnitude and medial diversity of this output, the perspective of having to attend to its manifold individual constituents is intimidating. Any attempt at mastering the immensity of the material seems to risk losing sight of the specificity of its components. The vastness of *the work* potentially swallows the discreteness of *the works* that comprise its body. The situation is complicated even further when one realizes that Kluge frequently reprises his material: he reuses themes, ideas and formal components, visual clips, segments from earlier films, images, entire short stories, literary and filmic characters, interviews, shots, etc., in later contexts. In these later (re-)assemblies they figure partly identically, partly in altered fashion. The challenge thus lies not only in mediating the relation between the work and the works in an assumed synchrony. Rather, it becomes clear that later works in part function as reworkings of earlier ones. Instead of amassing an artistic lifetime's worth of production through accumulating a more than impressive quantity of individual creations, Kluge seems to be permanently reworking what he has done before. This erodes both the monumentality of the œuvre and the distinctness of its individual constituents, as both become subject to an ongoing process of revision. In this activity, the generation of new material is interwoven with the alteration of older material.

One thus has to address what now looks more like a permanent immanent activity of artistic, filmic, and literary production. When speaking of

Kluge's "work," one seems to be talking about the activity of production as much as about its results. And this activity seems to no small extent to consist in recalibrating and altering its previous results, in the form of new instantiations. But how would one address "work" that realizes itself to equal degrees as an activity, as its individual products, and as the entirety of these products: as labor, works, and *œuvre*, while traversing a whole set of different media?

This book offers the first scholarly and critical account of Alexander Kluge's production that is based on such a problematized understanding of the concept of "work," which his practice, if scrutinized closely, ultimately demands. In discussions of Kluge's output, the position that his texts, films, and clips constitute "genres of their own" has become a topos.[1] While this formulation captures the stylistic distinctness of his productions, this uniqueness is intertwined with and results from a no less unique production method. This is one reason why Kluge's work is exemplary. There is, quite simply, no comparable case in which a practitioner—be it a filmmaker, clip artist, literary author, or thinker—has achieved a similar virtuosity working across media, while also giving rise to reflections about the very concept of work itself in a comparable way. As a consequence, the following analyses thematize Kluge the filmmaker, the maker of television, the author, the digital entrepreneur, and the theorist in an attempt at understanding him *generally* in his function as a producer.

In doing so—i.e., in understanding Kluge as a model for thinking production as a general rather than as a particularized activity—one also approaches two of the aspects that give his practice a certain timeliness at our particular moment. The first pertains to the question of media. The debate regarding whether artistic production in general, and its results in particular, should be reflexively bound to the various media in which they are situated, is ongoing. Defenders of the ideal of medium specificity are set against advocates of postmediality.[2] In a different vein of thinking—as in the primarily German schools of media archaeology and

media philosophy, especially as developed in the wake of Friedrich Kittler's writing—all sorts of articulations, not just artistic ones, are understood to be framed through the *a priori* of the (media-)technological states that enable them.[3] While it is in touch with both trajectories of thought, Kluge's practice presents an example in which the continuation of production takes primacy over questions of mediality. In Kluge's case, different media function as different habitats that need to be respected in terms of the distinct conditions they each present, but ultimately exist as vessels for an ongoing activity of production, which settles in them, but also traverses them. Grouping himself with none of the three factions (medium specificity, postmediality, or media archaeology), Kluge, rather, presents a case where production takes up and leaves its media, in a mode of temporary mediatization.

The second point at which the perspective of Kluge's production acquires a certain timeliness is the way it relates to the overall mode of production that characterizes our present. Already in 1981, in his joint theoretical work with philosopher Oskar Negt, *Geschichte und Eigensinn* (*History and Obstinacy*), Kluge offered an implicit answer to this question by introducing the term "permanent accumulation" to revise the Marxian understanding of capitalism as deriving from a set takeoff point, a so-called phase of originary or primary accumulation/expropriation, after which it then purportedly leads a more or less stable existence. Rather, Kluge and Negt hold, permanent accumulation refers to a state in which the activities of accumulation, expropriation, and production are permanently and immanently inherent, i.e., a state that perpetually (re)generates its own beginnings. One could call this, paradoxically, an inherently dynamic state. With this in mind, the Klugean practice of a permanent (re)actualization of older instantiations of his work, as well as a shift from work as an entity (or a set of entities) toward work as an activity—or, more precisely: toward work as an entity that is constantly reconfigured, because it is also an activity—appears to be a logical response. (Chapter 10 examines this question.)[4] The timeliness of his work, therefore, derives

from the fact that Kluge offers analyses and proposals for work under the condition of permanent accumulation.

THE FATE OF MONTAGE

And yet, for all of its inherently revisionist activity, Kluge's practice has nothing to do with propagating paradigms of flexibility, let alone programmatic inconsistency. Rather, a set of consistent themes and procedures runs through it, from its inception to its most recent articulations, and this book analyzes these as well. A central concern here is what Kluge has termed *still images*, a goal which in his system carries a number of implications. It is bound to the ideal of an exercise of the faculty of discernment, also and particularly on the level of affect. It is connected to an artistic politics of temporality. And it plays an essential part in renegotiating the strategies of montage that derive from the cinematic tradition of Sergei Eisenstein, Dziga Vertov, and Jean-Luc Godard. All three directors serve as important reference points for Kluge, and in a number of his filmic, visual, literary, and theoretical works their positions become subject matter. Another important source for the Klugean notion of montage is the theoretical writings of his teacher Theodor Adorno, as well as Bertolt Brecht.

Montage in this tradition functions as a cardinal technique for the realization of an aesthetics of discontinuity, which is bound to the predicament of criticality. (Chapter 2 provides an analysis of this tradition, and the various ways Kluge engages with it, charting both the common ground and the divergences between him and his precursors.) As considered through its afterlife in Kluge's work, one fundamental aspect of montage's critical impetus lay in the rupture which it was seen to inflict on the false re/semblance of "continuous" methods of (pictorial) representation, primarily the techno-ontologically stabilized type of imaging that characterized photographic and filmic recording, and with it all sorts of artistic programs of surface realism.[5] To put it differently: across

various arts, montage was positioned against a type of representation that privileged seamless description and intactness on the level of artistic representation itself. While it inherits this position, Kluge's practice pairs it with montage's assumed suitability for depicting and generating what resemblance-based modes of representation cannot depict or generate in the first place, namely context and relationality, which are encompassed in his use of the German term *Zusammenhang*. Both the interruption of semblance and the creation and representation of context rely on the moment of caesura for their realization: To do montage is to "break" resemblance, and to combine image components across a moment of rupture, a negation of continuity, in order to articulate contexts and relations, rather than to duplicate surfaces.

Deriving from the photo-filmic paradigm, the landscape of external (technological and mediatic) conditions in which montage came into being has in the meantime changed, not least through the advent of electronic image production and digitization. Over the course of its by now more than five decades of existence, Kluge's work has, accordingly, become the site for a recalibration of the practice of montage itself. Kluge implicitly proposes, first, a generalized notion of montage that coincides both with his practice of general production and with an understanding of the essence of "the filmic" as not inherently tied to the epoch of cinema; the latter position is succinctly summarized in his dictum, prompted by the emergence of digital technology, that "the principle of cinema [*das Prinzip Kino*]" is "older than the art of the movies [*älter als die Filmkunst*]."[6] But what would this general activity of montage, which finds in film something like a focal point, but not its defining medium, look like? Is there a way of thinking such a general image strategy beyond the confines of the filmic *dispositif*? Chapters 6 and 7 form an excursus whose partial function is to probe this Klugean predicament. They do so by exploring two image contexts, established through Kluge's own work, in which his production intersects with the historical and contemporary image works of German romantic artist Caspar David Friedrich

and contemporary painter Gerhard Richter. As literarily and filmically framed—or: *contextualized*—by Kluge, both artists appear as historically pre-filmic (Friedrich) and non-filmic (Richter) examples of a type of image work that is, if not identical with, at least closely related to the concerns and hopes with which Kluge invests his montage program.

The second major recalibration of montage practice has even more explicitly to do with a transformation in the medial environment in which Kluge's—like all other contemporary—activity is situated, namely digitization, although it would be problematic to understand this shift in Kluge's procedures merely as a reaction to the overall informatization of production. With the introduction of electronic recording technologies, which enable television and digital media, montage could no longer be deduced through the material conditions of production that characterized the age of cinema: the material dis/continuities of the celluloid strip, the material registration of light on film, and their existence within the broader panorama of an essentially Fordistically structured, classically modernist mode of production. But what becomes of the predicament of discontinuity, once the material base of continuity against which it was pitted, and which fueled its assumed critical potential, begins to erode? Does it lose its clout? The answer to this question, which Kluge gives implicitly through his practice, is that montage as an agent of discontinuity retains its validity, but also transforms itself. What now emerges is a type of montage that takes the constellation as its model. Instead of pitting the caesura against the continuities of resemblance production, montage now installs a multitude of possible recombinations. Instead of juxtaposing discontinuous units on the level of the material, it now also combines a host of latent and actualized units, "dormant" and "retrieved" content. Through its increased storage capacities and its encompassing of temporalized and non-temporalized visual information (images and clips/films), as well as texts, the digital is also the realm in which Klugean montage most forcefully takes up its own past productions, in order to reassemble and rework them. The constellations that it installs are hence

also diachronically situated. Montage takes place now, but it also navigates between this now and various past moments. This transition into digitality, and the recurrence of the constellation as figure and method, are discussed in chapter 4. Within the framework of these and related transformations, which could also be described more broadly as the transfer from writing and analog film to television and digital production, Kluge's work intervenes in a general shift in the history of discontinuous practices, and he advocates for their continued pertinence.

STILL IMAGES AND CRITIQUE

In the course of this move toward the constellational paradigm, the caesuras which such discontinuous practices necessarily produce present themselves less and less as marked interruptions within an otherwise coherent media stratum of artistic representations. Instead, a quality emerges that has belonged to the repertoire of Kluge's critical tropes from the beginning, but, as a result of this shift, has perhaps become more palpable than ever before. This quality is realized through the already mentioned instances that Kluge calls "still images." Initially, his concept of such still images was directly bound to his definition of montage. Montage, Kluge once said, does not combine images in a cumulative mode. Rather, the juxtaposition of these separate entities makes their difference appear. As a result, something becomes manifest that he terms a "third image," unseen, but embedded within the realm of the visible, from which it emerges.[7] According to Kluge, these third images are characterized by their stillness.

This theory is less esoteric than it sounds. It ultimately amounts to a differential understanding of image combinations, which correlates with an artistic practice that strives to construct these combinations in such a manner that their potential audiences will, in the act of reception, be enabled to exercise their critical faculties, rather than shutting them down. Still images are, then, pictorial types that seek to elicit a critical,

discerning activity on the part of the viewers. They do so partly by refusing, or actively blocking, the impression of image flows, by preventing their components from merging with one other, instead keeping them apart in a state of tension. Kluge has explained this effect with recourse to another image: he says that montage creates frozen lakes, not visual streams. Viewing them is akin to looking at ice-covered waters on a hike through a wintry landscape. The sober mode in which they are processed could be described as short-term instances of quiet contemplation from which all absorptive qualities have been sapped. This is a still mode of distancing that does not cast a spell on the viewer, but instead makes room for critique, in that it allows her or him to tell things apart, to discern them, in a sense which is present in the ancient Greek term *krinein*—to tell one thing from the other.

As Kluge's work progresses, this differentiating montage element is increasingly complemented by other techniques of generating comparable moments of still imagery. In his literary texts, short clips, and films there is a growing number of short takes and brief descriptions that focus on literally still subject matter: fields in the snow; a puddle; light effects in an empty film studio; etc. These correspond with strategic uses of filmic technology, like the deceleration of refilmed historical footage, or camera takes that show non-temporalized imagery and media (book pages, illustrations, etc.), all of which implement comparable effects of "stilling." In this book, these various strategies are explored throughout a number of chapters. Chapter 2 develops them in relation to questions of film; chapter 4 in the context of Kluge's constellational practices. The excursus in chapters 6 and 7 identifies the question of such still imagery as a shared concern between Kluge, his historical predecessor Friedrich, and his contemporary Richter.

Parts of chapter 3 explore related elements in Kluge's practice as a television producer. Through a number of operations that include, most notably, his interview technique, his handling of the predominantly motionless camera, and the positioning of the aural dimension (primarily

Kluge's voice and background interference) *vis-à-vis* the visual, Kluge has developed a strategy that could be described as "static" in the double sense of the term: it provokes the emergence of noise within the TV transmission, while sabotaging television's developmental logic into moments of arrest. Stillness here means a type of suspension that goes hand in hand with a mode of discursive overproduction, an intended complexity that characterizes the conversations in Kluge's features.

Chapter 5 provides an analysis of Kluge's theory of *Gefühl* (feeling). According to Kluge, feeling, ranging from tactility to emotions, serves primarily the function of discernment. In this sense, he defines feelings as producers of the faculty of distinction. To feel is in principle to distinguish and to differentiate. However, this discerning potential is permanently threatened, blunted, and deactivated by various ways in which feelings are symbolically represented and organized, for example in literature, the performing arts, or films. Kluge criticizes and counters any equation of affectivity with a fatelike, overwhelming motive force behind impulsive action. Consequently, his own texts, clips, and films seek to present his audience with occasions for considering feeling as a distinguishing faculty. The pause in a moment of stillness, the affective impenetrability of the faces in Kluge's films and features, as well as the frequent emotional unreadability of his characters, all create moments of distance which are intended to give critical activity and affectivity room to unfold.

Compared to a number of current theoretical frameworks, Kluge's program, whose roots reach at least as far back as his writings from the 1970s, is set apart on two points. First, Kluge does not conceive of affect and feeling in opposition to distinction and critique. Rather than constituting a mere object for critique, feelings are one of its anthropological sources (a source that is always at risk of drying up). Secondly, Kluge's notion of montage as a general—i.e., not medium-specific—technique seems at first to resonate with current assemblage theories, which have extended the idea of construction across a set of interfaces and hiatuses from the montage paradigms of classical modernity into an even more

encompassing combinatory mode. However, while these recent attempts are more often than not positioned explicitly against self-declared "critical" programs, Kluge retains the pertinence of criticality, and sees it as persistently bound to the caesuras, hiatuses, interruptions, suspensions, pauses, and moments of "stillness" that inhere within any activity that emphasizes the discontinuity of its elements.[8]

AN ARTISTIC POLITICS OF TIME

The impression of "stillness" has as much to do with the ability to exercise one's (affective) faculty of discernment as with one's experience of temporality. In this way it also adheres to what could be called an artistic politics of time that runs through Kluge's entire production. On a phenomenological level, this concern with questions of temporality relates most obviously to the characteristic Klugean economy of short and very long durations, or the typical brevity of his clips, stories, and other montage components, against the vastness of latent temporal reservoirs that can be stored under digital conditions—but are also evident in the ever-increasing dimension of his literary productions. Kluge's temporal economy, primarily explored in chapter 9, is extreme in that it relies on the brevity of its basic elements for the combination and recombination into contexts of maximal duration. (To this is added the particular temporality of ongoing revisions, alterations, and recontextualizations, which ultimately prevents Kluge's *œuvre* from forming a sequence of finished discrete works, instead incorporating the very temporality of reworkings into its own facture.)

The second marked feature of temporality in Kluge's work can be seen at the level of artistic representation. Through generating complex contextualizations, Kluge engenders multiple and maximal temporal scales. Given moments become the points of departure for time trajectories that lead to temporal dimensions as far away as prehistory, geology, and evolutionary processes. Along these trajectories the work accumulates various

temporal layers which Klugean representation refrains from homogenizing. Although they are an ongoing interest of this book, these strategies are most extensively investigated in chapter 8. Through comparing the media chronologies that are inherent to Kluge's work with the temporal models of media archaeology, this chapter also describes the fundamentally non-periodizing structure, the anepochal quality that characterizes Klugean temporality, and also his artistic presentation of history. The result is a complex and complicating—instead of an ordering and governing—experience of temporality.

A related element consists in the model of the constellation, for which Kluge varies a concept that he finds in the work of Walter Benjamin: the dialectical image, which describes a nonlinear and discontinuous relation between a given now, and a moment of the past (explored primarily in chapters 4 and 6). Another crucial strategy in establishing a relationship to the temporal dimension of the past is the so-called Klugean paraphrase. These paraphrases are pictorial, filmic, or textual condensations, mostly of past works, to which Kluge adds variations, and injects moments of speculation, quick ventures into the realm of the possible. They are central to Kluge's particular type of utopianism that relies on opening zones of possibility, terrains of unrealized developments—not in the future, but in the past. Established through narrative and pictorial fictions, these are the temporal variants of a more encompassing Klugean practice that sets the category of the potential against the verified and documented, thus developing a counterfactual method.

To summarize this rather diverse repertoire of procedures, it is helpful to describe the tendencies against which Kluge positions them. Heeding the title of one of his last feature films, the 1985 *Der Angriff der Gegenwart auf die übrige Zeit* (*The Assault of the Present on the Rest of Time*), one recognizes that Kluge's entire artistic politics of time is designed to undermine such a "presentification" of temporality, a summarizing of time and our experience of it under the (historical) moment of a "now." By contrast, the Klugean negotiation of time complicates and differentiates. It installs

stillness, caesuras, and constellation against an even flow. It pits latent against actualized durations. It maneuvers with both extreme extension and the brevity of the minimal unit. It generates, in sum, a facture of heterochronicity.[9] While the book's closing chapter looks at Kluge's heterochronic strategies, it also presents their important theoretical counterpart: the temporal aspects of a theory of permanent accumulation that Kluge develops in tandem with his longtime writing partner Oskar Negt in *Geschichte und Eigensinn*. Working through the discursive legacies of Marx, Haeckel, and Freud, it is here that the practice of heterochronicity finds an important discursive articulation, which also allows a reconsideration of one of Kluge's basic tropes of production—the cut.

A Note on Writing

After a pause during the 1990s, Kluge has resumed his activity as an author with an even higher output than before. His literature stands beside his theoretical works in the fields of film, poetics, and political philosophy, and outdoes them in terms of quantity. Kluge has also published a number of volumes of conversation transcripts, most of which go back to his television features. Just like his work in temporalized images, Kluge's stories and conversations function as partly fictional literature, while frequently also elaborating his theoretical concerns. This book treats them as such, taking them as objects for investigation while also considering them as sites for the production of critical knowledge. In this way they are interspersed throughout the entire course of the argument, forming one of its prime media. Kluge's voice as a philosopher, storyteller, and not least as an interlocutor and interrogator is audible throughout.

A Note on Translation

Kluge's approach to handling the translation of his writing resembles his method of producing perpetually modified, sometimes expanded,

sometimes cut, sometimes adapted versions of earlier works. Especially in the case of his more recent story collections, the available English-language versions frequently differ from and do not include the entirety of their corresponding German-language originals. This is even the case for *History and Obstinacy*, the translation of *Geschichte und Eigensinn*, which Kluge not only cut substantially, removing vast sections that referred primarily to fields of German history, but which, with the agreement of his editor Devin Fore, he also expanded in other ways: for instance, by adding a glossary that comprises definitions of concepts employed in the book. The textual bases for the analyses in my book are the original German versions. While I have relied on existing English translations in order to allow an Anglophone readership more or less coherent access to the available versions of Kluge's texts, it was necessary to translate not only untranslated works but also untranslated sections of works for which translations otherwise exist. To guarantee a unified basis for the scholarly reader, all notes list the relevant pages in the original German versions, along with published English translations where these exist. (If the English edition is not cited for a given passage, then this passage is missing from that edition, and the translation supplied is by the author.)

There is one particular instance of translation that requires a brief explanation, since it relates to one of Kluge's central concepts—*Zusammenhang*—which is present mainly in his work with the philosopher Oskar Negt, and to a certain extent in his writings on film. *Zusammenhang* translates literally as "hanging together" or "connection." On a more abstract level, it can designate a context, for example the context of production (*Produktionszusammenhang*). Kluge's use of the term encompasses all of these layers. In his pathbreaking essay "On Negt and Kluge," Fredric Jameson offered the the first English translation of this term as *relationality*.[10] By rendering *Zusammenhang* as *relationality*, Jameson emphasizes the establishment of connections and relationships through *Zusammenhänge*. He thus—very convincingly—highlights the term's sociological or sociohistorical meaning. As such, it was logically adopted in the translation of *Geschichte und Eigensinn*, and thus has Kluge's approval.

Where my own argument touches on questions of *Zusammenhang* in Kluge's work, however, it hinges in part on the co-usage of the term in his historico-sociological and film-theoretical thinking, where it figures, for example, in his dictum that montage presents a *Theorie des Zusammenhangs* (see chapter 2 below). Whereas montage, obviously, also negotiates and constructs the relations between its constituents, relationality seems to imply a slight element of intersubjectivity that would not have done justice to the question of images. I thus opt for a translation of *Zusammenhang* as "context." In addition, the term "context" also seemed to allow for including the binding, enclosing, and hence potentially subordinating forces that for Kluge and Negt are inextricably linked to the integrating capacities of *Zusammenhänge* (see chapter 2).[11]

STRUCTURE/SYNOPSIS

This book is divided into five main sections, which structure its sequence of consecutively numbered chapters. The prologue (chapter 1) functions as an exposition. It begins with a close study of the opening sequence of Kluge's 1983 feature film *Die Macht der Gefühle* (*The Power of Feelings*), then tracks three main themes—architecture, light, and time—into other Klugean clips, stories, and films. This chapter functions as a passage through images and themes, calling up shots, montage sequences, and segments of literary narrative, partly with the intention of demonstrating that in Kluge's work these entities, while retaining their concreteness and particularity, are almost always already on the way to becoming moments of theorizing in their own right. This chapter also gives the reader one example of the way in which Kluge constructs contexts (*Zusammenhänge*) (of images, theories, themes …) within a single work and beyond.

The second section, "Image Media, Forms, and Formats," consists of three chapters which move along the series film–television–digitality. They investigate the basic structuring principles of Kluge's work in these three media/technologies, while also developing a number of general

concerns. The chapter on film introduces the question of montage and discontinuity; the television chapter discusses interference, suspension, and complexity, along with the notion of the format; in the chapter on digital works, the figure of the constellation is one of the main topics. The subsequent section, "Affect and Distinction," comprises a single chapter that puts Kluge's theory of feelings and distinction at its core.

The excursus "Two Image Studies" functions according to a different logic. Its two chapters extend the argument to the work of two other artists, Caspar David Friedrich and Gerhard Richter. Kluge has collaborated with Richter on two books, *Dezember* (*December*) and *Nachrichten von Stillen Momenten* (*News of Quiet Moments*). The scope is hence extended laterally, into the visual artistic practice of one of Kluge's contemporaries, and vertically, so to speak, by establishing a historical axis that connects Kluge's work to German romanticism. While expanding the purview of the present study quite considerably, this section is at the same time based on an extreme contraction of the field of vision. Both chapters depart from and ultimately return to a very short story titled "Die gescheiterte Hoffnung" (The Wreck of the *Hope*), in which Kluge writes about Friedrich's painting and gives a nod to his collaborator Richter. Although the two chapters function as interrelated but independent analyses of Friedrich's and Richter's visual practices, this excursus also charts the image context established by Kluge in his story. At its thematic core stands the notion of the still image, the practice of constellating and paraphrasing, and an expanded montage practice. This section's function is to demonstrate that Kluge's theory of the third image—i.e., the still image—is also, and quite literally, situated in the historical field of pictures.

The last section, "Time, Duration, and Extension," comprises three chapters. The first explores the inherent media temporality and media historicity of Kluge's work, arguing that Kluge ultimately operates within an aperiodical model. The second chapter analyzes his method of constructing his works through a permanent (re)arrangement of minimal entities, i.e., by generating extended durations through an agglomeration of

segments that stand out for their brevity. Finally, the last chapter explores the notion of permanent accumulation, its correlates in Kluge's mode of production, and its theoretical unfolding in *Geschichte und Eigensinn*.

PROLOGUE

1

Light Play in Time

Alexander Kluge's 1983 feature film *Die Macht der Gefühle* (*The Power of Feelings*) begins, after the director's and actors' credits have run in Kluge's signature sans-serif typeface on a blue field, with an almost entirely dark frame where only a handful of minuscule luminous specks are visible, almost like a very distant, faintly perceptible stellar constellation. From this image onward a static camera captures the disappearance of these points of light, except for one thin strip located toward the upper-left-hand side of the screen. At a certain point, a subtle stream of reddish-yellow-tinted light begins a pulsating flow in the lower segment of the image. Then, the contours of two larger black formations become identifiable: one isolated on the right-hand side, the other extending toward the left edge of the screen, both increasingly illegible toward the lower third of the visual field. As this process unfolds, the viewer realizes that what had initially seemed to be a growing contrast of dark on dark is actually an increasing lightening-up of the background: as the luminosity of the image amplifies, it becomes clear that the dark contours mark elements within a silhouette of high-rise buildings set against a reddening

sky. As clouds stream past them and the light is caught on their increasingly modeled forms, as it is reflected on the glass surfaces of their windowed walls, the viewer understands that the film has been showing an extended period of time in compression. Inadvertently, she or he has witnessed a speeded-up, filmically condensed static take of a sunrise over a city: the city of Frankfurt, whose commercial and administrative mid-to high-rise buildings stand on the bank of the river Main, which cuts into the lower-right-hand corner of the image, its wind-agitated surface streaming in the same direction as the clouds in the sky—that is to say, away from a source point located somewhere beyond the image's right side. The water's reflections contribute to the continued play of light whose earlier elements can now also be identified: the tiny specks were lampposts lining the walkway by the river, the upper left band emanated from the top floor of a mid-rise building, the pulsing reddish stream, now engulfed in and eradicated by growing daylight, was the ephemeral trace left by cars during the early beginnings of rush hour. Some hours of darkness, followed by thirty minutes of unfolding light, have passed in one minute of cinematic time (figures 1.1–1.6).

Too General to Be Filmed Directly

This rather precise temporal determination is suggested by the following brief entry in Alexander Kluge's story collection *Geschichten vom Kino* (*Cinema Stories*), published more than twenty years after the making of *Die Macht der Gefühle*:[1]

> Um fünf Uhr früh muß die Kamera am Mainufer aufgestellt sein. Sie registriert in den folgenden Stunden das Verlöschen der Lichter der Stadt; für eine kurze Zeit ist es ganz dunkel (die letzten Menschen sind schlafen gegangen), dann erhebt sich vom Osthorizont des Herbsttages her ein schwaches Grau, das die Hochhäuser enthüllt. Aus deren Zentralka-

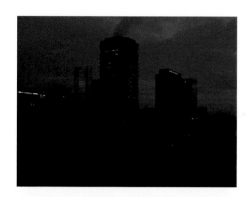 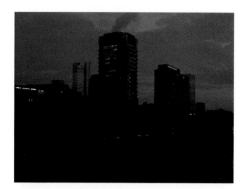

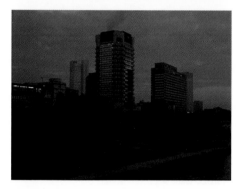 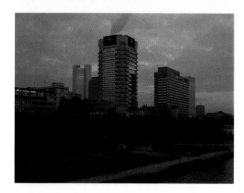

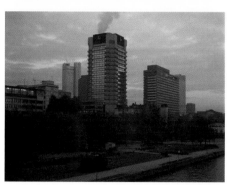 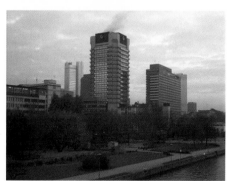

1.1–1.6 *Die Macht der Gefühle/The Power of Feelings* (1983, 35 mm, color and b/w, 113 min). Alexander Kluge / Kairos Film.

minen steigt steil eine Dampfsäule in die kalte Luft, die Hei-
zungen sind längst angeworfen. Die Sonne zieht über die Fen-
sterfront eines Hochhauses in Überstrahlung. Währenddessen
liegt der Westhorizont noch in blau-violetter Dämmerung.
Mehr als 1600 Farben unterwegs. Nach einer halben Stunde
hat die Sonne die interessantesten Anfänge dieses Tages gleich-
gemacht. Das Tageslicht hat die Einzelfarben zum großen Teil
verschluckt. Die Tagesarbeit hat begonnen. Die Kamera kann
abgebaut werden.[2]

[The camera has to be set up as early as five a.m. on the bank
of the river Main. During the following hours it registers the
fading of the city lights; for a short period of time it is entirely
dark (the last people have gone to bed), then a faint gray rises
from the eastern horizon of the autumn day that unveils the
high-rises. A column of steam rises steeply from the build-
ing's central chimneys into the cold air; the heating has been
on for a good while. The sun passes over the window front
of a high-rise in irradiation. Meanwhile, the western horizon
still lies in blue-violet dawn. More than 1,600 colors are on
their way. After half an hour the sun has leveled out the most
interesting beginnings of the day. Daylight has almost entirely
swallowed the individual colors. The day's labor has begun.
The camera can be taken down.]

This indeed very short story—*if* it can be considered a story at all and
not, rather, a report, for its near-absence of even a rudimentary narrative
plot-line—is titled "Zeitrafferaufnahme eines Sonnenaufgangs" (Time-
Lapse Take of a Sunrise).[3] It retells the opening sequence from *Die Macht
der Gefühle*.[4]

This entry corresponds with another text in Kluge's volume that pre-
cedes it by only one and a half pages. This story, titled "Solarkamera

Jupiter" (Solar Camera Jupiter), is anecdotal in style, and illustrated by a photo. Interrupted by brief passages of anonymous dialogue whose interlocutors partially discuss the accompanying picture, partially the event itself, the text describes the Edison company's attempts at establishing a camera, product name "Jupiter," that would be able to film the sun, especially the sunspots—with less than thrilling results:

> "And what was so interesting about this take?"—"That's what we were wondering, too, after we had seen the images. It's a strip of two minutes' length. … A commentator needed to point out to the audience that they had to pay attention to these barely moving spots: that they, who had paid an admission fee, were the first living beings on the planet to "really" see the sun and its wandering spots."[5]

Kluge's story lets Edison come up with an explanation for this failure, an explanation that closes the circle to the opening sequence of *Die Macht der Gefühle*: "The sun itself (*die Sonne selbst*), claimed Edison, was too general (*zu allgemein*). He explained the commercial failure of the film by saying that it was impossible to register 'light itself' (*Licht selber*), only objects or persons moving in light."[6]

These two narrative returns to the opening images of *Die Macht der Gefühle*, coming more than two decades after the filmic fact, help to establish an initial framework for determining what is conceptually at stake in that sequence. The chronologically earlier example from Kluge's filmic practice already demonstrates how the cinema is able to capture light through a particularization, or specification: by means of a temporally condensed contrast effect that sets and thus visualizes the growth of luminosity against the static, unchanging forms of buildings which make up a city. This inflected visualization of light through the architectural medium already occurs in a negative manner, as it were, in Kluge's 1974 film *In Gefahr und größter Not bringt der Mittelweg den Tod* (*In Danger and*

Dire Distress, the Middle of the Road Leads to Death), which, like *Die Macht der Gefühle*, begins with a series of shots of architecture. With buildings set against an open sky, the camera here records a time-lapse sequence that traces a shadow's movement across a façade, as if architecture were a sundial on which light in time becomes readable.

In Kluge's entire *œuvre*, takes like these stand in the context of an ongoing exploration of the camera's encounter with luminosity. Occasionally, this results in images of an almost pictorial still-life quality, such as simple shots of burning candles, or warmly colored desk lamps set against intensely blue backgrounds (figures 1.7–1.12). There are also more conceptual moments, such as a series of clips devised in collaboration with cameraman Michael Ballhaus, created through mounting systems of century-old lenses onto electronic cameras.[7] Here, the visual recording of a lit match which gradually goes out serves as an occasion to probe the technological apparatus's capacity for storing high-resolution luminous information. And then there are cases where Kluge employs light to generate peculiarly formalist structurings of the image—for example, in some of his television features in which a lightbulb on a cord hangs right into the upper half of the frame, where it functions as a strange radiating counterpart to the face of Kluge's filmed interlocutor. Or when he places light sources in the background of one of his shots, pointing them directly toward the camera, thereby creating luminous plays of halos and reflections.

Yet in none of these examples does Kluge explore the conditions which make light itself visible as clearly and methodically as in his takes of architecture. This is spelled out even more clearly in the shot which follows this opening sequence: here the glass façade of a high-rise becomes the reflector for one central emerging sunlike glow that radiates straight into the camera, as if the lens were pointed directly at the sun (figures 1.13–1.15). Following a series of three further shots that capture the morning sky against architectural silhouettes—two of them panning

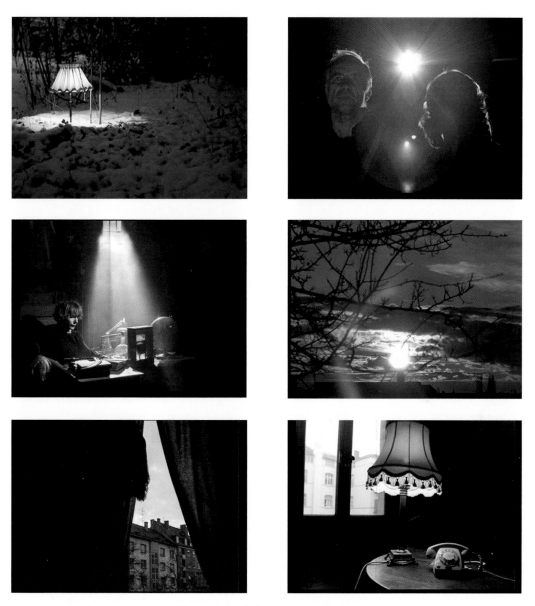

1.7–1.12 Treatment of light—*Landschaften mit Eis und Schnee/Landscapes with Ice and Snow* (2010, DVD, color, 180 min) (fig. 1.7); *Der Angriff der Gegenwart auf die übrige Zeit/The Assault of the Present on the Rest of Time* (1985, 35 mm, color, 113 min) (fig. 1.8); *Die Patriotin/The Patriot* (1979, 35 mm, color and b/w, 121 min) (figs. 1.9, 1.10, 1.12); *Die Macht der Gefühle* (fig. 1.12). Figure 1.7: Alexander Kluge / Filmedition Suhrkamp. Figures 1.8–1.12: Alexander Kluge / Kairos Film.

along with an airplane in flight—the sequence ends with a dim autumn sun that is gradually covered by clouds (figures 1.16–1.18).

GERMAN HISTORY

After a still frame showing the film's title, followed by what appears to be documentary war footage and a disturbing sequence of a dying child, the architectural element is taken up again, this time through refilmed and slightly slowed-down footage from Fritz Lang's 1924 cinematic version of the *Nibelungenlied*. We see a scene in which Krimhild has led Hagen, traitor and murderer of her former husband Siegfried, to join her at the court of her new spouse, Etzel, king of the Huns. Krimhild's pretense—a celebration of reconciliation—is discovered; in the ensuing fight she and Hagen are killed, and the palace is set on fire. The buildings—or, rather, their cardboard mock-ups—collapse like the proverbial house of cards. The scene recalls Wagner's specific blending of material derived from the early-medieval *Nibelungen* epic with the even older Ragnarök theme, which originates in ancient Germanic mythology, where it describes the ending of the world in flames. The filmic footage of tumbling architecture used by Lang—and Kluge—here is an echo of the burning down of Valhalla, palace of the gods. For Wagner, this story furnished the imagery for the apocalyptic finale of his *Ring* cycle in *Götterdämmerung*. In Kluge's *Macht der Gefühle*, this moment ties into the film's opening sequence, which is set to the score of another Wagner opera, the overture from *Parsifal* (figures 1.19–1.24).[8]

Dwelling on its German theme, Kluge's film then cuts to a sequence of documentary footage shot at the 1981 memorial service for Heinz-Herbert Karry, a politician from the Freiheitliche Demokratische Partei (Germany's liberal party) and former secretary of commerce (*Wirtschaftsminister*) for the Hessian state, who was assassinated in an attack for which the anarchist formation Revolutionäre Zellen claimed responsibility, while also declaring it "a mistake."[9] The depiction of this event recalls

1.13–1.18 *Die Macht der Gefühle*. Alexander Kluge / Kairos Film.

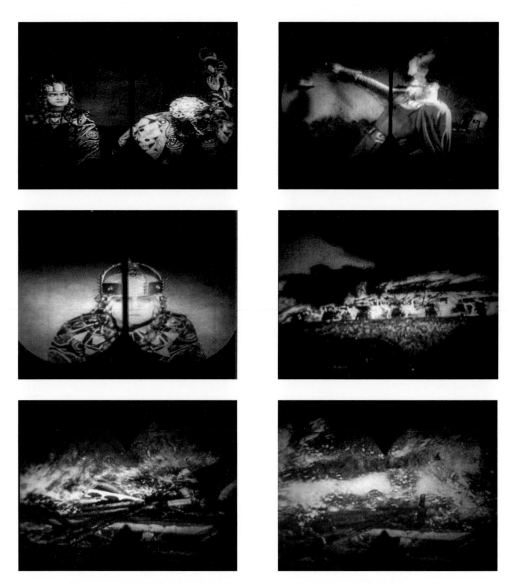

1.19–1.24 *Die Macht der Gefühle*—refilmed footage from Fritz Lang's *Nibelungen*, shot through masks and additional color filters. Alexander Kluge / Kairos Film.

segments from Kluge's contribution to the collectively produced and directed 1977 *Deutschland im Herbst* (*Germany in Autumn*), for which he had already filmed two funerals: that of industrialist and former SS member Hans-Martin Schleyer, who had been held hostage and was later executed by the leftist terrorist Rote Armee Fraktion (Red Army Faction); and the ceremony in Stuttgart's Dornhalden cemetery in which RAF members Gudrun Ensslin, Andreas Baader, and Jan-Carl Raspe were buried after committing suicide in Stammheim prison, after their comrades' unsuccessful attempt at forcing the German state into a "prisoner exchange" in which Schleyer and hostages aboard a hijacked Lufthansa jet would be "traded" for the Stammheim inmates. Through its architectural setting, the funerary scene also alludes to the immediately preceding Wagnerian allusion in Lang: the room's high circular ceiling; the German and Hessian state flags suspended from above; and the curved rows of black seating, all make it clearly recognizable as the Frankfurt Paulskirche, which housed the 1848 parliamentary assembly that instituted Germany's first constitution—a revolutionary movement with which Wagner was affiliated and for which he fought on the Dresden barricades. That revolution was quickly overthrown by the Kaiser's forces, who abolished the democratic constitution and forced Wagner into exile in Paris. After the architectural establishing sequence, a protracted shot introduces the mourning crowd and its prominent members (Holger Börner, the Hessian prime minister; Karry's widow; and federal chancellor Helmut Schmidt, who in 1977 had ordered the storming of the hijacked Lufthansa jet sitting on an airfield in Mogadishu, an event that triggered the Stammheim terrorists' suicide, and Schleyer's execution). The film then returns to the characteristic superimposition of architecture and light with which it had opened: filming diagonally upward, the camera captures the expanse of the room's upper part, an array of arched windows, and wooden beams that radiate outward from a large oval window in the center of the ceiling. Their formal arrangement is complemented by a set of light fixtures. These are straight chains that hang down into the room, each of them

a string of alternating metal wire elements and neon tubes whose light joins the sun shining in through the windows. The stylistic austerity and matter-of-fact documentary tone of the image renders its resonance with opulent baroque depictions of saints' or God's aureoles—as outwardly spreading systems of fine gilded metal bars—almost unnoticeable. Perhaps this architectural resonance is a comment from a decidedly Protestant aesthetic standpoint about the historical process of secularization, or a sublimation of Catholicism's imagery, by which the radiating halo is abstracted into the architectural structure of a Protestant church. It might also be a hint at the German history of reformation itself, with its subsequent split of religious and state power, which are evoked here by the locale of the event. This now-defunct church served as the site for a very short parliamentary intermission, and now houses a funerary service held by a republican state for a victim killed by this state's militant anarchist opposition (figures 1.25–1.30).

Unbinding Complexity from Architectural *Longue Durée*

This approximately seven-minute-long sequence highlights the astonishing (cross-)referential density that Kluge establishes through the montage of a set of filmic images none of which, considered by itself, would stand out as remarkable in terms of camera angle, movement, or location. In fact, in spite of the territorial and temporal reach unfolded in this image suite and in the subsequent film, Kluge never even had to leave the city of Frankfurt when he was making *Die Macht der Gefühle*. The confines of the setting are broken up, first, through the integration of archival material (Lang, World War I), and, second, through the spatial reference to distant places, like Stammheim or Mogadishu, that comes with the actual historical character of filmed buildings or events (the Karry funeral in the Paulskirche points to Stammheim, the Dornhalden cemetery, and the rites for Schleyer and Baader, Ensslin, and Raspe). This illustrates how Kluge's work essentially relies on the camera's documentary capacities—a

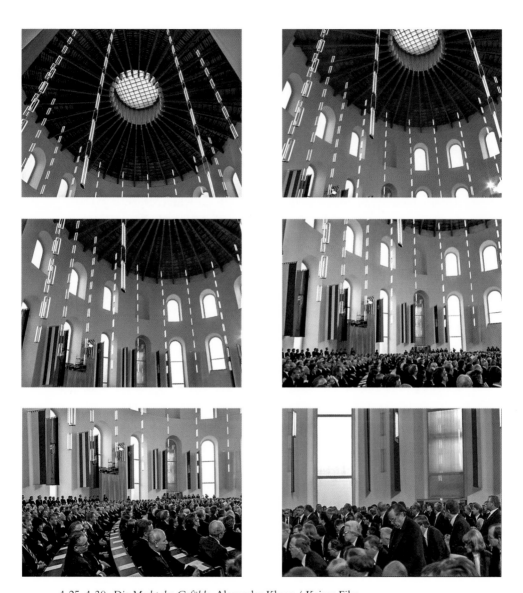

1.25–1.30 *Die Macht der Gefühle*. Alexander Kluge / Kairos Film.

correlate to the use of historical chronicles in his literary texts. Here, the integration of (West) Germany's political history results from the depiction—or, more precisely, the visual recording—of its specific sites and protagonists. At the same time, it shows clearly that Kluge's documentary practice is never reductively "factualist" or merely aiming at what is in front of the lens. The Paulskirche is being filmed because as a building it concretely embodies a site of German history, but also because this history and its architectural structure point to distant places and histories. Finally, the entire sequence demonstrates the frequently overlooked centrality which the theme of architecture holds for Kluge, especially in relation to cinema and film. Through the treatment of the built environment, the opening images of *Die Macht der Gefühle* constitute one variation on a theme that has been present in Kluge's textual and filmic output from the very beginning.

For example, Kluge's best-known literary story, "Der Luftangriff auf Halberstadt am 8. April 1945" (The Air Raid on Halberstadt on April 8, 1945), first published as Heft 2 of the 1977 volume *Neue Geschichten. Hefte 1–18. Unheimlichkeit der Zeit* (*New Stories. Notebooks 1–18. The Uncanniness of Time*), begins with the reproduction of a poster for Gustav Ucicky's 1941 Nazi home front propaganda movie *Heimkehr* (*Homecoming*), starring Attila Hörbiger and Paula Wessely (figure 1.31).

The image depicts a village street lined with two-story houses. A column of text extends down the left side, and fills the lower segment of the page. Here the reader finds a description of the cinema where a matinee screening of *Heimkehr* is scheduled to take place:

> The "Capitol" cinema is owned by the Lenz family. Frau Schrader, the sister-in-law, is the manager and cashier. The wooden panels of the balconies and the boxes, and the parquet, are in ivory tones; there are red velvet seats. The lamp covers are made of brown faux pigskin.[10]

Heft 2
Der Luftangriff auf Halberstadt
am 8. April 1945

I

[Abgebrochene Matinee-Vorstellung im »Capitol«, Sonntag, 8. April, Spielfilm »Heimkehr« mit Paula Wessely und Attila Hörbiger] Das Kino »Capitol« gehört der Familie Lenz. Theater-Leiterin, zugleich Kassiererin, ist die Schwägerin, Frau Schrader. Die Holztäfelung der Logen, des Balkons, das Parkett sind in Elfenbein gehalten, rote Samtsitze. Die Lampenverkleidungen sind aus brauner Schweinsleder-Imitation. Es ist eine Kompanie Soldaten aus der Klus-Kaserne zur Vorstellung herangemarschiert. Sobald der Gong, pünktlich 10 Uhr, ertönt, wird es im

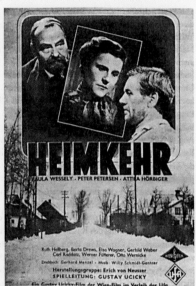

Kino sehr langsam, den dazwischengeschalteten Spezialwiderstand hat Frau Schrader gemeinsam mit dem Vorführer gebaut, dunkel. Dieses Kino hat, was Film betrifft, viel Spannendes gesehen, das durch Gong, Atmosphäre des Hauses, sehr langsames Verlöschen der gelbbraunen Lichter, Einleitungsmusik usf. vorbereitet worden ist.

Jetzt sah Frau Schrader, die in die Ecke geschleudert wird, dort, wo die Balkonreihe rechts an die Decke stößt, ein Stück Rauchhimmel, eine Sprengbombe hat das Haus geöffnet und ist nach unten, zum Keller, durchgeschlagen. Frau Schrader hat nachsehen wollen, ob Saal und Toiletten nach Vollalarm restlos von Be-

1.31 *Der Luftangriff auf Halberstadt/The Air Raid on Halberstadt (Chronik der Gefühle/Chronicle of Feelings version)*—opening page. Alexander Kluge.

Introduced by the casual remark "Now Frau Schrader saw, as she was being hurled into the corner, a piece of smoky sky, where the balcony row touches the ceiling," the text describes "probably the strongest shattering (*Erschütterung*) that the cinema had ever experienced under the direction of Frau Schrader, hardly comparable to the shattering (*Erschütterung*) caused by the best films"—a description that cuts right through the architectural setup of (the) cinema: "an explosive bomb had opened up the house, right down to the basement."[11]

Kluge's second film, the approximately ten-minute-long *Brutalität in Stein* (*Brutality in Stone*), co-directed with Peter Schamoni in 1960, charts a historically related architectural ensemble through accelerating montages of first static, then moving camera shots which capture, image for image, the Albert Speer-designed *Reichsparteitagsgelände* in Nuremberg, interspersed with photographs of Hitler executing sketches for the ensemble, as well as historical photographs and design drawings. *Brutalität in Stein* thus depicts a type of building which was notoriously intended to last for a thousand years and was supposed to enter a state of heroic decay afterward, an imaginary anticipation of (self-)destruction, attested to in the film's last images which show walls disintegrated into heaps of granite blocks.[12] This sort of ruining is markedly different from the total destruction experienced by Frau Schrader's cinema, along with her entire hometown, as an effect of the aerial *Vernichtungskrieg* (exterminatory warfare). We also see, of course, a terrain that became cinema history as the locale of Leni Riefenstahl's 1935 propaganda film *Triumph des Willens* (*Triumph of the Will*) (figures 1.32–1.37).[13]

The architecture of another Reich is explored in the 1977 short *Nachrichten von den Staufern* (*News from the Staufers*). If Kluge's literary stories occasionally highlight the historic constellation of *Stauferkaiser Friedrich Barbarossa* and the National Socialists' later attempt to establish a "third" Reich, claiming to follow a tradition that reached back to Friedrich's empire (exemplified by the Aktion Barbarossa, i.e., Germany's invasion of the Soviet Union in 1941), this piece, occasioned by the 1977 centennial

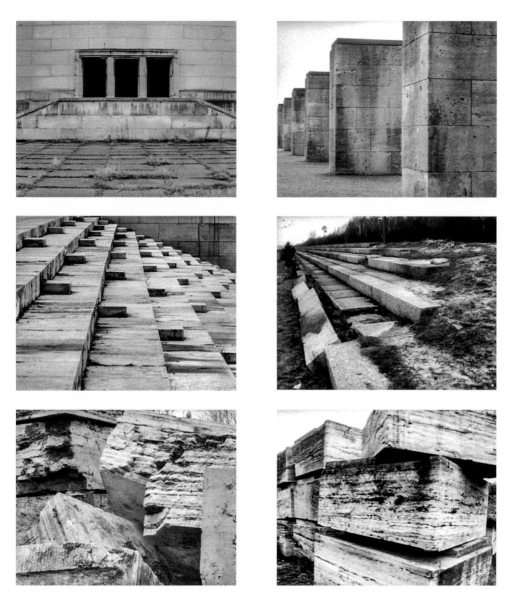

1.32–1.37 *Brutalität in Stein/Brutality in Stone* (1960, 35 mm, b/w, 12 min). Alexander Kluge / Kairos Film.

Staufer-Jahr (*Year of the Staufers*), is situated at least partially in formal parallel to *Brutalität in Stein*. The film's opening consists mostly of architectural documentary shots: it moves from an external view of a Romanesque apse into an exploration of its exterior frieze, to a 360-degree analysis of a ruined castle (subsequent shots explore its dimensions in height [a tower] and depth [the gorge on the border of which the building stands]) (figures 1.38–1.43).[14] In each case—and this also holds for the Paulskirchen images in *Macht der Gefühle*—Kluge's camera explores and exploits architecture as a medium of *longue durée* stability whose existence across periods of history allows for the unfolding of a multiplicity of historical layers unconnected by linear succession, or by strict patterns of cause and effect (one event led to the next): a type of causation that might prompt a completely different type of montage. Instead, a Klugean architectural sequence brings historical time as complex layering into visibility through cinematic montage in the first place, a procedure through which the depicted building is figured as an entity which in its particularity functions as the attractor for a specific long-term temporal sedimentation, as it were. For Kluge, this architectural *longue durée* includes political attempts to master it and to turn this domination into built machines of oppression (Nuremberg), as well as the consequence of some of these attempts, namely the annihilation of buildings, as with the *Kino Capitol* in the course of the "Luftangriff auf Halberstadt."

MEDIA OF FINALIZATION

In order to demonstrate the function of architecture in Kluge's work more clearly, it is perhaps inevitable to proceed from an assumption that entails the risk of a problematic connection: a leveling of differences between the National Socialist buildings and ideology documented in *Brutalität in Stein* and architectural activity in general. For Kluge, any architectural formation contains this potential for a bad type of historical consolidation or finalization, a tendency to become harmfully rigid, even

1.38–1.43 *Nachrichten von den Staufern I und II/News from the Staufers I and II* (1977, 35 mm, b/w, part I: 13 min, part II: 11 min). Alexander Kluge / Kairos Film.

oppressive, and no longer susceptible to transformation. Kluge has made some remarks to this effect in the addendum to the book *Der Angriff der Gegenwart auf die übrige Zeit* (*The Assault of the Present on the Rest of Time*) that accompanied the film of that title—a film that focuses on the nexus between cinema and architecture:

> Das Kino besteht aus Vorführsälen, Glaspalästen, Fronttheatern, vielen anderen Versammlungsstätten … Das vorliegende Filmvorhaben befaßt sich:
>
> (1) mit Elementen des Kinos
> (2) mit der Illusion der Stadt
>
> …Das stilistische Bindeglied … ist die Kategorie der Zeit (s.u.) Filmzeit, "verdichtete dramatische Zeit der Städte," Lebenszeit.[15]

> [Cinema consists of projection halls, glass palaces, mobile theaters at the war front, many other places where people congregate. … The present project for a film deals with:
>
> (1) the elements of cinema
> (2) the illusion of the city
>
> … The stylistic link … is the category of time (see below), filmic time, "condensed dramatic time of the cities," lifetime.]

In this addendum Kluge writes:

> Im Dezember 1983 rief mich Karl-Heinz Bohrer an, der … Herausgeber der Monatshefte MERKUR. Er fragte mich, ob ich ein Essay schreiben könnte mit dem Titel: Die Endgültigkeit der Städte. … Tatsächlich … spricht vieles dafür, daß die Städte, so umbaut wie sie es jetzt sind, die Wohnstätten sein werden, mit denen wir ins 21. Jahrhundert gehen.[16]

[In December 1983 Karl-Heinz Bohrer, editor of the monthly MERKUR, called me. He asked me whether I could write an essay under the title: The Finality of our Cities. … Indeed … many things suggest that cities, walled in as they are now, will be the homes with which we enter the twenty-first century.]

Instead of writing that essay, Kluge made *Der Angriff der Gegenwart*, a continuation of his previous film *Die Macht der Gefühle* (with its complementary focus on opera), both of which, like Kluge's entire project, at least test the statement: "Eine der schärfsten Ausdrucksformen der Endültigkeit ist der umbaute Raum. Bei einer Grabkammer merkt das jeder."[17] [One of the most acute forms of expression of finality is walled-in space. Everybody realizes this in the case of a tomb.] Just such a tomb appears in a sequence of historical footage integrated into *Die Macht der Gefühle* and shown there through the double oculus of a graphic mask over the filmic image. This "telescope" peeks at a scene from Ernst Lubitsch's 1922 *Das Weib des Pharao* (*The Loves of Pharaoh*), a cinematic version of Verdi's *Aïda*, acoustically accompanied by the opera's musical score, and reveals the image of the opera's protagonist, Aïda, and her lover, Radames, buried alive in the architectural enclosure of a pyramid grave (figures 1.44–1.47).

In this example, the finality of building, as exemplified in the *umbauter Raum*/walled-in space of the tomb, corresponds to another type of finality: namely, the fatelike structure of emotions which is associated with a specific logic of the sacrifice, in which reconciliation and redemption come at the cost of death; or so suggests Kluge's analysis of the plot structures of nineteenth-century opera and twentieth-century "entertainment" film, each of them the *Kraftwerk der Gefühle* (power station of feelings) to their respective periods, each of them thematized in one of the two sister films *Die Macht der Gefühle* (opera) and *Der Angriff der Gegenwart auf die übrige Zeit* (cinema) as institutions, art forms, genres and

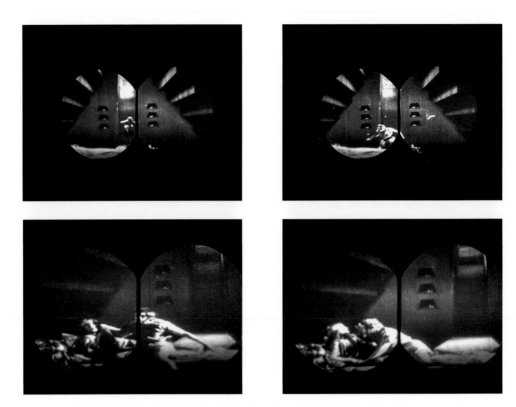

1.44–1.47 *Die Macht der Gefühle*. Alexander Kluge / Kairos Film.

material practices that partake in the formation of the historical subject's affectivity:

> Im 20. Jahrhundert ist der öffentliche Hauptsitz der Gefühle das Kino. Die Organisierung lautet: auch die traurigsten Gefühle nehmen im Kino einen glücklichen Ausgang. Es geht um eine Tröstung. Im 19. Jahrhundert ist der Hauptsitz der Gefühle die Oper. Die erdrückende Mehrheit der Opern hat ein tragisches Ende. Man sieht einem Opfer zu. … Sowohl in der Oper wie im klassischen Kino bleiben die Gefühle gegenüber der Macht des Schicksals ohnmächtig. Im 20. Jahrhundert verbarrikadieren sie sich um den Trost herum, im 19. Jahrhundert verschanzen sie sich um den Wahrheitsgehalt des tödlichen Ernstes.[18]

[In the twentieth century, cinema is the major public seat of feelings. The organization is as follows: even the saddest feelings have a happy ending in the cinema. The goal is consolation. In the nineteenth century, opera is the major public seat of feelings. The overwhelming majority of operas have a tragic ending. One watches a sacrifice. … Both in opera and in classical cinema, feelings are helpless against the power of fate. In the twentieth century, they barricade themselves around consolation; in the nineteenth century, they fortify themselves around the truth content of deadly seriousness.]

A sequence in *Der Angriff der Gegenwart* visualizes this relation, almost allegorically, by first splitting the screen horizontally into two layers on which run different segments of historical footage, perhaps documentary, perhaps fictional (the upper half shows a military parade of horsemen, then a clock, and a deck of cards, while the camera on the lower half

witnesses the sinking of a combat ship); the film then cuts to a single shot of an architectural façade at night, where the camera captures two rows of illuminated windows along which it subsequently begins to pan. Moving from horizontal split screen to a two-tier system of windows (figures 1.48–1.53), Kluge constructs an analogy between the illuminated field of the filmic image and the lighted transparent openings in a building which begin to resemble a celluloid strip. Through a movement from image to image, he thus establishes a nexus between architecture and cinema—a relation that can function as a parallel between its two poles as media of finalization.

And yet film is clearly not an irredeemable medium for Kluge. His own rich cinematic practice testifies against a sweeping dismissal of the moving image. That is to say: for Kluge, there is no finality to this finalization, and there is at least some chance of altering the course of things from within. He aims at establishing a critical practice within a problematic field, to produce difference within finality. (It would also be this type of difference within finalization that would redeem the earlier connection between Fascist, totalitarian architecture—i.e., building for the *tausendjähriges Reich*—and any other type of architectural production as a possible, but not a necessary one.) For Kluge, the (filmic) image is the site for a decision as to whether or not this finalization occurs:

> A subproject of this architecture is cinema, which is always ambivalent insofar as, on the one hand, it does not obey its administrators at all, while on the other it is a mechanism of appropriation. Only with regard to this second aspect could one say that cinema resembles a tomb, but the audience will always escape in time, and cinema will thus not function as a prison.[19]

1.48–1.53 *Der Angriff der Gegenwart auf die übrige Zeit*. Alexander Kluge / Kairos Film.

In Kluge's work there is no definite decision or verdict as to whether or not this finalization actually comes into effect. The prison never fully forms, but neither is its impending closure fully averted. Rather, Kluge's practice can be regarded as an ongoing negotiation of this precarious balance, a perpetual construction of escape routes from and openings within systems that have the constitutive tendency to harden into suppressive rigidity. Subsequent chapters in this book attempt to analyze the assumptions, implications, and strategies that in Kluge's work respond to these tendencies.

ARCHITECTURAL *DISPOSITIFS*, URBAN REALITIES

A sequence of early-twentieth-century animated drawings from *Der Angriff der Gegenwart auf die übrige Zeit* makes it clear that in Kluge's understanding, the connection between film and architecture is by no means purely metaphorical, i.e., that the political stance implied in the parallel between buildings and cinema as media of finalization belongs to the register of media-historical realities. Accompanied by the ongoing explanations from a commenting voice, the sequence begins with an image of a man drawing a film projector on a blackboard. The film then cuts to a black ground with animated white lines and letters that map out the mechanics and design of the projecting machine invented by the Lumière brothers: the construction plan for the film projector unfolds in time, and the resemblance to the construction plans for buildings that look like boxes can hardly be overlooked (figures 1.54–1.59).

In Jean-Louis Baudry's terms, one could say that here Kluge visually maps elements of the cinematic *dispositif*, i.e., the technological assemblage that formats filmic projection and reception. And just like Foucault—who picked up on Jean-Louis Baudry's concept of the *dispositif* as a model for a general elaboration of the architectural articulation and implementation of power—Kluge also connects his visualization and exploration of the film camera to an understanding of architecture as a formatting force.[20]

1.54–1.59 *Der Angriff der Gegenwart auf die übrige Zeit*. Alexander Kluge / Kairos Film.

Some passages from *Geschichten vom Kino* elaborate on this nexus between architecture and film, by talking about the "machines" that make up cinema. One of these "machines," Kluge explains, implements the principle of an "Öffentlichkeit gegen Bezahlung" [a public sphere in return for payment]. It functions through a very basic setup, an architectural enclosure to which access is granted through a single entry, coupled with a ticket office. In this sense, Kluge writes, the cinema continues the older model of the theater, the variety show, etc.[21] To account for the specificity of the cinematic *dispositif*, however—i.e., to account for the cinematic difference *vis-à-vis* these older institutions—Kluge has recourse to a genuinely urbanist model: Rem Koolhaas's theory of the "technologies of the fantastic" which he developed in his 1978 "retroactive manifesto for Manhattan"—*Delirious New York*—and which Kluge has Koolhaas describe in one of his stories to an audience of a thousand people in a lecture hall at a Munich university (it is unclear whether this actually took place).[22] According to Koolhaas, what contributed to cinema's commercial but also experiential success was a gesture of urbanist displacement which was at the same time a moment of economic repurposing: a process whereby a worn-out, almost obsolete technology was supposed to be dedicated to one last round of profit generation, when the cinema automata were transposed from the fairgrounds into the city, a maneuver that installed nascent cinema in the urban heartland. What started out as a mere capitalist enterprise inadvertently met a genuine longing, a desire among its potential audience of urban dwellers, who could "abuse" it for their own purposes. Kluge follows Koolhaas's argument about this displaced usage of the "technologies of the fantastic" on the pleasure grounds of Coney Island. Installed within the city's fabric, these initially mobile automata became little booths which, for one penny, allowed the customer to watch a short film through a peephole; hence was born the penny arcade, and the city received its own—sometimes escapist, sometimes utopian—architectural component.[23] Kluge emphasizes that this coming into being of cinema in its proper character

must not be confused with an individual entrepreneurial invention: "Es wurde nicht von Unternehmern erfunden" [It was not invented by entrepreneurs].[24] Rather, he stresses the accidental, contingent nature of an encounter between an economic drive to exploitation and profit maximization on the one hand, and on the other an actually existing, localizable urban unhappiness or misery of the city-dwelling subject who encounters and uses an architecturally implanted "technology of the fantastic." Cinema, according to Kluge,

> developed spontaneously from chance occurrences and the pent-up desire of passers-by who felt lost in New York and could not afford more than one cent. Their desire to withdraw from real life, at least for a short time, and to gaze through a peephole into a foreign world, proved favorable for a number of machines which had been set up to show filmstrips.[25]

Cinema in its urban implantation, then, carries an escapist potential—linked to the possibility of this desire's economic exploitation—from the moment of its accidental birth; but Kluge emphasizes that it also offers at least the promise, prompted by unhappiness in the city, of a different, utopian state: "moments of surprise, of a sudden glance into another world, the world of remembrance, provoked by the strip of film."[26] Moreover, it is this affective state—unhappiness, longing—and the *Ahnung* (glimpse, inkling) of a possible solution that generates a new medium: "Die Ahnung, daß es überhaupt Momente von 'besinnungslosem Glück' gebe, reiche aus zur Errichtung eines Mediums" [the inkling that there might be moments of "mind-blowing happiness" suffices to build a medium].[27] (See also Kluge's definition "Film = movie = Medium der Gefühle" [medium of feelings].)[28] In a shift from this description of an affective discrepancy (unhappiness) in a real architectural environment, Kluge then has Koolhaas extend the concept of architecture to films themselves,

to "die Bauten, welche die Filme selbst darstellten" [the buildings, which represent films themselves]:[29]

> Medien seien aber, weil die Gefühle sich solche Wohnungen, Höhlen oder Häuser suchten, in denen sie sich einnisten, am besten nach den Kriterien der Architektur zu beurteilen. Es wird nicht das Geschmacksurteil der Zuschauer eingefordert, sondern ihre Gewöhnung. Fühlen sie sich wohnlich, d.h., entstehen offene Räume, so ist es gleich, ob Kitsch oder Kunst regieren.[30]

> [Since feelings were searching for such dwellings—caves or houses to nest in—media were best judged by architectural criteria. It is not the audience's judgment of taste that is demanded, but the habituation of feelings. If they feel at home, i.e. if open spaces develop, it does not matter whether kitsch or art rules.]

Kluge thus makes Koolhaas a spokesperson for a theory that extends the architecture/cinema analogy by declaring media in general to be habitats for feelings and affects; constructed environments that are judged less according to criteria of taste, and more by affective habituation. Film is a medium that houses emotions.[31] The German play between *Gewöhnung* (habituation, familiarization, becoming used to something) and *Wohnung* (habitat, dwelling, house, apartment) indicates the theoretical subtext underlying this passage: Benjamin's theory of film as a technical medium that shares with architecture the function of affective habituation.[32] Kluge's work takes this theory to its conclusion: by spelling out the real unhappiness and longing of the inhabitant of a city; by describing the architectural *dispositif* (public sphere in return for payment, penny arcades) that reacts to this urban affective situation on the level of built

implementation; and finally, by positing the habituating function of cinematic "buildings," i.e., constructions, be they escapist or utopian, exercised in film. In Kluge's work, architecture and film can thus be described as actual *and* conceptual, historical *and* theoretical entities (early-twentieth-century Manhattan as a historical city versus architecture as a "metaphor" for filmic construction; film as a historical invention and intervention versus film as a "metaphor" for a medial organization of experience/feelings). Each can shift from one to the other on all levels: from historical to conceptual; film as a stand-in for architecture; architecture as a "conceptualization" of film. What binds them together, just like a spine around which they rotate, is the reality of *Gefühl* and *Erfahrung*: unhappiness in the city, the promise of happiness (*Glücksversprechen*) in film.

THE CAVE/THE GRAVE

If "die Grabkammer und das Kino" [the burial chamber and the cinema] mark oppositional architectural arrangements for Kluge, then they are also encryptions for an ancient epistemological topology that has been cited in prominent film-theoretical texts, most notably Baudry's *Le Dispositif*, to account for cinema's spatial configuration: the image of the cave, as it figures in Book VII of Plato's *Republic*.[33] Kluge has on at least one occasion entertained such a comparison: "I would compare cinema to the Platonic allegory of the cave, if that did not strike me as an exaggeration."[34] Even if Kluge relativizes the comparison, it is almost impossible not to perceive a Platonic echo in the story about the *Solarkamera Jupiter*'s failure to capture, to film, perhaps to "recognize" light directly. Plato's allegory provides images for the difficult negotiation of subject and knowledge in the terms of image and light: the inhabitants of the cave watch the play of shadows; their possible "liberation" from their ties; their ascent into open territory and their subsequent return to their fellows still bound in the realm of shadow projections. In Kluge's work, light as the medium from which emerges all camera recording takes the

role of this generality which, in its very generality, cannot be captured on film. This is why the opening images of *Die Macht der Gefühle* follow an alternative practice: they capture light through the medium of architecture. Or: light enters the image, because there is an image of architecture. This architectural particularization—the use of architecture as a medium for particularizing conditions otherwise too general to be represented—is crucial for Kluge. "Licht ist das Wesentliche, Zeitraffung, Licht, das unserem gewohnten Auge nicht entspricht."[35] [Light is essential, the compression of time/time-lapse, light that does not correspond to our habituated eye.]

A similar point can be made as far as the depiction of another generality is concerned: namely, time. Filming the built body allows for the observation and recording of temporal processes. This can occur on a level where phenomena and technology intersect (shots of unfolding reflections and wandering shadows on façades, the accelerated pulse of light against the static bodies of buildings). And it can occur as a montage-based exploration of the long and short history of a specific building which the camera documents in its particularity (e.g., the Paulskirche). In Kluge's work, architecture is hence also the privileged theme to emphasize the fact that represented time does not coincide with the time of technological recording. Neither is it the time of a potential film plot. Beyond narrative, Kluge is interested in the actual temporal extension of a building's existence. That is to say, he is interested in time in its manifestation as history.

The Klugean project partially resonates with a proposition formulated by Kluge's teacher, Adorno: "distance is abolished in film: to the extent that a film is realistic, the semblance of immediacy (*Schein von Unmittelbarkeit*) cannot be avoided."[36] The following chapters attempt to unfold the premises, implications, and consequences of Kluge's enterprise. Most of the time, however, they merely seek to reconstruct the operational logic which structures his work.

IMAGE MEDIA, FORMS, AND FORMATS

FILM, LIKENESS, CONTEXT: THE HISTORY AND THEORY
OF MONTAGE ACCORDING TO ALEXANDER KLUGE

(1) RUINOUS MONTAGE

MONTAGE AS NEGATION AND DISTINCTION

The first image that appears in Kluge's book *Der Angriff der Gegenwart auf die übrige Zeit* (*The Assault of the Present on the Rest of Time*)—it occurs after a few initial pages that summarize the volume's identically titled filmic sister project—is the reproduction of a drawing by Le Corbusier, a vignette-style portrait depicting a face split into two contrasting halves: on the left the distorted grimace of the Gorgon, her hair an aureole of winding snakes; on the right a face surrounded by a half-circle of rays, the serene expression of Helios, god of light, perhaps (figure 2.1). The very last image in the book—an illustration that closes the volume—is a partially schematized map of nineteenth-century Paris, charting the city area that extends northward from the Place du Théatre Français (figure 2.2). Or, more precisely: the stretch that once extended north from that square. What orients the map is a diagrammed strip that cuts horizontally right through the image. This dividing operation returns the viewer/reader to the volume's opening split image, the bisected portrait. In the context of the reproduced map, the division crosses an irregular system of small

2.1 *Der Angriff der Gegenwart auf die übrige Zeit/The Assault of the Present on the Rest of Time* (book version), frontispiece (drawing by Le Corbusier). Alexander Kluge.

Baron Haussmann war »Abrißkünstler« (artiste demolisseur). Er riß breite Teile von Alt-Paris nieder und baute auf der Grundfläche die Boulevards. Man kann heute von einer »Haussmannisierung des Geistes« sprechen, wenn man bestimmte Projekte der Neuen Medien verfolgt.

2.2 *Der Angriff der Gegenwart auf die übrige Zeit* (book version), closing image. Alexander Kluge.

streets and tiny patched-in building units—or, one might say, it crosses this system out. For this sectioning strip indicates the future trajectory of the Avenue de l'Opéra, one of the main arteries of Baron Haussmann's urban restructuring plan for Paris in which a system of regulated boulevards was intended to—and eventually did—replace the intricate post-medieval city structure. Once again, the now familiar unfolding of time through the representation of architecture plays out in Kluge's work. Here, the theme of building is extended from a single structure, or a single complex, to the geographically vaster territory of the city.

A historical rupture is coded into this reproduction of an urban map that traces the outlines of a mid-nineteenth-century plan for a then

future arrangement of buildings and streets whose implementation eventually led to the discontinuation of the existence of the older structures. Just as the map is split graphically by the diagram of a boulevard, the urban structures that it outlines are also subject to a set of temporal subdivisions. Not only does this plan allow the viewer to imagine the historical passage from what Baudelaire would call the *vieux Paris* to Haussmann's new city. By taking the temporal perspective of Haussmann the planner, before his urbanist work is actually carried out, this map also introduces a past-tense version of coming realizations and destructions. At that moment in time which this map assumes as the point of origin for its temporal perspective, the boulevards *would* appear, and the streets of medieval Paris *would* vanish. In both cases, this "would" indicates futures past.[1]

So far, the threshold images that lead into and out of the book version of *Der Angriff der Gegenwart* seem to perfectly continue the thematic and conceptual elaboration of the nexus between cinema and architecture which chapter 1 sought to analyze as a central theme in Kluge's work. The semantics of Le Corbusier's image seems to substantiate this interpretation: Helios's light, i.e., the light of projection and recording, the unfilmable sun; the petrifying gaze of the Gorgon, corresponding to the *umbauter Raum*/walled-in space; the urbanist activities of Le Corbusier and Haussmann as constructors whose conception of city planning and building involved the rearrangement of preexisting structures through acts of blunt destruction.

A commentary that accompanies the Paris map leads the way toward yet another connection between this (image-)material and the question of film: "Baron Haussmann was a demolition artist (*artiste démolisseur*). He tore down vast parts of Old Paris." This statement coincides with Kluge's appropriation of the term *artiste démolisseur*, usually employed to account for a Haussmannian type of urbanization, or for Le Corbusier's design ideal of the *tabula rasa*, to describe his own activity as a filmmaker: "The central point is that if one is making films, one acts to at least eighty

40

percent as an *artiste démolisseur*."[2] This idea—to model the actitivity of making a film as a tearing down, a demolition process—is intertwined with one of Kluge's basic theoretical propositions regarding images, which, in turn, implies a general anthropological assumption about the structure of cognition, perception, and affection on the one hand, and a concomitant conceptualization of the cinematic image on the other. On the level of anthropological speculation, Kluge operates with a brief definition of thought, perception, and feeling in relation to images as subtractive activities: "Wenn man denkt, wahrnimmt oder fühlt, macht man nicht mehr, sondern weniger Bilder [When one thinks, perceives or feels, one does not make more, but fewer images]." Kluge links this to a conceptualization of the perceptual and technological aspects of the filmic medium, which in his understanding is characterized by an interplay between light and darkness, visibility and invisibility, camera-recorded image and intermittent moments of non-recorded, blind slots, filmic frame and interframe. He writes that, rather than relying on the projection of 24 frames per second, the cinematic process is based "on an exposure of 1/48 seconds, followed by a dark phase of 1/48 seconds, the so-called transport phase. In average it is dark half of the time. For 1/48 second the eye looks outward and for 1/48 second it looks inward."[3] In *Geschichten vom Kino (Cinema Stories)* he extends this model into a theory of two streams which constitute every film: one light, the other dark; one based on recording, the other on its negation and supplementation through unseen, unrealized and possible images: "I see TWO FILMS, one made by the brain itself out of darkness, and one in light and color, as reported by the eyes."[4]

In his work Kluge recurrently (re)invents versions and variations of this basic theorem. For instance, his films frequently display rerecorded historic cinematic material at a slightly slowed-down speed. The resulting images, created by shooting footage as it runs through the monitor of an editing bench, are marked by a characteristic flickering pulse of the visual stream that is interrupted by ever-so-slight pauses. This

41

destabilizing fluctuation of the no longer continuous optical input, now shot through with moments of darkness, serves as a temporalized place-holder of negativity in (filmic) recording, projection, and reception.

On the level of filmic themes, the main protagonist of *Der Angriff der Gegenwart auf die übrige Zeit*, a blind film director played by Armin Müller-Stahl, embodies this cinema-epistemological proposition; it is also alluded to in a scene in *Die Patriotin* (*The Patriot*) in which the marriage broker Frau Bärlamm, played by Hannelore Hoger, and a voyeuristic secret service agent go through an impromptu perception training, blinking their eyes heavily—"wie kleine Filmaufnahmen [like miniature film takes]." Finally, Kluge quite literally presents this theory to one of its central proponents, Godard, on whose *aperçu* that films equals 24 times truth/second it is partially based. In one of his television features, whose transcript was later also reprinted in *Geschichten vom Kino*, Kluge shows the *cinéaste* an illustration of a blind man driving a car. Godard responds: "That's a fine picture. One should make a film about it."[5] Their ensuing exchange, for which this image serves as a point of crystallization, circles around the notion of *Blind Love*. This notion, which in its French version—*un amour aveugle*—also figures in Godard's video work *Histoire(s) du Cinéma*, refers to the genesis of the *Nouvelle Vague* out of passion for the first classics of cinema, from Eisenstein to *noir*, on the part of the group of young film critics who would later become directors. This passion was for the most part fueled through written accounts: i.e., its actual objects—the films—were initially unavailable to Godard and his colleagues. Already a "lost" tradition, they had become invisible:

> It's an expression in France. You say "love makes you blind," i.e., you love without asking questions, and in 'Histoire(s) du Cinéma' I tell the story how we in the Nouvelle Vague loved cinema before we really got to know it. The movies we talked about were not in distribution, you couldn't see them. We loved those films blindly.[6]

Or, as Godard puts it in *Histoire(s)*: "we knew the cinema, by way of Canudo, by way of Delluc, but without ever having actually watched it … the true cinema was that which one couldn't see … we had to love it blindly and by heart, same for the crowds in *October* and those in *Viva Mexico*, wouldn't you agree, Jay Leyda."[7]

What Kluge's (and Godard's) examples have in common is that they pit a principle of visibility and sensorial positivity against figurations of the invisible that interject moments of negation, be they discursive, thematic (the blind director), historic, or actually embedded in the image flow as impulses of darkness. In Kluge's work these double figures of seeing and blindness, light and darkness, sensorial positivity and negativity, belong in turn to only one half of a larger double figure where they function as variations on the elaboration of montage as image combinations. Kluge also articulates this in terms of destruction or ruination: "This is montage … that the two images destroy each other at the cut. If this occurs, then there is cinema."[8] Tied to this understanding of montage as a contrast, as a mutual aggression between or destruction of two images, "i.e., one shot, a second shot and … they violate each other through their contrast, their difference, or through tautology," is a filmic aesthetic that consequentially rejects the invisible cut. This Kluge associates with the enclosure of *umbauter Raum*/walled-in space: "Theories of the invisible cut merely pretend to have a program [*spiegeln ein Programm nur vor*], they place it 'in front of' perception [*stellen es vor die Wahrnehmung*],' in order to generate a closed building that blocks the cinema (*kinein* = to move)."[9] Or, as Kluge put it in "Wort und Film," a text co-authored with fellow directors Reitz and Reinke: "Film is made from an accumulation of momentary takes, which stand in tension with one another. The moments of rupture [*Bruchstellen*] that result from montage are articulations [*Äußerungsformen*] of this tension." Through layering these forms of expression, which include literary, acoustic, and visual elements, a given film's subject matter will settle "in the zones between these forms of expression [*Ausdrucksformen*]."[10]

In other words: if Kluge arranges sequences such as the opening images of *Die Macht der Gefühle* (*The Power of Feelings*) in which he juxtaposes a sunrise over Frankfurt, footage from World War I, images of a dying child, a passage from Lang's *Die Nibelungen* and a state funeral, he arranges series of images in which thematic elements begin to overlap and agglomerate, while at the same time the image constituents are positioned in confrontation with each other, which begins to violate their mutual integrity. In this process of "destruction" they will not form a closed ensemble, but will set off series of contrastive and heterogeneous statements whose very incongruence counterbalances the thematic assemblies of montage components. What seems to be a merely descriptive long take of high-rise architecture encounters recent funeral footage, and in this manner contrasts two types of documentary: one oriented toward capturing architectural impressions and light effects; the other a historical event. This filmic approach to history as documentary is questioned, again, through the contrast with Lang's fictional *Nibelungen* footage and the presence of the Paulskirche (a historical reference provided by an actual architectural site). Both contrasts also redefine the notion of history in a way that would hardly seem compatible with the capacities of the filmic medium: the first alludes to narratives of the Middle Ages and earlier Germanic mythology, while the second presents a notion of history tied to the durational existence of buildings. There is also the contrast between reused fictional film and so-called documentary shots. Such examples demonstrate that Kluge's practice organizes its assemblages around certain "themes."[11] However, such themes emerge as complexes from Kluge's image agglomerations, rather than relying on linear or consecutive developments.

TWILIGHT OF THE GODS IN VIENNA

Kluge has allegorized this type of production in a literary story titled "Die Götterdämmerung in Wien" (The Twilight of the Gods in Vienna) and in a conversation with Pierre Boulez, published under the title "Das

Ruinengesetz in der Musik" (The Law of the Ruin in Music). In that story, Kluge imagines one last performance of Wagner's *Götterdämmerung* before the troops of the Third Reich are forced out of Vienna by the impending Soviet invasion. Since Allied forces have already begun air raids, and the opera house is on fire, the orchestra is split up and distributed over nine bunkers; communication for the purpose of rehearsals and the performance itself is guaranteed first through field telephone, later through messengers. On the city's last available film stock, the performance of an orchestra and a Wagner opera in the state of destruction are recorded: "Man hörte und sah in der Aufzeichnung diese Szenen neunmal hintereinander gesetzt: Jedesmal ging es um die lärmende Teilgruppe der Partitur, die in dem betreffenden Keller geübt wurde."[12] [These scenes were heard and seen in the recording nine times, one after the other: a different cacophonous part of the score each time, as rehearsed in each separate cellar.]

In the story, one of Jean-Luc Godard's cutting assistants eventually acquires this footage after it has led a hidden—invisible—existence of many years in various archives. She restores it in Paris and presents it to an audience of *Cahiers du Cinéma* editors and authors.[13] The fictional result is a testament to a nonrepresentational notion and practice of the filmic image: "Das 35-mm-Filmmaterial ist durch Selbstbelichtung zunächst in Umrissen und in Fehlfarbe entwickelt und durch die anschließende Entwicklung der unbelichteten Negative im Kopierwerk nochmal entwickelt worden, so daß sich über die Umrisse und Fehlfarben Schatten und Echos gelegt haben."[14] [Auto-exposure meant that the 35mm film material first developed in a series of outlines and incorrect colors. Through the subsequent development of the unexposed negatives in the film lab, shadows and echoes overlaid these outlines and colors.] The restoration also requires the matching of non-identical sound and image tracks, resulting in a non-synchronized ensemble of acoustics and visual elements that clearly evokes a Godardian technique of non-synchronized sound and image editing. This fictive description of the

precariously "reconstructed" Wagner film reads as if it were lifted from a factual account of Godard's *Histoire(s) du Cinéma*. In this epic video project Godard makes ample use of electronic mixing techniques to create extended sequences of superimposed imagery. The screen becomes a site for the appearance and disappearance of strangely discolored, often bleached-out "shadows" and outlines from the histories of painting and film, which are set to tangential comments spoken, or rather murmured, by the director himself. What is presented to Kluge's readers as an odd fictional hybrid between documentary film, experimental cinema, and mere development accidents may also partly encode a description of the French director's explorations of the history of cinema in the realm of electronic images. In Kluge's story, the ghost of Godard's work thus participates in a parade of specters, in which film documents a production of Wagner that is blasted to pieces in many ways. That hypothetical film's fictional status, as essentially "unseen" and imaginary, in turn transforms it into a memento of the narrative of the Nouvelle Vague's birth out of "blind love" for the classics of a lost cinematic tradition.

CONVERSATION WITH PIERRE BOULEZ: OPERA AND FILM AS RECONSTRUCTED RUINS

In a rather striking congruence, Pierre Boulez offers a matching anecdote when Kluge summarizes the plot of "Die Götterdämmerung in Wien" for him in the course of an interview feature. Boulez describes how he once sat in on a performance of the *Ring* in Bayreuth in 1966, conducted by Karl Böhm. He wanted to study his famous colleague in action, but, this being Bayreuth, Ur-architecture of the orchestra's visual removal from operatic performance, there is no seat in the audience where vision can possibly capture the conductor. Boulez thus had to sit in the orchestra pit, next to the percussion section, behind the trombones. Therefore he attended an acoustically distorted, fragmented performance in which brass and percussion were overproportionally present, while the rest, including the singers, were at best reduced to a

"background landscape."[15] But, Boulez maintains, this experience demonstrated that the example of the Vienna *Götterdämmerung* shared something with the structure of *any* orchestral or compositional setup: "This was a spatial distribution, for the first time … what is interesting about a good orchestration is—and Wagner is very, very good—that each section of the orchestra can be listened to independently, because they are of course part of a larger group, but also as (sub-)groups they all make sense."[16] An observation summarized in the axiom "To me an orchestra is something like a reconstructed ruin."[17]

Kluge conceptualizes a manner of production that proceeds by destruction ("wenn ich die Bilder nicht zerstören kann, kann ich sie nicht halten [if I cannot destroy images, I cannot keep them]"), and he theorizes the outcome, the product of such a manner of making (films): "i.e., one shot, a second shot, and each is not identical with the image, they violate each other through their contrast, their difference or tautology. From this results a third image, an image that sits in the cut [*in der Schnittstelle*] and which is not material."[18] This third immaterial image is directly defined as (the product of) montage: "Through the montage of images, I attempt to create spaces in between, which do not turn into images but in which a third image emerges, an epiphany."[19] The Klugean third image—"ein drittes Bild, das nie zu sehen war [a third image that was never seen]"—is, then, the result of a contrastive autoaggression of filmic images ("the contrast between two shots; that's another word for montage").[20]

In all of these moments—illustrations, films, stories, pieces of dialogue, but also elements of theory—Kluge articulates a concept of montage that pits two principles of image-making against one another. On the one hand, there is the image recorded by the camera, a bastion of sensorial positivity, anchored by the documentary capacities of the apparatus; on the other hand, there is the movement and moment between images, the transition from one image to another, i.e., the zone that lies between images. This is the register of the third image, which has three

characteristics: First, it is defined as a correlation between the sensorial and the technological, i.e., visible and recordable elements. Secondly, it implies and exercises a negation of its constituents which plays out as the (partial) "destruction" or "ruin" of these positivities. Thirdly, it manifests the element of possibility, in the sense of that which is not yet realized, that which does not belong to the order of facts.

This representation of montage as a destructive act, along with the idea of a type of (image-)construction that locates its central characteristic in the unresolved tension between the elements forming a work, emerge from at least two theoretical and artistic strands. The first consists, not surprisingly, of a specific vein of filmic montage theory and practice. It is exemplified in the *œuvres* of three main cinematic antecedents whom Kluge often calls his trusted advisors, and whose works he frequently thematizes in his own productions: Sergei Eisenstein, Dziga Vertov, and Jean-Luc Godard. The second strand consists of a corpus of theoretical writings that partly, but not entirely, also touch upon questions of filmic montage. Mainly, however, these texts advance a general critique of a representational notion of the image as based on likeness or depiction. The two main authors whom Kluge draws upon here are Bertolt Brecht and Theodor Adorno. The following sections will first unfold Kluge's relation to his theoretical and artistic precursors in the history of film, followed by a second step in which the connection of Klugean montage to Brecht and Adorno will be elaborated.

(2) CINEMATIC ANTECEDENTS

KLUGE WITH EISENSTEIN: THE IMAGE AS THIRD TERM
The most prominent Eisenstein reference in Kluge's *œuvre*—it has an almost reverential character—is the 2008 DVD work *Nachrichten aus der ideologischen Antike* (*News from Ideological Antiquity*). The piece encompasses three discs, and runs for more than nine hours. It takes its cue from a work that never was: Eisenstein's project for making a film of Karl

Marx's *Das Kapital*.[21] Kluge thus produces nine hours of visual and discursive material out of an enterprise that never achieved cinematic form beyond a few pages of notes.

The first disc begins with a sequence in which Eisenstein's unrealized project, as sketched in the Soviet director's working notes, is approached in a number of different ways. It includes clips in which we hear excerpts from Eisenstein's text read by actress Hannelore Hoger—a Kluge veteran since *Artisten in der Zirkuskuppel* (*Artists under the Big Top*)—and Kluge himself, who reads from Marx. In between these takes, there is a single-screen montage, the visual field divided into a grid of rectangles, in which various outtakes from Eisenstein films are shown (figures 2.3–2.5); there is also a conversation with film scholar Oksana Bulgakowa about the historical circumstances in which Eisenstein attempted to embark on his undertaking.

The section's centerpiece is formed by a series of visual "transcriptions"—Kluge calls them "paraphrases"—of the *Capital* notes. These consist of quite easy executions of some of Eisenstein's ideas, for example a simple take of a pot sitting on a stove that refers to Eisenstein's idea—also presented by Kluge onscreen as a "transcribed" note—of framing his exploration of capital through a domestic scene, in which a wife who is cooking soup at the stove waits for her husband to return from work.[22] Further elements are fields of onscreen lettering in various colors and shapes, in which Kluge transcribes segments from Eisenstein's *Capital* manuscripts.[23] This variety of paraphrastic treatments of Eisenstein's notes already touches upon the Soviet director's montage theories. Scholars and philosophers of film have repeatedly pointed out that Eisenstein conceived of filmic montage and Marx's materialist dialectic as equivalent methods. As Noël Carroll puts it: "Eisenstein envisioned his analytic editing consummating, in an analogical sense, with the form of analysis or analytic thought operative in Marx."[24] Jacques Aumont has pointed out that in this vein, Eisenstein's *Capital* project would have acquired particular importance, in that it would not have functioned as

conventionally "telling" "the story ... of surplus-value rather than any other story," but that Eisenstein here intended to find a filmic counterpart to "Marxist method itself" through montage.[25] Gilles Deleuze generalizes the analogy even further, and goes as far as claiming that for Soviet filmmakers like Eisenstein, "the dialectic ... was primarily a conception of images and their montage."[26] A similar point is made, with a higher degree of specificity, by Annette Michelson, who explains that "the dynamics of the dialectic" functioned as the grounding for Eisenstein's conceptions of montage, which would in turn have become the dialectic's "concrete filmic form."[27] The "articulation of montage" would thus have played its part as the "formal instantiation of cinema's ... rehearsal of the dialectic," a phrase which might turn out to unwittingly also describe the relation between montage and the dialectic proposed in *Nachrichten aus der ideologischen Antike.*[28]

For there is a moment in Kluge's return to Eisenstein's notes which falls in line with this idea of cinematic montage as a "rehearsal" of the dialectic. At one point a note dated April 11, 1928 begins to be transcribed onscreen (see figures 8.18–8.21): "Über die Wiederholung, im Hinblick auf die dialektische Analyse, d.h. eine Analyse in Widersprüchen, ist ein solches Verfahren eine sehr gute Sache. [Regarding dialectical analysis, i.e., an analysis in contradictions, the method of repetition is a very good thing.]" In the immediate context of Kluge's DVD film, this thematization of repetition addresses Kluge's own iterative practice of combining transcriptions of Eisenstein's ideas for scenes and shots, on the one hand, with actual takes that broadly and provisionally approximate their execution. In this manner, when Eisenstein writes about showing a pot, Kluge will show a pot. Kluge has defended this iterative practice by pointing to Eisenstein's support for the rhetorical figure of *repetitio*. Through constructing this text/image "redundancy," Kluge also forces each of these elements into a position of autonomy, in that the filmic image no longer needs to carry the information provided in the fields of lettering (see chapter 8 below). However, in addition to these internal strategies of

iteration, Kluge's entire transcription of Eisenstein's notes can be considered a repetition of the connection that Eisenstein had established between the material dialectic of history and economy, and the filmic dialectic promised by montage. In this sense, Kluge's DVD "rehearses" the Eisensteinian cinematographic/historical dialectic, in a gesture that repeats the rehearsal of the historical dialectic in filmic montage.

A much earlier, more direct and concrete reference to Eisenstein's montage approach can be found in *Die Artisten in der Zirkuskuppel: ratlos* (*Artists under the Big Top: Perplexed*). In one scene the film's main protagonist, Leni Peickert, played by Hannelore Hoger, goes to the movies, where she attends a screening of Eisenstein's *October*, i.e., the film whose production immediately preceded the episode of the projected work on *Capital*. We see Leni Peickert, seated in the complete darkness of a cinema, between rows of empty seats. The darkness is traversed by the projection ray that casts a flickering image onto the oblong field of the screen—a very quick succession of intermittent shots depicting alternately a soldier's face, aiming through a set of cross hairs, and a firing gun (figures 2.6–2.8).

The reference to Eisenstein's theory of editing encoded in this image could hardly be more topical, for the Soviet director used precisely the sequence of two intercut static images which we see Leni Peickert watching to illustrate his theory and practice of dialectical montage in a lecture on "A Dialectical Approach to Film Form" which he gave in 1929 in Berlin.[29]

The particular relationship of Kluge's work to the Eisensteinian concept and practice of montage is perhaps already indicated in a remark from the *Ulmer Dramaturgien* (*Ulm Dramaturgies*): "We would not derive the concept of montage from Eisenstein."[30] This declaration makes Eisenstein the film-historical touchstone for a theoretically advanced interpretation of montage activity, but it is careful not to cast him as an authoritative model. The example of Eisenstein's work is summoned in order to reject its exemplary character. The task consists, then, in

2.3–2.5 *Nachrichten aus der ideologischen Antike. Marx—Eisenstein—Das Kapital/News from Ideological Antiquity. Marx—Eisenstein—Capital*, 2008, DVD, color and b/w, 570 min). Alexander Kluge / Filmedition Suhrkamp.

2.6–2.8 *Die Artisten in der Zirkuskuppel: ratlos/Artists under the Big Top: Perplexed*, 1967, 35 mm, b/w and color, 103 min). Alexander Kluge / Kairos Film.

distinguishing the Klugean understanding of montage from Eisenstein's, while still acknowledging that Kluge occasionally casts his own practice as a *rehearsal* of Eisenstein's technique of superimposing montage and dialectics.[31]

The earliest observations on this subject have been made by Miriam Hansen, who proposed to separate Eisenstein from Kluge according to the respective importance or nonimportance granted in each case to the hiatus of the cut. She argues that Kluge centers montage around cut and interruption, whereas Eisenstein supposedly posits the shot as the basic unit for filmic signification through montage: for Kluge, "the minimal unit of montage is not the individual shot, as for Eisenstein, but its negation."[32] This view might be difficult to defend, because it seems to represent the position of Lev Kuleshov and Vsevolod Pudovkin, two of Eisenstein's fellow Soviet filmmakers, rather than that of Eisenstein, who even distanced himself explicitly from their approach in his 1929 essay *The Cinematographic Principle and the Ideogram*.[33] There, he quotes Kuleshov's axiom "The shot is an element of montage. Montage is an assembly of these elements," as well as its illustration through the brick principle: "If you have an idea-phrase, a particle of the story, a link in the whole dramatic chain, then that idea is to be expressed and accumulated from shot-ciphers, just like bricks."[34] Against the opinion of his contemporary Pudovkin, a Kuleshov student, Eisenstein set his noncumulative principle of the shot as a cell of montage which, in the filmic process, will thus both produce a conflictual encounter and undergo an internal division by turning into a site of contradiction: "The shot is a montage cell. Just as cells in their division form a phenomenon of another order …, so, on the other side of the dialectical leap from the shot, there is montage. By what, then, is montage characterized and, consequently, its cell—the shot? By collision. By the conflict of two pieces in opposition to each other."[35] Eisenstein later extended this idea into a description of a two-tier system consisting of an overarching organization of montage segments whose antagonism reiterates the conflictual relation inherent to each of these

segments: "Between themselves, the montage segments reproduce the very same process that occurs between the individual frames within each segment."[36] As Deleuze recognized, this principle of opposition as "the internal motive force by which the divided unity forms a new unity on another level" extends down to the level of the single image: "each image … contains its caesuras, its oppositions, its origin and its end. Each image not only has the unity of an element which may be juxtaposed to others, but the genetic unity of a 'cell,' which may be divided into others."[37] This also entails that the Eisensteinian model of production is not cumulative, but based on a principle of dialectical division. The basic "unity of production" is a "*cell* which produces its own parts by division, differentiation."[38] In contrast to the additive mode, Eisensteinian montage generates transpictorial units by letting the individual image elements collide with each other, and by inducing moments of division into single images. The emerging montage entity is, then, one of interacting contrasts and contradictions.

In Eisenstein's cinematic practice this approach is realized, famously, as a style which arranges the elements of film in such a manner as to release their collisional character. Eisenstein uses several techniques to produce this collision. These range from the formal—in which the visual unit of the shot is "broken up" by planes which stand in contrast to one another—to the thematic—in which the "themes" of several shots are bound to one another through montage, and thereby supposedly articulate a thematic contradiction (for example, the combination of a shot of a general with a take of a porcelain figure of Napoleon, articulating both the general's counterrevolutionary usurpatory aspirations, and the pettiness of his ambitions transported through a particularly kitschy example of decorative arts).

Such a collisional program cannot be found in Kluge's work, which holds images in tension, but does not treat this irresolution *as* opposition. To begin with, Kluge's montage sequences simply do not offer the degree of formalization that enables Eisenstein's viewers to, for example,

identify a set of diagonal planes positioned (*qua* montage) against another set of (oppositely tilted) planes *as* conflicting elements. Moreover, Kluge never aims to produce the experience of an intensive moment, which is central to the construction of Eisensteinian conflict. This becomes especially obvious whenever he represents political or social struggle, a clash between state authority and citizen, or even warfare. Kluge's literary stories about the devastations of war, such as "Der Luftangriff auf Halberstadt" (The Air Raid on Halberstadt) or *Schlachtbeschreibung* (*The Battle*), both executed in a montage of perspectives, historical documents, technological and meteorological information, etc., never position their constitutive elements in such a manner that they center around dramatic conflict. Their tone is eerily sober, even neutrally observing. The same holds for the rather distant mode in which the camera shows a struggle between police and squatters in *In Gefahr und größter Not* (*In Danger and Dire Distress*). Although in that film Kluge makes extensive use of montage techniques, for example by intercutting segments of a fictive plot with documentary footage, these are never arranged to highlight or emphasize the clash of forces—aggression and resistance—as it is about to unfold.

The second difference between Eisenstein's and Kluge's approaches concerns the putative *analytic* character of montage. As Annette Michelson has shown in her study of Eisenstein's montage technique in *October*, that film's famous sequence of the "lifting of the bridges," which undercuts the people of St. Petersburg's first uprising, functions as a disjunctive analytic procedure in which the depicted event is splintered, as it were, into a series of chronologically reordered shots.[39] All of these takes depict segments of the process of the raising of the bridges, but their non-chronological, partially repetitive editing does not aggregate into the visually seamless representation of a stream of events. Eisenstein's "technique of interruption," writes Michelson, fosters "the spectator's sense of *disjunction* between shots, angles, movements, and, in some cases, light sources"; it generates a perception of "fragmented space" and also extends on an analytic level to

the constituents of the represented action.[40] Klugean montage, by contrast, is certainly disjunctive, but it is not analytic, at least not in the sense established in Michelson's interpretation of Eisenstein. That is to say: Klugean montage never conveys the sense of a pre-filmic or pre-textual "whole" which it analytically dissects. Here it is important to remember that the impression of an uninterrupted entirety, as rendered through a combination of images or linguistic expressions, is of course itself the product of specific visual or textual techniques of representation; i.e., it is not an ontological given. The impression of coherence on the level of the object of representation is hard-earned and requires either a skilled combination of filmic images, or an ordered linguistic rendering from which emerges the sense of a represented event, occurrence, or process. Eisenstein's analytically disjunctive montage would, then, still generate the idea of a coherent process against which it pits the discontinuities of his image dialectics.

When Kluge writes a literary text, such as "Luftangriff," about the bombing of his hometown Halberstadt, with its combination of narrative perspectives of various inhabitants of the city, maps of flight routes, fictional interviews with commanding officers, and construction diagrams for bombs, these elements no longer point to a unified sequence of events that could be "analyzed." The contingencies and incongruities of the various historical trajectories that come together in the eradication of a town and the lives of its inhabitants are matched by the multiple patchwork of montage elements.

Another example would be the overall structure of Kluge's book *Geschichten vom Kino*, which certainly deserves to be called a montage in its own right. Yet although the volume traces a history of cinema relatively closely, its many historical entries are interspersed with anecdotal narratives from Kluge's own biography as a filmmaker; they contain references to unrealized films, as well as to the political and economic conditions of filmmaking. The result is a book-length series of narratives each of which evokes fictive and factual moments from film history,

but whose combination never conjures up *the* historical development of cinema in a monothematic or linear form. The montage in question is indeed one of cinema stories, not of disjunctive moments carved out of a grand developmental arch of cinema history. In Kluge's visual production, this refusal of overarching narrative trajectories is already apparent in the case of his early feature films, which still follow a loose but vaguely perceptible plotline.[41] The drive toward a disaggregation or full rejection of plot elements becomes increasingly prominent in his short cinematic clips, so-called "minute films," and in his last productions in analog film, in which one work often combines several shorter narrative episodes, sometimes presented in compact order, sometimes distributed over longer stretches. But these are only single elements among complex successions of images, refilmed illustrations, and entirely non-narrative documentary takes.[42] In such sequences the disjunction is one between images, not between a number of depictions that all relate to a pre-pictorial event. What has vanished is the organizing fiction of a "common realm," represented in images, that would pull these representational images together, would need to be constructed as a continuum through the coalescence of images, and against whose drive for coherence montage could be played out as a disjunctive analytic.[43] What begins to emerge, instead, is the image as an autonomous entity brushing up against other autonomous images.[44] This is not to say that each of these autonomous images does not perform a representational task. On the contrary: Kluge frequently invests his images with the full weight of the documentary power of the camera (the Paulskirche, at the beginning of *Macht der Gefühle*, needs to be shown as "Paulskirche," otherwise the constructional logic of that opening sequence loses a central pillar). It simply means that in Kluge's practice, the autonomy of the image does not equal visual abstraction, and that documentary referentiality does not form the gravitational center for the organization of images.

The third difference between Kluge's and Eisenstein's projects consists in their respective modeling of montage as a process of concept

formation. Eisenstein's most important comparison of the montage prin-
ciple with the process of concept formation is an analogy between the
combination of supposedly depictive individual signs into abstract enti-
ties in Japanese writing. Eisenstein's argument is based on the assumption
of a depictive—i.e., pictorial—origin for Japanese characters. Through a
progressive reduction, each character has become abstracted into ideo-
grammatic elements which, when combined, shed their image origin
and turn into abstract concepts, such as "a mouth + a bird = to sing," or
"a mouth + a child = to scream."[45] In this phase of his work, Eisenstein
thus compares the production of meaning through montage to ideo-
grammatic systems of writing: the shot, understood as a primary, depic-
tive, and motivated recording, is compared to an assumed original phase
of image-making in which an object is depicted *qua* likeness. In the
course of the history of writing systems, this motivated (or resembling)
image initially becomes abstracted, and then is turned into a conventional
sign. More important for Eisenstein, however, is the Japanese writing sys-
tem's supposed method of building representations for concepts or ideas
through the combination of two initially depictive signs which come to
signify a third, entirely unrelated entity. During this phase of Eisenstein's
œuvre the hiatus that is immanent to montage is thus bound to the con-
ventionality of the montage-sign. In this sense, Eisenstein understands
cinema as a further episode in the history of writing which achieves an
ideogrammatic effect through, for example, combining numerous shots
of religious idols into a concept of "idolatry" (or so goes his reasoning).[46]

At an early point in his filmic career, Kluge did—in apparent accor-
dance with Eisenstein—claim the paradigm of concept formation for
his approach to montage: "Film always works with concrete forms of
expression. The image is always concrete, there is nothing you can do
about it. But through montage it is possible to form concepts at the
same time; that is, sums of concretions."[47] This summative model seems
difficult to reconcile with Kluge's later theory of montage as distinction
(which relies precisely on the difference between the image elements,

not on their addition). Nonetheless, it is clear that Kluge's filmic practice never coincides with Eisenstein's model, because he never seeks to establish quasi-syntactical combinations of image elements. Nowhere in Kluge's work (and this includes his literary texts) would one encounter a combination of images that seek to spell out, as it were, a concept (for example, "history"). If there are conceptual themes in Kluge's work (such as "history"), they are always the product of a process of distinction, as exemplified in the opening sequence of *Die Macht der Gefühle*; that is to say, they are subject to an internal complication and multiplication, rather than being referred to or "denoted" conceptually.[48] What connects Kluge's early and late statements, as well as his entire filmic and literary production, is, however, an addition of negativity (the cut) to the positivity of filmic recording (the shot), which in their combination produce distinction.

One last difference between Eisenstein's and Kluge's montage concepts can, finally, be found on the level of affectivity. Already while developing his grammatological concept of montage, Eisenstein devoted his attention to the affective implications of image combinations. In *The Cinematographic Principle and the Ideogram*, he does not draw merely on the comparison with writing systems, but also with the literary tradition of the *haiku*.[49] The way in which montage combines images is therefore not just likened to the generation of hieroglyphs. It also resembles the aesthetic and affective impact generated by the condensed evocation of poetic imagery. The implied effect of a poetic intensification only foreshadows the director's later open and ample deployment of a cinema of pathos (as witnessed, for example, in *Ivan the Terrible*). At that point, Eisensteinian film presents a much more "conventional," "integrated," i.e., more descriptively and narratively oriented style. Images are no longer combined in such a manner as to designate concepts or to articulate the cellular divisions of revolutionary dialectics. Yet the cut still signifies for Eisenstein, albeit differently, affectively. While the concept-oriented image combinations have disappeared, films such as *Ivan the Terrible*

extend the graphic program of division by, for example, superimposing the tsar's profile in a sharp diagonal over the country's wide, white landscape. Now the director reads the interruption between frames, as well as between montage elements, and by extension also within the shot, as a caesura that will produce a maximum (tonal) difference which engenders an emotional arousal. The most prominent example of this shift is the late text "On the Structure of Things," with its subsection "Organic Unity and Pathos," in which Eisenstein offers a reinterpretation of his earlier film *Battleship Potemkin*.[50] He recognizes one constitutive principle extended throughout the entire development of the film which he declares to be the central formal constituent of pathos production: "the action … inevitably 'leaps' and 'hurls itself' through the caesura, … because each time the diapason of the new quality, into which the first half passed, was the maximum possible: Each time it was a leap into the opposite. … Thus, it appears that in all decisive compositional elements we encounter a basic formula of the ecstatic everywhere: a leap 'beside oneself,' which unavoidably becomes a leap into a new quality."[51] In the director's late interpretation of his much earlier work, his cinema has, in other words, shifted from a linguistic and syntagmatic paradigm to a paradigm of rhetoric in which the intervening caesura no longer serves as the structuring separation of discrete images which turn into characters. Rather, the hiatus is now employed in such a way as to generate (violent) affective arousal. It is in terms of this affective politics of the hiatus that Kluge's cinema, with its dedication to the ideal of "still images," could not be further removed Eisenstein's project (see chapter 5 below).

Yet beyond this set of complex proximities and divergences between Eisenstein's and Kluge's practices, there is one element both clearly share: the interdependence which they establish between the terms image, montage, and thirdness. Just like Kluge, Eisenstein defined the function of montage as the engendering of a "third something."[52] Also like Kluge, he described this third entity as an image, exemplified in the following case through the example of a rendering of movement: "From a

collision between pictures of two consecutive phases of a movement there arises the *image* of a movement."[53] The congruence even extends to the associative, cognitive quality which both directors ascribe to this combinatory operation, as well as to the contrast they see between such combinations and modes of mere depiction, associated with the single picture: "the degree of intensity with which *such an image is experienced* is far greater than the *depiction* that is created and executed by someone else."[54] What Eisenstein names *this third something*, or the image *tout court*, i.e., the product of a combination of two discontinuous sets of depiction, Kluge calls *the third image*. In both cases, this third image is understood to be the equivalent of the cognitive conjunction between two depictive elements, and it is based on the technique of montage which, precisely through refraining from mediating the disjunctive constituents, provides the necessary discontinuity from which the third term can emerge.

KLUGE WITH VERTOV: FROM INTERVAL TO INTER-IMAGE DISTANCE

The two most overt references to Vertov in Kluge's work are a "minute" film with the title *Für Vertov* (*For Vertov*), and an entry in *Geschichten vom Kino* called "Verfilmung des 'Mehrwerts.' Ein Plan von Eisenstein und von Dsiga Vertovs Bruder" (Filming "Surplus Value": A Plan by Eisenstein and Dziga Vertov's Brother).[55] The brother in question is Mikhail Kaufman, the camera operator for Vertov's *Man with a Movie Camera*.[56] In his story Kluge imagines that Eisenstein's plan for a film of *Capital* actually derives from a sketch by Kaufman dating from 1921, as a result of which Eisenstein supposedly entertained the idea not just of accounting for the history of capitalism, but of documenting all the classes and social formations in history, including those preceding capitalism, and those that are not "classes."[57] The spatial expanse of Vertov's documentaries, which combined material from geographically distant locations into a single film, would thus have been transposed into a temporal reach that would have rendered the Marxism of Eisenstein's *Capital* project less orthodox, and less compliant with Party doctrine.[58]

Für Vertov consists of a typically simple Klugean combination of images: we see an outmoded television monitor: judging by its design, most probably dating from the 1970s. By electronic manipulation, Kluge has inserted a high-speed version of a scene from one of Vertov's city films, probably *Man with a Movie Camera*, that now seems to "play" on the monitor's screen. The film thus presents a contrast between the static monitor and the high-paced pulse of traffic through a large city's streets. It also stages the difference between the "framing" image of the television set that dates from one period, and the filmic material that derives from a visibly earlier period.

In both this clip and in *Verfilmung des Mehrwerts*, Kluge establishes two main connections between his work and Vertov's. First, as suggested by the compressed outtake in *Für Vertov*, there is the relation to the tradition of the city film which found in Vertov one of its early documentary masters. Kluge thus relates his treatment and documentation of the subject of the city, as witnessed in *Die Macht der Gefühle* or *Der Angriff der Gegenwart*, to Vertov's historical example, and in particular to *Man with a Movie Camera*. However, these cases also indicate an initial divergence between Kluge and Vertov. In *Man with a Movie Camera*, the Soviet director constructs the image of a metropolis using footage filmed in various geographically distant cities in the USSR. Out of shots from specific cities, Vertov builds the image of "a" Soviet city in the general sense. There is a movement from the particular to the general. Kluge, by contrast, edits material from merely *one* city—Frankfurt am Main—whose topography is treated in different ways: in some cases emphasizing its generality, in others its specificity. For instance, the opening minute of *Die Macht der Gefühle* functions independently of the question of which city we are seeing as the sun rises. The point here is the contrast between static buildings, streams of river and traffic, and the temporal play of light. Only shortly thereafter, however, the images of the Paulskirche rely very much on that building's specificity, its history, and the associations it triggers. Whereas Vertov synthesizes many cities into one general metropolis, the

Klugean approach divides the image of the city into elements that function as generic placeholders for "a city," and sites which must be explored in their specificity.

The second difference involves an alteration of the category of "distance." In *Man with a Movie Camera*, editing functions primarily across spatial distance. The city film is an assembly of images that originate from various points in the Soviet Union. For Kluge, the category of distance is primarily temporal. This temporal distance can be seen when static elements—such as buildings—are contrasted to dynamic elements such as light, as in *Die Macht der Gefühle*, or when a static and a moving image are combined, as in *Für Vertov*. The ensuing contrasts—between developments on the different scales of the *longue durée* and shorter terms; or between movement and stasis on the level of the image—allow for visualizing such temporal distances. Finally, through montage, Kluge's category of distance also explores the temporal expanse of history, as evidenced in the example of the Paulskirche (see chapter 1 above).

Overall, scholars, as well as Kluge himself, have suggested a certain affinity between Vertov's and Kluge's concepts of montage. Miriam Hansen, for example, has suggested that the Klugean approach "recalls Dziga Vertov's emphasis on 'intervals' as his practice of montage," and Kluge has observed that, were he to choose between Eisenstein and Vertov, he would side with the latter: "To me, Dziga Vertov would be the better cousin," claiming that like Vertov, and unlike Eisenstein, he preferred to work "mit der Differenz [with differences]."[59] Following film theorist Jacques Aumont, it is indeed possible to describe Vertov's practice of the filmic interval as "a differential power [*une puissance de différence*]" which is realized in "a cinema of visual discontinuity."[60] In fact, Vertov did define his idea of the "kino-eye" as a "theory of intervals."[61] This theory, first put forward by the kinoki in a variant of the manifesto "WE" in 1919, was one that Vertov considered best exemplified in *Man with a Movie Camera*.[62] According to him, the "school of kino-eye" demanded "the construction of the film-object upon 'intervals,' that is, upon the movement

———

between shots, upon the visual correlation of shots with one another, upon transition from one visual stimulus to another."[63] Crucial here is Vertov's emphasis on the correlative nature of the interval, which he describes as an entity or force that engenders the interrelation within a single image, as well as between several images.[64] In this sense, the Vertovian interval has no substance; it is an empty link, a negative articulation of image positivities.[65] It is most concretely described as the movement between shots, or even more basically—in Annette Michelson's words—as the "movement between frames."[66] One could therefore call it a progression, a movement from one element of montage to another. What seems no less central is that Vertov understood these negative elements or transitions as the actual connectors for the resulting work: a "tectonic whole" is "joined through intervals ... by the great craft of montage."[67] That is to say, in Vertov's films montage designates a constructive mode that encompasses the fabrication of image recordings—positivities—whose ultimate organization, and even agglomeration, is achieved through negative transitional moments.

Deleuze noted that the "originality of the Vertovian theory of the interval is that it no longer marks a gap which is carved out, a distancing between two consecutive images but, on the contrary, a correlation of two images which are distant."[68] This is true in at least two senses: first, in that the Vertovian interval can connect visual elements which are nonconsecutive; i.e., images from different points in the film can relate to each other. Second, it also means that the Vertovian interval can serve as a connecting separation between two images of distant origin, as witnessed, for example, in *Man with a Movie Camera*. (One way to picture these negative transitional moments, although by no means the only one, would be to relate them to the distances that separate the diverse points of origin for the shots in *Man with a Movie Camera*.)

The Klugean montage concept shares with Vertov's the emphasis on the constructive role of that which lies between frames and interpictorial movement: on the genuine contribution of the negative to the

construction of the entire work. (As in, for example, Kluge's definition of montage as the tension and movement between the constituents entering montage contexts, as well as montage's destructive character.) And Klugean montage is also characterized by what Deleuze has termed the characteristic distance of the Vertovian interval. Besides locating this distance rather in the temporal than in the spatial register (see above), in Kluge's films, editing makes this distance between the sites where different scenes have been shot much more clearly recognizable. For example, Kluge's concept of "portraying" a character relies on filming the actor in different locations. In the editing process, these different locations are not concealed, in order to—as Kluge explains—avoid "isolating this person," not only spatially, but also from the wider montage economy of the entire film. The fact that this distance between shots is made visible means that characters or scenes are not "sealed off" in a conventional narrative or mode of description.[69] Klugean montage takes this distance even further when it combines images from different categories and origins: documentary, fictional, appropriated historic footage, filmed illustrations, etc. The closer affinity which Kluge professes to share with Vertov, rather than with Eisenstein, derives from this approach to image combination. While Eisenstein interprets the cut as a conflictual negation of the pictorial unit, Kluge and Vertov understand it as a pure (connecting) separation of distant images. And where Eisenstein combines images of different origins in order to articulate concepts—by means of montage/negation: that is, to ultimately find a common denominator between them—Kluge and Vertov never yoke pictures together in search for such conceptual meaning. In their work, the implementation of the cut is not geared toward the production of a hieroglyphics in Eisenstein's sense, in which moments of negativity interrupt depictions in order to infuse film with a linguistic or, more precisely: with a scriptlike quality. Kluge departs from the Vertovian tradition in that he does not subject the construction of the whole of montage to the documentary imperative. Individual image units in Kluge's films are intended to perform

a documentary function, but montage here combines "documentary" images with all sorts of other image units. In fact, Kluge's understanding of the very term "image" owes more to Eisenstein than to Vertov, in that the former defined the image as the combination of two discontinuous depictions.

Kluge with Godard: Difference, Distinction, and the Past

Of all three cases discussed here, Kluge's allegiance to Godard is perhaps the most direct and pronounced. Kluge has stated that the French Nouvelle Vague served as an example for the concept of the "Autorenfilm" (*auteur* film), a term by which he and his peers of the Oberhausen group described their mode of cinematic production.[70] Moreover, he has repeatedly singled out Godard—who similarly professed a strong orientation toward Eisenstein and Vertov—as an important model for his own work.[71]

There are also concrete conceptual parallels between Godard's and Kluge's approaches to the structure of montage sequences. Following Serge Daney's lead, it has been argued that Godard's practice is characterized by a critical impetus directed toward the vast spread of visual media representations, against which montage is positioned.[72] Kluge argues along similar lines when he declares, with reference to Godard's work, that montage "gains a renewed urgency with regard to the Internet. People certainly feel that the plenitude of images which they encounter online, from commercials to film and all different sorts of uploaded content, is too much. In this sense, we need montage interventions to interrupt the omnipresence of electronic imagery."[73] As an antidote, Godardian montage "draws on the Eisensteinian distinction between 'image' (*obraz*, related in Eisensteinian theory to montage) and 'depiction' (*izobrazhenie*, sometimes translated as 'representation' and related to the individual shot)."[74] Godard also characterizes this non-depictive cinematic mode as a thirdness that emerges in the passage from one pictorial element to another: "cinema ... is an image, then another image, the two of which

form a third image; this third image is constructed by the viewer in the moment when she or he is watching the film."[75]

Godard and Kluge would, then, have their common historical base in Eisenstein's work, and they would both propagate a montage-based concept of the image conceptualized as a result of two disjointed depictive units being joined by a separating gap. This position is summarized in Godard's statement that "the image itself is always-already a montage."[76] This general relation between Kluge's and Godard's projects is articulated on several, more specific levels. First, Godard proposes a relational and differential understanding of montage which he combines with montage's capacity to make something evident, in the sense of visible. In his *Introduction à une véritable histoire du cinéma*, he writes: "one always has to look twice. ... That's what I call montage, a simple approximation. That's the extraordinary power of an image, combined with sound; or of sound, combined with an image."[77] And he specifies that this is not an iteration, but serves to give visibility to the interconnection between two distinct elements: "it means to put things into a relation with one another, and make people see things ... an evident situation."[78] (There is a similar tone to Kluge's understanding of montage as an "epiphany," as the sudden emergence of some sort of knowledge or impression that results from the combination of two images plus their difference.) The salient feature of montage, then, is a rapport that is constructed by the viewer combining and comparing the different constituents:

> When people saw a film, there was something that was at least double, and since someone was watching, it became triple. In other words, there was something, there was something else, which in its technical form became gradually known as montage. It was something that filmed not things, but the relationship between things. In other words, people saw relationships, and first of all they saw a relationship with themselves.[79]

This formulation may at first sight seem to be reminiscent of Eisenstein's definition of the essential montage character of the third image. Yet Deleuze clarifies that in contrast to Eisenstein's cinema, Godard's method does not rely on (conflictual) associations: "Given one image, another image has to be chosen which will induce an interstice *between* the two. This is not an operation of association, but of differentiation."[80] The combination of two depictions that will form the third image of montage is, therefore, determined qualitatively as a differentiation. The two constituents are selected in such a way as to articulate their mutual distinctness: "in Godard, the intersection of two images engenders or traces a frontier which belongs to neither one nor the other."[81] The result is a focus on their non-identity: "What counts is … the *interstice* between images."[82] The notion of the interstice also helps to distinguish Godard's project from the Vertovian notion of the interval that foregrounds a correlational separation between the montage elements, their distance from one another, but not their difference. At this point Kluge's project touches directly upon Godard's, in that Kluge, like his contemporary, does not understand montage merely as production of a third image (like Eisenstein), nor as a progression across the distancing hiatus between two elements (like Vertov). Neither does he define montage, in Eisenstein's sense, as conflictual negation, or, in Vertov's vein, as the necessary share of negativity in the construction of the whole. Rather, both Kluge and Godard determine these interpictorial moments as difference or distinction.

A second parallel between Kluge's and Godard's understanding of montage is related to the temporal and historical position that they both assign to film and cinema. Godard once described montage as "the moment which to me is unique in the whole world, which I don't find in video, where you can't cut. Montage gives you a moment physically, as if it were an object [*comme un objet*]."[83] This definition proposes a double temporality for montage: first, montage is described as a technique for creating a visual "moment": "You have the present, you have the past,

and the future."[84] Godard thus accounts for the material construction of the flow of images that will eventually result from splicing and gluing celluloid strips. This is the time of the image perceived. The second temporal definition concerns the very technology that enables this transition from material combination to image flow: the infrastructure of cinema and film that, as Godard implies, ceases to exist under the conditions of electronic image recording in video or television. Classical montage is, therefore, understood increasingly as a thing of the past. By comparison with electronic image procedures, classical montage is also figured as the result, even the articulation, of its technological conditions of possibility: that is to say, celluloid and editing bench. In the wake of television and video, the material undergirding of the cinematic thus acquires increased significance. In Godard's work, this retrospective thrust is perhaps already evident in the initial impulse for transitioning from writing about a largely inaccessible—invisible—historical corpus of the cinema into a filmic production. It is certainly present in the enormous recuperative attempt which is *Histoire(s) du Cinéma*—first a television production, later a DVD collection and a book—in which Godard assembles and superimposes a wealth of images from the history of film and painting in an ongoing montage suite.

This tendency is shared by Kluge, who often stresses that his initiation into the world of the cinema as an intern on the set of Fritz Lang's last film in the 1950s was a disappointment that prompted the realization that his true interest lay in the period of classical and archaic, silent cinema.[85] In Kluge's work, the optical pulse of historic footage refilmed at the editing bench visually transports this knowledge about the material infrastructure of the filmic image's "pastness." This means that Kluge's and Godard's montage concepts are marked by their orientation toward this—vanishing—technological base. For example, this base is quintessential to Kluge's definition of film's "blind" or "dark" elements as materialized in the dark segments of the interframe transport phase,

which no longer appears in electronically recorded material. To a certain extent, then, both Godard and Kluge theorize and practice montage in hindsight. In this respect, their concept differs crucially from the one advanced by their common champion Vertov, for example. When Vertov, in *Man with a Movie Camera*, let the film come to a halt (in order to single out an individual frame depicting a horse-drawn carriage that had just seconds before been visible in speedy progress), that operation amounted to demonstrating how the powers of montage contributed to the production of an animated whole, driven by the negative forces of the interval. Once that interval ceased to exist, or was no longer traversed, the components fell apart and the image froze. When Kluge returns to classical montage, the pulsing picture signifies the machinations of a historical technique still at work, but under the serious stress of present conditions. Moreover, perhaps one can even say that when Vertov performed his cinematic experiment he was showing his audience how the images they were seeing were being manufactured. What he showed them was modernist montage "in the making," so to speak: modernist montage as it was being developed at the time, as a general technique of production; but also montage in the act of making a specific film, namely *Man with a Movie Camera*. In Kluge's work, as well as in Godard's, film's temporal co-presence with classical montage, which has now become a thing of the past, has ceased to exist. Montage is no longer the general technique for the production of images; rather, it has become the object of the image itself. It no longer merely combines shots or depictions, but becomes the object of a recovering gesture, as it were; a textual and visual reconstruction. Or, in a final twist, instead of serving only as a prime critical technique for the production of images, it also becomes the object of montage itself. What Kluge and Godard seek to produce is, in part, an image of montage as it was.

(3) CRITIQUE OF MERE DEPICTION, THEORY OF CONTEXT
(ADORNO AND BRECHT)

As we saw in section 2, Klugean montage develops in part through a complex engagement with a series of historical and contemporary bodies of filmic work. However, for Kluge montage is also a *general* artistic procedure, and an object for (narrative) representation, as is the case, for example, in the story "Götterdämmerung in Wien," in which it is thematically interwoven with processes of destruction and construction, both artistic and real. By linking it to the operations of negation and distinction, as Kluge does in several statements, montage is finally also defined as a theoretical object. In this latter capacity, just as in its function as a cinematic artistic procedure, Klugean montage also relates to a set of intellectual precursors, namely Adorno and Brecht, and it correlates to what could be called two critical imperatives: a *Kritik der Abbildlichkeit* (a critique of likeness, or mere depiction) and a *Kritik des Zusammenhangs* (a critique of context).[86]

Kluge summarizes Adorno's attitude toward cinema ironically: "Adorno's relation to film was based on the principle: I like to go to the movies; the only thing that bothers me is the image on the screen."[87] Asked by Gertrud Koch whether his technique of making films responds to the Adornian postulate of a "ban on images," Kluge specifies where he sees a connection to the philosopher's theories by referring to the "tautological duplication [*Verdopplung*] of real circumstances through the camera image."[88] In other words: because for Kluge the process of filming, including the professional organization of labor and the technical data of the camera, always involves a mere replication of the problematic status quo, he insists on montage as a destructive intervention that will disassemble this status in order to reassemble it in a way that will at least not hide the stitches by making the cut invisible. Or, as formulated even earlier in the *Ulmer Dramaturgien*: "Das filmische Verfahren würde mit großem Aufwand versuchen, die dem Film durch zuviel Anschauung

anhaftende Oberflächengenauigkeit wieder zu zerstören. [The filmic procedure would make a great effort to destroy the excess of likeness that adheres to film through its exact rendering of surfaces.]"[89] Kluge's statement here again echoes Adorno's predicament; in "Filmtranspa-rente" (Transparencies on Film), an essay penned in support of Kluge and the other authors of the 1962 Oberhausen manifesto, he had written: "distance is abolished in film: to the extent that a film is realistic, the sem-blance of immediacy [*Schein von Unmittelbarkeit*] cannot be avoided."[90] In other passages, the philosopher's argument is even closer to Kluge's, as is the case in the following definition of photographic depiction:

> Die photographische Technik des Films, primär abbildend, verschafft dem … Objekt mehr an Eigengeltung als die ästhe-tisch autonomen Verfahrungsarten; das ist im geschichtlichen Zug der Kunst das retardierende Moment des Films. Selbst wo er die Objekte, wie es ihm möglich ist, auflöst und modi-fiziert, ist die Auflösung nicht vollständig.[91]

> [The photographic technology of film, primarily depictive, places a higher intrinsic significance on the object than aes-thetically autonomous procedures; this is the retarding aspect of film within the historical trajectory of art. Even where film dissolves and modifies its objects as much as it can, the dis-solution is never complete.]

Furthermore, Adorno defines "the reactionary character of any aesthetic realism today" as "tending to reinforce, affirmatively, the phe-nomenal surface [*erscheinenden Oberfläche*] of society."[92] This critique of depictive realism leads him, with recourse to the artistic practices of the historic avant-gardes, to advocate montage: "The obvious answer today, as forty years ago, is that of montage, which does not interfere with things, but rather arranges them in a constellation akin to that of writing

[*schrifthafte Konstellation*]."[93] Kluge's artistic program responds to a similar diagnosis, and to a desire not unlike the one formulated by his teacher: Film "hätte nach … Mitteln der Unmittelbarkeit zu suchen [Film must search for means, or media, of immediacy]."[94]

Another predecessor, mentioned by Kluge himself, is Brecht. *Geschichte und Eigensinn* (*History and Obstinacy*) includes the following famous Brechtian quote:

> A simple "rendering of reality" says less than ever before about reality. A photograph of the Krupp Works, or of AEG, yields nearly nothing about these institutions. Actual reality has slipped into the functional. The reification of human relations, such as the factory, no longer returns these relations. Hence the necessity to "build something up," something "artificial," "contrived." [*Es ist also tatsächlich "etwas aufzubauen", etwas "Künstliches", "Gestelltes".*][95]

Even if one subtracts the problematic historical model of *Verdinglichung* (reification) as a process leading from a state in which functions and interrelations are legible, to a state of functional illegibility, this Brechtian comment does reveal a central element of Kluge's montage project—an element also indicated by an illustration in the 1983 text *Utopie Film*, a photograph to which Kluge has added the explanatory sentences (figure 2.9): "A media corporation. It is invisible [*Man kann ihn nicht sehen*]. What is typical of it is that there is nothing typical that would depict it [*was ihn abbildet*]."[96] The photograph captioned in this manner shows a typical 1950s high-rise office building whose specific function is unidentifiable, and nothing indicates the proclaimed connection of this architectural structure with a media holding. The lack of referential specificity is highlighted by a little arrow, hand-drawn perhaps by Kluge himself, that points toward the building, forming an image of indexical emptiness, because, while gesturing toward the rather generic

Abb.: Ein Medienkonzern. Man kann ihn nicht sehen. Das Typische für ihn ist, daß es nichts Typisches gibt, was ihn abbildet.

2.9 Illustration from *Utopie Film/Utopia Film*. Alexander Kluge.

architectural complex, it still fails to produce any remotely descriptive or specific information about the functions that are being performed inside. This goes further than the mere critique of representation and likeness as reduplication of the status quo, and points to the second critical imperative that grounds Kluge's montage policy: the *Kritik des Zusammenhangs* (critique of context).

As the didactic example of the (image of) the media corporation demonstrates *ex negativo*, and the opening sequence of *Die Macht der Gefühle* establishes positively: for Kluge, montage's interruption serves on the one hand as a tool for blocking the formation of false surface resemblances. On the other hand, it also produces a type of representation that depicts functions, contexts, and distinctions, which a merely descriptive, duplicatory image cannot do. In this sense Klugean montage is always a destructive and constructive intervention in one and the same gesture. In other words: if Klugean montage (if not montage as such) goes beyond the critique of unquestioned surface representation, it does so in its capacity of depicting what cannot be shown *qua* likeness or photographic recording: *Zusammenhang*. "Montage," Kluge writes, "ist eine Theorie des Zusammenhangs [Montage is a theory of context]."[97] In this sense, montage counts as a constructive intervention.

Yet in Kluge's work, *Zusammenhang* is at the very least an ambivalent category. The third volume of *Geschichte und Eigensinn* is titled *Gewalt des Zusammenhangs* (*Violence of Context*), and it harks back to Adorno and Horkheimer's *Dialektik der Aufklärung* (*Dialectic of Enlightenment*). This indebtedness is clearly articulated when Kluge and Negt bring up the notion of the "violence of context" in a passage in which they discuss the biblical monsters Behemoth and Leviathan in their function as magical representations of collective (political) formations, from the Judeo-Christian tradition, leading up to their history in political philosophy through Hobbes to Schmitt (figure 2.10).[98] ("Das Bild dieser Tiere [the image of these animals]" encompasses both "Grauen [horror]" and "Gewalt des Zusammenhangs [violence of context].")[99]

esoterische Verhüllungen; er selbst hat von sich gesagt, daß er mitunter ›Ouvertüren‹ mache, seine wirklichen Gedanken aber nur zur Hälfte enthülle, und daß er so handle wie Leute, die für einen Augenblick ein Fenster öffnen, um es aus Furcht vor dem Sturm rasch wieder zu schließen. Die drei Erwähnungen des Leviathan, die im Text des Buches auftauchen, wären dann möglicherweise drei solche, für einen Augenblick geöffnete Fenster‹ (a.a.O., S. 44).

Für die Grunderfahrungen, die sich in den Furcht und Anziehung ausübenden beiden Ungetümen ausdrücken, gibt es seit Ende des 16. Jahrhunderts nur noch allegorischen oder gar keinen Ausdruck. Das bedeutet nicht, daß es diese Grunderfahrungen, Anziehungen oder Ängste, nicht mehr gibt. Sie bleiben nur dann ohne zusammenfassenden Ausdruck, sie drücken sich aus wie in der Zerstreuung: Furcht und Anziehung, bezogen auf alles mögliche.

Der Leviathan ist gedeutet als *Magnum corpus*, als aus allen Menschen zusammengesetzter Gesamtmensch oder Gesamtarbeiter. Den Menschen, die den gewaltigen Körper zusammensetzen, sind die Waffen genommen, die weltlichen und geistlichen Gewalten stehen *für sich* und schützen den Friedenszustand, so geht Hobbes' Gedankengang.

Hobbes deutet den Leviathan als sterblichen Gott (deus mortalis), der durch den Schrecken seiner Macht (terror) alle zum Frieden zwingt. Das Prinzip der Direktheit wäre – nach Hobbes – die Demokratie. In ihr herrscht der Naturzustand. Jeder kann jeden töten; »jeder kann dieses Höchste«. In diesem Zustand hat jeder Angst. »Ein Mensch ist des anderen Wolf.«

Es sind aber intelligente Wölfe, die eine Maschine, einen »sterblichen Gott« aus sich herauszuspinnen vermögen, den Leviathan. Es heißt dann: Der Mensch wird für den Menschen zum Gott (homo homini deus). Das ist die rationale Nachkonstruktion der kollektiven Erfahrungen des englischen Revolutionszeitalters und des anschließenden Zerfalls dieser Revolution. **Der Staat ist der verhinderte Bürgerkrieg.** Mit den Grunderfahrungen, die sich in den Bildern des Behemoth und des Leviathan im Buch Hiob verbinden, hat das nur dadurch zu tun, daß das Konstrukt Leviathan ein Stück Gott, Maschine, Tier und außerdem aus Stücken von Menschen zusammengesetzt ist.[11]

[11] Man vergleiche den an den Mastbaum gefesselten Odysseus, den ungefesselten Protest Hiobs gegen die Ungerechtigkeiten Gottes, die Herleitung der Autorität Jahwes aus der Bändigung der Welttiere. Auf jede dieser Situation läßt sich eine *Dialektik der Aufklärung* und auch die Dialektik der Rebellion gründen. Erstere ging immer von der Individuation aus. Die Dialektik der Aufklärung stößt auf neuartige Konstellationen, wenn sie von der Fesselung (verbunden mit der Entfesselung der Waffen indirekter Gewalt) ausgeht, die im Bilde des Hobbes-Leviathan *allegorisch*, in den modernen Gesellschaften *wirklich* dargestellt ist.

1024

Abb.: Titelseite der englischen Ausgabe des Leviathan nach der Ausgabe von 1750. Leviathan ist jetzt ein riesenhafter Mann, der aus zahllosen kleinen Menschen zusammengesetzt ist. Links unten Burg, Krone, Kanone, eine Schlacht. Rechts unten Kirche, Bischofshut, Bannstrahl, zugespitzte Distinktionen, Syllogismen, Dilemmen, ganz unten ein Konzil.

1025

2.10 Page spread from *Geschichte und Eigensinn/History and Obstinacy*, including a reproduction of the frontispiece from Hobbes's *Leviathan*. Alexander Kluge.

Intelligent wolves have the capacity to spin a machine out
of themselves, a "mortal god," the Leviathan. ... This is the
rational reconstruction of the collective experiences of the
English revolutionary age and the subsequent disintegration
of the revolution. The state is the prevention of civil war.
This has ... in so far to do with the basic experiences bound
to the images of Behemoth and Leviathan in the book of Job
that the construct of the Leviathan is part God, machine, ani-
mal, and also assembled from pieces of humans.[100]

Negt and Kluge continue by explicitly comparing this scenario
to the one developed by Adorno and Horkheimer in the *Dialektik der
Aufklärung*:

Compare Odysseus tied to the mast, Job's unconstricted pro-
test against God's injustice, and the derivation of Jahweh's
authority from the taming of the world-animals. One could
base a dialectic of enlightenment and a dialectic of rebellion
on each of these situations. The former always departed from
individuation. The dialectic of enlightenment encounters
new constellations when it departs from binding (combined
with the unbinding of the forces of indirect violence) which
is represented allegorically in the image of the Hobbes-Levi-
athan, and in reality in modern societies.[101]

That is to say: Negt and Kluge adapt from Horkheimer and Adorno
the concept of a dialectic which maps the relapses of supposed "progress,"
for instance in processes of rationalization, which in the *Dialektik der
Aufklärung* is depicted in the image of Odysseus tied to the mast:

The ratio which supplants mimesis is not simply its coun-
terpart. It is itself mimesis: unto what is dead. The subjec-
tive spirit which dissolves the animation of nature can master

———

despiritualized nature only by imitating its rigidity. ... The pattern of Odyssean cunning is the mastery of nature through such adaptation.[102]

Through the image of the Hobbesian Leviathan, Negt and Kluge thus speculate about a similarly fatal dialectic of collective binding (through images, political apparatuses, etc.).[103] To this end they define violence of context in the following manner: "All humans, the powers, the animals, the machineries are terrible and fatal as context. Everything becomes too large and is already caught up [*ist gefangen*], before anyone could express themselves [*sich äussern*]."[104] It is this assumption—that any form of contextualization or totalization, be it artistic or political, necessarily produces relations of insubordination, and entails an annihilation of difference—that also factors into Kluge's theory and practice of montage, or into his interpretation of montage as a practice and theory of context.

The point is that the production of *Zusammenhang* is not free from violence and insubordination either, and thus must be interrupted. In other words: there must be a distinction between *Zusammenhang* as violent and *Zusammenhang* as what exceeds and criticizes false likeness. To no small extent, montage in Kluge's work enacts this dialectic, in which an understanding of *Zusammenhang* as critical is pitted against an understanding of *Zusammenhang* as subordinative: in which montage as a critical intervention stands against montage as the technique for the construction of a subordinating system. What takes place in Kluge's work is also always an ongoing distinction between *Zusammenhang* and *Zusammenhang*, between montage and montage: a distinction within *Zusammenhang* and montage, one could say. This position can perhaps be described as a metadialectics of montage, with explicit reference to the Eisensteinian model of "dialectical montage," in that it not only defines montage as a dialectical image technique (or the technique of dialectics in the field of images), but also subjects the very technique of montage to a dialectical critique in that it no longer safeguards its unquestioned status as inherently "critical."

———

In this context, the analogy between architectural construction and destruction in Kluge unfolds its fully nonlinear character: there is no direct equivalence between the destruction of buildings and the destructive intervention of the cut; or: between the constructive erection of buildings and the making of a film. For Kluge, the activities of destruction and construction are subject to the same operation as the term *Zusammenhang*; they are subjected to inherent distinctions: destruction as the abolition of the architecture for a *tausendjähriges Reich* (thousand-year Reich) versus destruction as the bombing of the air raid; destruction as the technique for producing an anticipated scenario of power kitsch (*Reichsruinengesetz*—the law of ruins) and destruction as the technique of critical intervention. Construction as the erection of totalitarian architecture versus construction as the arrangement of fragmentary noisy elements of an opera; construction as the formation of a violent *Zusammenhang* versus construction as the critique of false likeness in representation. And so forth. This distinguishing activity finds its correlate in a model of artistic making in which fragmentation and production are part of the same activity, and eventually become coextensive, reaching a point where destruction can become a generative mode. On the level of form, this leads to individual works which Kluge never fully allows to coalesce into fixed states. Instead, he subjects them to an ongoing treatment of (partial) readaptation and variation (see chapter 10 below). His work, both filmic and textual, does all this at once, and over and over again. Accordingly, Kluge rejects the notion of *Handlung* (plot, action) to describe what occurs in his works: "Das tut so, als ob es eine Handlung hat. In Wirklichkeit sind es lauter Differenzen, verschiedene Beobachtungen—das könnte man das authentisch Filmische nennen. [All this only pretends to have a plot. In reality, it is nothing but differences, different observations—one could call this the authentically filmic.]"[105]

3

Aural TV (Tone, Voice, Noise)

Aural Definition of TV: The Tone of Opera, Theater, Film, and Book

Television is by designation a visual medium. It is thus noteworthy that Alexander Kluge defines the distinguishing characteristics of his TV feature programs in aural terms: "I trust the tone. Our programs are not characterized by their content, but by a tone that comes from operas, books, and from the history of film; a tone that the audience can verify."[1] In fact, Kluge sketches a minimal programmatics of his television work in this statement—that is to say, he transposes the experiential content and knowledge articulated in books, opera, and cinema to the medium of television, opening a reservoir within television for these other types of articulation; and he describes the effect of this transposition, again in acoustic terms, when he says that in his features, television is supposed to (re)produce "the original tone from the realms of music, theater, book, and film."[2] Although in this statement Kluge emphasizes tone *over* content, it is with regard to the latter term that his description initially makes sense. Indeed, the realms of music (operatic, classical, but also electronic contemporary), the philosophical and literary discourse tied to

the medium of the book, and the history of film and cinema, have all occupied major proportions of Kluge's considerable broadcast time on German networks such as RTL and Sat1.[3] Kluge's programs (*News & Stories* for Sat 1, *Primetime* and *Ten to Eleven* for RTL, *Mitternachtsmagazin* for VOX) can be roughly separated into two formats: the major part consists of interviews—or, more precisely, conversations—in which Kluge questions cultural or political protagonists about a given topic. While most of his interlocutors are actual experts and appear as themselves, sometimes they are fictitious, and played by actors. Some of them appear only once; others are recurrent conversation partners. The most prominent of Kluge's dialogic counterparts include the East German poet and theater director Heiner Müller; film scholar Miriam Hansen; cultural theorist and literary scholar Joseph Vogl; the film, theater, and opera director and performance artist Christoph Schlingensief; Kluge's longtime co-author, Marxist philosopher Oskar Negt; the thinker Peter Sloterdijk; and management theorist Dirk Baecker. The actor, author, and former Fassbinder producer Peter Berling—until his death—regularly appeared as fictional experts, such as generals or industrialists, as does Hannelore Hoger—a central protagonist of Kluge's filmic team (questioned, for example, as a prompter). The comedian and musician Helge Schneider has in recent years assumed many roles. Politicians, artists, and intellectuals of all stripes have made one-off appearances.[4]

The remainder of Kluge's *Kulturmagazine* is made up of documentaries that often depict theater or opera productions (sometimes performances, sometimes rehearsals).[5] These are occasionally complemented by contributions on contemporary electronic dance music.[6] Theater also figures in the form of interviews with actors, or as a conversational topic with, for example, Heiner Müller and playwright Einar Schleef.[7] Literature and philosophy are thematized (in interviews about Goethe, Nietzsche, Frankfurt School theory, Benjamin, Schiller, Juvenal, etc.), and so are neuroscience, theoretical physics, etc. Film is explored historically (for example, in conversation with Miriam Hansen about the medium

in its nascent stage as a fairground "attraction"), but also with a more recent and technical focus.[8] If Kluge declares his intention to introduce the "original tone" of the book, the stage, and the cinema to the realm of TV, this is then realized simply, directly, and effectively: either by documenting and broadcasting stage performances, or by devoting broadcast time to the authentic discourse of protagonists from these realms of cultural production. In Kluge's *Kulturmagazine*, the experiential knowledge of philosophers, poets, theater directors, scientists, and others is recorded and transmitted in their own embodied and specific voices.

The "Tone" of the Feature

If the term "tone" thus applies to the content of Kluge's programs, it can also be understood metaphorically to describe the overall impression of a Klugean *Kulturmagazin* that differs markedly from its televisual environment. Tone, then, would need to be understood as a synonym for a general "style." A Klugean feature usually begins with the program's title, or logo (*News & Stories, Primetime, Ten to Eleven*), all of which are designed mostly in white and red on a black ground—a color code that replicates the appearance of (news)print *ex negativo* (black letters on a white ground) and reappears throughout the duration of a feature, when a conversation is interrupted by fields of text (figures 3.1–3.4).

Sometimes a brief title introduces the interviewee and the topic of the conversation. The program continues with a shot that will be maintained subsequently, for practically the entire duration of the feature: an approximate three-quarters-angle portrait of Kluge's interlocutor, from the chest or shoulders upward, in front of a non-studio location (e.g., the foyer of the *Volksbühnen* theater for the actress Sophie Rois; sometimes the spatial situation is not easy to decode, as is the case, for example, in an interview with Sloterdijk, who sits in front of an indistinct dark background, with a single lightbulb hanging from above into the frame) (figures 3.5–3.8).

3.1 Opening credits, dctp. Alexander Kluge / dctp.

3.2–3.3 Opening titles, *10 to 11*. Alexander Kluge / dctp.

3.4 Opening title for dctp television feature with Dirk Baecker on post-heroic management. Alexander Kluge / dctp.

3.5–3.8 The Klugean interview shot: Niklas Luhmann, Sophie Rois, Heiner Müller, Christoph Schlingensief. Alexander Kluge / dctp.

Camera movements are limited to occasional minor zoom-ins or zoom-outs; lateral swings occur only, and if so minimally, when Kluge interviews a non-German-speaker whose discourse is translated by an interpreter who is nearly always also visually present, seated next to the interviewee. Shots like these continue for several minutes, recording long passages of question/answer exchanges between Kluge and his partners. This obstinate, visually absolutely steady conversationality sets a tone that differs from other TV programs in its temporal and visual economy: no soundbites, no fast cuts, nothing visually "interesting" that would pull the camera's focus from the face of the person speaking. At the same time, the absence of what the viewer has come to regard as "professional" decoration and light patterns also marks a Klugean program as distinct from a talk show or interview that is produced in the strategic isolation of the studio, where a discursive exchange can be arranged in such a manner as to optimize its televisual recordability. The tone of a Klugean program is thus set by a certain "impure eventlessness" on the level of the image—by the standards of current televisual practice. Its correlate is a foregrounded spoken discourse that is a) visibly concretized and embodied through the always visible face of Kluge's interlocutor; and b), although foregrounded, always also subject to slight disturbances that come from a co-recorded environment which is not "sanitized," i.e., non-optimized in terms of information processing.

This arrangement is occasionally interrupted by textual elements of two types: one is a strip of text, separated by a thin horizontal red line, that runs along the bottom of the image from left to right; this setup mimics the chyron format familiar from "actual" TV news programs (think of any "breaking news" bar, for example) or from public LED boxes (installed at airports and in public squares). This proximity is countered by Kluge's preference for quanta font, a particularly old-fashioned-looking typeface with bulging dots at the end of the letters—a typeface that he has in fact been using at least since the early 1980s—for example, in the book *Die Patriotin* (*The Patriot*).[9] The second category of

textual interventions consists of full replacements of the camera-recorded image through black-grounded fields on which words and commentaries appear—sometimes as static elements, sometimes as a sequence of inter-related written components. These substitutions are always exclusively visual: i.e., the audio of the conversation carries on while they appear. The content of both bands and fields of text is tangential *vis-à-vis* the spoken dialogue; they serve either as syncopating highlights or as additional information.

For another way of altering the camera image, Kluge makes use of graphic alterations that rely on blue-box or green-screen technology, and appear in the form of digitally or electronically manipulated backgrounds. In these cases, the photographic recording stays untouched in the area that extends from the person portrayed to the camera lens. The ground beyond the seated figure is occasionally subject to color changes, or to the montage of sometimes drawn, sometimes photographic, sometimes still, sometimes moving illustrations whose content is, again, not precisely but only tangentially relevant to the subject of the conversation between Kluge and his partner. The material is always recognizably "found," i.e., not manufactured for the occasion. In this manner, a dialogue between Kluge and Joseph Vogl about the moon as an object of cultural and scientific knowledge is suddenly "backed" by a large-scale photograph of a lunar surface. Or, during a conversation with the sculptor and photographer Thomas Demand, elements from the artist's images are copied into the TV picture. These graphic manipulations are characterized by technological simplicity and deliberate stylistic ease (their closest relatives are perhaps Chris Marker's early experiments with electronic image alteration in *Sans Soleil*): the manipulation of the image is never clandestine, i.e., it is always recognizable (and thus in line with Kluge's rejection of invisible cutting); it is also done in a deliberately unsophisticated manner. This conscious edginess—or, to use a Klugean term, this coarseness[10]—and the visible courting of an aesthetic of the (printed) page contribute, again, to the specifically "bookish" tone that characterizes

Kluge's features. The tone of the book, then, extends beyond the direct employment of textual elements well into the "look" of these programs.

If the temporal economy of the shot in Kluge's programs is marked by persistent duration, the ends of his features are typified, in contrast, by an abrupt arrival: one last time, the camera image is replaced by a text field that reiterates the title of the conversation and the name of Kluge's interlocutor (for example, "Joseph Vogl on …"). The sound recording first continues and then fades out quickly, while the logo and name of the given program appear. Then commercial TV switches back to its routine—the swift fade-out of Kluge's audio signifying both that there would have been more material worthy of broadcasting, and an unwillingness to mediate by constructing a soft exit or "bridge."

THE TONE OF THE VOICE, ITS LOCUS

The tonal characterization of a Klugean television feature applies, furthermore, on a concrete level and is most personally identified with the producer/director: with Kluge's own voice. If one were to identify a central aural signature of his programs, it would certainly be the unique tone and conversational style in which Kluge poses his questions: he interrupts and prompts his conversation partners to elaborate on the agreed topic.[11] Kluge's voice can be described as both restrained and insistent; his manner of questioning is characterized by a certain reserve, but he is always ready to cut his conversation partners short, and redirect their discourse by confronting them with a question or statement to which they have to react. This direct phonic address and intervention correspond to Kluge's vehement criticism of voice-over commentary, and even any additional sound elements, when it comes to television work: "We reject nondiegetic sound."[12] In his films, by contrast, Kluge employs voice-over quite frequently. The voice is always his own. There is thus an acoustic element that binds his cinematic work to his TV productions: the author/director/producer's characteristic voice. One way of distinguishing Klugean

cinematography from his television work would be to describe the different modes of address in which this voice figures: directly and located onsite, as part of a diegetic continuum (TV), versus generally, as a non-diegetic element that speaks as one additional signifying element in a montage of layers (film).[13] Once this is taken into account, one could reformulate Kluge's interdiction of a televisual voice-over commentary as the interdiction of an indirect, non-concretized *comment* from the off-screen space; the directly *addressed*, i.e., non-commenting voice from a concretized, yet invisible space beyond the camera's field of vision is not just allowed here: it is what generates the Klugean televisual dialogue in the first place.

Throughout a TV feature the camera stays entirely with Kluge's interlocutor: i.e., although Kluge is onsite, he practically never shows himself. In film-theoretical terms, one could say that while Kluge is for most of the time invisible, except for part of a hand resting on a table that occasionally enters the frame, or a shoulder that is just caught by the camera, he is always located *hors-champ*, i.e., in a zone which the camera, were it to start moving, could potentially explore. This invisible, but firm—at times even physically palpable—localization is communicated by the fact that Kluge's questioning voice is audibly recognizable as a part of the acoustic continuum recorded onsite, that is, integrated into the synch sound panorama in which the conversation is originally voiced and heard.[14] It is also transmitted by the direct, spatially concrete address with which his interview partners make their statements, or listen to his questions. One of these interlocutors, Joseph Vogl, has described the effect of this constellation as a process of being held accountable, or even "arrested," through a steadfast recording of one's face.[15] This face becomes, in turn, the site where the arrival, impact, and effect of Kluge's questions are visibly recorded:

The offscreen space of the question coincides with a face
that now becomes the site of a microdrama, of the struggle,

the imbalance, and the suture of question and answer. …
The imperative mandate of the question, its inevitability …
is transferred from the interviewer to the apathic presence of
the camera, which registers not only the answer, the move-
ment and the expression of the act of answering, but also the
arrival and effect of the question.[16]

Just as in the case of the voice, the different visual approaches to
the face also become a potential point of comparison between Klugean
TV and Klugean cinema: in Kluge's films the camera regularly records
extreme close- ups, primarily of actresses (Alexandra Kluge, Hannelore
Hoger) whose eyes are either still or shift from side to side, in both cases
giving the impression of a face that does not register that it is being seen
or addressed. The faces of Kluge's TV partners, by contrast, always register
and express the fact that they are being addressed (through Kluge) and
their own address (toward Kluge). (figures 3.9–3.14).

One elementary function of Kluge's conversation features therefore
consists in the fact that they enable the audience to witness concrete
address. The poles of this type of mutual address between Kluge and
his interlocutors are asymmetrically distributed in terms of visibility and
audibility. Nonetheless, or perhaps because of this asymmetry, these posi-
tions are absolutely non-dissolving: they are never sacrificed for a "more
complete" filmic or televisual spatial description.

In this constellation, Kluge is present as an invisible interlocutor,
as a dialogic counterpart who remains hidden from the vision of the
TV audience but is seen by the interviewee, and thus indirectly visually
"anchored." As a result, his voice and tone attain signature status.[17] The
hors-champ as the zone of origin for a concrete voice is permanently called
into memory, but never shown even through a camera pan or reverse
shot, the standard tropes for constructing spatial interaction between
filmed figures. In this way, Kluge's televisual locus is at once emphasized
and withdrawn—an emphasis that is to a certain extent the result of this

3.9–3.11 *Abschied von gestern / Yesterday Girl* (1966, 35 mm, b/w, 88 min), close-up (Alexandra Kluge). Alexander Kluge / Kairos Film.

3.12–3.14 *Die Macht der Gefühle / The Power of Feelings* (1983, 35 mm, color and b/w, 113 min), close-up (Alexandra Kluge). Alexander Kluge / Kairos Film.

withdrawal; a site that is emphatically not fed into the semiotic economy of cutting and visual relationality, but is always within reach of the microphone. The result is a monolithic image of the interviewee which is not resolved into the usual sequence of shot/reverse shot, which never attains visual closure or saturation: an image of truncated visibility, linked to an excessive acoustic zone captured through audio recording technology.[18]

THE TONE OF THE CONVERSATION, THE STRUCTURE OF THE QUESTION

Finally, "tone" relates to the specific and, again, highly recognizable manner in which Kluge poses his questions and conducts the dialogue. He speaks in a mixture of breathlessness and precision, with an attitude toward his interlocutors that gives them room to develop their own discourse, although an interruption and potential provocation from his side are always imminent. One central characteristic is Kluge's repeated "Ja" (yes) with which he punctuates his own questions, his discursive development of a complex theme, or the utterances of his partners: this "Ja" never functions as an affirmation that would signal acceptance or closure to a statement; i.e., it never occurs as a discursive seal that marks the end of an articulation or the end of a conversational subsection. Rather, it is always spoken in such a manner—Kluge raising his voice a little toward the end of this monosyllable, as if to signal a question, an implicit: "Are you (still) following me?," or "Can one really put it (that is, the previous statement) this way?" The psychological effect is double: Kluge's "Ja" keeps both his interlocutors and himself permanently alert (some of his partners [Vogl and Rois, for example] literally pick it up and mimic him: repeating the "Ja" as a question); the "Ja" also encourages them to describe, depict, explain, elaborate, even imagine, in order to make them incessantly producing speakers in Kluge's own image. The resulting conversations are potentially unending two-sided floating discourses. Kluge suggests that it would be possible to elaborate, fantasize, and continue the

talk forever. (This effect is reinforced through the "unbridged" beginning and ending of the features, the swift fade-ins and fade-outs.)

This impression—that there is an abundance of "content" to be thematized, or that content here always exceeds its exhaustibility by conversation—is also the result of Kluge's specific mode of posing questions, which Joseph Vogl has analyzed: "Kluge's questions … are not the neutral doppelgänger to a possible answering sentence, they spare themselves the satisfaction that lies in compensating questions through answers."[19] Kluge frequently achieves this effect of undercutting a potentially compensatory relationship between answer and question (i.e., a relationship in which the answer would satisfy and therefore neutralize the question) by presenting his interlocutors with a perplexing statement or phenomenon, and linking this presentation—which is not a question *per se*—to a request for elaboration. The result is, conversely, more of a statement or comment than an answer in the conventional sense; often these responses involve an imaginary and inventive production "on the fly," while the speaker is being filmed. This is combined with the fact that Kluge's questions often concern the experiential and/or professional expertise of his interlocutors. For example, Kluge confronts Pierre Boulez with a fictional anecdote about a performance of *Götterdämmerung* in Vienna, addressing him in his function as an expert: as a composer and conductor. In return, Boulez relates an anecdote about watching an opera from the orchestra pit at Bayreuth (see chapter 2 above). In such cases, the excess of extant knowledge *vis-à-vis* the scope of a question that addresses the field of expertise guarantees a discursive surplus whose revelation is often instigated by Kluge's responses (the above-mentioned "Ja?," but also occasionally a half-surprised "Ach?" that encourages the expert to elaborate further).[20] Again, Joseph Vogl has provided the most succinct account of the general conversational situation that results from Kluge's "interrogation" technique:

> At the center of the Klugean question stands something that
> one could call a "complex theme." A complex theme is …
> characterized by raising a heterogeneous and complex cir-
> cumstance that produces perplexity, i.e., literally a multiple,
> manifold, and therefore intricate issue.[21]

Vogl also emphasizes that this complex theme—that is to say, the
"topic" of a Klugean conversation—is not a given. Rather, it is the result
of a certain method of asking that evokes a certain type of response.
Kluge's questions are not directed toward a

> substance … , at something that sits behind words, concepts,
> and things, like a virtually immutable hidden kernel. Rather,
> they are concerned with definitions in a rigorous sense, with
> defining, delimiting, cutting, and isolating, i.e., with the fac-
> ulty of distinction that generates the object in question in the
> act of determination.[22]

If a Klugean conversation can be described from this perspective as
a venue for the unfolding of a faculty of discernment, then distinction is
not employed here in order to minimize complications. Rather, the dis-
tinctive faculties of Kluge and his interlocutors work in order to generate
a surplus of imagination, an excess of complication—in other words: to
produce complexity.

NOISE: STATIC, RESOURCE, AND COMPLEXITY

If Kluge's questions systematically provoke the production of complexity,
it is possible to link this courting of a non-systematic surplus of knowl-
edge to the above-mentioned (informational, televisual) "impurity" of
the Klugean feature. Media theorist Georg Stanitzek has written, with
recourse to the paradigms of communication sciences, about Kluge's

deliberate tolerance of disturbances (*Störungen*), which results in "noisy communication."[23] In Kluge's programs there is a both a visual and an aural realization, a signature-style intervention which emphasizes this potential openness toward noise, and to some extent already creates it. In a number of cases, Kluge places the interviewee in front of a visually uneven background in which vaguely perceptible movement occurs. Conversations take place in hotel lobbies, in front of moving escalators, in cafés and canteens. Occasionally, one sees the silhouettes of passers-by gliding through. The microphones deployed foreground the exchange of words between Kluge and his partner(s), but the aural focus is still wide enough to catch an audible stream of background noise: the clinking of tableware if the location is a café, the murmur of the other guests, or a piano player practicing in a theater foyer (for example, in the interview with Sophie Rois). These are elements which Kluge's synch sounds do not filter out. There are corresponding moments in the non-documentary parts of the TV features that fulfill a similar function in terms of a strategic "contamination" of the program. During the run of a feature, the background in front of which we see the interviewee might change to an openly recognizable digital montage (for example a landscape, the surface of the moon, or an abstract pattern) (figures 3.15–3.18).

In addition to the filmed figure there is a second layer to the shot, constructed from some anonymous visual vernacular whose illustrative function is either too obvious or too strategically inadequate to blend with the talking head to form a compact message. Kluge's questions function similarly: by presenting his interlocutors with a perplexing topic, a complex theme, Kluge deliberately invites "noise" into his interviews: the question is not quite clear, the theme is far-fetched, strangely put, etc. In return, Kluge receives answers that are shot through with "noise," too. Affectively tinged by the slight irritation provoked by the question, these answers are often articulated in a tone that hints at insecurity, indicates a minor concern that the guest might not have understood Kluge "correctly" and is uncertain if she or he will be able to produce an adequate response.

3.15–3.18 Interview shots from dctp television features, including electronically replaced background images—with Ulrike Sprenger and Oskar Negt. Alexander Kluge / dctp.

Georg Stanitzek has suggested that Michel Serres's analysis of the noise/message relation as parasitical can be applied to the Klugean feature in general. According to Stanitzek, Kluge "invites" these disturbances because they potentially lead to the "transformation of systemic states."[24] This suggestion would be in line with the paradigms of a critical theory of noise, such as Jacques Attali's, which departs from the basic premise of information science that "noise is a resonance that interferes with the audition of a message in the process of emission. ... Noise, then, does not exist in itself, but only in relation to the system within which it is inscribed: emitter, transmitter, receiver."[25] From these premises Attali develops what could be termed the parameters of a critical noiseology, a theory that recognizes in noises the potential to attack, destroy, and "transform" preexistent networks "if the codes in place are unable to normalize and repress them."[26] Noise, then, both interferes with functioning routines—it subverts exchanges that rely on a clear channel—and becomes the site for the emergence of other circuits and exchanges: "The presence of noise ... makes possible the creation of a new order on another level of organization, of a new code in a new network."[27]

As Stanitzek suggests, Kluge's production could exemplify such unprecedented types of exchange through interference within an established medial infrastructure and its communication routines. The Klugean televisual feature "reads" as noise against the discursive and stylistic codes of its environment. It quietly but insistently violates these codes through appearing "print"-like, through gesturing toward the cultures of (silent) film and opera, and through combining factual and fictive referential content.

While the connection to Serres thus proves relatively fertile, one argument, however, counters a "transformative" interpretation of noise (in Kluge); the observation that Kluge's televisual practice is characterized, both as a whole and within a single feature, by steadiness rather than by change. The use of visual and aural noise in his television features is in part so intriguing because Kluge refuses to assign a transformative

function to interference. Here, irritating sounds or moderately disturbing visual choices neither engender an undoing of a preexistent order, nor clear the way for a future, not-yet-realized type of structure. In Kluge's work, noise is static in that word's sense as a noun—uncontained, raw signaling—and in the term's adjectival sense, both intransitive (the system is not altered through the interference of noise), and immobile (noise neither comes nor goes: it is just there).

Part of the fascination of Kluge's TV output is the fact that it has changed little over nearly three decades (and, moreover, that there is little transformation within each individual feature)—in other words, the agenda is *not* to transform, but to continue.[28] Or that a transformation, if it occurs, never relies on noise; rather—as in the alteration of the background of a shot—it is always done in order to *produce* at least a minimal amount of noise.

Perhaps more pertinent to an understanding of Kluge's inclusion of noise in his work is another passage in Serres's text where the philosopher suggests that we should understand "interference … as an art of invention," or where he says that with the parasite, "a second order appears."[29] In Kluge's framework, systematically unexcised "noise" functions as both a symptom and an indicator of a "critical" method of analysis and production.[30] The admission of noise into the system is thus at once a pragmatic and a political gesture.

The political/critical understanding of "noise" is spelled out in theoretical terms in Negt and Kluge's *Geschichte und Eigensinn* (*History and Obstinacy*). Here, the category of "noise" (*Rauschen*) or "interference" (*Störung*) appears as a constitutive counterpart to the process of *Selbstregulierung* (self-regulation) by which any given *Zusammenhang* (context) feeds gathered information back into its own system and adjusts, that is, alters itself. Self-regulation also describes the autodynamics or self-productivity of a *Zusammenhang*, a type of activity that results from that context's specific *Lebendigkeit*, its being-alive: "Selbstregulierung … ist … die Kategorie des Zusammenhangs, indem vom Zusammenhang

ausgehende jeweilige Eigentätigkeit bezeichnet wird [Self-regulation … is … the category of context by virtue of the fact that it designates every activity that emanates from this context]."[31] The notion of self-regulation derives from the "Beobachtung, daß etwas, das einen Zusammenhang bildet, sich auch als ein solcher Zusammenhang anzuwenden versucht [observation that something which forms a context attempts to apply itself as context]."[32] One example of self-regulation would be the internal modulation and modification of a subject–object interaction through the feedback and distinction generated by feelings.[33] The point is that for Negt and Kluge, self-regulation must not be confused with a process of optimization (like the distinctive faculty of feeling which serves to differentiate, not to motivate, action, or to make it more efficient). Moreover, self-regulation never appears in a pure form: "There is no self-regulation in and for itself."[34] Because a self-regulating system never acts on its own, because it always interacts with other systems ("self-regulation develops from friction with the object"), and also because even through recourse to itself it will not achieve perfect reflexive closure, disturbance or interference is always involved in self-regulatory processes.[35] "Selbstregulierung" occurs "sobald es um Geschichtsverhältnisse geht, nirgends ohne Störung [Where historical relations are concerned, self-regulation never occurs without interference/disturbance]."[36] In reference to a—certainly not unproblematic—model of alienation, Negt and Kluge even go so far as to describe "noise" not just as a necessary by-product of self-regulation, but as identical with the effect of self-regulation: "Self-regulation is an encompassing order that usually appears under the conditions of alienation as the disturbance of organization, and not as an organizing moment [als Störung von Organisation und nicht als organisierendes Moment]."[37]

Even though Kluge has not made an explicit connection between this political theory of noise and interference and his televisual aesthetics, it is perhaps possible to suggest just such a connection by analogy with the Klugean critique of *Abbildlichkeit* (likeness) that grounds his montage practice as a necessary construction of *Zusammenhang* (context). (For an

analysis of the nexus between *Abbildlichkeit*, montage, and *Zusammenhang* in Kluge's work, see chapter 2 above.) If the camera recording needs to be broken—or "disturbed"—through the intervention of montage to expel its purely affirmative character, its incapacity to show *Zusammenhang*, there is perhaps a comparable gesture that motivates the "impure," noise-oriented recording of the Klugean TV feature, and specifically the conversational interaction that forms its main axis: a clear channel, audio, or picture would be false in that it presumes a freedom from interference that would not be historical. The result would be a simulacral communication of direct message transmission, without any information loss. The "noisy" program would, then, be the necessary aesthetic correlate to an understanding of historicity as an always mediated and therefore "disturbed" condition—the "expression" of this condition, perhaps.

Noise has yet another function in the Klugean project: as a productive force. In order to analyze this function, we must turn to yet another theoretical framework. We find this alternate understanding of noise in a series of TV conversations between Kluge and the systems and management theorist Dirk Baecker. Kluge had been introduced to Baecker's work through Heiner Müller, who had taken a strong interest in theoretical accounts of management structures and work processes presented in a slim volume that Baecker, a student of systems theorist and sociologist Niklas Luhmann, had published with Merve Verlag under the catchy title *Postheroisches Management. Ein Vademecum (Post-Heroic Management: A Vademecum)*.[38] Transcripts of Kluge and Baecker's conversations were later published under the title *Vom Nutzen ungelöster Probleme (The Use of Unsolved Problems)*, referring to an identically titled brief chapter in *Postheroisches Management*. In his first encounter with Kluge, Baecker develops, with reference to Francisco Varela's theories of embodied cognition, a theory of reflexivity that resonates with Negt and Kluge's account in *Geschichte und Eigensinn*. Baecker proposes the minimal thesis "that intelligence is obviously impossible without the self-recursion of a brain to a body in which it sits without being identical to it, and further

through this body to the world in which it finds itself."[39] He clarifies that this notion describes not just an inevitable but unwanted "extra" that intelligence receives through its non-identical part. In Baecker's framework, this non-identity of a consciousness that refers back to the body is *constitutive* of—or, in other words, the very source of—intelligence: "Intelligence seems to depend on encountering something other than itself already in recursion, to be able to explore the world on the basis of this first experience of difference."[40] In his account, this moment of non-identity in recursion is thus interpreted as a constitutive interference—referred to in his title as an "unsolved," useful "problem." Accordingly, it would be misleading to think of a "problem" as an external obstacle to brain activity. Rather, there is no such thing as brain activity without "problems": "The point is to no longer think of the brain as a machine for problem solving that switches to standby when there are no problems to solve."[41] With the characteristic smoothness of systems theory, Baecker employs this cognitive model in *Postheroisches Management* to describe "den Nutzen ungelöster Probleme [the use of unsolved problems]" for understanding and running a company, or an enterprise: "An enterprise is not an instrument for the solution of problems, but an instrument for the identification of problems. Business structures crystallize where there is uncertainty as to how to continue. And not where one already has things under control."[42] It is this shifted understanding of what constitutes a problem—an understanding that no longer seeks to dissolve problems, a thinking that does not propagate the "removal" of interference, does not seek to "solve" paradoxes—which interests Kluge, who translates it into the question

> by which theoretical means one could approach the task of mastering an everyday life whose continuation is the sum of smaller and larger defeats/failures [*Scheitern*]. Intelligence compensates for breakdowns. A business company, a marriage, a battle, or an act of perception are possible only because they repeatedly seek to solve problems which cannot be solved.[43]

It would be wrong to assume a direct applicability of this account of problem hedging, or complexity exploitation, which derives from a managerial and consultancy-biased branch of systems theory, to Kluge's model of "noisy" television. Yet neither can one deny that there is a certain affinity between the economists' stimulation of productivity *qua* unresolved contradiction and the strategic interference generated in Kluge's system.[44] It is perhaps best understood if one considers the aforementioned non-compensatory relation between question and answer in Kluge's conversations. Such a manner of asking stimulates a type of discourse that results in "unsolicited" knowledge: replies that do not just go beyond the scope of a question but, due to the absence of scope within the question, are difficult to accommodate within the economy of a dialogic encounter. And yet, heeding Baecker's advice, this "noisy" excess becomes describable as some sort of discursive surplus production: the induction of material into Kluge's system that surpasses its limits by virtue of the fact that it is generated by a person other than the author/producer/interviewer. Because Kluge stimulates responses that function more on the level of a general remark, an explanatory statement, and not on the level of a dialogic "answer" to a question, the gathered and recorded articulations add a genuinely non-scripted addition to his system. It is their non-scriptedness—that is to say: their non-foreseeable status (from the perspective of the interrogator)—that makes them "noisy" in the first place. Furthermore, they are kept in this state because Kluge's conversation management almost never seeks to reduce their complexity, or to "resolve" their density by posing "mediating" questions. Nor does he ask his partners to explain and break down their statements. (Kluge's programs are remarkably free from any anxiety that the audience might not "understand" them.) The same non-developmental structure generates the irritating noisy visual and aural elements in his television features. In these cases, elements of visual and aural noise never fully unfold, never turn into "actual" chains of narrative or stylistic layers. In other words: if we see a digitally animated, cut-out paper spaceship flying

through the background, or through a visual "intermission" between two interview sections, such an element will never develop into a little sub-plot of an alien arrival, or a trip to the moon, for example. All illustrations in a Kluge TV feature receive this non-developmental treatment: they are summoned, appear, and stand as a blocklike presence in the course of the program. With the same certainty, one can say that the camera in a Kluge TV feature will never begin to travel and explore the ambiance of an airport lobby whose visual and aural repercussions have been wavering into and out of the image. Its remote-but-palpable status will never change to that of a documentary on business travel, for example. Here, aural noise (such as the practicing piano player) also never becomes a bridging introduction for a conversation—a common deployment of film sound that uses the acoustic ambiance to help "describe" a site. In Kluge's programs such processing does not occur: noise and conversation are always co-present, and constantly interfere with each other. Or: "noise" is present only because it is always recorded with the dialogue, and thus never (semiotically) "resolved." To put it differently: there is noise in Kluge's programs not just because they invite or record interference, excess information, etc., but also because they do not process, integrate, and therefore compensate for this excess.

In this respect, the analogy between Baecker's theoretical account of interference and "problems" as resource and Kluge's "noisy" television aesthetic is fully in place—not so much as an application of Baecker's description and advice to Kluge's system, but rather as a parallel between Baecker's discussion of noise as resource and the way in which noise and interference are positioned within the Klugean feature: as unprocessed elements not yet transformed into proper information and constitutive crackle. Noise in Kluge, then, describes a terrain in which a potential distinction could take place, but is deliberately kept in a state of possibility; thus the distinction is never actualized. If—as already briefly outlined above—Kluge's work is partially characterized by a critique of formal finalization (for a full analysis, see chapter 10 below), the presence of

noise in his programs must be considered a contribution to this critique. Moreover, noise is also an element that signifies that there is still a distinction ahead: the separation of useful and non-useful elements of interference. The process of distinction is hence marked as non-finite, and ongoing.[45]

ASSEMBLING A FORMAT, OR THE DIALECTIC ON TV

When we discuss Kluge's TV work, it is striking to note that the terms provided by Stanley Cavell's now canonical analysis of the medium of television are still valid. In his seminal essay "The Fact of Television," Cavell observed that what is "memorable, treasurable, criticizable" in television "is not the individual work, but the program, the format"— and this is exactly what Kluge has achieved on this medial terrain: the development of an entirely unprecedented *format*.[46] With his television work, Kluge has developed a format that is generated through a basic formal setup—an inventory of (formal) elements. Its more than 3,000 individual instantiations do not "compete with one another for depth of participation" in a hypothetical common genre, nor do they "comment upon one another for mutual revelation," as Cavell put it.[47] This makes for a viewing experience in which any Klugean feature claims full validity on its own, and in which none competes for an "optimal" fulfillment of the rules and conditions staked out by its blueprint, let alone their transformation. Viewing Klugean TV, therefore, is a radically open and egalitarian experience. Seeing one feature is as good as seeing fifty, at least when it comes to understanding its particular form. There are no "key" installments that would allow for privileged insights, and hence make their respective viewers privy to information otherwise withheld from the general viewing public. There is no separation of the "cognoscenti" from those who missed Kluge's program on a certain day. That is to say: although they are not strictly identical, almost all these features equip the viewer with an equal knowledge about the basic setup and the potential

way in which they provide content. As a result, the "content" of each con-
versation does not contribute to a serialization of previous and subsequent
features; that is to say: Kluge's programs are not structured as "episodes."[48]
Neither are they variations on a basic theme. Rather, their blueprint
resembles the building principle of a news format. In this sense, the title
of one of Kluge's programs—*News and Stories*—refers to the principle of
permanent content updates, but it also describes the structure of such fea-
tures which is, first, robust enough to support a continued existence over
many years, and yet, second, flexible enough to function as a forum for the
broadest variety of possible content that Kluge's interlocutors might bring
to the table, or which he solicits from them. In the medial realm of tele-
vision, where programs are permanently evaluated and formats adjusted,
Kluge's programs are hyper-stable exceptions that have existed, with only
minor changes, for more than a quarter of a century.

As an instigator and aggregator of articulations, the Klugean TV
feature can also be considered a format in the sense recently defined
by David Joselit. Building on the notion of "assemblages" proposed in
actor-network theory, Joselit defines formats as "dynamic mechanisms
for aggregating content." Formats establish "nodal connections and dif-
ferential fields." They "establish a pattern of links and connections," and
hence exist as "configurations of force."[49] A format, then, is ultimately
neither form nor medium.[50] A medium—here television—is its habitat,
the site where it takes hold.[51] Forms may enter into the construction of
a format (the various formal elements of the Klugean feature analyzed
above), or they might in turn be enabled by this format (the discursive
activities of Kluge and his interlocutors). But they are not identical with
the rules and routines through which formats assemble and articulate
different components. All of this is said with the caveat that any Klugean
theory and practice of assemblage will differ from an orthodox actor-net-
work perspective on social, technological, and formal associations, at least
through its dialectical character. Latour's science of associations privileges
the analysis of a given assemblage's material—or thingly—components,

at the expense of thinking the systemic dynamics and constraints that emerge in or frame such associations beyond the immediate material component agglomerates.[52] Kluge, by contrast, operates on the assumption that any assemblage—or montage, for that matter—not only potentially articulates the relationality and difference between its components, but potentially also suppresses and subsumes its constituents. Hence the necessity for discernment between the articulation of such contexts and interconnections as both producers of difference, and potentially repressive structures, which forms an integral element of Kluge's theory of context (see chapter 2 above). With regard to Kluge's invention of a new format within the institutional, medial, and technological conditions of television, this is the basis for his specific televisual strategies: because the available arrangements exclude and suppress certain forms of articulation, they need to be reassembled—to form a counterpublic.[53]

Kluge's features further serve as an exceptional proof of Cavell's hypothesis that television's successful formats function as "revelations … of the condition of monitoring."[54] By "monitoring" Cavell understands a mode of reception that scans more than it examines, searching for outstanding rather than routine occurrences, as opposed to attentively processing a singular structure. If "the event is something that the television screen likes to monitor, so, it appears, is the opposite, the *uneventful*, the repeated, the repetitive, the utterly familiar."[55] Yet again, we need to recalibrate terms that were devised for the description of television's routines in order to understand Kluge's specific operations in that medium. There is plenty in his television work that counts as an "event" in the overall logics of television: the lettering fields; the "news" chyron; the visible splitting of the onscreen image into (bichronic) constellations; the insistent localization of the voice in the *hors-champ*; the deliberate disregard for the conventional separation of fictionality and factuality, etc. But all of these elements belong to the general setup of the Klugean format. That is to say: they have entered the structure of his TV productions to such a degree that none of them could mark an individual feature, or even

a singular moment within a feature, as "eventful," let alone "momentous." The Klugean format functions as an event within the medial ecology of television in terms of its construction *as a format*, but there is nothing that sets an individual feature in the context of Kluge's production stream apart from the preceding or following instantiation—not to mention the insistently "horizontal," or "flat," dramaturgy of these conversations for the camera, where nothing ever peaks.

Strictly speaking, the only moments that stand out in these programs are, again, the cuts where the visual of a conversation is inadvertently dropped for a static shot of a book illustration, where a field of lettering appears, or in which the entire feature suddenly breaks off without facilitating a smooth exit. In themselves, all of these elements are characterized by the same impermeability to transformation, and only where they are abruptly cut against one another does something like an occurrence in the conventional sense of the term emerge. And it is, again, this obstinate durability, in which the category of the event (if applicable at all) is reserved for a structural feature that consists in the negation of a transition between temporally extended static visual elements. This negated transition, in turn, makes for the "event" character which these programs justly claim in their medial realm.

With this assessment in place, it is also possible to review and perhaps adjust Cavell's contention that a general "realm of the uneventful" emerges in television, interrupted only by the "intrusion of emergencies," and thus delineates a dimension where "serial procedure is undialectical."[56] Cavell's concept of the dialectic here is admittedly tied to an idea of "classical narrative," understood as "the progress from the establishing of one situation, through an event of difference, to the reestablishing of a stable situation related to the original one." With this he contrasts "a stable condition punctuated by repeated crises or events" where there are "no developments of the situation requiring a single resolution."[57] Kluge's works for television require a different notion of the dialectic, for they have an absolute right to be considered as dialectical interventions

in that medium that do not function as attempts to make television conform to the developmental and temporal standards of what, frankly, is a theory of narrative, but not of film, let alone media in general. Rather, the Klugean dialectic on TV unfolds—paradoxically—as a blockage, as a switch to stasis, to a freeze. What is thus put on hold is a type of work that structurally obstructs the logics of its medium by setting extended moments of non-developmental recordings against each other. There might be a more appropriate account of the dialectic to explain such work. This might be another example of a dialectic at a standstill—the dialectic put on hold in a constellation of contradictions, but also a temporalized arrangement of non-unfolding bits of time whose conflict does not enter the flow: a dialectic at a standstill, which, as Benjamin once defined it, characterizes the image.[58]

Starry Skies and Frozen Lakes: Digital Constellations

Loops and Loose Couplings: Website and DVD

In response to the media-technological shift of digitization, Kluge has integrated the DVD and the website into his work. His television production company maintains an online presence, <www.dctp.tv>, which functions as a repository for a large number of clips, most of which derive from Kluge's TV repertoire, with a significant number also consisting of excerpts from his analog films for the cinema. On opening the site, the viewer/user encounters a field that breaks down into three major components (figure 4.1).

At the center sits a frame, placed slightly closer to the window's upper than to its lower edge, in which a clip begins to play. Just beneath the frame's lower border lies a typical controller for playing films through an online interface, which the viewer will recognize from platforms such as YouTube, allowing for volume control, fast-forwarding, switching to full-screen mode, reposting to social networks, etc.

The website's second component is a bar that lies below the central frame. It is a laterally scrollable menu which consists of an alignment of rectangular fields, each representing a clip by a still image. Below each field, the respective feature's title is indicated. At each end of the menu,

4.1 dctp.tv—theme loop *Kapitalismus ist keine Einbahnstrasse/Capitalism Is Not a One-Way Street*, clip "Lichtadern /Veins of Light." Alexander Kluge / dctp.

two outwardly pointing arrowheads allow the viewer/user to move through a selection of further clips, ultimately leading her or him back to the point of departure. That is to say: although it is represented as a linear selection, the scrollable succession of clips is actually programmed as a loop in which one end leads into the other.

The website's third main component consists of four quarter-circles, each in one of the site's corners. In each circle segment sits a diagonally placed title. These titles read, clockwise from the upper-left corner: "Grosse Themen" (Broad Themes), "Gärten der Neugierde" (Gardens of Curiosity), "Partner & Events" (Partners & Events), and "Nachrichten-werkstatt" (News Workshop). In a short explanatory note under the link "Gärten der Information" (Gardens of Information) at the upper edge of the page, these topics are referred to as "Kontexte" (contexts). When the cursor moves across one of them, a system of rectangular "strips" moves into the window (figure 4.2).

4.2 dctp.tv, activated context menu "Gärten der Neugierde/Gardens of Curiosity," displaying information window for theme loop *Man kann nicht lernen, nicht zu lernen/ One Cannot Learn Not to Learn*. Alexander Kluge / dctp.

Five of these "strips" are visible at a time, and the central one protrudes slightly further. Each displays a small window containing an image, and a short title heading, like "Liebe macht hellsichtig" (Love Makes for Clairvoyance), "Der schönste Schatz der Evolution" (The Most Beautiful Treasure of Evolution), or "Ohne Musik ist das Leben ein Irrtum" (Without Music Life Is a Mistake). Each "strip" represents another loop of many clips, which, if clicked on, begins to play in the site's central window. An arched arrow parallel to the quarter-circle's circumference indicates another possibility of bilateral scrolling for further loops. These four quarter-circles and the thematic "strips" that "rotate around" them, then, function as a four-part meta-order from which the user choses theme loops, which in turn break down into individual clips. Each of the four thematic sections, as well as each individual loop, is programmed as a bidirectionally traceable sequence. The thematic groupings are represented in the four corners of the website; the level of the currently activated loop is situated

in the central window. The corner menus allow for selecting loops; the central window and its menu allow for selecting clips.[1]

Kluge's use of his other digital medium, the DVD, started as documentation of his analog and early electronic filmic *œuvre*, which he made accessible in 2007 as a single boxed set, followed by another compilation containing a selection of television features.[2] A crucial development occurred in 2008, when Kluge published his first proper production for DVD, *Nachrichten aus der ideologischen Antike* (*News from Ideological Antiquity*) (three discs, approximately 9 hours), which takes as its point of departure an investigation into Sergei Eisenstein's unrealized attempt at filming Marx's *Das Kapital*.[3] The term "published," with its associations of magazines, newsprint, and book editing, is chosen deliberately: the *Nachrichten*, as well as Kluge's major subsequent works for DVD, have so far all been distributed through the Suhrkamp publishing house, which is also home to Kluge the literary author and theorist. Through the medium of the DVD Kluge has, therefore, devised a strategy for commercially mediating his time-based visual work that allows him to bypass the channels of the film industry and television—a potential that, as he has explained, may also possibly be offered by online platforms such as YouTube.[4]

The *Nachrichten*, as well as its successors *Früchte des Vertrauens* (*Fruits of Trust*—occasioned by the financial crisis of 2008 and its ongoing effects) and *Wer sich traut reißt die Kälte vom Pferd* (*Who Dares Unseats the Cold*) (2010), are clearly recognizable developments of Kluge's earlier analog, televisual, and authorial productions.[5] To varying degrees, the works consist of clips, interviews, segments from Kluge's analog films, and sequences of onscreen lettering extended to unprecedented durations. They most closely resemble Kluge's late works for the cinema (e.g., *Die Patriotin* [*The Patriot*], 1979; *Die Macht der Gefühle* [*The Power of Feelings*], 1983). These are characterized by a picturebook style of montage which often gives the viewer the feeling that she or he is leafing through the pages of a printed and illustrated volume, interspersed with acted scenes and plot fragments. Kluge's DVDs now offer a similar viewing

experience. They also feature a new type of filmed segment whose design is governed by a commitment to *ars povera*, an aesthetic doctrine that renounces any artistic splendor, embellishment, or high production values.[6] These clips frequently consist of a single static take—one could call them visual sketches—in which the camera captures the simplest motifs. In the *Wer sich traut* project, for example, one sees formations of snow; flakes drifting close to the lens with the blurred surface of a frozen lake in the background; the view of wintry trees from the balcony of Kluge's apartment (figures 4.3–4.8). Here Kluge captures variations on the theme of ice and snow with a matter-of-fact approach that never seeks to derive an aesthetic surplus-value from the potentially romantic theme of the beautiful cold. (Chapters 6 and 7 below further explore polar imagery in Kluge and in the paintings of Caspar David Friedrich, which stand at the center of one particular Klugean story and clip, as well as in works by Gerhard Richter, with whom Kluge has collaborated on a book dedicated to the month of December. These are treated in conjunction with Kluge's attempt at creating "still images"; see also chapter 5 below.) With their unassuming, stripped-down style these images provide further evidence of Kluge's declared renunciation of plenitude, instead presenting reduced and sober visual examples of these motifs.

In comparison with Kluge's long films and his television features, the elements of the DVDs are less rigidly coordinated. The films and features necessarily follow a linear structure and arrange their individual components successively, with later segments partially referring back to their earlier counterparts. On his DVDs Kluge seems to have eroded this mode of sequential development in favor of more general groupings, all of which relate to a common topic, but none of which ultimately depends on being deciphered in a particular order, before or after another sequence. The elements of the DVDs have thus entered a stage of loose coupling, as it were, an organizational flexibility enhanced by the collections of literary stories that come with each DVD project. These are included as text files, as well as in accompanying booklets in which

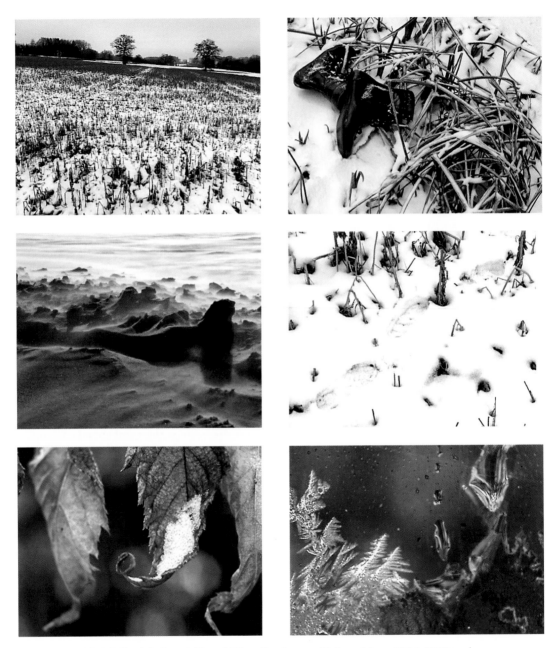

4.3–4.8 *Landschaften mit Eis und Schnee/Landscapes with Ice and Snow* (2010, DVD, color and b/w, 180 min). Alexander Kluge / Filmedition Suhrkamp.

the usual information (the list of disc chapters, producer credits, etc.) is often relegated to the back. The booklets form an integral part of the DVD works; in the case of the *Coldness* project the booklet has even been given a proper title—*Stroh im Eis* (*Straw in the Ice*)—while the actual disc bears the title *Landschaften mit Eis und Schnee* (*Landscapes with Ice and Snow*). Together, they constitute a digital/print diptych which appears under the overarching heading *Wer sich traut reißt die Kälte vom Pferd* (*Who Dares Unseats the Cold*).

PICTURING THE CONSTELLATION

One way in which Kluge addresses the digital is by figuring it as a constellation. This figure appears, for example, quite concretely on Kluge's website, where the central window and the quarter-circles in the corners sit on a dark field across which are sprinkled numerous faint blue dots (figure 4.9).

This view of a dark sky with a multitude of distant stars constitutes a reprise of a number of prominent illustrations of the starry night in Kluge's work—for example, in his feature films *Die Patriotin* and *Der Angriff der Gegenwart auf die übrige Zeit* (*The Assault of the Present on the Rest of Time*), as well as more recently on the DVD *Landschaften mit Eis und Schnee* (figures 4.10–4.15).[7]

In Kluge's work, then, the constellation is an image in the full sense of the term. In the context of his website this visual "theme" is expanded in the design of the quarter-circles that occupy the interface's four corners. The curve of each circle segment is bordered by a gray band that follows its bend. The color of this border is light and opaque where it touches upon the quarter-circle's sharp edge, and washes into a darker and more transparent tone the further it "bleeds" away from it "into" the dark background. The image is one of planets, enveloped in an atmospheric veil, as seen against interstellar space.

4.9 dctp.tv, theme loop *Werkstatt der Chroniken/Workshop of Chronicles*, clip "Der Unterschied zwischen Kairos und Chronos/The Difference between Kairos and Chronos." Alexander Kluge / dctp.

4.10 *Landschaften mit Eis und Schnee.*
Alexander Kluge / Filmedition
Suhrkamp.

4.11–4.13 *Der Angriff der Gegenwart auf die übrige
Zeit/The Assault of the Present on the Rest of Time*
(1985, 35 mm, color, 113 min). Alexander Kluge /
Kairos Film.

4.14 *Die Patriotin/The Patriot* (1979,
35 mm, color and b/w, 121 min).
Alexander Kluge / Kairos Film.

4.15 *Die Macht der Gefühle/The Power
of Feelings* (1983, 35 mm, color and
b/w, 113 min). Alexander Kluge /
Kairos Film.

Once the menu is activated by the movement of the cursor—that is to say, once the strips that represent it swivel "out" from "underneath" the quarter-circle—this impression changes to the schema of a sun, with a corona of rays protruding outward into space—an image that also recalls related solar imagery from Kluge's films and stories (see chapters 1 and 2 above). Kluge's themes are thus integrated into a visual system that resembles an astronomical, or perhaps even astrological, map, on which formations of stars are charted and named (figures 4.16–4.18).

The imagery of the sky and of celestial bodies (planets, stars), familiar from Kluge's analog work, acquires a new function in this digital context, where it partly serves to provide an image for the way in which Kluge's website—and, by extension, the internet—are structured. Kluge has also used the image of the constellation discursively to this end: "You can certainly say that the internet, in terms of its potential and actualization, functions like a constellation of autonomous celestial bodies that can't be connected by fixed relations."[8] Through this constellation he thus pictures the multiplicity of internet users, the attention that they invest, as well as the unstable interrelation that connects them and turns them into a conglomerate of individually attending and producing subjects that form a dynamic context.[9] On his website, the "complex themes and motifs" (see chapter 3 above) characteristic of the organization of Kluge's films, books, conversations, and television features are first ordered into "contexts"—represented as stars, planets, or suns—"around which loops gravitate" or "from which loops emanate," which in turn break down into clips. The "body" of each of these contexts consists of nothing but the theme loops that it agglomerates. That is: no context has a substance, or a "kernel," of its own. Rather, it is made up of possible combinations of loops and clips. The constellational order of the skies thus becomes the image for a formal principle of organizing a mass of clips into a website. What used to be a motif in Kluge's earlier work, the starry sky, has become an organizational image in this digital context.

4.16 dctp.tv, detail. Alexander Kluge / dctp.

4.17–4.18 dctp.tv, information clip "Gärten der Neugierde/Gardens of Curiosity."
Alexander Kluge / dctp.

Kluge also rotates this image, as it were, from a synchronic into a diachronic dimension, when he declares that the constellation may also serve to model the historical relation between digital media and the analog and electronic media that preceded them: "My image for this ... relation would be a constellation. ... The image of the constellation serves to symbolize the accumulation and supplementation among the qualities of classical film ..., and the possibilities of the internet."[10] The constellation thus becomes a structural figure for a relation in time, a media-historiographical model shaped by the epistemological stance that new media do not cancel or supersede old media.

Moreover, beyond this general historiographical perspective, the figure of the constellation can be understood as specifically depicting the temporal signature of Kluge's own work. As such, the constellation relates, first, to one of the fundamental construction principles according to which Kluge builds a subcategory of his images. Ever since the analog celluloid beginnings of his visual œuvre, his work has encompassed layered or constellated images in which refilmed historic footage is supplemented by and viewed through masking devices and hazes of color. It is a method that constellates old and new elements in order to produce multilayered structures (see chapter 8 below). Another example of such a constellational procedure can be found in the television features, in which Kluge sometimes "places" an interlocutor, originally filmed in a blue box, "in front of" footage shot elsewhere (for example, a hotel in Venice, already filmed by Visconti, or the rotating moon, as filmed in a several-hour-long take at night). Here, the electronically generated image configures segments of different temporal origins and durations into a spatial arrangement by assigning them the positions of front and back within a picture. Kluge's viewer sees, for example, German director and artist Christoph Schlingensief conversing about the tragedy of *Hamlet*, while "behind" him runs an accelerated, hazy camera recording of Schlingensief's 2001 Zurich staging of Shakespeare's play, where an ensemble of shadow silhouettes—the actors—circulate through a misty

zone illuminated by irregularly pulsing stage lights. Through such procedures, the figure–ground distinction that structures the image as spatial representation assumes the function of an intrachronic hiatus.

This constellational layering of onscreen images is further developed by digital media in Kluge's DVD projects. Whereas his earlier films construct these multilayered images through analog means (for example, by refilming historic footage at the editing desk, through color foils stuck to the camera), the computer has enabled him to, for example, select cut-outs from a digitally photographed Caspar David Friedrich painting— the iconic *Das Eismeer* (*The Polar Sea*) (circa 1823–1824)—and impose them onto a series of photographs of Western cities, various sites around the world, and icebergs adrift in the Arctic Ocean (see chapter 6 below). The result of this conjunction is a visual fiction of the earth thrown into the stasis of a new ice age, an operation through which the epoch of history itself is bracketed as an episode of geohistory, a glimpse of a reverse diluvian horizon where the human age does not emerge from the floods, but reaches its frozen end.

There is, finally, a way of understanding the constellation as picturing the recombinatory potential that digital media introduce to the history of Kluge's production *in its entirety*. Through its binary base, the DVD, just like the computer, can function as storage for the texts as well as the originally analog, electronic, or digital time-based visual works that constitute Kluge's output. By virtue of this quality, digital media offer the possibility of collecting current and older fragments from different phases of Kluge's working life. In this manner, literary stories about the theme of ice and snow can be juxtaposed with short visual takes of these motifs. On dctp.tv Kluge can construct combinations, such as one loop titled *Man kann nicht lernen, nicht zu lernen* (*One Cannot Learn Not to Learn*) that contains segments from his 1963 short film *Lehrer im Wandel* (*Teachers in a Time of Change*). These are filmic capsules consisting of photographs, fields of lettering, and Kluge's voice-over commentary, in which he audiovisually constructs fictive biographies of teachers who lived and

worked during the Third Reich, the basic plots deriving from an even earlier phase of his literary work: stories like *Der Pädagoge von Klopau* and *Margit M.* (*The Pedagogue of Klopau; Margit M.*), which appeared first in *Lebensläufe* (*Case Histories*) (figures 4.19–4.22).

Within the context of the dctp.tv program loop, the filmic segments now stand side by side with conversations about the role of experts in the Middle Ages, such as an excerpt from a discussion with Wolfgang Edelstein, professor of education science, on Alcuin, tutor to Charlemagne; or a conversation feature in which Kluge questions his veteran co-author and interlocutor, philosopher Oskar Negt, about Kant's 1784 pamphlet *Was ist Aufklärung?* (*What Is Enlightenment?*).[11] The loop is anchored in a clip, also titled *Man kann nicht lernen, nicht zu lernen* (*One Cannot Learn Not to Learn*), an excerpt from Kluge's first feature film, the 1966 *Abschied von gestern* (*Yesterday Girl*). Here, Alexandra Kluge, in her role as Anita G., engages Peter Staimer, who plays her lover, in an absurd little exchange of words. She claims her right to and desire for education—"Ich will ja lernen [I want to learn]"—but her discourse immediately stops short when she runs into the puzzling discovery that it is impossible to learn not to learn "Es ist unmöglich zu lernen, nicht zu lernen [It is impossible to learn not to learn]" (figure 4.23). The excerpt ends abruptly; its title appears in lettering on a dark ground. Through such constellations between more recent and earlier elements, Kluge's digitally rearranged clips are linked to their historically precedent order in analog film (and literature). Kluge has employed such a method of combinatory reediting as a principle in constructing his books from the beginning of his activity as an author (see chapter 9 below). The digital now allows him to extend the reach of this principle into the pictorial dimension.

4.19 dctp.tv, theme loop *Man kann nicht lernen, nicht zu lernen*, clip "Der Pädagoge von Klopau/The Pedagogue of Klopau." Alexander Kluge / dctp.

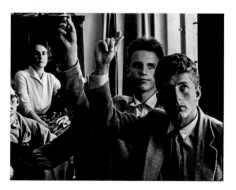

4.20–4.22 *Lehrer im Wandel/Teachers in a Time of Change* (1963, 35 mm, b/w, 11 min). Alexander Kluge / Kairos Film.

4.23 dctp.tv, theme loop *Man kann nicht lernen, nicht zu lernen*, clip "Man kann nicht lernen, nicht zu lernen/One Cannot Learn Not to Learn." Alexander Kluge / dctp.

Paraphrasing the Constellation

In its diachronic aspect, as the model for a conjunction between the present and a remote past, the Klugean term of the constellation points to one of its possible origins: the concept of the dialectical image as found in the work of Walter Benjamin. For Benjamin, the dialectical image described a constellation between a "now" and a previously obfuscated and forgotten moment of the past, separated by a temporal gap—that is to say, the two points in time are not connected by a linear development.[12] Benjamin found several examples of such a relation: for instance, contemporary fashion's appropriation and reinvigoration of an outmoded aesthetic as discontinuous, a movement which he called fashion's tiger's leap into the past; the surrealists' trophy-hunting in the stylistic cosmos of the late nineteenth century, a world of outdated tastes; or the French Revolutionaries' "citation" of ancient Rome.[13] Thus, the dialectical image structurally describes a temporal constellation in which the disconnected past reenters a present while still articulating the caesura that marked it as a relation across time. And for Benjamin this proved a structural figuration of the image as such, amounting to a definition of the image *as* constellation. Kluge appropriates this figure when he says that his image for the supplementary relation between digital and analog technologies "would be a constellation. There is Grandville's famous illustration of the planet-bridges, which Benjamin cherished. … The internet, in terms of its potential and its actualization, functions like a constellation of autonomous celestial bodies."[14] Here Kluge uses the *specific* image of a constellation of stars in a night sky to account for the digital, and in doing so he submits it to both a contraction—condensing the term's history into a picture—and a variation. The variation consists of the term's application to the field of media technologies, where it now accounts for the relation between the digital and its technological antecedents; or to relations between historical strata of visual production as manifest within a single image (historic footage rerecorded and altered). Kluge occasionally refers

to this appropriation of preexistent themes and concepts, which in his work always includes a condensation and at least a slight modification, as a procedure of paraphrase. For example, he has described his treatments of Eisenstein's notes as "paraphrases," and the above-mentioned series of transpositions of ice floes from *Das Eismeer* carries the title *Paraphrase zu einem Bild Caspar David Friedrichs* (*Paraphrase on a Painting by Caspar David Friedrich*; see also chapter 6 below).[15] And a paraphrase is also the Klugean image of the constellation that rehearses the older concept of the dialectical image, to which it adds the difference of media history, as it appears from the standpoint of our digital present.

THE DIGITAL AS RECONFIGURATION

Kluge's concept of the constellation thus relates to his understanding of the digital as a reconfiguration of its preceding techniques, strategies, types of production, and so forth. The digital enables Kluge to recalibrate the activity of montage, which is no longer necessarily tied to the linear temporal unfolding of a film or a literary text. And it gives him the opportunity to readjust the economies of short and long durations. These transformations are not without precedent in his work. In fact, a comparable revision occurred when he integrated the means of the television feature—short programming, brief intertitles, graphic elements, etc.—in order to further develop the specific relation of short elements and long duration that had characterized his literary texts (in which anecdotes/stories make up texts/books) and films (in which short montage episodes constitute the entire, often quite extended, film, and create its "picture-book" style).[16]

Thus, for Kluge, the transition into the digital is not a mere reordering of the elements and formal features that constitute his earlier work. It is also the return to a preceding reconfiguration that took place when he expanded from the systems of literature and film to the system of television. In Kluge's work, digitization thus amounts to reconfiguring

the very process of reconfiguration, a sort of second-order reordering, by which the activity of assigning a new arrangement to an extant combination turns upon itself. The terminological correlate to this movement lies in the reconstellation of the notion "constellation." In digital terms, the concept of the constellation articulates the historical difference between separate states of media technology. But it also enters into a relation—a constellation—with the previous meanings of the term constellation itself, which had carried different implications under analogical terms, as elaborated, for example, in the work of Benjamin. These earlier meanings are neither erased nor "corrected" by their digital counterpart, but, rather, subjected to a paraphrasing variation.

The Potencies of Storing

This reconfiguring activity is to no small extent enabled by the augmented capacities and altered possibilities of storing which digitization produces through implementing the basis of the binary code for textual, visual, and aural information alike. Kluge puts this general medial transformation to use for his own ends in that it allows him to assemble the various formats he works in within the context of a single medium, such as the DVD. In this sense, the DVD allows for a miniature representation of all the various media in which Kluge is active: film, television, and literature—to which is added the digital format that functions both as storage for the aforementioned forms of artistic articulation, and as a new medium used by Kluge in its own right.[17]

The second quality of digital storage of which Kluge takes advantage derives from what could be considered, at least from the recipient's perspective, a kind of latency. None of the individual elements contained on a disc is visible to the eye of the recipient in the same way as printed pages in a book, or still frames on a printed strip of celluloid, are visible. In the latter cases, units of visual information may be "jumped," by browsing a volume or by fast-forwarding a film in the projector, but these

acts of accelerated movement through a medium are categorically differ-
ent from skipping a track on a DVD, or going through a set of icons that
represent text files on a screen. On a DVD, the act of reception involves
a retrieval of elements from a state of latency. This selective actualization
constitutes another type of constellating activity, a mode of deciphering
artworks that responds to the type of storing specific to the digital. In
the case of Kluge's DVDs and website, the elements of this correlating
retrieval can belong to his current output, but they may equally consist
of earlier—now digitally restored—work segments. Each of these acts
of correlation thus potentially amounts to constellating elements from
the present and the past. Instead of defining digitization historically and
temporally as a radical break or as a categorical rupture with a preexistent
analog and nondigital electronic order, Kluge's work makes use of the
digital as the realm for such temporal conjunctions.

The temporal vector of Kluge's work, however, is oriented not just
toward reconfiguring a relation to the past, but also toward the future. As
Kluge has explained, the digital offers unprecedented storage capacities
which he exploits with full knowledge that the recorded work will never
be exhaustively retrieved in a present, single act of viewing or reading:

> as a storage medium the DVD allows you to put something
> on reserve at a minimum economic risk. And by the term
> "economy" I am referring not to finances but to the currency
> of attention. … We are practically manufacturing a luxury
> product here, which we are putting on reserve. But once you
> load these images onto a digital raft, such as the DVD, there
> is at least the option of paying attention. And there is at least
> the possibility that these … qualities will be recognized when
> we show them in a projection in the public sphere.[18]

The constellational character of reception, enabled by digital
information's latent prolificness, thus responds to a type of work whose

definite formal articulation becomes less and less a matter of the artist/ author's or the public's present. Instead, the artwork is as much addressed to an uncertain future—whose indefinite futurity enters the very body of the work, which never fully constitutes itself for a single viewer or reader. Kluge's image for this partial future-directedness is the "raft" ("the digital world forms rafts. One such raft is the DVD"), a maritime vessel of comparative simplicity that the artist of the present sets into motion, in the hope that future audiences will encounter it one day, and unload its aesthetic freight.[19] These qualities are tied to a transformation in the character of the artwork itself, which, at least in Kluge's interpretation, takes on the structure of storage.

Disjunctive Strategies in Electronic Images: Delinearization, Exploration of the Image-as-Space

The way in which Kluge does *not* conceptualize the digital is as instructive as the way he does. Significantly, for example, he does not deduce the primacy of smooth compositing from the possibilities of the digital, as others have done, i.e., he does not equate the emergence of an informational infrastructure for artworks with the end of the disjunctive aesthetics of montage: "montage … gains a renewed urgency with regard to the internet. … We need montage interventions to interrupt the omnipresence of electronic imagery."[20] Kluge thus dialectically recognizes a renewed necessity for montage techniques in digital environments, insisting that montage does not consist merely of the articulation of an aesthetics of disruption; rather, this discontinuity, through the immobilization of the flux of sensory impressions, serves to generate suspended moments of reflection, as if a viewer had briefly paused on a walk through the woods to let her gaze wander across a thicket of bare stems and branches. In Kluge's terms: "If used in the right way, montage does not aim at creating a … flow of images. … Instead, it creates frozen lakes. The result is a still image that you don't necessarily need to contemplate

for an extended period of time, but you need to look at it in a calm state of mind."[21] In this sense, the landscapes with ice and snow that we see in Kluge's *Coldness* DVD—the visual recordings of flakes drifting, of footprints in wintry fields, of a pair of boots set against frozen grass, or of a sunset on the Arctic Circle—are also meta-images depicting, in the brief duration which their maker has allowed them, a reflective stillness: islands of quiet observation with which Kluge seeks to freeze and suspend the pressures of a merely reactive attentiveness exerted on audiences present and to come.

In this conceptualization of montage's potential—to create still images in a realm of actual pictorial correlates—Kluge returns to his earlier, more encompassing, theory regarding how the human faculty of discernment may actually be rooted in human affectivity; and how our capacity for critical judgment might be linked to moments of affective "stillness," which he now describes as occurring within the stratum of the digital. In chapter 5 I will develop a more extensive analysis of how Kluge localizes the source of our capacity to judge, and in particular to judge critically, in a discerning manner, in the stratum of human feelings, provided that this affectivity has undergone such a "calming." I will also show how, accordingly, Kluge attributes to "still images" the function of enabling such beneficial modes of affective distancing: a conviction which, in his work, corresponds with a practice of producing such "still images"—pictorial bases for criticality—in both analog and digital media (see chapters 6 and 7 below). Within the present context of an analysis of Kluge's evolving work in digital media, however, I will focus on two examples in which he makes the case for a continued validity of critical montage programs under slightly different premises. In both cases he takes advantage of the delinearizing potential of digital and electronic media. One of these instances harnesses the aforementioned constellational capacity of the digital, and involves a particular artistic politics of time which Kluge positions against an imperative to overall synchronization; the other, which he recognizes in a short film on which he

collaborated with the German director Tom Tykwer, relies on a digital reinvestigation of classical filmic imagery.[22]

Yet before I present these two cases, I should briefly rehearse a few of the central arguments that speak to the transformed conditions under which the "critical" aesthetics of montage finds itself, once its former analog (image) infrastructure vanishes. As film scholar Dudley Andrew puts it, in the digital era "the cut is losing its edge," and this dulling of the potential impact of montage techniques seems to be inherently linked to the shift in the material and informational basis of the photographically recorded image—a process that is sometimes also described as a shift away from the image's ontological status of indexicality.[23] Having traversed the digital border, or perhaps already even after crossing the threshold into the era of electronic recording of video and television, historical hindsight now reveals that the two elements whose respective predominance used to divide schools of film theory, and to a certain extent even cinematic practices—the foregrounding of the ontological status of the image as an extension of physical reality (Bazin, Kracauer) on the one hand, and the great montage schools with their Soviet ancestors (Eisenstein, Vertov) on the other—may in fact have been complementary.[24] Perceived as founding mutually exclusive image practices, the cut and the technologically grounded documentary power of light recording are two interdependent counterforces of the temporalized photo-image in the analog order. This (artistic) economy was in fact shaped by the complementarity of indexical image and montage.[25] The recording power of the shot and the intervention of the cut counterbalanced each other in the time of the cinematic image. The discontinuity of the cut played out against the continuous stream of analog recording. The positivity of recorded light had its necessary counterpart in the sensorial negativity of the cut. Together they formed what was understood to be the (filmic) image. With the emergence of electronic and digital recording, this equilibrium has been thrown out of balance.

It has been influentially argued that in computer culture, montage cedes its aesthetic dominance, as the (filmic) cut is replaced by the figures of "a digital morph or a digital composite."[26] Lev Manovich, a prominent proponent of this position, has claimed that wherever "old media relied on montage, new media substitutes the aesthetics of continuity."[27] In this view, the discrete form of digital encoding, upon which so-called new media are based, discontinues the regime of analog media, and finds its prototypical incorporation in the assembly of (visual) elements from different sources that culminates in the creation of "a single seamless object."[28] This object can be a sound, a scene, a simulated space, or the image itself.[29] Digital compositing, then, is seen as necessarily demanding an aesthetics of continuity and seamlessness, burying the older aesthetics of the cut and the critical promises of suture.[30]

One standard example that is often discussed to illustrate this development is close to Kluge's project: the video work of Jean-Luc Godard, with its culmination in the monumental *Histoire(s) du Cinéma*.[31] Manovich views Godard's work as the embodiment of an "aesthetics of continuity that relies on electronically mixing a number of images together within a single shot" and pits it against, for example, the use of jump cuts and temporal montage in the director's earlier work.[32] A similar claim has been made, minus the recourse to the technological base of the filmic or televisual medium, by philosopher Jacques Rancière, who has described this development as the overtaking of a formerly dialectical procedure of montage by an essentially neosymbolist practice that blends image components into mysterious superimpositions.[33] Film scholar Tom Conley has sided with Rancière, stressing the vanishing of "provocative dissensus" and "antagonism."[34] The "shock of contraries" that formerly enacted "division essential to dissensus" is now replaced by a formal language of "fusion" that constructs the "kinship of heterogeneous things."[35]

It is striking that none of these observations applies to Alexander Kluge's digital work. By contrast, Kluge employs digitization primarily for the purpose of undoing the sequential prerogative of filmic and

literary montage by shifting to the principle of the constellation. That is: rather than championing an aesthetics of seamlessness, Kluge harnesses the delinearizing potential of electronic media to redefine a politics of the caesura under constellational terms.[36] As evidenced by his electronically generated composite images (in which components never blend into a visual continuum), Kluge's digital shift does not result in an obliteration of disjunctive elements and the creation of an enhanced (simulated) continuity. In his work, rather, digitality unmoors the moment of interruption from its inscription within a linear order, to turn it into the constitutive hiatus of constellational arrangements that unfold on multiple temporal scales. In analog contexts, the disjunctive force of montage intervened most significantly either in the construction of Kluge's books and stories, or in the linearly unfolding stream of one of his clips and films. On his website and DVDs, montage also serves to combine latent and actualized segments. Hence, the cut no longer merely connects and separates moments within a temporal flow of information whose passing elements can clearly be assigned the positions of "now," "past," and "yet to come." Rather, we are dealing with a temporal order in which montage connects and separates "stored" and "activated," latent and actualized, segments of temporalized information. If, as explained above, the work now partially takes on the character of *a storage*, the activity of montage also encompasses those operations by which elements are retrieved from this repository and inserted into the panorama of (temporarily) actualized forms. Under these altered conditions, the critical impetus of Klugean montage shifts into a different register. Its differential strategy was previously directed against resemblance-based modes of pictorial representation, and toward the articulation of contexts and relationality (see chapter 2 above). Now, one of its chief impacts consists in contributing to Kluge's artistic politics of time.

Remarkably absent from Kluge's digital work, by contrast, is an emphasis on simultaneity, a perspective that would equate to, or even emphatically welcome, the emergence of digital technology with

acceleration and synchronization, as, for example, in the writings of Paul Virilio, or in the recent theoretical movement of accelerationism.[37] Indeed, Kluge had already thematized and rejected this possibility in his 1985 film *Der Angriff der Gegenwart auf die übrige Zeit*, which is partly about the disappearance of cinema and the emergence of electronic media, such as television and computerization. While Kluge certainly emphasizes the all-encompassing character of the internet, in his perspective this quality leads to a deregulation rather than a synchronization of temporal orders. The result is a mode of reception characterized by a new level of differentiation and accuracy, whereby people engage with and make use of time.[38] In turn, it becomes mandatory that artworks and texts readjust their temporal economies if they are to persist in the digital realm.

Another example of a digital practice that does not comply with the supposed imperative of seamlessness is that of German film director Tom Tykwer's *Der Mensch im Ding* (*The Man in the Thing*), his contribution to Kluge's Eisenstein DVD, although all the evidence seems at first to undermine this interpretation. At the beginning of this approximately 10-minute-long clip, Tykwer's camera captures an anonymous woman as she runs in parallel to the picture plane, i.e., in profile, along a boardwalk. Between her and the camera we see a narrow strip of the street; beyond her lie the wall of a building and its front door. Suddenly the image freezes to a halt, and Tykwer begins a set of peculiar audiovisual maneuvers. A series of visual movements and perspectival shifts unfolds and traverses the space of the image, approximating a number of objects in it. Every time one of these objects—for example, the woman's handbag, the doorbell, or a traffic sign—is approached, Tykwer's voice begins to narrate that particular thing's history of production (figures 4.24–4.29).

In the context of Kluge's Eisenstein project, this exercise functions as an attempt to find a filmic form for the Marxian concept of the commodity fetish by coupling visual recordings of objects with a linguistic rendering of the labor-power that contributed to their making.[39]

4.24–4.29 Tom Tykwer, *Der Mensch im Ding/The Human in the Thing*, from Alexander Kluge, *Nachrichten aus der ideologischen Antike/News from Ideological Antiquity*. Tom Tykwer / Alexander Kluge / Filmedition Suhrkamp.

Its immediate effect is almost uncanny. The passages through this newly accessible, frozen visual space, which only seconds ago existed as the image of a continuum for a moving body, are almost too daring; the tilts too agile; the way in which the perspective comes to rest on strangely hovering objects is slightly unsettling. In fact, these are not a camera's movements traversing space. They are movements through a space that has been computer-generated by transforming an arrested analog filmic image into a simulated spatiality.

At first glance, the strange depth of this simulated space, and the impossible mobility with which the visual movement traverses it, seem to follow the doxa of "seamlessness." But the piece as a whole frames this moment with a "regular" digital rendering of analog film which unrolls in the temporalized two-dimensionality of old movies. Through this strategy, which allows the viewer to witness how the semblance of spatiality springs from a halted analog filmic image, Tykwer illustrates that the objective here is not to establish a new level of perfected simulation. Instead, he generates the impression that the image itself has acquired an actual depth, and has thus (been) turned into a space. Instead of subsuming pictorial elements under an illusionist representation of space, Tykwer assigns spatiality to what is in fact a single halted frame. Kluge has described this work as sitting on the border between digital and analog media, as occupying a threshold zone between electronic and celluloid film: "This type of quality emerges in the zone of friction, at the suture, if you will, between the means of classical cinema and electronic cinema, because half of Tykwer's clip is still film."[40] Following Kluge, one could say that there is indeed a constitutive gap here that runs between the digitally generated space of the image and the filmic image of space from which it sprang.[41] Under what conditions could such a work, as Kluge seems to indicate, be understood as continuing the project of disjunctive cinematic practices, as they were classically embodied in a radical montage aesthetics? If we are to situate *Der Mensch im Ding* in this trajectory, it is certainly not by virtue of discontinuous editing. Rather, the hiatuses,

the caesuras, and the negational force reside in that clip's overt situatedness on the analog–digital frontier. The smoothness of digital imaging is not employed to produce an ever more convincing simulation, to amplify the powers of resemblance. Rather, the visual space that one smoothly traverses here is a product of digital technology as reapplied to the classical filmic image, which can now be examined *as a space*: a space in which new tropes for an artistic analysis of the commodity have become possible; a space opened up through the constellation of the digital and the analog.

Seamless Is to Digital as Discontinuous Is to Analog: Excursus on a False Analogy

As well as pointing to these specific examples by Kluge and Tykwer, in which digital work does not amount to producing a new degree of fusion, one could also ask, on a more general level, whether the "seamlessness," the unsutured appearance of the digital image, understood as a result of compositing procedures, can claim the same status, the same inevitability, that was ascribed to the figure of rupture under the conditions of analog montage. For this is the basic analogy one encounters in accounts of electronic imagery as tending toward "fused" appearances. Analog base is to rupture and suture as digital base is to seamlessness and continuous surface. The answer to this question is no, the analogy is skewed. First of all, seamless appearance is in no way intrinsically bound to the digital composite. It is perfectly conceivable that a digital composite displays moments in which the distinct elements that have been brought together are combined in such a way that they do not merge into a continuum, with or without the intention of their maker. A digital artist may choose not to "mend" visual interruptions at all—as Kluge does in his constellational imagery, for example. She or he may also lack the competence to achieve the impression of an intact visual continuum. A poorly done digital composite shows very clearly that its elements

are not "correctly" combined: they may appear to be "glued" onto one another, or awkwardly positioned against each other. In such a case the impression of seamlessness is the effect of an operating individual's skill, not the result of some inherent quality of the digital process. The discontinuity of the analog cut, by contrast, is related to the inevitable finitude of any take on film.[42] (Digital) seamlessness needs to be achieved, whereas the (analog) cut needed to be concealed, if so desired. Hence techniques like "invisible cutting," which had to be gradually developed. Seamlessness does not emerge automatically in digital images, or in response to some alleged tendency inherent to the digital.

There are also a number of cases in which digital imagery whose continuity effects used to convince us only ten years ago loses its spell, and ceases to be as visually convincing as it was when initially produced. Digital media now look back on a history that is just long enough for the first effects of obsolescence to appear. Their logic does not differ from that of those described by Béla Balázs in the 1920s, when the first generation of movies began to look "funny," their tricks and technology awkward, their cuts clumsy.[43] The realm of digital visuality now includes examples of earlier attempts at simulation that are no longer convincing, and almost trigger a feeling of retroactive embarrassment, laughed off when one mockingly refers to a motion effect or a spatial simulation that would have left one's viewing self thoroughly impressed only a few years before.

The transition from analog to digital culture, and their corresponding artistic practices and aesthetics, is therefore only insufficiently accounted for as one from discontinuity to continuity, from hiatus to seamlessness, from disruption to smoothness. This is a mere surface description. The transformation is less bound to phenomena. The critical charge of montage, at least in its filmic incarnation, relied on the connection which it seemed to offer between the appearance of the film, its aesthetic realization, and its medial base. Discontinuous editing not only punctured the continuous stream of filmic appearances, shooting it

through with moments of visual and aural negativity. This negativity was also read, first, as an articulation of the technological medium's facture, and, secondly, as an articulation of the discontinuity between appearance and medium. Discontinuous montage, then, negated the stream of appearances as well as the continuity between appearance and technological medium, and this double negation also seemed to promise access, albeit negatively, to the realm of technological infrastructure that was allowed to intervene on the perceivable level of the artwork. This was the epistemological, critical, and even ethical promise of discontinuous montage practices, in comparison to continuity editing and invisible cutting. To say that digital media have merely replaced this predicament of discontinuity with a hegemony of continuity is inadequate. The crucial shift hinges upon the nonrelation between the level of sensorially processable appearance and technology, which characterizes digital structures in contrast to their analog counterparts. Information cannot be seen, heard, smelled, or touched. And a binarily coded 0/1 sequence translates into neither continuity nor discontinuity on the plane of the sensible, because the informational on/off principle does not correspond to the sensorially discrete or nondiscrete.[44]

To put it differently: an informational infrastructure does not demand "seamlessness," any more than it demands "discontinuity," from the images that are built upon it. The step between digital code and visual representation is a nonentity. There is no aesthetic—in the sense of sensorially receivable and processable—correlate to digitized information. The iconography of the first years of the digital age—"streams" of "numbers" "flowing" across the screen, the entire rhetoric of the alphanumeric "rain"—already betrays helplessness in its rather futile attempts at "picturing" the digital. Accordingly, if the relation of analog to digital is modeled on the image as a positioning of discontinuity versus continuity, this seems to result from a categorical error.[45]

The cut in the analog order thus marked a moment of perceptual negativity, but in this moment the relation between the visible elements

of the image and its technological infrastructure became—albeit nega-tively—perceivable. Digitality, by contrast, is indifferent to appearance. That is to say, it does not even have a negative correlate on the visual plane. Whereas all infrastructural and technological elements of the ana-log order are at least potentially perceivable, digital information is not. It escapes the dichotomy of visibility versus invisibility. Strictly speaking, the digital is not even invisible. Its medial order lies beyond the register of the senses. It is not imperceptible, but in-perceptible.[46] The pathos of analog montage was grounded in its direct access and open articula-tion of the material base of technological production as discontinuous. Digital montage does not only not prolong this promise; it also erases the difference between digital and analog montage—they potentially look the same.[47] And perhaps the very question of whether there can be an aesthetic correlate to the infrastructure of a work of art, its technological support, a given medium, etc.—a question answered by filmic montage with the aforementioned emphatic affirmation—already belongs to the analog age.

THE EMERGENCE OF CLASSICAL MONTAGE: MODERNITY AS OUR ANTIQUITY

In this sense, digital work indeed marks a significant departure from ana-log strategies. Along with it, one important principle underlying broad expanses of a modernist understanding of art and aesthetics, from archi-tecture to painting and literature, is called into question. In modernism, all of these art forms offered the possibility of constructing the artwork in such a way that it would "express," "demonstrate," "lay bare," "impart," or at least point to the material, the constructive support, or even the medial structure in which it was realized. Informational work does not allow for this possibility.

This entails that the genealogical self-positioning of Kluge's work as fundamentally indebted to the montage projects of classical modernism

(Vertov, Eisenstein) must also undergo a revision, or a renewed distinction, once Kluge begins to work in the digital realm. The early references to Eisenstein, as they appear in *Artisten in der Zirkuskuppel* (*Artists under the Big Top*), still stand under the prerogative of the cinematic medium. Approximately thirty years later, in the opening passages of Kluge's first DVD project, *Nachrichten aus der ideologischen Antike*, the return to Eisenstein takes on a different character. Whereas in 1967 Eisenstein's work appeared as a cinematic projection in Kluge's film, in his 2009 digital montage this reference takes the form of a complex combination of staged readings, visual transcripts—"paraphrases"—from Eisenstein's notes; multiple split-screen breakdowns of historical footage; all of which are interspersed with extended documentary sequences depicting industrial production (see the analysis in chapter 2 above). Depictions of automated assembly lines, a culmination of Fordism, are set against Marx's analysis of capitalism. They are also juxtaposed with an investigation of Eisenstein's intended visualization of serialized production and commodities, for which he had envisioned an array of animated dancing stockings, in the mode of a chorus-girl revue.

The transformation between the earlier and the later example could be described as a disappearance of the notion of Eisenstein's concrete cinematic work—on the DVD, the sense that there might be a concrete historical filmic touchstone has vanished. This is to a certain extent inevitable, since Eisenstein never realized the film of *Kapital*, which was intended to follow *October*. Yet Kluge does not even choose to foreground the materials for this unrealized film: Eisenstein's notes. This decision stands in clear contrast to his treatment of *October* in *Artisten*, which contained the Soviet director's work in the form of refilmed projections on a cinema screen. Eisenstein's *Kapital* notes are certainly present in Kluge's DVD film, but only in a highly mediated, contextualized, transformed manner—in readings, as references in interviews, and so on. Remarkably absent are, for example, shots of manuscript pages—a potential filmic approach to the subject of Eisenstein's notes that would

have been very closely related to Kluge's standard visual trope of filming printed pages (see chapter 8 below). Instead, Eisenstein's work is now contextualized within modes of industrial production. The examples of montage and the imagery of factories are all representative of modernist production, whose structural proximity to the cinematic technique of montage has been demonstrated by Annette Michelson and others. The generative mode and form of this type of production—industrial and filmic, then—*was* montage.[48] What changes in this transition are the phenomenal traits of montage and its constituents. Under digital conditions, these fragments decreasingly figure as the results of a destructive process; instead, the fragment is the organizational status quo from which constellational production takes off. The fragment no longer reads as the truncated remnant of an attack launched on a coherent and integrated whole. On the level of phenomena, this altered appeal of the fragment is perhaps most palpable on Kluge's website, with its organization of film excerpts and clips into thematic loops. None of these clips betrays a sense of incompleteness. Hardly a mark points to their earlier existence within the formal economy of extended contexts, from which they would have been forcibly extracted. The aesthetic through which digital editing constructs new formal units thus correlates to a new ontology of the part. For some reason, these short, small formal entities no longer evoke a sense of partness, as it were. No continuity seems to have been ruptured in order to generate a small-scale component. The fragment is no longer wrested from the whole.

At the same time, digital montage also resuscitates the forms and articulations of analog modernity. The overall logic of this operation is spelled out by the work's title, *Nachrichten aus der ideologischen Antike*, and by the proximity between Kluge's recent montage work and a constellational logic (see above). Kluge's DVD casts Eisenstein's work, the project of montage, but also industrial production in general, *as* antiquity. The point, of course, is not that industrial production has simply vanished under digital conditions. What has changed, however, is the perceived

―――――

temporal relationship of artistic strategies and the development of form with the industrial model. Whereas classical modernism sought to align them, this synchronicity has in itself become a thing of the past.[49] Kluge intersperses his reconstruction of Eisenstein's Marx project with a remarkable number of clips that thematize, in one way or another, Ovid's *Metamorphoses*. One reason for Kluge's interest in the ancient author lies in a perceived parallel between Marx's notion of the commodity as a transformation of human labor into a tradable thing on the one hand, and Ovid's rich explorations of the model of shape-shifting, change, and metamorphosis on the other. The second reason for establishing this parallel lies in the intention to contextualize Eisenstein's work as "*antique*," turning it into a "classic." One could add that, thirdly, the notion of metamorphosis applies to the structure of capitalism, production, labor, and their technological correlates as well, all of which have "morphed" since the age of the assembly line. Just as, in the general economy, the unidirectionality of the assembly line has been replaced by the polycentric layout of distributed production, the temporal forward thrust of the celluloid strip dissipates into multiple elements of short-term duration whose overall linear alignment is no longer backed by the material dispositions of a medium. The fragmented linearity of these moving images (each clip unfolds a separate segment of time) is due to the temporality of individual acts of recording and viewing, not to the order of the medium (the interrelation of the various segments is purely informational, not materio-temporal, as would be the case for a celluloid arrangement).[50] Along with processes such as the tertiarization of production and the informatization of labor (which have led some to proclaim the age of the network society, relational aesthetics, postproduction, smooth compositing, etc.), the general equivocation of montage and production may very well have attained the status of antiquity. Of a classic, one could add.

As classical montage dissipates in the passage from the assembly line to the network, its survivals lie in the figure of the constellation. The constellational mode characterizes, first, as described above, the

recombinability of loosely coupled elements that must be retrieved from informational latency. The constellation is, second, Kluge's structural figure for the specific nonlinear actualization that derives from the model of the dialectical image (see above). And finally, the constellation—in the sense of a "citation" of a forgotten past, by which that past is retrieved, but also marked as "antiqueified"—now relates to the very object of classical montage itself. That is to say: in Kluge's digital work, classical montage is cast as a quasi-antique technique, which was once lost but now also becomes the potential object of a critical reactualization forgoing a false pretense of continuity.[51]

In reconstellating the modernist technique of montage, Kluge's work is part of a wider historical repositioning of classical modernity. In bidding his *Farewell to Modernism*, art historian T. J. Clark has argued that the artistic modernism and, one could extrapolate, also the aesthetic principles of classical modernity have turned into our antiquity; to differing degrees of complexity, contemporary exhibitions and criticism have made similar claims.[52] Beyond the undeniable fact that the formal vocabulary and the artistic achievements of modernism are increasingly becoming a repository of forms for contemporary work, and are therefore "quotable," there is also a transformation in the way the form–time nexus is calibrated.[53] As this aesthetic regime is now historically appropriated, its condition has become our antiquity.

AFFECT AND DISTINCTION

5

FEELING

GRASPING, EMOTION, AND DISTINCTION

Kluge's 1983 film *Die Macht der Gefühle* (*The Power of Feelings*) contains two sequences, one documentary, the other fictional, that mirror each other. In the first, an industrial worker demonstrates how to tighten the nut on a bolt. It is apparent from his interactions with the camera, and his explanations, that he has been asked to perform this activity and to comment on it. While the camera captures the play of his fingers (he holds the object in his other hand), he explains that the trick is to make the nut neither too tight nor too loose: there needs to be a little room for play, and the capacity that allows him to perform this task is the haptic sensorium in his fingertips. The sequence looks like a filmic commentary on the German-language concept of *Fingerspitzengefühl*, literally "fingertip feeling," which refers to a particularly fine-tuned sensitivity and aptitude in handling delicate issues (figures 5.1–5.6).

In the second episode, the couple Mäxchen and Schleich murder the Yugoslav businessman Ante Allewisch, who has come to Germany to buy a large number of household machines for import purposes. While attempting to steal a pouch of diamonds with which Allewisch had

5.1–5.6 *Die Macht der Gefühle/The Power of Feelings* (1983, 35 mm, color and b/w, 113 min). Alexander Kluge / Kairos Film.

intended to pay for the machines, Schleich hits him over the head with a large, heavy version of the same tool that the documentary sequence presented in miniature form.

For Kluge's audience, this juxtaposition of two variations of hand/ tool or finger/object interaction is familiar. Another sequence in *Die Macht der Gefühle*, for example, simply consists of a cinematographic compartmentalization of Max Ernst's 1923 mural painting *Au premier mot limpide* (*At the first clear word*): Kluge's camera separates the central motif of a hand reaching through the opening in a wall, then focuses on two elongated, twisted fingers squeezing a red ball-like object. At another point the film features a documentary scene in which fine-tuned manual labor makes the difference between life and death: construction workers have unearthed a bomb from World War II which now needs to be defused by a team of experts. Finally, illustrations of three grasping, or holding, hands are also encountered by the reader of Negt and Kluge's *Geschichte und Eigensinn* (*History and Obstinacy*), fourteen pages into the first volume. In one of Kluge's characteristic layouts, a sequence of approximately two and a half pages of text is encased by a thin black frame. Within this frame the field of letters is also enclosed within the frame of blank page-space (figures 5.7–5.8).

The overall impression is one of a visually reproduced page from a different publication, although it is unclear from which book, and in what format, since the cumulative length certainly exceeds all usual Western proportions of print. This graphically set-off segment is headed—whether by the title of a textual entry or the top-of-the-page caption in a continuing piece of writing is unclear—with the words "Das Greifen [Gripping]." The three illustrations track from left to right: a hand that grasps a large cylindrical object (reminiscent of the tool used in Allewisch's killing); a hand whose thumb and index finger hold a very thin stick (vaguely associable with the delicate manual labor of tightening the nut); and a hand whose fingers are held inward, as if forming a fist, within which sits a walnut—a position from which to exercise enough pressure

HAMMER, ZANGE, HEBEL
Gewaltsamkeit als Arbeitseigenschaft

Die Grundform der meisten mechanischen Arbeitseigenschaften, die die menschlichen Körper auszuführen vermögen und die, auf Werkzeuge und Maschinen übertragen, zwischen den Menschen und die Arbeitsgegenstände treten, beruht auf der Anwendung **unmittelbarer Gewalt.** Bei der Umarmung ist dies mehr oder weniger doppeldeutig: wo sie nichtgewaltsam ist, bewahrt sie die Autonomie des Umarmten; als Vereinnahmung, Ringkampf, politische Taktik des Untergehenlassens der Gegenposition in der politischen Umarmung ist sie sicher ebenso gewaltsam wie Stoßen, Hebeln, Zwängen, Sicheln, Hämmern. Die Unterscheidung liegt zunächst nur in der direkten oder indirekten Anwendung solcher Gewalt oder in dem Maß, in dem die Gewalt die Gegenwirkung des Anderen, also das, was Fallenstellen oder Listen ausmacht, einbezieht oder nicht. Von dieser Unterscheidung ausgehend gibt es Gewalt, die auf die Eigenschaften des Gegenstandes eingeht, und solche, die dies nicht tut. Der Otto-Motor z. B. beruht auf dem Prinzip permanenten Explodierens. Alle Einzelkomponenten dieser Erfindung sind zerstörerisch. Im Aggregat treiben sie Fahrzeuge an. Unvollständige Produktionsprozesse, d. h. die brüchige Versammlung von Arbeitseigenschaften dieser Art oder ihre naive Anwendung in Bereichen, in denen sie nicht erprobt wurden, führen regelmäßig zur Zerbeulung.

Wir halten alle Anwendungen dieses Prinzips, gattungsgeschichtlich und individualgeschichtlich, für **eine** Arbeitseigenschaft. Ihr steht das größte Arsenal an Werkzeugen zur Verfügung. Sie sind sämtlich robust. Ihr Problem liegt in der Dosierung, für deren exakte **Steuerung** die Arbeitseigenschaften der Gewaltsamkeit keine Kriterien geben.

BEHUTSAMKEIT, SICH-MÜHE-GEBEN, KRAFT- UND FEINGRIFFE

Für die Eigenschaften, die in menschlichen Körpern die Muskeln, die Nerven und die Hirne, übrigens auch die Haut, d. h. sämtliche Rückkopplungssysteme miteinander **assoziativ vereinigen** (sog. »Rücksicht«), ist die Unterscheidung zwischen Kraft- und Feingriffen die bedeutendste evolutionäre Errungenschaft. Auf ihr beruht die Steuerungsfähigkeit, die allerdings durch Außendruck, der die Selbstregulierung stört, am leich-

14

testen zu erschüttern ist. Selbstregulierung ist die ausgeführte Dialektik von der Beziehung zwischen Kraft- und Feingriffen.[2]

[2] List scheint etwas, gemessen an Gewalteingriffen, prinzipiell Gewaltloses zu sein. Indem ich mich listig verhalte, weigere ich mich, die Dinge frontal anzugreifen, und mache den Versuch, die inneren Kraftverhältnisse der Gegenstände für mich in Bewegung zu bringen. In der Tat verknüpft sich aber das listige Verhalten mit den Kräften des Gegners in einer Weise, die zu einer Umkehrung der Richtung dieser Kräfte führt, bis zur Verkehrung ins Gegenteil. Die Kräfte werden dorthin gelenkt, wo sie von sich aus unter keinen Umständen hinwollen. Das bezeichnet man aber als Gewalt.

Das Greifen

Bei der Mehrzahl der Arbeitsbewegungen werden zunächst Arbeitsgeräte, Bedienungsgriffe und Werkstücke ergriffen und sodann in Bewegung gesetzt. Die Art des Zugreifens und die Bewegung selbst sind voneinander abhängig. Zweckmäßiges oder unzweckmäßiges Ergreifen begünstigen oder hemmen den Bewegungsablauf. Ebenso sind das Loslassen oder Absetzen eines Gegenstandes von der vorangegangenen Art der Bewegung abhängig. Entsprechendes gilt, wenn eine Bewegung vorausgeht, um einen Gegenstand heranzuholen oder etwa ein Bedienungselement zu betätigen.

Beim Ergreifen und anschließenden Halten und Betätigen eines Werkzeuges kommt es nicht nur darauf an, daß genügend festgehalten wird. Die Hand hat bei solchen Verrichtungen nicht nur die Aufgabe des Haltens; sie muß zugleich auch als Wahrnehmungsorgan tätig sein. Der bei der Betätigung von Bedienungsgriffen notwendige Druck muß so gewählt werden, daß noch ein entsprechendes Feingefühl der Hand möglich ist.

Abb. 8
Links: Breitgriff, Mitte: Spitzgriff, Rechts: Daumengriff.
Nach: Baeyer, H. v., Der lebendige Arm. Jena, Fischer, 1930, Tafel 7 und 8.

15

5.7–5.8 Page spreads from *Geschichte und Eigensinn/History and Obstinacy* (1981) (German-language, Suhrkamp edition), sections "Hammer, Zange, Hebel: Gewaltsamkeit als Arbeitseigenschaft. / Das Greifen."/ "Hammer, Pliers, Lever. Violence as an Aspect of Labor. / Grasping."

Bei der Abhängigkeit des Greifens vom notwendigen Griffdruck, von den Wahrnehmungsmöglichkeiten, von der Art des zu ergreifenden Gegenstandes und der auszuführenden Bewegung ergibt sich eine solche Vielzahl von möglichen Griffarten, daß eine allen Variationen gerecht werdende Klassifikation kaum möglich sein wird. Nach Sauerbruch werden drei Grundtypen unterschieden: der Breitgriff, der Spitzgriff und der Daumengriff (Abb. 8 nach v. Baeyer, 2). Der Breitgriff gestattet die größte Kraft des Festhaltens, erlaubt aber Bewegungen nur in Hand-, Ellenbogen- und Schultergelenk. Alle feineren Arten des Zugreifens erfolgen mit dem besonders vielseitig variierbaren Spitzgriff, der auch das feinste Bewegungsspiel ermöglicht.

Giese (16, S. 31) kommt durch Bezugnahme auf die zu ergreifenden Gegenstände· auf zwölf Typengriffe, die er nur zeichnerisch darstellt (Abb. 9). Davon sind die Nr. 3, 6, 11 eindeutig Breitgriffe, Nr. 9 und 12 Abwandlungen dieser von allerdings spezifischer Ausprägung, Nr. 2, 4, 5, 7 und 10 sind Spitzgriffe, Nr. 8 ein Daumengriff. Nr. 1 könnte als ein weiterer Breitgriff angesehen werden, stellt aber wohl eher eine Sonderform dar, die als Haltegriff bezeichnet werden könnte.

Abb. 9
Grifformen

Nach: Giese, Fr., Psychologie der Arbeitshand. Berlin und Wien, Urban und Schwarzenberg, 1928, S. 32

In noch stärkerem Maße auf die Arbeit und Arbeitsgeräte bezogen sind die von Herig (18) unterschiedenen Formen des Greifens. Da seine grifftechnischen Bemühungen in erster Linie auf die sachgerechten Handhaben der Werkzeuge und Geräte ausgerichtet sind, für die er den Ausdruck »Griff« reserviert, nennt er die unterschiedlichen Formen des Greifens und Haltens »Arbeitshaltungen«[1]. Für den Umgang mit freibeweglichem Gerät unterscheidet Herig Schreibhaltung, Bohrhaltung, Schneidhaltung, Schlaghaltung, Klemmhaltung. Schreib- und Bohrhaltung sind Spitzgriffe, die letztere mit einer verstärkten Möglichkeit zum Drücken in der Arbeitsrichtung wie etwa bei der Benutzung eines im Handteller anliegenden Schraubenziehers. Schneid- und Schlaghaltung sind Breitgriffe, die Klemmhaltung eine durch das Gerät bedingte Abwandlung: Halten von Zangen, Scheren, Pinzetten.

AUFRECHTER GANG, GLEICHGEWICHT, SICH-TRENNEN-KÖNNEN, NACH-HAUSE-KOMMEN

In einigen Texten wird neben der Erfindung der Feingriffe, der Eigenschaft des Auges, aus 1,60 m Höhe Horizonte wahrzunehmen (das macht einen Unterschied zur Wahrnehmungsweise von Kriechtieren und Vierbeinern), die Entwicklung der Sprache, sowie die Entfaltung des Hirns, als eines Organs eines Mangelmutanten, als das Spezifischmenschliche bezeichnet.[3] Tatsächlich ist es plausibel, daß der aufrechte Gang die Hände zur Arbeit und Zeichensprache freisetzt und damit der Mund disponibel wird zur Sprache. [. . .] Es genügt, daß wir feststellen, daß der aufrechte Gang dem ursprünglichen Aufbau des Skeletts nicht entspricht. Menschen sind, wie Napier erwähnt, für Gleichgewicht nicht vorgesehen. **Beim Vorwärtsschreiten würden Menschen in Richtung ihrer Nase zu Boden stürzen, wenn nicht subtile Gegenbewegungen der Muskulatur dem entgegenwirken. Ein strammstehender Soldat hat insofern kein Gleichgewicht, sondern rotiert, für die Vorgesetzten unmerklich, um einen imaginären Gleichgewichtspunkt.** Die gesellschaftliche Auswertung mutativer Chancen erfolgt offenbar in einem

[3] In der Evolutionstheorie nennt man einen Mangelmutanten dasjenige Lebewesen, das in seinem Stoffwechsel nicht autonom, sondern auf die spezifische Assoziation mit anderen angewiesen ist. Also ein Wesen, das Gesellschaft voraussetzt.

to crack the nut's shell. These illustrations, taken from an orthopedic and anatomical study (Herbert von Baeyer's 1930 *Der lebendige Arm* [*The Living Arm*]), unfold a spectrum of manual activities, from the focused exertion of violence (nut-cracking) to fine-coordination tasks; from a rough grasp to the delicate holding of a fragile object.[1] The next page in *Geschichte und Eigensinn* expands on this differentiation by displaying twelve further variations of grasping, holding, clutching, etc.—an illustration from Fritz Giese's 1928 *Psychologie der Arbeitshand* (*Psychology of the Working Hand*), a canonical publication in the science of ergonomics.[2]

If the protagonist of Kluge's film *Die Patriotin* (*The Patriot*), the history teacher (*Geschichtslehrerin*) Gabi Teichert, intended to teach her subject as a history of bodies (*Geschichte der Körper*); and if Negt and Kluge had already in the early 1980s seized upon Foucault's call to theorize a politics of the body (*Politik des Körpers*),[3] it is perhaps permissible to recognize in this variety of hands depicted holding, grasping, hitting, screwing, etc., a collection of nuclei for potential histories of the body—or, more precisely, histories of one body part, the hand. Two such nuclei feature in the film *Die Macht der Gefühle* (one the episode documenting the worker's account of his *fingertip feeling*; the other a fictional story of violence and murder); another story is told on a much larger temporal scale in *Geschichte und Eigensinn*, as well as in the book that accompanies *Die Macht der Gefühle*.

Negt and Kluge comment further on this set of hand illustrations: "In such manual activities, the hand's task is not only to hold something. It must also function simultaneously as an organ of perception [*Wahrnehmungsorgan*]."[4] With this basic definition, the authors focus on the quality that enables this plurality of modes of grasping, from rough to fine, in the first place. The hand must not only function as an organ or body part for actively intervening in the world, it must also be a sensory organ that gathers data, feeds it back into the system, and enables a modulation or tuning of this interaction (hand/tool; human/world). As exemplified in the field of ergonomics from which Negt and Kluge's visual material originates: "The pressure required for operating handles, knobs, buttons,

and switches must be dispensed in such a way as to still allow for the discriminating sensitivities/feeling [*Feingefühl*] in the hand to unfold."[5] If Negt and Kluge thus establish a rudimentary dichotomy of the functions of the hand, with "intervention" and "distinction," or "motor action" and "feeling" as its basic poles, the latter element ("distinction"/"feeling") has the function of regulating, differentiating, and shaping the former, because that former element lacks an internal capacity to do so—the force exercised by the hand to achieve a motor task cannot regulate itself: "die Arbeitseigenschaften der Gewaltsamkeit [the labor characteristics of violence]" provide "keine Kriterien [no criteria]" for "exakte Steuerung [exact control]."[6] Feeling, then, is what differentiates the grasps of the hand, and opens grasping onto a variety of internal modulations— an opening which Negt and Kluge describe as a central evolutionary achievement in human development:

> Für die Eigenschaften, die in menschlichen Körpern die Muskeln, die Nerven und die Hirne, übrigens auch die Haut, d.h. sämtliche Rückkopplungssysteme miteinander assoziativ vereinigen (sog. "Rücksicht"), ist die Unterscheidung zwischen Kraft- und Feingriffen die bedeutendste evolutionäre Errungenschaft. Auf ihr beruht die Steuerungsfähigkeit. ... Selbstregulierung ist die ausgeführte Dialektik von der Beziehung zwischen Kraft- und Feingriffen.[7]

> [Of all the characteristics responsible for associatively unifying the muscles and nerves, the brain as well as the skin, i.e., the human body's feedback systems, with one another (so-called "consideration"), the distinction between power grips [*Kraftgriffen*] and precision grips [*Feingriffen*] is the most significant evolutionary achievement. Control is based on this faculty. ... Self-regulation is the exercised dialectic of the relation between power grips and precision grips.]

To put it differently, and returning to *Die Macht der Gefühle*: for Negt and Kluge, feeling is what makes the difference between fastening a bolt and killing a person by hitting them with a blunt object; feeling is what makes the difference between *Kraft-* and *Feingriff*, between power grips and precision grips, in that it enables the sensing/acting embodied subject to distinguish between these types of manual action. Or, as Kluge puts it in the book version of *Die Macht der Gefühle*, on the subject of the activity of screwing the bolt: "Welches Feingefühl dazu erforderlich ist, ist eine sehr wichtige Unterscheidung, ein Unterscheidungsvermögen gewissermaßen, da sind die Gefühle Produzenten [The necessary sensitivity constitutes a very important distinction, a faculty of distinction, so to speak; it is here that feelings are producers]."[8] This description of feeling(s) as producer(s) of the potential/the faculty to make distinctions must be regarded as one of the axioms that structure Kluge's artistic and theoretical output. In brief: "Gefühle können unterscheiden [feelings can distinguish]," or "Gefühle betreiben eine Massenproduktion an Unterscheidungsvermögen [feelings engage in a mass production of the faculty of distinction]."[9]

Yet the Klugean *Kritik des Zusammenhangs* (critique of context) also applies here (see chapter 2 above for an analysis of Kluge's "critique of context"). That is to say: while feeling as such produces the potential, or faculty, for distinction, the aggregation of feelings poses a problem: "A single feeling [*einzelne Gefühl*] is never deceived, but all feelings together [*alle Gefühle gemeinsam*] follow a devastating course, as if they were blind."[10] If feelings accumulate, they turn from agents of distinction into motivating forces: "In this compound form [*zusammengebauten Gestalt*], they lose their faculty of distinction [*Unterscheidungsvermögen*] and become driving forces [*Antriebkräfte*]."[11] If they accumulate into larger complexes, feelings turn from analysts to agents: "Wenn ich Gefühle zum Antreiben verwende, während sie doch Unterscheidungsvermögen beinhalten, dann werden sie gegen den Strich gekämmt, sie werden als Händler verwendet … während sie in in Wirklichkeit Analytiker sein könnten. [If feelings

are used as motivating forces, while they actually contain the faculty of distinction, they go against the grain. They are employed as agents or traders ... while they could actually be analysts.]"[12] Such agglomerations of feelings stabilize the status quo, and block its alteration: "they are the lubricant, the putty that holds circumstances together."[13] They become "driving energy [*Antriebsenergie*] for the preservation of the status quo [*eines Bestehenden*]," or agents of an unquestioned affirmation.[14]

A Counter-Organization of Feelings: Critique of Affirmative Affectivity and Formal Closure

Kluge offers a surprisingly concrete example for this rather abstract theory of the affirmative nature of agglomerated feelings; an example that cuts right to the center of his production as a filmmaker; an example that is to some extent surprising, because it also highlights the breadth of the Klugean notion of "feeling":

> In the twentieth century, cinema is the major public seat of feelings. This is how it works: even the saddest feelings come to a happy ending in the cinema. The goal is consolation. In the nineteenth century, opera is the major public seat of feelings. The overwhelming majority of operas have a tragic ending. One watches a sacrifice. ... Both in opera and in classical cinema, feelings are helpless against the power of fate. In the twentieth century, they barricade themselves around consolation; in the nineteenth century, they fortify themselves around the truth content of deadly seriousness.[15]

This statement makes it clear, first, that for Kluge the term "feeling" actually encompasses the entire spectrum, from the immediate sensory impact on the perceptual nerves (e.g., the skin of the hand) to non-sensory emotions (e.g., sadness, consolation, happiness). It offers, second,

an understanding of nineteenth-century opera and twentieth-century film as media for the organization of feelings. According to Kluge, both suggest and reproduce a certain type of emotional spectrum through the repetition of plot structures that have been implemented along with the respective genre laws that tend to regulate production in these art institutions and media: the logic of the sacrifice and of the tragic ending in nineteenth-century opera; the logic of the happy ending and consolation in twentieth-century (Hollywood) film. In each case, the (artistic, medial, genre-specific) organization combines feelings and the category of fate, or treats them as if they were subjected to a fatelike course of events that has an always-already predestined outcome. Kluge finds this tendency formulated programmatically in the title of Giuseppe Verdi's 1862 opera *La forza del destino* (*The Power of Fate*), and the title of his own work *Die Macht der Gefühle* must be read, accordingly, as the program for a counterpoetics of affect.

With his rejection of fatelike, finalizing styles of representation, Kluge links his critique of affirmative affectivity to a critique of formal closure, a critique of closure as structuring "form," that also determines his own artistic production. The unspoken question behind a Klugean work, then, is: What would a formal arrangement that does not suggest an ending look like? What would a formal arrangement that does not "end" be?

Kluge once stated: "Das Kino ist eine Gefühlsmaschine [Cinema is a machine for feelings]." And he formulated the inherent dilemma that governs the output of this machine: "In filmic drama and dramaturgy [*Filmdramatik*] the strong primal feelings [*die großen Gefühle*] lead to a happy ending only if one builds in a couple of lies. In terms of filmic drama, lesser feelings [*die kleinen Gefühle*], which lead to happy endings, are not considered attractive."[16] If his own project of a "Politik der Gefühle [politics of feelings]" is bound to the invention of a formal repertoire that does not gravitate toward finalization, always keeps the inherent tendency of the genre to "end" at bay, and defers "The End," its

affective goal is to prevent the formation of a *Zusammenhang* of feelings that will suspend their distinctive potential.[17] Kluge artistically counters the prevailing tendency toward emotional context formation by atomizing affect into minimal units: into separate or distinct entities that will, reciprocally, allow for affective distinction, rather than affirmation. (That is to say: for Kluge, the opposite of affirmation is not unquestioning rejection, but distinction and critique.)

INVESTIGATING FEELINGS: A CASE OF JUDGMENT

There is an amusing emblematic formulation of this project in a scene from *Die Macht der Gefühle* in which Hannelore Hoger plays a wife on trial for shooting her husband after surprising him in bed with their daughter (and accidentally shooting herself in the leg).[18] In typical Klugean fashion, this surcharge of emotional determination worthy of an ancient Greek tragic plot of intergenerational slaughter is not played out in terms of a fatelike constellation which would drive the characters into a scenario of inevitable, bloody mutual annihilation. Instead, Kluge stages a courtroom scene that could also not be further removed from today's televised courtroom dramas, or from the classic cinematic examples of the courtroom film, for that matter.[19] In his film, a judge seeks to understand—i.e., to analyze—the deed in order to assess its status as a crime. In other words: Kluge demonstrates a process of judgment. The means for this juridical investigation involve questioning the accused and, significantly, a demonstration of how she handled the rifle with which the crime was committed. The gun is passed around in the courtroom; its motor handling—i.e., the fine coordination of hand and tool—is demonstrated: how to pull the trigger, how to hold and turn the rifle, etc.; the ensuing dialogue seeks to reconstruct the physical and affective mechanics of the act (figures 5.9–5.14).[20]

By intertwining motor and affective processes, the scene returns to the original continuum between feeling in the sense of an emotional

5.9–5.14 *Die Macht der Gefühle*. Alexander Kluge / Kairos Film.

response, and feeling in the sense of sensory discrimination. In other words, through representing the investigation of a so-called "crime of passion," Kluge opens up his own, parallel artistic investigation into the nature of feelings; while some of the scene's protagonists—the judges— seek to evaluate an action by explaining it as a reaction to a purported motivation on the level of emotions—i.e., by treating feelings as "grounds for action"—Kluge's film and text categorically refuse to treat feelings as such "motivations." The inquiry thus takes place not only on the level of the depicted scene, but also on the level of the poetics that generates the present work. The emotional response—or lack thereof—displayed by Hannelore Hoger's character *vis-à-vis* both the deed and the judge's questioning is of no small significance here. In what could be called an impersonation of the Negt/Klugean term *Eigensinn* (obstinacy), she simply refuses to show remorse, but neither does she allege a passionate motivation of her deed by claiming "hatred" for her husband. Kluge also eschews all visual tropes for the production of an affectively saturated visuality that are often characteristic of the cinematic courtroom drama: expressive gesturing, close-up shots, or continuity editing which places the viewer "in the midst" of events and directly among the procedure's participants (judge, defendant, lawyers, etc.).[21]

In this scene, Kluge reduces the comparative affective "sobriety" of German legal procedure even further. Due to the absence of a jury and the presence of the public prosecutor, who investigates all aspects of a case, for and against the defendant, German courtrooms are usually described as less prone to becoming arenas for adversarial conflicts and their potentially "dramatic" effects.[22] The emotional quality of the judge's reaction in Kluge's film—and the reaction on the part of the viewer, who also faces the challenge of proto-juridically, or at least ethically, evaluating the defendant's act—can be described as perplexity. If, as has been suggested, the presence of a documentary camera encourages the dramatization of trials, and if the courtroom film has made ample use of this potential for an intensified theatricality through the encounter of law

and lens, Kluge has invented a counterstrategy that overtly deflates this affectively potent mixture, and renders it devoid of saliency.[23]

The scene culminates in a dialogic coup: asked what, if not hatred, did she feel at the moment when she discovered her husband in bed with their daughter, Hannelore Hoger's character responds: "neidisch [envious]," and thus leaves everybody perplexed—herself, the judges, but also Kluge's audience. Withholding a conclusive result, Kluge thus also refuses to "close," or motivate the scene with an affective grounding. In other words: "emotion" will not serve here as an initial motivator either for a specific act, or for a film scene built around this act (which is represented only through its legal aftermath, namely the court proceedings). In this way, feelings remain an object of ongoing investigation.

THE CLOSE-UP MINUS AFFECT

The most tangible visual manifestation of this programmatically opaque rendering of affectivity consists in Kluge's use of the close-up of the face. When Kluge captures the eyes, eyebrows, forehead, and mouth of his protagonists, most memorably those of Alexandra Kluge and Hannelore Hoger—sometimes as full shots of their face, sometimes in detail—these features most often assume a strange attentive form of passivity *vis-à-vis* the lens. The eyes might move from left to right, the lips might open or close ever so slightly, but never do these impressions add up to an expressive fullness through which the face would appear affectively "charged" (figures 5.15–5.20).[24]

As a result, the face no longer figures as the primary locale for the expression of emotions: a role which classical cinema has successfully exploited by cultivating the close-up of the visage as an inexhaustible generator of emotional variety and saturation. Conversely, the affectivity of Kluge's characters is no longer localized in their faces, and hence no longer a matter of expression. Kluge's displacement of classic cinematic strategies of conveying and eliciting emotion leaves the audience puzzled.

5.15–5.20 *Abschied von gestern/Yesterday Girl* (1966, 35 mm, b/w, 88 min), close-ups (Alexandra Kluge). Alexander Kluge / Kairos Film.

In his close-ups we are not only confronting faces whose expressions and feelings we might find difficult to decipher; on an even more basic level, as we watch one of Kluge's films, we wonder where, if anywhere, the site of affect is.[25]

By turning feelings into objects of inquiry—i.e., by stripping them of their supposed motivational, and thus explanatory, quality—Kluge's work seeks to link affectivity and analysis, and thereby leaves the viewer or reader in a puzzled state. Feelings have thus lost their unquestioned intermediary quality which under "regular" conditions allows them, for example, to contribute to a situational change by motivating a character's actions.[26] In the perspective developed in *Geschichte und Eigensinn* this practice would amount to a first step in the direction of reconnecting emotions, i.e., "feelings," to their initial evolutionary or anthropological discriminatory and analytic function ("Gefühle können unterscheiden [Feelings have the ability to draw distinctions]"). This gesture of a phylogenetic tracing, however, is precisely what *prevents* an ontologizing of "feeling," in the sense of an evolutionary grounding: it is functional through and through. In other words: the recourse to prehistory does not lay bare an "essence" of emotions, or a limited number of affects, as did the pathos catalogs which regulated seventeenth-century rhetorics in painting or on stage, for example (Nicolas Poussin, Charles Le Brun, Jean Racine). Rather, Kluge's tracing of the roots of affectivity reveals feeling in its distinguishing function.

Kluge has provided at least two hints on how to connect this critique of affectivity to a) his theory and practice of montage and b) the classical doctrine of philosophical aesthetics. Both connections are contained in the formulation "Das dritte Bild ist das stille Ideal [The third image is the still ideal]" (see also the more extensive discussion of the notion of the third image in relation to montage in chapter 2 above).[27] This sentence merges the definition of montage—the third, unseen image as the product of two differing elements or shots, i.e., the difference between these elements—with the classical notion of the aesthetic

ideal as inducing stillness, affective equilibrium, calm, or at least freedom from arousal.[28] At another point Kluge even describes the calming or soothing that is achieved through the hiatus between two shots/images with a slight reformulation of Kant's famous definition of aesthetic pleasure (*Wohlgefallen*) as *interesselos* (disinterested): "If one could extend these pauses and thus create a deep silence [*eine große Ruhe*], if one could calm interestedness in such a manner, then this would be the aesthetic ideal in the cinema. All great films achieve this."[29]

These attempts at formulating the affective effects of montage are not striking because they invoke the authority of philosophical aesthetics to dignify a late-twentieth-century artistic practice. Rather, what makes them remarkable is their tacit redefinition of what might cause these effects. Idealist aesthetics—if this sweeping generalization is permitted for a moment—saw the calming of emotions as bound to either the experience of the (artistic representation of the) ideally beautiful body (Winckelmann's "edle Einfalt, und eine stille Größe [noble simplicity and calm greatness]"), or to the cathartic process (a purification or conversion of affects) engendered by the empathic experience of witnessing a dramatic process (Lessing's Aristotelian approach).[30] Kluge relies on neither of these two models. Instead, he claims that a similar effect can be achieved through the perpetual splitting of agglomerated feelings into their smallest components, i.e., through the differentiation of emotions described above. The intended result—to return the faculty of distinction to the level of affectivity—would, then, be Kluge's redefinition of aesthetic judgment: a feeling judgment that is categorically disinterested, i.e., will not serve to "motivate" action.[31]

CODA: THE EISENSTEINIAN SUBLIME VERSUS THE KLUGEAN STILL IMAGE

Once this insight is formulated, it is also possible once again to return to and sharpen the distinction between Klugean and Eisensteinian montage (see chapter 2 above). Eisenstein's project is a filmic reformulation

of an aesthetic of the sublime, with its characteristic double intention of wresting a conceptual formulation from experience (inserting the limits of experience into the realm of experience) and producing affective intensity through the implementation of a maximum contrast, a tension between the two components of montage (as exemplified in the linguistic and rhetorical strands of his work). (In Deleuze's words: "The cinematographic image must have a shock effect on thought, and force thought to think itself as much as thinking the whole. This is the very definition of the sublime.")[32] The Eisensteinian method, then, is intended to induce shock and concept formation in a single montage operation; his is an affectively intense analytic, not a detached segmentation. Eisenstein's work suggests that the segmentation process at the heart of analysis amounts to the conflictual splitting into contrastive parts from which results an emotional arousal and a rush of pathos. Kluge's montage practice is rooted in the opposite example of aesthetic experience, which he redefines as an exercise of affective differentiation.

This also becomes evident in the two filmmakers' distinctly different ways of handling the disjunctive potential of montage to create a sense of temporal suspension. Annette Michelson has described the famous sequence of the opening of the bridges across the Neva in *October* as a "vast wedge of time" inserted into "the flow of progress of action."[33] Eisenstein's technique of interruption here serves to suspend "the action in an abeyance of time's passing."[34] The discrete, disjointed elements do not add up to a flow, but confront one another as constituents of a dramatic peak at once analyzed and emphasized through its distention. The effect of this sequence is a "momentousness of … style," the visual equivalent of a verbal account of a dramatic event that seeks to add emphasis by segmenting the narrative into a sequence of "nows," "thens," and "heres," clearly set apart from each other: "now he leaves the building and steps into the street; now he catches sight of him; now he reaches for his gun."[35] In Kluge's work, by contrast, discrete elements never describe a distended moment: there is no suspense, in the sense of a suspension of

temporal progress, or an eagerly awaited, prolonged anticipation of the outcome or resolution of an action.

And yet, in a number of cases, Kluge does engage with the aesthetic category of the sublime, but only under the premises of the most rigorous mediation and distancing. One good example of such an engagement with the sublime is his negotiation of the pictorial heritage of the work of Caspar David Friedrich, to which chapter 6 is partly devoted.

EXCURSUS: TWO IMAGE STUDIES

The Polar Sea and Other Stills: Paraphrases on Three Themes from the Work of Caspar David Friedrich

Introduction: Constellation and Paraphrase in a Case Study

As the first of two excursuses titled "image studies," this chapter leaves behind the more or less systematizing analyses of the implicit and explicit poetics of Kluge's work as it can be traced in his theoretical and literary writings, in his practice as a filmmaker, and as a producer in the media of television and the internet. The focus now turns instead to one specific instance in which Kluge establishes a particularly rich context of pictorial and textual elements: in two interrelated pieces which appear in the 2010 *Wer sich traut, reißt die Kälte vom Pferd* (*Who Dares Unseats the Cold*) project, one a short clip called "'Die gescheiterte Hoffnung.' Paraphrase zu einem Bild Caspar David Friedrichs" ("The Wreck of the *Hope*." Paraphrase on an Image by Caspar David Friedrich), the other a brief story titled simply "Die gescheiterte Hoffnung" (The Wreck of the *Hope*), which is included in the print booklet that accompanies the DVD.[1] Their common reference point is the work of German romantic painter Caspar David Friedrich. Each of the chapter's three sections starts out from a close reading or a detailed description of segments from Kluge's clip and text, then charts the routes from these segments into Friedrich's *œuvre*. By

combining detailed examinations of Kluge's textual and filmic work and close analyses of a number of Friedrich's paintings and their artistic, critical, and aesthetic contexts (most importantly, one piece of art criticism by the romantic poets Kleist, Brentano, and Arnim), this chapter widens the temporal scope of this book, which so far has mostly been limited to the span between the beginning of Kluge's work (about 1960) and our present. These five decades are extended into two centuries.

The analysis of the relation between these two bodies of work, Kluge's and Friedrich's, will serve in part to concretize the Klugean predicament of a constellational image that establishes a temporal connection hinging upon the discontinuity between its constituents. Certain components from Kluge's work, and certain pictures by Friedrich, function as elements that enter into such a constellational relation. The following section is thus not concerned with reclaiming any sort of artistic "influence" exerted by Friedrich over Kluge's work, nor does the subsequent analysis derive its legitimacy by proclaiming to reconstruct such an authorizing relation. Moreover, this venturing into historical depths is not intended to establish a continuous trajectory between Friedrich and Kluge. There is no genealogy to be followed here. It would hardly make sense to trace a transformative development leading from the early nineteenth into the early twenty-first century, while omitting the approximately 200 intervening years. Instead, the analysis takes the Klugean concept of the constellation seriously, and seeks to describe the connection between his work and that of the romantic painter as one exemplary case of such a relation.

Each section explores one type of connection between Kluge's and Friedrich's work: first, Friedrich provides a historical counterpoint and example for the production of what Kluge calls "still images" (see also chapters 2–4 above); secondly, by virtue of being retroactively "targeted" by Kluge as a constellational "counterpart," Friedrich functions as an antecedent for the activity of generating image constellations; thirdly, Friedrich offers a related model for a type of pictorial operation through

which an image reaches a determination of the indeterminate, hence anticipating Kluge's program of montage as producing distinction in and through images.

In addition to exploring this transhistorical kinship between two types of image work, this chapter also attempts a close examination of the Klugean practice of the paraphrase. Referred to in Kluge's title—*Paraphrase zu einem Bild Caspar David Friedrichs*—and already described on a conceptual level above (see chapter 4), the Klugean paraphrastic relation will subsequently be analyzed more concretely. The intention is to provide one exemplary case study of how Kluge's medially diverse work picks up on, condenses, and varies preceding positions, in this case Friedrich's. Kluge's two very short pieces (the story takes up about two and a half pages; the clip runs for about four minutes) encapsulate themes (the still image; the constellation; the determination of the indeterminate) that correspond to an extensive range of elements in Friedrich's work, which the artist articulates in a whole panorama of pictures. In an anticipatory mode, it finally also provides one example for Kluge's poetics of short forms, which will be analyzed systematically in chapter 9.

(1) The Polar Sea and Other Still Images

Paraphrase on an Image by Caspar David Friedrich

Six chapters into Kluge's *Coldness* DVD there is a sequence which consists of a series of takes in which we see patterns of ice floes laid over photographs and illustrations depicting scenes and sites from around the world. These include recognizable landmarks such as the pyramids in the Egyptian desert, the Brandenburg Gate in Berlin, and the Eiffel Tower, as well as unspecified cities and maritime landscapes. Around the globe, a nearly identical picture: natural and cultural landscapes are buried under frozen masses (figures 6.1–6.3).

The thematic proximity between these segments is reinforced by a closeness in terms of color. The images are dominated by a hazy gray

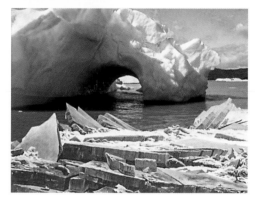

6.1–6.3 "Die gescheiterte Hoffnung. Paraphrase zu einem Bild Caspar David Fried-
richs/The Wreck of the *Hope*. Paraphrase on a Painting by Caspar David Friedrich"
(from *Landschaften mit Eis und Schnee/Landscapes with Ice and Snow* [2010, DVD, color
and b/w, 180 min]. Alexander Kluge / Filmedition Suhrkamp).

that, in the sections based on black-and-white photographs, spreads into a darker and lighter spectrum. In the images based on color-photo originals, this gray tonality mixes with nuances of lavender. There are tones of aquamarine, ranging from radiant blue to turquoise. And finally, there is a muted white tone that indicates areas of snow under nebulous conditions. Nowhere do these images betray the sense of scenery exposed directly to sunlight, in which the whites would glisten. These muffled tonal harmonies, the proximity between the floes' upheaving fractured geometries in each image, and the similarity of the ice's visual rendering in each take, quickly make it clear that all of these elements derive from the same source. Kluge has strewn cut-outs from a single picture over (images whose origins lie in) vast geometrical distances. In one or two, a wooden ship's stern peeks through the ice; in a few other cases one recognizes an isolated, shattered mast. If the angular and obliquely positioned formations of sharply contoured ice have not yet revealed the source of these visual fragments, these glimpses of the vessel's covered body confirm their provenance. Kluge's camera has captured Caspar David Friedrich's 1824/25 painting *Das Eismeer* (*The Polar Sea*) (figure 6.4), or, more likely, a reproduction thereof, because none of the image's segments shows any material mark that would convey the canvas's or the paint's facture, let alone a trace of brushwork.

The sequence is titled *Paraphrase zu einem Bild Caspar David Friedrichs*, and Kluge's appropriation of the romantic painter's work is characterized here, first, by the original image's fragmentation and its collage-like, constellational redistribution over an array of different pictures. Just as the mirror in Hans Christian Andersen's fairy tale *The Snow Queen* is shattered, and its shards are blown by the wind all over the world (the topic of a later conversation feature with literary scholar Ulrike Sprenger on the DVD), Kluge's procedure has broken the visual entity of *Das Eismeer* and scattered the earth's image with its remnants. Andersen's allegory of the coldness of the heart finds its correlate in the image of a glacialization of the globe. What are hardly perceivable, almost dustlike

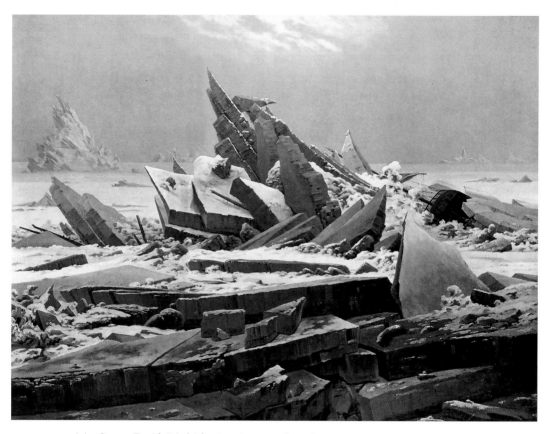

6.4 Caspar David Friedrich, *Das Eismeer/The Polar Sea*, 1823–1824, oil on canvas, 96.7 × 126.9 cm (38.1 × 50 in). Hamburger Kunsthalle. Public domain.

yet razor-sharp particles of glass in the fairy tale, so light that a breeze of air carries them away, are here the heavily massed sheets of ice which spread at an excruciatingly slow tempo, yet inevitably and vastly.

The expansive movement which must have taken place here, if we accept the visual fiction offered by this electronic collage, is another expression of Kluge's interest in depicting extremely extended temporal processes (see chapter 10 below). Elsewhere Kluge achieves this goal, for example, through representations of the theme of architecture (see chapter 1 above); he frequently also employs time-lapse photography, in which duration is technologically condensed to a similar end—a technique which he calls *Zeittotale*, the temporal long shot. In the case of the Friedrich clip, such a representation of what could be called a *très longue durée* process is accomplished indirectly. From the short film we can infer that a temporal process of glacial dimensions must have occurred. The sequential presentation of a number of still images describes a state ("covered in ice and snow") and a geographical span ("the globe"), which in combination add up to a temporal diagnosis. This series of images suggests that another ice age must have come. The theme of the expanding ice, finally, responds to the artistic gesture with which Kluge has generated this sequence: the visual spreading of segments from a painting by Caspar David Friedrich "over" a number of photographs which are now visually "covered," just as the earth is concealed under ice.

Friedrich Then and Now

This clip is not the first occasion on which Kluge has turned to the German romantic painter's images. Works by Friedrich have appeared in Kluge's films and books from the late 1970s and early 1980s. For example, the 1979 *Die Patriotin* (*The Patriot*) includes a shot of Friedrich's sepia drawing *Wallfahrt bei Sonnenaufgang* (*Procession at Sunrise*), as well as one of the 1811 *Winterlandschaft* (*Winter Landscape*). But these earlier appropriations of Friedrich's works functioned differently, because in them, Friedrich's pictures were always left visually autonomous. Kluge did not

combine them with superimposed material from other pictorial sources, as he does in the *Coldness* DVD project. In these earlier examples the camera also always captured a Friedrich image in its entirety, sometimes even leaving a black frame around it that set the filmed painting apart from the edges of the screen on which it appeared. In these cases, the romantic artist's images functioned as photographically rendered integral visual units within the unrolling picture promenade of a Klugean montage sequence whose constellational power relied on the actual unfolding of time. In the more recent work, Friedrich's painting itself has been broken up and become part of static visual constellations.

In the earlier films, the semantic context also determined a narrower signification for these appropriated pictures. For example, in *Deutschland im Herbst* (*Germany in Autumn*) and in *Die Patriotin*, they stood within the frame of works on the subject of history, primarily the history of Germany. Friedrich's *Wallfahrt bei Sonnenaufgang* hence formed a counterpoint to documentary footage shot by Kluge and fellow director Volker Schlöndorff at the funeral of the Red Army Faction members and Stammheim suicides Jan-Carl Raspe, Andreas Baader, and Gudrun Ensslin at the Dornhalden cemetery in Stuttgart, with its procession-like character. *Winterlandschaft* appeared to be a model for a by now iconic sequence which figured in both films: a series of shots of actress Hannelore Hoger in her role as the increasingly confused history teacher Gabi Teichert, who goes on a nightly outing into the snow-covered German countryside to "dig" for remnants of German history (figures 6.5–6.7). And even the themes of ice and snow resounded with this theme of history, as they appeared within the context of filmic works emerging from the "German Autumn"—*der deutsche Herbst*, referring to the late-1970s violent radicalization of left-wing terrorism and the state's militarization, including the passing of laws which suspended civil liberties while implementing heavy surveillance measures. The wintry imagery, finally, was reminiscent of nineteenth-century poet Heinrich Heine's meditations *Deutschland—Ein Wintermärchen* (*Germany—A Winter's Tale*),

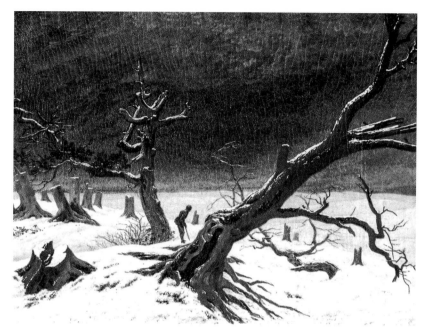

6.5 Caspar David Friedrich, *Winterlandschaft/Winter Landscape*, 1811, oil on canvas, 33 × 46 cm (13 × 18.1 in). Staatliches Museum Schwerin. Public domain.

6.6–6.7 *Die Patriotin/The Patriot* (1979, 35 mm, color and b/w, 121 min). Alexander Kluge /Kairos Film.

in which the Jewish-German liberal reflected on his politically fraught *Heimat* from his exile in Paris.

In these earlier films, Kluge thus employed the romantic artist's images in their function as works by Friedrich "the German painter," and they resonated within an exploration of the history of the nation-state.[2] Their import derived not least from the fact that they were coeval with the historical formation whose investigation motivated their visual recapturing in the first place. Friedrich's art stands, along with the literature and theater of contemporaries such as Heinrich von Kleist, in the context of a romantic Germany in which the political project of a German nation-state was proclaimed. Set against the occupation by Napoleon's armies, this liberal project was also marked by a viciously anti-French strain from its inception. This resentment still fueled the Franco–Prussian war of the 1870s, as well as World Wars I and II. In these earlier films, Kluge thus makes use of Friedrich's images not only as visual and cultural reference material, but also in a genuinely documentary and even historiographical spirit as *sources* that factor into the investigation of the fraught and violent history of nationalism in Germany. They appear in *Deutschland im Herbst* and in *Die Patriotin* partly because they document "German history." In his later appropriations of Friedrich's work in the *Coldness* project, the context of German history merely hovers on the fringes of Kluge's later uses of Friedrich's paintings, while the focus now encompasses a much wider temporal horizon that possibly even exceeds the limits of historical dimensions.

STRANDED IN SINKING

With the bonds of a more narrow political semanticization loosened, Kluge's recent treatment of Friedrich's painting foregrounds less of a "historical" and more of a "temporal" dimension.[3] *Das Eismeer* casts an image of stillness and stasis. A liquid element—water—has frozen into massive plates; the fluid space of the ocean has acquired a hardened surface, solid enough to carry a human body, rigid enough to develop

tectonic tension, and strong enough to crush and bury a ship. The stalled vessel is arrested in fatal immobility.

This theme has a correlate in the procedure through which Kluge appropriates Friedrich's images. As the (onscreen) picture is moving, and the flux of time is hence marked, the profilmic still image is qualified as such—namely, still. One of its essential qualities—that it exists as a non-temporalized object, a quality that is obfuscated in the direct act of looking at it—is rendered visible in the take. While Friedrich's painting points to the absence of movement through its theme (water turned to ice, a ship that is stuck), Kluge indicates the absence of movement in the still image through setting it into medial tension with the technology of film.

This emphasis on a suspended, immobilized state finally corresponds to a specific way in which Friedrich's painting engages with a number of cultural topoi and iconographic traditions. Within the iconographic system of maritime painting, this canvas occupies a peculiar threshold position between two thematic registers. The ship in *Das Eismeer*—or, at least, the comparatively small section of its stern which the viewer can visually access—is almost fully keeled over; its body protrudes into an invisible depth covered by ice. This tilted position, drastically thrown out of the seesawing vertical that enables its velocity as a vessel, usually characterizes (depictions of) the stranded ship, as exemplified, for instance, in Friedrich's 1836 canvas *Wrack im Mondschein* (*Wreck in Moonlight*).

But while in more conventional painted versions of that theme the vessel has struck land—be it a beach, a sandbank, or a cliff—whose solidity blocks its movement and holds its body in place, Friedrich's *Das Eismeer* surrounds the broken wooden corpus with plates of frozen water that lock it at its awkward angle. In his image of around fifteen years earlier, *Schiff im Eismeer* (*Ship in the Polar Sea*, 1798), the artist had opted for a more conventional rendering. In that image, a brig has been jammed between shoals that must have drifted toward it from both sides. Or, perhaps, it vainly attempted to pass through a too-narrow passage between them. Its keel sits firmly in the grip of two formations.

Its position is nearly identical to that of a vessel cast ashore. In *Schiff im Eismeer*, ice is a substitute for land. The later *Eismeer* does not allow for such an interpretation.

In *Das Eismeer*, ice forms the towering peaks of two iterative and parallel structures, each asymmetrical, each protruding diagonally upward, their right-hand slopes shooting up in nearly straight lines, their left sides slightly hollowed into an inward curve, as if these were not piles of ice, but dynamically agitated, cusping waves, driven by a parallel force of wind and sea, each on the verge of breaking. The shoals that have slid above the vessel also conform to the direction of this powerful imaginary current. Had they been rendered only minimally less rigid, they would almost form an image of water licking over the ship's body. And does not the puffily rendered snow that, strangely, covers the ice only in the middle ground and background of the picture, and is especially prominent in the region surrounding the vessel, remind the viewer of curling and bubbling formations of foam? This would be the frothy upsurge of water, if this ship were not stuck in sheets of ice but caught in the very moment of being swallowed by the ocean. *Das Eismeer*, then, conveys the image of a sinking ship, of breaking waves, but frozen to a standstill—as if it were possible to depict a ship that is at once stranded and sinking: stranded in sinking.[4]

Friedrich's picture here transcends the analogy between ice and (flat) land in two ways. First, it captures the dynamic power of agitated water, while also, secondly, staging an almost mountainous scenario. The heaps of ice are reminiscent of Alpine peaks, of geological rubble, while the sheets in the foreground, whose color merges into a muddy gray, have the visual solidity of rock.[5] *Das Eismeer* thus points toward the stormy sea, and the mountain range. Friedrich's ice is both geomorphic and liquid-like. A mountain and a wave. This is an image of dynamics in stasis.

THE BUFFERED SUBLIME

This particular superimposition of static and dynamic conditions, this interlocking of visual references to stillness and movement that

characterizes *Das Eismeer*, has a correlate in the peculiar position which this painting occupies within the tradition of pictorial topoi: that is to say, how it is situated *vis-à-vis* its pictorial predecessors. In the eighteenth century—and in fact still widely prevalent in Friedrich's age and beyond—renderings of a ship's demise often struck a decidedly dramatic note. The perishing of a vessel at sea was usually orchestrated by towering, upsurging crests of waves. The sky is dark with the dense formations of storm clouds, from which flare arrows of lightning. These overpowering forces of nature, which engage the frail vessel in a lethal struggle, will drive it into a set of sharply rising cliffs that will ultimately seal its fate. The art historian and theoretician Johann Georg Quandt, the painter's contemporary, who had commissioned an earlier, now lost canvas, *Ein gescheitertes Schiff an Grönlands Küste im Wonnemond* (*A Stranded Ship on the Coast of Greenland in the Month of May*), from Friedrich, described such a depiction of a shipwreck, which he had seen on a journey to Italy, accordingly:

> A thunderstorm by Tempesta causes veritable horror. Pitch dark clouds turn day to night; the storm plows the bowels of the sea; the furious floods throw waves toward the sky, which collapse into foam, and with no rescue in sight the courageous sailors must perish in the battle of the elements. … The demise of the courageous ones is sublimely tragic.[6]

This is, in a word, the sight of a catastrophe—a sight which the art theories of the eighteenth century and their ancient precursors had singled out as an emblem, and an exemplary constellation, for the experience of the sublime. First shaped in the works of ancient Latin authors such as Pseudo-Longinus's *On the Sublime*, then famously adopted and modified by eighteenth-century philosophers and poets (for example, Schiller and Kant), the paradigm of the experience of the sublime is here described as witnessing a shipwreck from the safe territory of the beach.[7]

The aesthetic consumption of a horrible, and horribly impressive, scene is mapped onto a topography that guarantees a combination of existential safety and spectators' *frisson*. The nautical pictorial topos of the shipwreck recasts this (spatial) distribution as the relation between viewer and represented theme. The image is thereby redefined as the connection between perceiving subject and horribly grandiose—i.e., sublime—occurrence, a situation in which the image's function is to safeguard the (aesthetic) distance that ultimately sets any sublime experience apart from a true threat to the viewing self's existence. The image shows, and at the same time buffers, an event in which both people and vessel perish.

In Friedrich's *Eismeer*, this register is still evident, but only in the form of a ghostly presence. In these hypothermic regions, the image has severed all representational ties to the event, and crystallized into a static arrangement. The dramatic demise in the clash with the forces of nature has been replaced by slow death from hypothermia and crushing tectonic forces which exert their fatal pressure excruciatingly slowly, far too gradually to be captured in a picture. In this post-catastrophic image, the individual apocalypse of the vessel's crew has long since played out, if it ever took place as a dramatic eruption, and the sublime terror has frozen into stasis, condensed into a moment of motionlessness. The dynamic interplay of opposing powers has solidified into a tense diagram of suspended force and counterforce. And just as this painting refers to, but is no longer part of, the pictorial tradition of the shipwreck, the image of the sublime "event" haunts it as its aesthetic and affective past.[8]

A similar relation could be established between Friedrich's mountain-like depictions of imposing masses of ice and the sublime subject of the Alps, or the *Harz*, a theme which he had depicted in works such as *Der Watzmann* (*The Watzmann*) (dating from around 1824–1825, i.e., exactly parallel to the production of *Das Eismeer*), or, with the addition of a central rear-view figure, *Der Wanderer über dem Nebelmeer* (*Wanderer above a Sea of Fog*) (around 1818) (figure 6.8).

6.8 Caspar David Friedrich, *Der Watzmann/ The Watzmann*, 1824–1825, oil on canvas, 133 × 170 cm (52.4 × 66.9 in). Alte Nationalgalerie, Staatliche Museen Berlin. Public domain.

In terms of inner-pictorial scale, the scenery in *Das Eismeer* certainly qualifies for sublime dimensions. If we compare the miniature windows that open in the demised ship's stern, which open out to the leaden northern sky, we can easily imagine how tiny a human figure would appear, were it to be placed somewhere in this visual zone. But then again, these impressive dimensions on the level of the represented subject are counterbalanced by the picture's rather small actual format— it measures just below and a little above one meter in height by width (96.7 cm high × 126.9 cm wide), hardly scaled to draw the viewer into the realms of the grandiose and terrifying. Moreover, the visual traces that provide clues to the model for Friedrich's masses of ice also preclude an unmitigated sublime effect. Even Friedrich's contemporaries recognized that the artist—who never actually traveled to the Arctic regions— had taken formations of ice drifting on the river Elbe in his adopted hometown of Dresden as the model for his scenery.[9] An iceberg could never, of course, come gliding down a central European stream; furthermore, the way in which these shoals of ice interlock with and overlay each other implies a thrusting river undercurrent, not the dynamics of an ocean's upper layers. The transferring of ice typical of a river to the frozen masses of the Arctic Ocean does not erase all traces of the image's origin. Inscribed into this pre-photographic blow-up are elements that tend to scale down the impression evoked by the picture. Somewhere under Friedrich's polar sea, the river Elbe is still quietly meandering through the valleys of Germany. And finally, although the picture's reach into the register of the Alpine is undeniable, although its intentions to depict the solidity of rock are crystal-clear, the ice's liquid past and future frame its temporal and pictorial existence. Its solidity and massiveness are marked as impermanent. And the way in which it will eventually vanish will be no grandiose apocalyptic ending. One day it will just melt. Friedrich's *Eismeer*, then, conjures the specter of the sublime rather than embodying it. It alludes to its history, and allows it to appear, but in contrast to the frozen state which it depicts, this aesthetic register is not stable. Rather

than forming a sublime image—an image that would elicit an aesthetic-affective response of pleasurable liminality, a shudder in the presence of the immeasurable—Friedrich gives the viewer an image of the sublime, i.e., an image that depicts this aesthetic category without enacting it, or forcing it upon its viewers.[10]

"SHOWING" IMAGES

At this point a structural proximity emerges between Friedrich's and Kluge's much later project, something like an elective affinity that perhaps motivates Kluge's decision to use Friedrich's *Eismeer* in the context of *Wer sich traut reißt die Kälte vom Pferd*. In Friedrich's tranquil restaging of an agitated and heroic sublime, we can recognize an anticipation of Kluge's engagement with the affective and conceptual styles of sublime montage, with Eisenstein's method of representing the unrepresentable historical rupture of the revolution as an interruption and a distension within the flow of images (see chapter 2 above). *Das Eismeer* relates to the pictorial topos of the shipwreck in a way that is similar to the way Kluge's work relates to the heroic age of classical modernist montage. As Friedrich pictorially freezes the seascape as a site for dramatic action, Kluge devises a program that no longer casts the cut as an event of negation—not because he denies the relation between cutting and negativity (although his strategy of distinction entails a swerve away from this equation into the territory of differentiation; see chapter 2 above). Rather, his work rests on the premise (at which it arrives through a shift from the modernist poetics of montage) that neither cut nor negation belongs to the category of "events" or occurrences. The Klugean "third image," understood as the combination of two images to which is added their difference, is instead characterized by its stillness, and in Friedrich's suspended images it finds a historical predecessor which it incorporates as fragments into its own temporally unfolding visual body. Both works, although centuries and artistic worlds apart, operate with a comparable gesture: they "show" images.

This "showing" is the pictorial equivalent of a demonstrative gesture. It indicates the type of pictorial operation that allows Friedrich to make the image of the sublime appear in the medium of *Das Eismeer*, without letting this painting ultimately take on the qualities of a sublime image. Through allusions and the careful negotiation of visual topoi, Friedrich conjures the sublime, without letting it take control of his work. Kluge, on the other hand, relegates such quasi-demonstrative operations to the shot and montage. The camera (re)films an image, while cutting secures its autonomy as a visual unit. In fact, this is one of the central production principles of Kluge's visual *œuvre*. In these cases his camera, and the pictures which it renders, are employed in order to achieve the effect of "showing" images. These can be illustrations, book pages, the shot of Eisenstein's *October* playing at the cinema, "periscoped" and colored historical footage, and so forth. They include the transcriptions of Eisenstein's notes, and even the visual paraphrases of the Soviet director's unrealized *Kapital* film. Finally, Friedrich's *Das Eismeer* itself belongs in this group. In both Friedrich's and Kluge's works, the image shows another image, and this demonstrative maneuver, by which the presented image is subject to quiet contemplation and examination, is possible only because the image that serves as the medium (painting/film) and the image that appears in it (the sublime/the cut) are non-identical. This differentiation has nothing to do with strategies of framing, quoting, *mise en abyme*, or comparable operations. In contrast to these, Kluge's and Friedrich's strategies are not reflexive or recursive. Their principle can be described much more clearly if one applies the Klugean concept of the third image (two images and the difference that separates them) to a phenomenon that does not amount to a linear, temporalized, or sequential presentation of these two constituents. In the cases discussed here, one element appears in the medium of the other (a filmed or painted image), but not as one segment within a larger representation, or a detail within a bigger picture. Each shows an image by way of another image, while also displaying the difference between them.

Regarding Kluge's work there is, finally, the fact that his visual appropriation of Friedrich's *Das Eismeer* doubles this pictorial "showing" of images. Kluge's digital camera lets Friedrich's painting appear in a series of individual stills, and Friedrich's painting in turn conjures the image of sublime scenarios. Just as Kluge's notion of the digital constellation served to reconstellate the Benjaminian concept of the image constellation (i.e., the constellation between two images, but also the concept of the image as constellation), his *Paraphrase zu einem Bild Caspar David Friedrichs* functions as the paraphrase of Friedrich paraphrasing the sublime (see chapter 4 above).

(2) Friedrich Constellations

Recounting Art Histories / Recounting Image Histories

Only nine pages into *Stroh im Eis* (*Straw in the Ice*), the slender volume that serves as a print counterpart to the digital moving images on the *Landschaften mit Eis und Schnee* (*Landscapes with Ice and Snow*) DVD, the reader encounters another paraphrase of Friedrich's work. The brief text in question—"Die gescheiterte Hoffnung" (The Wreck of the *Hope*)[11]—begins in more or less classic narrative manner, but ends in a dialogue rendered in Kluge's typically stripped-down writing as a mere sequence of entries by dashes. The dialogue's speakers, Elfriede Ewers and Carla Stiffels, two visitors to the Hamburg Kunsthalle, make a sudden appearance in the text's last section to discuss Friedrich's *Das Eismeer*, which they have just seen in the exhibition. The focus of the text's initial paragraphs is on rendering facts and circumstances about the painting's creation, and there is no formal connection between the two textual segments. With its juxtaposition of a descriptive section dedicated to Friedrich and "the making of" *Das Eismeer* on the one hand, and a dialogue counterpart set in our present on the other, the text's primary organizational principle is again best captured by the term montage.[12] The underlying unit to which both sections refer is Friedrich's painting. In this sense, the text

"Die gescheiterte Hoffnung" functions as a direct correlate to the clip on the DVD. Whereas the latter constructs a filmic montage from a series of takes showing (sections of) Friedrich's image, the former presents a montage of textual approaches to that work by the romantic artist.

The title of Kluge's text—"Die gescheiterte Hoffnung"—already gestures toward Friedrich's work. As Kluge informs us at the beginning of his text, in 1822 Caspar David Friedrich produced a painting which he called *Ein gescheitertes Schiff an Grönlands Küste im Wonnemond* (*A Stranded Ship on Greenland's Coast in the Month of May*). The ship in this image—Kluge writes: "das Bild ist nicht erhalten [the painting went missing]"—had its name, "Hoffnung" (Hope), inscribed on its stern.[13] Apart from two minor details, this account conforms to art-historical fact. Friedrich did paint this image in that very year; it was titled—and this is where Kluge's text departs very slightly from the original—*Ein gescheitertes Schiff auf*—not *an*—*Grönlands Küste im Wonne-Mond* (*A Stranded Ship on* [not "at"] *Greenland's Coast in the Month of May*)—and this painting was indeed lost to posterity.[14] Kluge's text then proceeds, still in line with the historical record, to state that the slightly later *Eismeer* was frequently confused with the earlier painting ("wurde mit dem verschollenen ersten Bild verwechselt"). In the confusion between an extant and a lost image, the extant one was given the title *Die gescheiterte Hoffnung—The Wreck of the Hope*.[15] Kluge concludes his brief opening passage with the accurate—i.e., factually correct—information that during Friedrich's lifetime *Das Eismeer* was never sold.[16]

This sequence of pictures and correctly and falsely ascribed titles is relevant to Kluge in that his text itself is titled "Die gescheiterte Hoffnung," and thus partakes in the game of title-swapping. The story borrows a title that points to a suite of visible and invisible images. It is derived from a lost image, namely *Ein gescheitertes Schiff auf der Küste Grönlands im Wonne-Mond*, for which no visual documentation exists. This unseen image served as a source for the title of a later painting, namely *Das Eismeer*, which at the time of its creation proved so unpopular that it failed

to leave the artist's possession, never entering the circulation of the art market, and was therefore seen only by a very limited number of viewers. Kluge's text appropriates exactly the one title out of this substitution of images and words that does *not* refer to a factually documented, planned, or lost actual image. There never was a painting titled *Die gescheiterte Hoffnung*, and there never was to be. The planned or lost image was called *Ein gescheitertes Schiff …*; the image Kluge uses on the *Coldness* DVD is *Das Eismeer*, which was (and to this date still regularly is) misnamed *Die gescheiterte Hoffnung*. The image to which Kluge's text refers is, therefore, fictitious.

A River for an Ocean: Painting, Filmified

The text subsequently shifts toward a different configuration of visibility and invisibility, of the seen and the unseen: "Friedrich never directly saw a polar landscape. The consistency of ice was something he knew only from the pried-open winter ice on the Elbe that formed bizarre blockades. 'With sharp pointed, plates of ice stacked on top of one another.' (\rightarrow chapter 6 of DVD).]"[17] Kluge's reference here implies that his own visual treatment of Friedrich's painting could serve as an example of the fact that the painter based his image of the Arctic region not on his experience of this geographic region, but on the model that his own hometown in central Europe afforded him. As discussed above, the painting does indeed betray its fluvial, as opposed to maritime, origin precisely by the sharp-edged, densely piled plates of ice, which Kluge mentions here. And, as I have already pointed out, scholars have indeed been able to establish with a considerable degree of certainty that Friedrich did work from the visual impressions of the Elbe's late-winter icebreaking, as described by his friend and correspondent Carl Gustav Carus in his literary text *Bild vom Aufbruch des Elbeises bei Dresden* (*A Picture of the Breaking of Ice on the River Elbe near Dresden*).[18] It has even been suggested that Friedrich, whose studio's windows faced the river, did not have to leave the house to gather the visual material that fed (into) *Das Eismeer*.[19] That

is to say: there is a good chance that for this painting the artist did not rely on his practice of taking extended hikes into the countryside, where he would sketch from nature, later constructing his paintings from these impressions collected under the open sky. This time, Friedrich just stayed put. To find the visual material for his dramatic frozen structures, a look outside the window would have sufficed.

The second source for Friedrich's image, Kluge suggests, was newspaper reports and panoramic depictions of polar expeditions that were in popular demand at the time: "The fantasy in the images dates back to newspaper reports, as well as panoramas displayed in exhibitions in Prague and Dresden, like 'Winter Sojourn of the North Pole Expedition,' that responded to the theme in the popular press in the years 1822 and 1823."[20] This, again, is true to the facts of art history. Friedrich had learned about William Edward Parry's 1819–1820 attempted traverse of the Northwest Passage in 1821 through the prominent repercussions of Parry's own "Journal of the Voyage for the Discovery of a North-West-Passage from the Atlantic to the Pacific" throughout Europe, and he might even have been familiar with the book itself.[21]

Kluge certainly does not formulate these lines merely in order to reiterate the well-established facts of art history. Rather than pointing from the present to the past, "recounting" the facts and conditions of past image production, the temporal vector of this narrative points from the past into the present. For Kluge's account of the making of *Das Eismeer* clearly parallels his own image production. First, with respect to the role of sensory observation in the process of generating a picture. Although Friedrich's painting incorporates elements that derive from direct observation—the artist sitting by the window of his apartment, glancing out at the Elbe—its subject diverges from this view. While it is based on visual material from central Europe, the work depicts the Arctic Ocean. In the history of Western painting and drawing, such a mining of one visual context for the purposes of representing another, different visual context is, of course, a procedure so perfectly ordinary that it would hardly merit any mention.[22]

However, in the context of Kluge's work—and this means both the individual DVD/print project *Wer sich traut* and Kluge's output in its entirety—Friedrich's method begins to resonate with current conditions and production strategies. First, like the romantic artist who uses sketches of local scenery in his paintings, Kluge assembles "local" footage on his DVD: namely, the brief visual "sketches" of wintry landscapes which punctuate the visual flow of his digital film. All of them look like typical central European, probably even German, scenery. The DVD's closing clip is explicitly declared to originate in the director's closest geographical surroundings. It is titled "Zeitraffer mit Schneetreiben vor meinem Balkon Elisabethstraße 38 in München" (Time-Lapse Take of Dense Snowfall from My Balcony at Elisabethstr. 38 in Munich). This is a mere minute-long, static shot into a group of dark branches, probably a segment of a tree at night, through which drifts a chaotic mass of snowflakes. Another clip, titled "Zugefrorener See" (Frozen Lake), corresponds to the story "Stroh im Eis" (Straw in the Ice), from which the booklet derives its title. It is a narrative about Kluge's father, who was a doctor in Halberstadt, located, like Friedrich's Dresden, in central Germany, the region now known as Sachsen and Sachsen-Anhalt. Kluge's father saves the goldfish in the family's wintry garden pond by drilling tiny holes into the ice and sticking hollow stems of straw through them to maintain the exchange of oxygen between water and air, without which the fish would suffocate. On the DVD, these elements are then combined with both animated sequences and documentary (found) footage showing, for example, a sunrise or an aurora borealis on the Arctic Circle. In other words, although Kluge does not organize visual elements from regions far and near into a single picture, he still produces a context in which the visual poetics of Friedrich's *Das Eismeer* emerges as a point of historical correspondence for his own method. The romantic artist's generation of images by a combination of the aesthetic topos of the sublime with impressions of his local surroundings, and the representations of a historical event through media such as the panorama and the

press, now emerges as a reference for Kluge's own practice. This correspondence even exceeds the basic parallels between both protagonists' usages of local imagery for the production of visual fictions of distant regions. There is, for example, an analogy between the medial origins of Friedrich's painting and Kluge's work. Notably, Friedrich's visual sources lay partly in panorama shows of Parry's expedition. In its fairground character as a visual spectacle (Kluge's story groups it among the activities of "Schausteller"—fairground showmen), the panorama doubles the *kino-automata* and nickelodeons of the cinema of attractions, which function as a reference within and for Kluge's filmic and televisual work. There is also the structural parallel between Friedrich's procedure and Kluge's general filmic method of combining "local" documentary footage through montage with found fictional elements, in order to produce overarching contexts (*Zusammenhänge*), which are situated beyond the level of these primary elements (see chapter 2 above). In Friedrich's work, sketches of the iced-up river, a fairground staging of a polar expedition's demise, the visual topos of the sublime, etc., conjoin to produce *Das Eismeer*. In Kluge's work, documentary footage from his immediate geographical surroundings, found film clips from the Arctic Circle, interview features, a montage based on Friedrich's painting, and a collection of literary stories form a constellation that depicts "the cold."

The segments from Kluge's literary narrative which thematize the production of Friedrich's painting thus perform a similar function to the visual paraphrases of that very image in Kluge's digital montage. They serve to reconstellate not only Friedrich's work, but also Kluge's. Or, more precisely: they constellate Friedrich's work with Kluge's in that they establish the former as a historical point of orientation for the latter. Just like works by Eisenstein or Benjamin, Friedrich's *Eismeer* emerges here as the earlier half of a transhistorical constellation whose later position is occupied by Kluge. The method for establishing such a temporal relation consists, again, in producing relations within the body of a single, more or less synchronous work: here, Kluge's *Wer sich traut reißt die Kälte*

vom Pferd. The construction of this work as a zone in which such a relation can emerge in the first place, by retrieving several of its multiple components—either both at once, or in a consecutive sequence—is the precondition for Kluge's momentary reach into the realm of romantic painting. As a result, Kluge's work in its entirety is cast as the territory for possible connections between the method and conditions under which Friedrich painted his picture, and those conditions under which Kluge makes films and television features, and writes stories. In other words: the literary paraphrase of the making of *Das Eismeer* installs Friedrich's painting as a historical counterpart for Kluge's *Wer sich traut*, but also for his work in general. The content of this paraphrase and constellation is method, in that it pits Friedrich's and Kluge's artistic procedures against one another.

It is important to stress that this relation does not precede the reconstellation of Friedrich through Kluge, and not just because of the banal truth that prior to Kluge's thematization of Friedrich, nobody would have thought of such a connection. Rather, the crucial point here lies in the fact that prior to the actualization of Friedrich's work through Kluge's, the qualities that become the substrate of this constellation were certainly present in the painter's *œuvre*, but they were not yet imbued with the salience and anticipatory potential that emerge only when Kluge turns his attention to Friedrich's art. Moreover, they were not necessarily strongly connected. That Friedrich did not paint the polar sea from his own visual experience; that the ice on the Elbe running through Friedrich's hometown served as model for the floes on the painting; that the visual spectacle of the dioramas and panoramas may have furnished Friedrich with an initial pictorial idea of Parry's stranded exhibition; all of these circumstances and conditions of making *Das Eismeer* were obvious, or at least could have been obvious, to both Friedrich's contemporaries and later historians, but they were just a few among many possible facts to be known about that painting. Constellated by way of Kluge's work, however, they begin to speak to our cinematic and digital

present. Using the Elbe for picturing the faraway waters of the polar sea anticipates Kluge's employment of documentary footage, shot in his own geographical vicinity, for the montage construction of images of distant territories and times, as well as for depicting a general theme like "coldness" by assembling clips, stories, interviews, etc., into contexts. It also anticipates the Klugean critique of pictorial likeness. Painting from the diorama anticipates Kluge's turn to the fairground formats of the cinema of attractions. And even more profoundly, the regular discontinuities of producing a picture in Friedrich's time now anticipate the hiatuses across which the art of constellating pictures unfolds. It is as if romantic painting has been subjected to the filmic imperative, and to the conditions of the camera and digital image production: as if Friedrich had been filmified by Kluge, or, to use Vertov's and Godard's term, as if Kluge had produced a kinofied rendering of *Das Eismeer*, although he leaves the original image's stillness perfectly intact.

In this sense, the Klugean constellation of Friedrich constitutes a genuinely bilateral relation. Not only does this method establish Friedrich as a historical counterpoint to Kluge. It also solicits a hitherto latent constellation of elements in (the making of) Friedrich's picture that anticipates our present, although this configuration did not exist before Kluge's work entered into the constellation with Friedrich. One could call this a moment of *Nachträglichkeit*, of belatedness, but applying this term would eliminate half the temporal import of this strategy. Because, as well as retroactively orienting one image of the past toward the images and stories of our present, this procedure also orients present pictures and narratives toward that one painting of the past that now emerges as the other section of what could be called a paraphrase or a dialectical image.

The historical relation thus established is genuinely differential, i.e., it identifies the interconnection between its constituents as a difference. Clearly divided into an earlier and a later part, the later element does not "develop from" the earlier one, nor does the earlier predetermine the making and conditions of its later counterpart. In fact, before Kluge

began filming and (re)narrating Friedrich's images, there was hardly any continuity between these two artists' works. Nor does the later element position itself as a straightforward continuation of its predecessor. That is to say: Kluge's *Paraphrase* does not perform an "update" of Friedrich's work that would erase historical difference in an attempt at producing a version of that work that fits our present. Rather, Kluge presents a variation on Friedrich, a differentiation of *Das Eismeer* that cannot supplant the canvas with a newer and more current version for structural reasons, because it exists only *as this historical and differential relation*. In the present case, as in the case of many other texts, clips, and films, Kluge has invented a work that almost completely takes on the character of pure historical relationality.

A Differential Politics of History. Possible Pasts: A Note on Klugean Utopianism

The politics of history associated with this artistic strategy is far from monumental, or monumentalizing. It does not install the artist of the past, or her or his work, as a source from which to derive authority for present-day production. Rather, by retroactively assigning the work a role within a transtemporal constellation, an act in which the past is reconfigured as differentially pointing to our present, it injects a dimension of the nonfactual into bygone eras. This is one of Kluge's versions of a critique of the normative power of facticity, and its realm is history. In his work, *Das Eismeer* emerges as a possible past for his digital output, or, conversely, his digital work appears as a possible future for romantic painting. What Kluge redeems here from former days and works is their potential for future difference; or, in other words: other futures that could have been our present. The category of possibility, understood as a potential and, as such, unrealized anticipation of a later present, is assigned to the past.[23]

We may very well encounter here one of the deeper meanings of Kluge's enigmatic *gnomon* "Die Utopie wird immer besser während wir auf sie warten [Utopia is getting better only while we're waiting for it]."[24]

Klugean utopianism never imagines a better future. Rather, it unfolds as a relation between past and present. This quality also immunizes his work against any possible co-option by neoliberal ideologies of (self-) realization and the exploitation of potentiality. While Western (cultural) production is increasingly taking on the character of "the project," with its imperative of realizing any sort of cultural work—be it an exhibition, scholarly research, a text, or a collaboration—Kluge firmly plants the category of the potential in the realm of what has been. Nowhere in his *œuvre* do we find the potential figure as a launching pad in the present from which would spring what is to come, as the ideology of project work would require. Instead, Kluge creates counterhistories of possible pasts and their futures, i.e., our potential present, whose only mode of existence lies in his images, clips, films, and texts. These modes of possibility will never be recruited in the service of surplus production.[25]

And while now, within Western and increasingly global culture, subjects and situations are profiled in terms of their potential for "future development," Klugean potentiality cannot be assimilated in this sense, because it is firmly relegated to the past. Its differential character, and its directedness toward our "now," also distinguish it from what-if types of speculation ("What would our past look like, if National Socialist Germany had won the Second World War …?"). Kluge does not sketch an alternate present by imagining a different factual past. He pictures the past in the mode of the possible, in a procedure that lets fact and fiction coexist. Thus, rather than imagining the possible as a dimension that attracts and solicits future "realizations," he generates a state in which the factual is shot through with the possible.[26] And unlike his teacher Adorno, who at one point sparked the anger of the student movement by frankly declaring that his philosophy had no applicability, Kluge's utopianism is not purely negative. It provides the positivity of actual and possible images, stories, and histories.

(3) THE HORIZON OF IMAGES

Kluge's short story "Die gescheiterte Hoffnung" ends, as I said above, with a brief dialogue between two visitors to the Hamburg Kunsthalle. The conversation between Elfriede Ewers and Carla Stiffels takes place over coffee at the museum's café, and its subject is Friedrich's *Das Eismeer*, which the two women have just seen in one of the galleries. Their dialogue culminates in a funny laypersons' exchange about the philosophical status of Friedrich's image, and the conditions within which the work can be judged. The first visitor asks: "Was findest du besser, den Titel oder das Bild? [What do you find better, the title or the painting?]," and her companion, evidently a model member of an educated art audience, replies: "Es kommt doch angesichts des Bildes auf mein Urteil gar nicht an! Du sollst kein Urteil abgeben, wenn es um Erhabenheit geht, so steht es wenigstens im Katalog. [In view of the painting, my judgment doesn't matter in the least! You shouldn't pass judgment when you're dealing with the sublime. At least, that's what it says in the catalog.]"[27] Kluge's text even furnishes the reader with the source of authority from which this well-prepared cultural consumer so readily asserts the inappropriateness of any judgment in the face of the sublime (image). The meteorologically named "Dr. Detlef Sturm" (which translates as Dr. Storm), an ironical gesture toward the wrecked ship, has authored a catalog text in which he discusses the theme of the ice as a mode of the "Darstellung der 'ERHABENHEIT' [representation of 'SUBLIMITY']."[28]

By framing Friedrich's *Das Eismeer* as a test case for the representation of the sublime, Kluge again hews to the factual limits of the history of images and aesthetics. And by representing, albeit ironically, the viewer's response to the image as a potential crisis of judgment, he refers to Kant's famous definition of the sublime in his 1790 *Critique of Judgment* as that case in which the limits of the imagination are inscribed into the act of judging.[29] The typical Klugean variation that is also contained in this (textual) piece—i.e., its deviation from a mere factual account—lies

in its specific combination of content and form. For the fictional conversation at the Hamburg Kunsthalle performs a variation on one of the source texts of art criticism in the German romantic tradition that was also written on the occasion of an exhibition of a painting by Friedrich. The text in question is Heinrich von Kleist's 1810 "Empfindungen vor einer Seelandschaft Friedrichs" (Feelings before a Seascape by Friedrich), which appeared in the *Berliner Abendblätter*, a journal edited by the poet.[30] More precisely: Kluge's text presents variations on two texts prompted by a Friedrich painting, because Kleist's article was an edited version of an earlier piece: an essay submitted to him for publication in the *Abendblätter* by the poets Achim von Arnim and Clemens von Brentano.[31] In other words, Kluge presents a variation not just on a single text but, rather, on a sequential textual variation deriving from Friedrich's work.

Brentano and Arnim's earlier version contained fictional short dialogues, supposedly overheard in the 1810 Berlin *Akademieausstellung* in which Friedrich showed his work. These conversations, omitted by Kleist from his journal, are now picked up by Kluge in the form of the conversation between Stiffels and Ewers. In all likelihood, one of the first satires on the awkward encounter between a more general museum audience and the works of—then—contemporary art—i.e., a report about art in the public sphere, and a fine parody on a whole variety of positions in eighteenth-century aesthetic philosophy—this piece forms the historical counterpoint to Kluge's ironic dialogue at the Hamburg Kunsthalle. Brentano and Arnim's version opened with a segment of prose, which Kleist retained and modified slightly, while cutting the dialogue section for publication. Both versions ascribe to Friedrich's painting a similarity with Edward Young's dark verses in his 1742–1745 *Complaint, or Night Thoughts*, and attribute to it an "apocalyptic" quality.[32] Accordingly, Brentano and Arnim have one of their museum visitors actually point out the sublime qualities of Friedrich's painting, which he qualifies as "Unendlich tief und erhaben [infinitely deep and sublime]."[33] All in all, the themes developed in these romantic texts seem to fit well with the concerns

negotiated in Kluge's visual/filmic and textual treatment of Friedrich's image. Kleist, Brentano, and Arnim foregrounded the aesthetic category of the sublime in relation to the painter's work, and Kluge's text makes reference to these theories, while he identifies the romantic image, here *Das Eismeer*, as the past counterpart for a transtemporal constellation.

Where the question of judging the image is concerned, Kluge's text also operates within the parameters established by Arnim, Brentano, and Kleist: after cutting the dialogue from the submitted text without consulting the authors, Kleist issued an apology in which he acknowledged that through this intervention he had altered the piece's character to the effect that it "nunmehr ein bestimmtes Urtheil ausspricht [now passes a determinate or certain judgment]" on Friedrich's work, probably alluding to the fact that in the earlier version the ironic dialogue counterbalanced and also relativized the statements—and judgments—in the introductory passage of prose.[34] When Kluge has one of his museum visitors exhort the purported necessary abstention from judgment in the face of sublime imagery, he is also referring to this quarrel between Arnim and Brentano's (ironic) collection of several possible judgments, and Kleist's actualization of these potential evaluations into one determinate judgment.

Keeping in mind the smoothness with which the historical and the contemporary approaches to Friedrich's work play into one another, it is astonishing to note the one fundamental difference between Kluge's text on the one hand, and those of the romantic poets on the other. Arnim, Brentano, and Kleist did not write about *Das Eismeer*. Their "Empfindungen vor einer Seelandschaft" (Feelings before a Seascape by Friedrich) had as its subject Friedrich's 1810 *Mönch am Meer* (*Monk by the Sea*) (figure 6.9), an entirely different painting. Hence, Kluge's work here does not lead back to a single source image. Rather, at its inception stands the substitution of one image—*Das Eismeer*—for another—*Mönch am Meer*. Kluge's Friedrich paraphrase here thus consists of two "streams" or trajectories, one pictorial, the other textual, which it sets side by side. There

6.9 Caspar David Friedrich, *Mönch am Meer/Monk by the Sea*, ca. 1808–1810, oil on canvas, 110 × 171.5 cm (43.3 × 67.5 in). Alte Nationalgalerie, Staatliche Museen Berlin. Public domain.

is a series of two images—*Mönch am Meer*, followed by *Das Eismeer*—and along with it runs a sequence of texts prompted by these images and their substitution for each other: Arnim and Brentano's text, which juxtaposes the dialogue purportedly overheard in front of Friedrich's work with an independent critical assessment of the painting; followed by Kleist's editorial treatment of the piece (consisting by and large in a reduction to that one moment of critical assessment); followed by Kluge's text "Die gescheiterte Hoffnung."

Mönch am Meer functions well within this context as a companion image, or a pictorial predecessor, to *Das Eismeer*, because it counts as a pictorial paradigm of a sublime aesthetic, which the painter sought to realize in a number of his landscapes, even leading some authors to recognize in Friedrich the beginning of a modern painterly tradition of the sublime.[35] And yet the principle that Friedrich puts in place in this painting to negotiate the sublime differs from that which dominated in *Das Eismeer*. Whereas the latter "presented" a suspended version of the sublime image *through a differing image*, in *Mönch am Meer* Friedrich performs an operation in which, as we shall see, he strategically segments and sectors the image; and in which, as I hope will become clear in what follows, he implements a particular interplay between determination and indetermination, of scaling and an erasure of all measuring, out of which he generates a sublime effect. In other words: whereas *Das Eismeer* negotiated the history of sublime imagery, and developed a method of presentation that relied on an internal difference between the presenting and the presented image, *Mönch am Meer* depends on a specific type of formalization. Friedrich's contemporary commentators Arnim, Brentano, and Kleist already sought to formulate the principle behind this formalizing operation. They did so in the sentence that opens both versions of the review of *Mönch am Meer*: "Herrlich ist es, in einer unendlichen Einsamkeit am Meeresufer … auf eine unbegränzte Wasserwüste, hinauszuschauen. [It is splendid, in infinite loneliness by the seashore, … to stare at a limitless expanse of water.]"[36] The key terms here are infinity

and the absence of limits, or limitlessness. Indeed, Friedrich's painting—
with the extreme lateral pull of its strip of stone-colored beach and the
leaden ridge of the sea (both of which, combined, take up a mere fifth
of the image's height) and the enormous block of sky—offers an over-
whelming impression of an expanse of unfathomable vastness.[37] Kleist
described the experience of viewing Friedrich's painting as follows: "so
ist es, wenn man es betrachtet, als ob Einem die Augenlieder wegge-
schnitten wären [when one looks at it, it is as if one's eyelids had been
cut away]."[38] Friedrich deframes the image, as it were: he cuts away the
framing zone that serves as a mediating threshold between viewer and
image, instead throwing the onlooker right into the depicted vastness,
making him or her no longer a detached spectator capable of treating
the edges of the canvas as the inevitable ends of any pictorial rendering,
as the necessarily overlooked necessity to any necessarily finite repre-
sentation. Instead, these ends make themselves felt almost painfully, as
a brutal rupture, as if one's lids had been severed from one's eyes. Kleist
and his fellow-writers spoke about the "Abbruch, den mir das Bild that,"
the *detriment* that this image inflicts upon its viewers.[39] It deprives them
of something, it functions as a visual subtracting agent whose negative
force makes itself felt as a *découpage*, as a marked incompleteness.[40] To put
it more concisely: all pictures have finite extensions, but there is hardly a
picture that makes its limits as brutally felt as Friedrich's *Mönch am Meer*.
It is as if Friedrich had prematurely invented the category just beyond
the image's limits which film theory will later refer to as the *hors-champ*,
the out-of-field. And yet this cut visually rebounds into a widening effect
of lateral vastness, a violent stretching of the visual field that anticipates
the expanses of CinemaScope, and a maximized aerial extension that
approaches atmospheric proportions. The emphasized fragmentary sta-
tus of the image in relation to the world that it could potentially depict
leaves the imagination with no choice but to figure that which it is not
presented with as infinitely and monotonously extending beyond the
limits of representation.[41] Looking at *Mönch am Meer*, then, conjures a

view into infinity, while immediately truncating this expanse. Or, in the logic of marked fragmentation: only because it is so violently truncated does the image conjure the infinite and place it in the viewer's mind.

Kleist, and Kleist alone, described this effect: "and so I became the monk, and the image became the dune, but what I gazed on with yearning, the sea, was missing."[42] Upon taking the perspective of the turned figure—the *Rückenfigur*—of the Capuchin monk, the viewer experiences a slippage by which the picture itself becomes the equivalent of the dune on which the tiny figure stands staring out into the open sea and sky.[43] Looking at Friedrich's image, Kleist suggests, primes the viewer for a visual ascent into the infinite, while ultimately withholding that vastness from her or his actual experience. Or: the experience of viewing this picture may be compared to the ever-so-slight protrusion by which the dune seems to be extending into the space of the sea. Its irregular and subtle, but ultimately recognizable, convex curve may indicate the far-stretched sinuous outline of a sandy elevation; or it could, in a manner that Friedrich adopted in images such as the 1832 *Das grosse Gehege* (*The Great Enclosure*) (figure 6.10), even simulate the curved outline of a large plane that pushes forward into an engulfing space; the zone of the viewer pushes into the landscape in allusion to the curvature of the globe, only to be ultimately hedged in by the orthogonal horizon line which bisects the image.[44]

The monk, a stand-in for the viewer, would then occupy a position toward the edge of the shore, where he would not just confront the space of the sea, but ultimately move in its direction. This image carries, notably, all the characteristics that mark the technological and epistemological rupture in the visual field analyzed by Jonathan Crary in his *Techniques of the Observer*.[45] Comparing this landscape to any of its predecessors in, for example, Dutch genre painting highlights its difference. The sky in these earlier images may lay claim to a comparable vastness; but nowhere do such images relate a similar experience of exposure to the depicted world. As Svetlana Alpers has shown in her canonical study

6.10 Caspar David Friedrich, *Das grosse Gehege / The Great Enclosure*, ca. 1832, oil on canvas, 73.5 × 102.5 cm (28.9 × 40.4 in). Galerie Neue Meister, Staatliche Kunstsammlung Dresden. Public domain.

The Art of Describing, such Dutch paintings—Vermeer's *View of Delft*, for instance—are, by and large, products of the camera obscura, a separating and encasing quasi-architectural arrangement that reduces the world, in the process of its becoming-picture, to the luminous influx through a single isolated opening, the proto-lens, and ultimately to an already mapped-out projection onto the camera's back wall, where it awaits retracing. While the resultant pictures appear as fragments of the world, the optical apparatus of the camera that constructs them distances and ultimately contains them, too.[46] Friedrich, who produces images under a media regime that is no longer structured by this optical device, instead makes a painting that carries all the traces of its exposed origin in the world. It is a visual sibling to the viewing body that has exited the space of the camera, as denizen of the exterior that is the world. As if he wanted to emphasize this quality of exposure, Friedrich also produced images, such as *Frau am Fenster* (*Woman by the Window*) (1822), or the sepia drawings depicting the two windows that faced out from his studio toward the Elbe (1805–1806), in which the architectural interior functions like a visual echo of the medial setup of the camera obscura (figures 6.11–6.13).

But these chambers are mere faint reverberations of what used to be a governing technology for depicting the world. Now, the artist's windows are flung open, and the picture's structuring grid lies on the interface between inside and outside, in contrast to the mapping organizational back-wall topography of earlier imagery. The female figure in *Frau am Fenster* leans outward. The foreshortened perspective does not allow a definite location of her upper body, but it is possible that her face might even penetrate the imaginary sectioning plane and peek out into the open.[47] As if to mock the ultimate futility of any geometric attempt at measuring the world, both the artist's right-hand window and *Frau am Fenster* show the rigging of boats passing by. Their triangularly fanning linear systems are a last nod toward the calculation of angles and straight lines, which are now in the world, but have lost their power to visually describe it, and hence can also no longer form the basic order for its pictures.

———

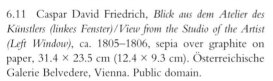

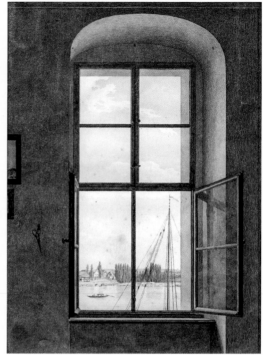

6.11 Caspar David Friedrich, *Blick aus dem Atelier des Künstlers (linkes Fenster)/View from the Studio of the Artist (Left Window)*, ca. 1805–1806, sepia over graphite on paper, 31.4 × 23.5 cm (12.4 × 9.3 cm). Österreichische Galerie Belvedere, Vienna. Public domain.

6.12 Caspar David Friedrich, *Blick aus dem Atelier des Künstlers (rechtes Fenster)/View from the Studio of the Artist (Right Window)*, ca. 1805–1806, sepia over graphite on paper, 31.4 × 23.5 cm (12.4 × 9.3 cm). Österreichische Galerie Belvedere, Vienna. Public domain.

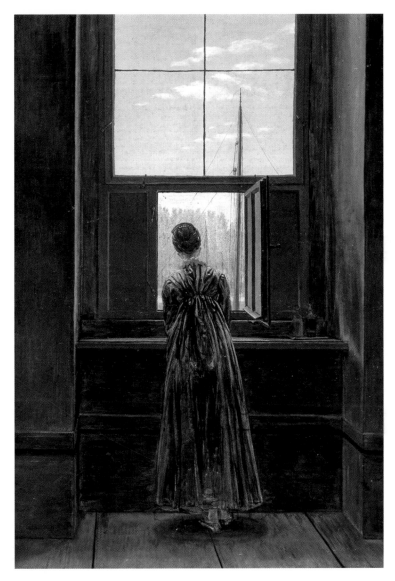

6.13 Caspar David Friedrich, *Frau am Fenster/Woman at the Window*, 1822, oil on canvas, 44 × 37 cm (17.3 × 14.6 in). Alte Nationalgalerie, Staatliche Museen Berlin. Public domain.

And yet *Mönch am Meer* is not entirely devoid of measuring moments and elements. Just as the impression of infinity and limitlessness that it generates emerges only as a correlate to the picture's abrupt truncation and delimitation, the impression of the world's expanse beyond measurements corresponds to the implementation of three formal operations that inscribe a notion of scaling and order into this image. There is, first and most obviously, the figure of the monk that enables the viewer to draw a comparison between her or his viewing of the world, and the view offered by the image. Judging by the minuscule height of the figure, the scenery we are confronted with must be overwhelmingly large. There is, second, a relationship between formal detail and its absence that provides the viewer with points of orientation, and makes for disorientation where it is lacking. That tiny figure of the monk is the smallest of details within the panorama of the whole painting, and yet it is the only piece of visual information that allows the viewer to assess the proportions of what is depicted. Friedrich's picture, then, is characterized by the juxtaposition of a single, minimal, isolated detail, against which the absurdly expansive remainder of the image reads as empty and unmarked. The figure of the monk is the necessary mark that makes the rest of the picture appear (proportionally) unmarked. (In fact, Friedrich even painted over a further indication of scale and proportion, namely a boat's rigging, hence reducing and focusing the encounter of proportioning mark and its absence to a dramatic confrontation between a single detail and the rest of the visual field.)[48] And third, there is the formal segmentation of the painting into an upper and a lower section by the orthogonal line of the horizon that runs between its left- and right-hand edges. It separates the painting's surface just as neatly as it inscribes the sharp divide between sky and sea. This divide, in turn, contrasts with the gradual tonal bleeding of a darker into a lighter blue, which turns into white and then an even calmer blue again, by which Friedrich has depicted an expanse of storm clouds accumulating in the upper regions of the atmosphere. Hence two segments of the pictorial surface are contrasted, two zones of

the depicted world; and, finally, the principle of a contrasting separation (the horizon line) is juxtaposed with the principle of a gradual transition (the color spectrum of the sky). This unbroken line serves as the necessary delimitation against which the immense sky appears limitless. As Friedrich scholars have observed, we are presented here with a zone where measuring, proportionality, and ultimately all description, are bound to fail.[49] As a consequence, the image is determined as a section of infinity.[50] Where quantitative determination loses all foothold—or, in the logics of image-making: where space can no longer be measured in the geometrical system of perspective—infinity can be determined only through negation.[51] The segmenting operation of the orthogonal horizon, and the juxtaposition that it introduces between segmented image and the unsegmented fragment of infinity, is therefore the necessary complement to the "deframing" treatment to which Friedrich submits the picture.[52] Both the horizontal cut and the contingent delimitation of the image as fragment are pictorial operations that determine what the image shows—that is, the wideness of sky and landscape—as indeterminable.[53]

Arnim and Brentano's text—especially in Kleist's edit, where it presents a determinate judgment (*bestimmtes Urteil*), then, continues the work that is already begun in Friedrich's painting: they seek to draw a distinction regarding the image. Yet in this case, this determination can only determine the end of its own relevance. It can only distinguish what escapes distinction. It can only adjudge that it confronts a situation where judgment is no longer applicable. In an ironic tone, Kluge has one of his fictional museum visitors in "Die gescheiterte Hoffnung" rehash the doctrine set forth in the exhibition catalog: thou shalt not judge the sublime (image). This visitor has just missed the point. The sublime is that appearance, moment, or image in which the only possible mark registers the absence of markings, and in which the limits—the horizon, the edges of the canvas—determine the unlimited.[54]

And it is here that a final parallel, or another constellation, between Friedrich's and Kluge's work emerges. For here the Klugean notion of

montage, understood as an artistic practice that strives to enable, and even to enact, moments of distinction and discernment in and through images, is identified as a correlate to the philosophy of judgment that was formed by the classical aesthetics of the eighteenth century, most importantly Kant, picked up and modified by Kleist and his contemporary romantics in their writings about art, and was even germane to the very construction of Friedrich's painting. Through an entire ensemble of artistic strategies, Friedrich builds an image that transforms its external and internal limits (the horizon lines, the edges of the canvas) into moments of delimitation by which the limitless is both determined and conjured. The sensation of infinity is evoked in the viewer without undermining the critical distance that separates her or him from the picture. In a similar manner, Kluge theorized feelings as producers of distinction, thereby situating the operation of critique within the sensory and affective realm. We could situate all this, finally, in a constellation with Klugean montage in which (image) contexts are constructed in such a manner as to articulate the difference or distinction that separates their components, thereby inserting the limit (in Deleuze's term: the interstice) between these constellating images into the very structure of the constellation. As if montage could (have) consist(ed) in setting the wideness of the sea against the vastness of the sky, thereby constructing a horizon not just within an image, but between images.—Montage: The horizon of images.

Passing Richter: How to Make Still Images: Toward an Extended Notion of (Klugean) Montage

Introduction: Gerhard Richter at the Hamburg Kunsthalle

In what seems at first to be merely a digression, Alexander Kluge's story "Die gescheiterte Hoffnung" (The Wreck of the *Hope*), published as part of the volume *Stroh im Eis* (*Straw in the Ice*) that accompanies the DVD film *Landschaften mit Eis und Schnee* (*Landscapes with Ice and Snow*), mentions Caspar David Friedrich's painting *Das Eismeer (The Polar Sea)* (1824–1825), informing us that "Gerhard Richter sah es in der Hamburger Kunsthalle [Gerhard Richter saw it on view at the Hamburg Kunsthalle]."[1] In the text there is no follow-up to this statement. However, the artist's name does resonate on the contextual level of the entire work of which this story is part, namely *Wer sich traut, reißt die Kälte vom Pferd* (*Who Dares Unseats the Cold*). For one origin of this work was, as Kluge has explained, the idea for a collaboration between him and Richter on a shared project. The basis for this collaboration would have been a set of photographs which Richter took during a voyage to Greenland in 1972, a number of which he eventually exhibited as part of his so-called *Atlas*, a vast collection of photographic material and studies for works, like maquettes and drawings, which is organized in a series of plates.[2] As Richter has repeatedly stated, the Greenland trip was inspired by seeing Friedrich's *Eismeer* (figure 7.1).[3]

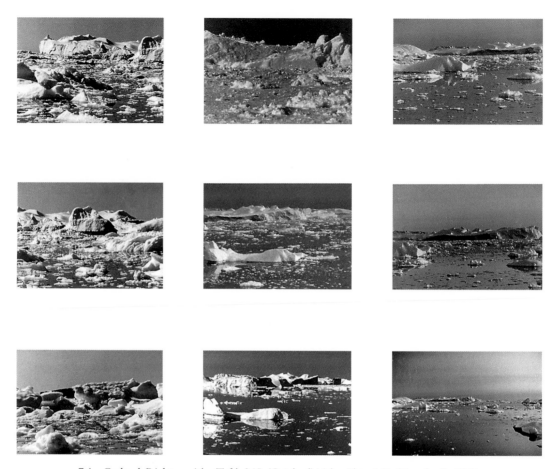

7.1 Gerhard Richter, *Atlas-Tafel 345 (Grönland)/Atlas Plate 345 (Greenland)*, 1972, 51.7 × 73.5 cm. Städtische Galerie im Lenbachhaus und Kunstbau München. © Gerhard Richter 2017 (0195).

Richter ultimately rejected the idea of a collaboration with Kluge on the Greenland pictures, and the two agreed to produce a different work. The project came to fruition with *Dezember* (2010), a pocket-book-sized volume that juxtaposes 39 brief Klugean stories with 39 photographs by Richter that were taken in the environs of the Swiss Alpine resort town of Sils Maria.[4] In accordance with the book's title, which names a winter month, its central theme is the cold, in connection with an exploration of questions of temporality and stillness (figures 7.2–7.3).

These topics are visible in Richter's images, which encapsulate momentary glimpses of snow-covered woods and mountainsides, and they are explored in a range of variations in Kluge's stories, from anecdotal observations about a German Wehrmacht engineer who, trapped in an ice storm in Russia in 1941, researches the anatomy of mammoths, to short speculations about the mismatch between the timespan of institutions, as manifested in calendars, versus the temporality of individual lives.[5] The entire project is appropriately framed by the conditions under which it came into being. For a number of days around New Year's Eve 2009–2010, Richter and Kluge retreated to the Hotel Waldhaus in Sils.[6] In the seclusion of the wintry mountains, during a time that marks the most significant event in the Western calendar—the ending of one year and the beginning of the next—Kluge and Richter collaborated on their book about coldness and temporality. The book's subject thus corresponds to the temporal, spatial—and meteorological—conditions under which it came into being.

The theme of coldness has a long history in Kluge's *œuvre*, first appearing in the 1964 *Schlachtbeschreibung* (*The Battle*), a literary rendering of the German army's defeat at Stalingrad in the winter of 1943, where thousands of civilians and soldiers not only fell victim to the protracted battle, but actually froze to death. Shots of wintry landscapes and refilmed paintings and illustrations showing snow-covered scenery are prominent features of Kluge's films from the late 1970s, like *Die Patriotin* (*The Patriot*) and *Deutschland im Herbst* (*Germany in Autumn*). The cold

übriggeblieben? Sie hatten wenig Kinder? Sie fingen groß an,
und es stockte bald?
- Das Böse bewegt sich nach wie vor in einem Versuchssta-
dium.[3]

3 Der Biochemiker Martin Eigen in Göttingen, der eine Abschrift dieses
Gesprächs der beiden konservativen Gelehrten besaß, das von einer Steno-
graphin festgehalten worden war, hat in seinen Computern die Überle-
bensfähigkeit des Guten und des Schlechten unter den Voraussetzungen
von Freiheit nachgerechnet. Er kommt zu dem Ergebnis, daß mangels
Durchschnittlichkeit das Böse (weil überheblich, weil äußerst anstren-
gend, weil ungesellig) mit zunehmendem Freiheitsgrad menschlicher oder
göttlicher Entscheidung statistisch zurückbleibt. Voraussetzung dafür ist,
sagt er, daß man das Gute definiert, wie: »es tut gut«, »es taugt für ein
Landgut«, ein Ding hat »gewohnt gute Qualität«, »jemand verhält sich
gut«, d. h. er respektiert das Interesse des anderen oder was dieser sagt.
Martin Eigen zählt deshalb die »Phantasmen des Guten« zum »Schlech-
ten«. Der Übergang der Freiheit zum Guten hänge, sagt er unter Hinweis
auf eine weitere Stelle bei Thomas von Aquin, von der korrekten Defini-
tion des Guten ab (es gehe um den »Gebrauchswert des Guten«).

30

7.2–7.3 Alexander Kluge and Gerhard Richter, *Dezember/December* (page spread).
© Gerhard Richter, Alexander Kluge.

31. Dezember 2009: EINDRUCK VON UNDURCHDRING-
LICHKEIT. In der Sammlung der Brüder Grimm wird erzählt,
daß es nur zwölf Gedecke gab für die zwölf »weisen Frauen des
Landes«. Die 13. Fee wurde nicht eingeladen. Ähnlich wie bei
der Havarie von Tschernobyl oder dem Sturz des Bankhauses
Lehman Brothers die Fakten ausgegrenzt werden, die wenig spä-
ter Unglück bringen. Die 13. Fee aber rächte sich, indem sie das
Schloß und das Reich auf eintausend Jahre in Schlaf versetzte.
Zugleich umgab sie das Schloß mit einer Hecke aus Bäumen
und Gestrüpp, das Gezweig ineinander verschachtelt, einen
»Verhak« bildend. Schnee lag auf dem Geäst. Es entstand der
Eindruck von Undurchdringlichkeit. In der Lebenspraxis aber
zeigt sich, daß am Boden eines solchen Geästs ein Weg durch
leichten Schnee zu finden ist. Man muß nur das Bild bis un-
ten verfolgen, wo auf einem Quadratmeter Erde Milliarden
Milben siedeln.

Die Macht der »Zeit«

Was ist das: »Zeit«? Ich bin Kalenderforscher, nicht Physiker,
antwortete der Mönch Andrej Bitow. Es sind die TRENNER
zwischen den Zeiten, auf die es ankommt, also Jahreswechsel,
Wechsel von Tag und Nacht, Abwechslung (zum Beispiel des
Wetters), die Einteilung nach Stunden und Minuten (auch Se-
kunden, in denen einer sterben kann), nach Generationen und
Lebensläufen: Zeit, sich zu fürchten; Zeit, zu lieben.

98

is also present in *Abschied von gestern* (*Yesterday Girl*, 1966), and in the corresponding literary story "Anita G.," which Kluge published in his 1961 debut collection *Lebensläufe* (*Case Histories*). In both versions the protagonist, Anita G., is arrested for stealing a woolen sweater in summer. When a judge questions her about the untimeliness of her crime, she responds: "Ich friere auch im Sommer [I'm cold even in the summer]."[7] In an introductory note to *Stroh im Eis*, the booklet in which the stories for *Wer sich traut* are compiled, Kluge quotes from a letter sent to him by Adorno, in which the philosopher returns to this precise passage: "That incomparable scene from 'Yesterday Girl' where Lexi says ... 'I'm cold even in the summer' has stayed with me. I'm deadly serious. This is what all of this is really about."[8] Adorno suggested that he and Kluge collaborate on the theme of coldness, a project that would have addressed the affective and social meanings of this term, including the notion of a *Kältestrom*, a stream of coldness that permeates society and culture: "for a thousand reasons I want to talk to ... you about the idea for a film about coldness."[9] The project was ultimately left unrealized, preempted by Adorno's sudden death in 1969.[10]

Richter's and Kluge's collaboration in *Dezember* thus continues the complex treatment of temporality that is present throughout Kluge's entire *œuvre* (see chapters 1 above; 8–10 below), and it responds to numerous treatments of the theme of coldness in his films and stories. But the book also continues the series of Kluge's works that respond to earlier, unrealized projects. Like *Wer sich traut reißt die Kälte vom Pferd*, the DVD–book combination on the theme of coldness which recalls the intended but unfulfilled collaboration between Kluge and Adorno, or like *Nachrichten aus der ideologischen Antike* (*News from Ideological Antiquity*), Kluge's DVD film which centers around Eisenstein's unrealized *Kapital* film, *Dezember* exists in place of a potential work which Kluge and Richter would have created on the basis of the artist's Greenland photographs. *Dezember* is thus inserted into a series in which extant works carry the indices of non-extant works of the past. What is achieved is positioned

against the unrealized; what is there to be read and seen is pitted against what cannot be read and seen, because it never was. The Klugean strategy of constellating present works against unrealized potentialities of the past finds a literal continuation here. Or, to reverse the perspective: through Kluge's constellating activity, works that could have been now lead a substitute existence in their alternate derivations.

This chapter explores the interrelations between the works of Richter, Friedrich, and Kluge set up by Kluge's story. While Kluge's and Richter's works refer to one another, and share a common reference in Friedrich's painting, this analysis ultimately develops from a decidedly Klugean perspective. Just as the framework—the *Zusammenhang*—for this investigation is set out by one of Kluge's stories, "Die gescheiterte Hoffnung," the guiding questions investigated here derive from Kluge's work and are transposed to Richter's art. They could be summarized thus: is it possible to consider Richter a producer of "still images" in Kluge's sense, and is there a correlate in the artist's work to the combinatory, disjunctive, and suspending type of activity which Kluge calls "montage"? Can his art—as briefly indicated in Kluge's story, but also as elaborately laid out in his actual collaboration with Kluge himself in *Dezember*—be understood with respect to Klugean montage, i.e., to image combination, disjunction, and suspension? And if so, how does Richter return to and vary Friedrich's politics of the still image—which Kluge's story evokes?

The analysis of Richter's work in this chapter, before the focus returns explicitly to Kluge, is based on the assumption that such an approach will generate insights that derive from the specificity and singularity of Richter's work. In the process, however, Richter is subjected to a Klugean reading. First, because the guiding terms for the subsequent analysis ("still image," "montage") derive from Kluge's discourse. It is crucial to insist on this particular framing of the argument, because adopting this perspective implies to a certain extent taking a position that does not coincide with the artist's statements about his own work. For instance, on the few occasions when Richter has spoken about the principles behind

the image combinations, or image–text combinations, that generate his own books, he seems to prefer the term collage, not (filmic) montage.[11] And if the term montage indeed plays a crucial role in one of the central and most complex discussions of Richter's work—Benjamin Buchloh's analysis of the artist's enormous photo *Atlas* as an "anomic archive"—it is with reference to the historical practice of photomontage, not cinematic editing. Buchloh demonstrates that, even as a negating gesture, Richter's quasi-serial, strictly grid-oriented agglomeration of photo panels must be understood in relation to two tendencies in modernist "collage/montage aesthetics": the "structural emphasis on discontinuity and fragmentation," as embodied in early Dada collages; and an archival impulse that explored the photograph's mnemonic functions as well as opening a perspective onto the possibility of a more lateral, nonhierarchical world: "The photographic image in general was … defined as dynamic, contextual, and contingent, and the serial structuring of visual information implicit within it emphasized open form and a potential infinity, not only of photographic subjects eligible in a new social collective, but, equally, of contingent, photographically recordable details and facets that would constitute each individual subject within perpetually altered activities, social relations, and object relationships."[12] Richter's *Atlas*, Buchloh argues, must be understood as an inversion "of the utopian aspirations of the avant-garde" that initially played out on these two "poles of opposition": "the order of perceptual shock and the principle of estrangement on the one hand, and the order of the statistical collection or the archive on the other."[13] It must be emphasized that in the discussion here, with its eventual complete return to Kluge's work, the term "montage" is used in its filmic—and constellational Benjaminian—sense, not that of the related but structurally different terminology which investigates the artistic practice of photomontage and its legacies. Accordingly, this chapter has nothing to say about Richter's *Atlas* project.[14]

There is a second reason for stressing that the context in which Kluge's, Richter's, and Friedrich's works are set alongside each other here

is ultimately and concretely established through Kluge's storytelling and constellating agency. It is connected to an important proviso concerning how the following argument models a potential relation between the positions of Friedrich and Richter. The premise of chapter 6—that any interrelation between the *œuvres* of Friedrich and Kluge under consideration is strictly constellational, i.e., not one of influence or filiation—applies here, too; and this must be emphasized even more strongly in the face of Richter's repeatedly stated penchant for Friedrich's art.[15] It was again Buchloh who first clarified that any such connection cannot be based on a hypothetical shared essence between Friedrich's and Richter's projects, but rather "owes its historic dynamism to real situations of imposed restrictions and opposition that did not permit the realization of subjectivity in actual life"—in this case, a history of political conflict that connected the epoch of romanticism and 1970s (West) Germany. Buchloh also points out that the connection between these two artistic positions is, further, subject to a tectonic shift in the history of media technologies: the advent of photography.[16] Other critics have followed suit, and emphasized that any alleged "return" in Richter's work, especially in his landscape canvases, to the art of Friedrich can be credibly posited only as also articulating the impossibility of such a return.[17] Yet even the rejection of the possibility of a continuation is— *qua* specific negation—still bound to (the idea of) a tradition. Following the paradigms of a Klugean approach, the subsequent argument is much more hypothetical, and its scope is more limited: wherever the argument joins the works of Friedrich and Richter, this is done in a constellational operation that assembles elements for a speculative history of montage beyond the history of montage proper, as posited in Kluge's fictional and theoretical *œuvre*. This is not to insinuate a relation of filiation, let alone one of "inheritance," between Friedrich and Richter.

And one final caveat: this chapter does not offer a perspective on the *œuvres* of Kluge and Richter in their many parallel aspects and developments. When Kluge describes himself and Richter as "Zeitverwandte,"

as "relatives in time," this term does not refer only to the anecdotal fact that both men were born only five days apart in the year 1932.[18] Kluge's formulation also captures a certain affinity in the concerns and issues that both address in their respective works: if Kluge's 1961 *Brutalität in Stein* (*Brutality in Stone*) engaged with Germany's National Socialist past through a filmic employment of that period's visual documents, so did Richter's 1965 painting *Onkel Rudi* (*Uncle Rudi*), for which he worked from a portrait of his maternal uncle in the uniform of the Wehrmacht; if Kluge was instrumental in the organization and filming of *Deutschland im Herbst*, arguably the most important filmic response to the country's terrorist crisis and its increasingly authoritarian and repressive politics of the state, Richter's cycle *18. Oktober 1977*—albeit not produced until 1988—occupies a similarly central function in the field of the visual arts. If Kluge's story "Der Luftangriff auf Halberstadt am 8. April 1945" (The Air Raid on Halberstadt on April 8, 1945) sought to find an adequate literary response to the experience of aerial bombing, Richter's 1963 and 1964 canvases *Bomber* and *Mustang Staffel*, painted after photographs of fighter jets dropping bombs, might be seen as sharing that concern.[19] Both Kluge and Richter also express a reservation and outright criticism regarding our culture's dominant modes of visual and pictorial mediation, while still opting to work in the realm of images. And, finally, it could be said that the problematization of (artistic, authorial) work that we encounter in Kluge's production (see preface and chapter 10) finds a counterpart in what Buchloh has called, with reference to the immense quantity and variability of Richter's abstract works, "a theory of production that would be concerned with suspending the reality of a closed, individual work, as well as the idea of a closed and coherent *œuvre*, produced over the period of a lifetime, and in which one could recognize a succession of phases, from an early work to a late style."[20]

Yet none of these questions will be addressed here. Just as in chapter 6, then, the argument, while looking for trajectories into an extended understanding of Klugean montage, spells out the (pictorial

and) constellational content of a Klugean film clip or short story. Or, the question could quite simply be: What are we to make of one of the images with which Kluge's story "Die gescheiterte Hoffnung" provides us—the image of Gerhard Richter at the Hamburg Kunsthalle, looking at a painting by Caspar David Friedrich?

Iceberg in Mist: Image Poetics of the Freeze-Down

At first glance, a connection between Richter and Friedrich could be recognized in a set of thematic correspondences. Like his romantic predecessor, Richter invests a number of his works with Arctic imagery, for example paintings like *Eis* (*Ice*, 1981) or *Eisberg im Nebel* (*Iceberg in Mist*, 1982), which are based on photographs from his Friedrich-inspired voyage to Greenland (figures 7.4–7.5).[21] The latter work—*Eisberg im Nebel*—could even be read as not just incidentally related but directly responding to *Das Eismeer* (figure 7.6).

The massive formation of the iceberg, as it floats in nearly still waters, is only partly perceptible. The contours of its upper section disappear into a milky blur of fog which also obliterates the division between sea and sky on the left-hand side of the image. The frozen body's transition into the indiscernible points to the invisibility of the zones that lie beneath the ocean's surface, where, as we know, the iceberg possibly has incalculable dimensions, its mass a permanent threat to vessels that sail in its vicinity. In the light of this potential deadliness, the glacial formation looms disquietingly. The image seems to anticipate an event of the order that might have sealed the fate of the ship in Friedrich's painting. And while Friedrich's image presents a post-catastrophic rigor mortis, a stasis after the accident, Richter here potentially gives his viewers a type of stillness that seems deceptively calm and treacherous: the proverbial silence before catastrophe strikes.

The correspondences extend to the implicit poetics that generate each of these two pictures. Friedrich's *Das Eismeer* evokes a movement

221

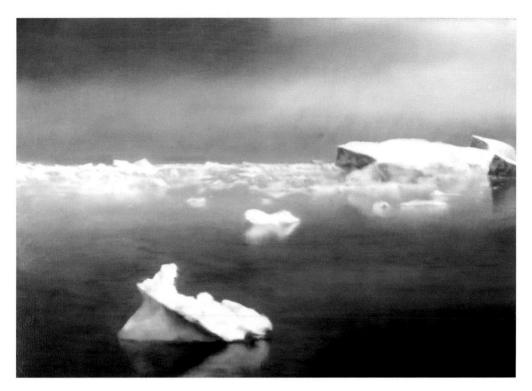

7.4 Gerhard Richter, *Eis/Ice*, 1981, oil on canvas, 70 × 100 cm. Private collection (Cat. Rais. 476). © Gerhard Richter 2017 (0195).

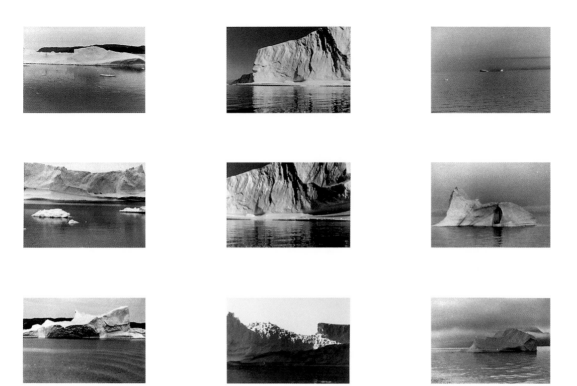

7.5 Gerhard Richter, *Atlas-Tafel 351 (Grönland)/Atlas Plate 351 (Greenland)*, 1972, 51.7 × 73.5 cm. Städtische Galerie im Lenbachhaus und Kunstbau München. © Gerhard Richter 2017 (0195).

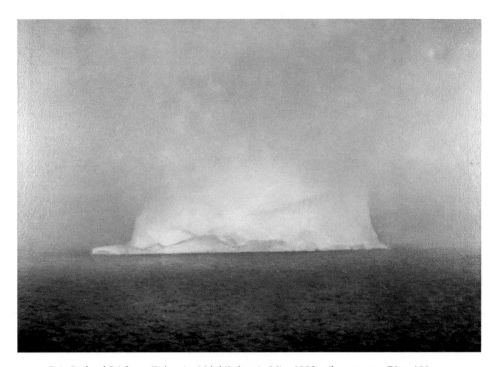

7.6 Gerhard Richter, *Eisberg im Nebel/Iceberg in Mist*, 1982, oil on canvas, 70 × 100 cm. The Doris and Donald Fisher Collection, San Francisco, USA (Cat. Rais. 496-1). © Gerhard Richter 2017 (0195).

which it freezes into a still image; it forms a dynamics in stasis. It could be argued that Richter's *Eisberg im Nebel* also implements an entropic program, a poetics of the freeze-down. However, it does not do this through an interpictorial negotiation like Friedrich's, in which waves are depicted through the figure of towering shoals of ice; or in which the aesthetic category of the sublime is "shown" in a distanced, literally and metaphorically cooled-down version. Rather, Richter renders the iceberg in his signature technique of blurring that steeps the depicted subject in a visually unfathomable field of haze. In *Eisberg im Nebel* this Richter blur becomes indistinguishable from the mist that hovers around the floating mass of frozen water and also lies on the surface of the nearly motionless sea, which is only faintly ruffled by a ripple of waves.

Looking at this image involves a perceptual process similar to the sailor's or passenger's attempts to discern the iceberg in mist. In trying to visually assess the depicted theme, to get closer to its texture and contours, one's gaze inevitably gets caught up in the layers of mist that surround the object, or in the painterly blur in which the shape is shrouded. This results in a shifting and perpetually displaced attention. In trying to decipher as much of the rather sparse detailed visual information that Richter's image affords, one slips into a contemplation of the blurry aura that gives the picture the artist's signature style. And whenever one attempts to focus on the painter's technique of softening all edges and sharp contrasts into a misty layer of paint, the theme demands our attention again. In the concrete situation of the exhibition space, this ambiguity results in the viewer's typical movement back and forth in front of Richter's canvases.[22] The physical displacement of the onlooker's body is a sign that the eyes, when tackling a Richter blur, are necessarily inadequate.[23] Prolonged visual engagement with one of these images leads to a diminution of attention, an exhaustion that slows down the process of seeing until all perceptual activity freezes to a halt. The experience, paradoxically, numbs the visual sense. First looking, then staring, at Richter's *Eisberg* leaves the viewer with a strange sense of feeling nothing, a view

into an anesthetized section of the field of vision that somehow fails to send data back to the sensitive eye. A visual segment, perhaps, whose fluidity and animation have cooled to rigidity, and thus lost the flexibility that makes a medium transmit, so that it no longer carries information.

Like other works by the artist, this picture parts with the conceptualization of painting as a transparent window, because instead of effacing its materiality for the purpose of clear rendition, it visually thickens it.[24] In the case of this particular work, Richter even reinforces this effect by offsetting the surface of the picture plane against the canvas's outer edges, which he has painted in a shiny black with the consistency of lacquer. The image literally hardens into the form of an opaque block. All maneuvers being stalled in the no longer navigable waters of vision, the picture embodies its central theme, the floating iceberg, and the iceberg in turn embodies Richter's image poetics of the freeze-down.

The Iridescence of White Nights: Photographs of Greenland and the Polar Sea

In 2011 Richter published a book titled *Eis* (*Ice*) which contained a vast number of photographs taken on his trip to Greenland—that is to say, the very pictures that would have formed the basis for the artist's planned initial collaboration with Kluge.[25] These images make a similar case against conceptualizing the image as a transparent medium, but one that corresponds with their specific medial status. In most cases, Richter's pictures show the surface of the Arctic Ocean, sometimes still, sometimes in various states of slight animation; shoals, islands, icebergs sit in the water, sometimes mere fragments strewn across the calm sea, sometimes as massive as a coastal line of cliffs (figure 7.7). In many images, the horizon divides sea and sky, but the coloring of these two zones is strangely similar (figure 7.8).

Perhaps this is an effect of the light during the white nights of the Arctic summer; it might also be the result of the artist's treatment of

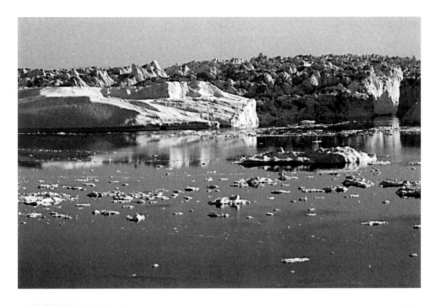

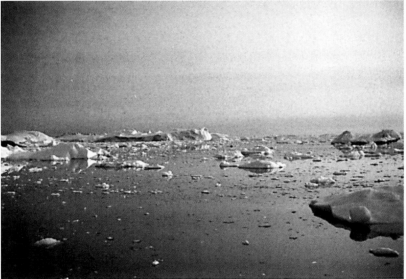

7.7–7.8 From Gerhard Richter, *Eis*, 2011. © Gerhard Richter 2017.

either the photographic negative or the print. The outcome is an unsettling chromatic continuity between what we know must be water that stretches out as a plane in front of the viewer into the depth of space, and the open atmosphere that extends above it. This chromatic proximity is so strong that both segments of the image, the surface's extension into depth and the wide-open Arctic sky, tend to collapse into one planar continuum that runs parallel to the picture plane. What used to be a recession into space has now been flattened into a surface that confronts the eye of the viewer as coextensive with the level of the page where she or he encounters it in Richter's book. This effect is reinforced by the quality of the print and paper that Richter used for *Eis*. The pages, and especially the images, have a slight silvery gloss. Moved under light, they give off a very faint reflection. Clearly the artist has gone to some lengths to avoid a visual "muffling" of the whiteness of the page. There is no material dullness to it; under certain light conditions the pages even look as if they have been lightly coated with a reflective varnish. And then there are the tonal values. The spectrum ranges from a leaden blue and silvery gray of both water and sky to darker shades of white ice that in some places fades into an unreal haze of turquoise; it also includes pale tones of peach and some implausible shades of pink, probably the effects of the Arctic sunset. The material images seem to take on the palette of an aurora borealis. Their overall impression is one of opalescence, a shiny, hardened layer that deflects the gaze rather than allowing it to penetrate the vastness of the Arctic territories. In this way, *Eis* deploys its own version of what Buchloh has identified as a "dialectic of reflection and transparency," of "translucency and opacity," that Richter has developed in other artistic media over decades.[26]

In Richter's canvas *Eisberg im Nebel* the space of pictorial representation is swallowed up by the dullness of impenetrable hazes of paint; his photos in *Eis* freeze over that very same vastness with an iridescent coating. Both pictures correlate with Friedrich's *Das Eismeer* in that their constitutive image tropes consist in an operation of stalling, a gesture

of hardening. A zone that used to be characterized by transparency and liquidity becomes solid, a space that could be traversed is blocked, and the act of exploratory voyaging that constituted that very traversal is barred.

WITHDRAWAL FROM EVENT

There is also a positioning of the image in antithesis to the category of the event and, by implication, a renegotiation of the nexus between time and image. Friedrich's *Das Eismeer* withdrew from depicting noteworthy occurrences, or the eventful, by marking its difference from the Longinian topos of the shipwreck (see chapter 6 above). Again, Richter is close to Friedrich's model in *Eis*. Leafing through the pages of this volume, one gets an initial sense that this work could be intended as the record of a journey to the Arctic. Richter combines a stream of photographs of the Arctic Ocean with a significantly smaller number depicting coastal areas. Whenever the camera captures a glimpse of ice-free terrain, the ground appears barren, a pure geology of rock formations with only very occasional flecks of moss and the lowest patches of evergreen shrubbery (figure 7.9). A few isolated images—some taken from the sea, some on land—depict loose groupings of single- and two-storied bunkhouses, a pier, and cylindrical storage structures—small architectural units on the waterfront, scattered settlements and rudimentary seaport infrastructure (see figure 7.14).

In three of the photographs, a medium-sized ship in port is visible. Single pictures show a boy amid a pack of sled dogs (figure 7.10); and a group of four men photographed on the pier against the background of the waters of a bay. Standing among them to the right is Richter himself, his argyle-patterned V-neck sweater, high-collared shirt, and the coat over his arm setting him apart from his travel companions in their outdoor utility gear of parkas and woolen hats (figure 7.11).

One image introduces a different accent into the rather neutral tone of visual recording that dominates the book. It is taken from aboard

7.9–7.13 From Gerhard Richter, *Eis*, 2011. © Gerhard Richter 2017.

a vessel; the wide-angle long shot focuses on an imposing cliff whose sides, captured from the front, drop steeply into the Arctic waters (figure 7.13). On the rock's upper surface is a more gently sloping terrain whose rusty tones, traversed by veins of green, display a fine cover of vegetation. In its upper regions, also marking approximately the bottom of the upper third of the image, is a bank of perhaps three dozen white crosses, irregularly dotted throughout the landscape. Perhaps just a memorial site, perhaps an actual burial ground, this mark undeniably points to the past tragedy of a nautical catastrophe. Seafarers, professional or mere passengers, have lost their lives in a nondescript shipwreck in the same waters now traveled by the vessel from which Richter has taken this picture.

The basic elements of a story are all here, related through Richter's visual material. We gather a rudimentary plot—the artist travels to the Arctic, most probably as a passenger on a cargo ship or an exploratory

vessel; he encounters the inhabitants of these northern regions, and comes across the telltale signs of a past catastrophe. This initial impression that the arrangement of images in *Eis* describes a passage in time is reinforced through the first and last pages of the book. At one end Richter has placed the photograph of a ship in port, suggesting either the beginning or the ending of a journey, an arrival or a leave-taking (figure 7.14). At the other end the viewer sees an image that shows a moment of changing light, whether dawn or dusk is unclear (figure 7.15). The light of the Arctic sun is reduced to a diamond-shaped halo; a glowing streak shimmers in the water, a luminescent pool spreads over the ocean's surface. The image seems to either close a day, or open a new day's course.

The sense that *Eis* narrates some sort of story is also reinforced by the opening lines of the long text that runs through the volume's stream of images. It weaves in and out of the flux of photographs, occasionally disappearing for several pages, to reappear later. Its opening lines read like the beginning of a travel narrative: "Greenland is surrounded by Baffin Bay, the Davis Strait, the North Atlantic Ocean, the Arctic Ocean, Smith Sound, and Kennedy Channel." However, what begins as a description of Greenland's geographic location—a perfectly suitable opening for a the story of a journey—soon moves in a direction that does not conform with the aims of storytelling: a rather lengthy account of the Arctic island's history, beginning with its discovery in 876 by the Icelander Gunnbjörn, followed by the enumeration of numerous landings and explorations between that date and the mid-nineteenth century. Rather than tracing the plot of a journey to Greenland, the text produces a dry history of Greenland as a whole. Instead of telling a tale, it rattles off a series of dates. What starts as a story turns into a chronicle, oddly prefaced by general geographical information. The explanation for this strange turn lies in the text's actual genre. Only in fine print does the book's colophon provide the information that the text is extracted from the 1871 edition of the Brockhaus *Allgemeine Encyklopädie der Wissenschaften und Künste* (*General Encyclopedia of Sciences and Arts*), first section, letters A–G. In other words,

7.14–7.15 From Gerhard Richter, *Eis*, 2011. © Gerhard Richter 2017.

this is a nineteenth-century encyclopedia entry, judging by its length in Richter's book, as well as by the roughly sixty pages it occupied in the original source: more an in-depth essay than a short article. Its alphabetical placement in the section A–G, as well as its subject matter, suggest that it is an entry dedicated to Greenland, and an outdated one at that.

The book's images similarly dismantle the initial sense that we are dealing with a narrative. Although the volume aligns groups of photographs that depict similar motifs, probably taken in similar locations, upon closer inspection this alignment no longer adds up to the visual record of a journey, either in time or in space. In fact, the images on the book's outer pages could also be read as subverting the sense of beginning and/or ending which they initially seem to convey. The ship in port may just as well be making an intermediary stop on a longer voyage, and the image of changing Arctic light fails to make clear whether it shows a sunset or a sunrise, dusk or dawn. Rather than opening or closing a story told in pictures, these images depict a passage of the Arctic, without ascribing a fixed temporality to it. *Eis*, while conjuring a sense of narrative—not least by combining images and text in the medium of the book—ultimately only conveys the impression of a story told in pictures and accompanying sentences. It evokes a sense of passing time, but the passage of time remains virtual, without ever being actualized. It is as if, for this book, Richter had heeded the Klugean dictum that the various forms of (pictorial and textual) context that are generated through assemblage only seem—or pretend—to have a plot, but actually consist of an assemblage of differences. Just as Klugean textual and visual montage can evoke the impression of developing narratives while actually performing the non-narrative activities of paraphrasing, constellating, and differentiating, Richter's image combination here produces the mirage of a narrative in pictures, while in the very same gesture allowing it to disperse into its constituent elements.

Writing about Richter's paintings, Hal Foster has called our attention to one of the artist's statements in which he observes that

"Illusion—besser Anschein, Schein ist mein Lebensthema [Illusion—or rather appearance, semblance—is the theme of my life]."[27] Picking up on Richter's terminology, Foster suggests that we should understand the artist's photo-paintings—in their relation to the medium of photography and painterly abstraction—as interventions regarding the problem of semblance, or, more precisely, as "a phenomenology of mediated appearance, of the new *Schein*-ing of the modern world."[28] The term semblance, as Foster explains, allows us to address two different strands, or tendencies, in Richter's work: "semblance is not the resemblance found in representation, any more than it is the negation of this resemblance in abstraction. Semblance comprehends both modalities because it concerns the very nature of appearance, and it is this phenomenon that concerns Richter above all else."[29] Even within the much narrower parameters staked out by *Eis*, this approach—to understand Richter's production as a mode of working through semblance—is valid: what we encounter in the book's pages is also the semblance of a story: a story's appearance, but also its undoing, its voiding.[30]

Just as in the case of *Eisberg im Nebel*, it is also possible to recognize a connection between *Eis* and Friedrich's *Das Eismeer*. The book relates to the romantic painting, first, through a number of references. There is the theme of the nautical voyage to the pole; there is the allusion to the shipwreck in the field of crosses on the cliff. The encyclopedia entry quoted in Richter's book even mentions a ship called *Die Hoffnung* (*Hope*) on which a Danish priest named Egede reached Greenland (in 1721); and at one point the text refers to the Arctic Ocean as the *mer de glace*, hence providing elements of both the false and the correct titles by which Friedrich's painting is generally known (*Das Eismeer, Der Untergang der Hoffnung*). One could even interpret the silvery gleam of the reproductions in the book as referring to the daguerreotype, which appeared at the end of Friedrich's life. In some of Richter's images there seems to be a visual remnant of the reflective surface through which these early camera images not only recorded light, but also reflected it.

In addition to these thematic correspondences, there is also a structural convergence between Richter's polar imagery in *Eis* and Friedrich's *Das Eismeer*. Each work produces an image of time, without subjecting the pictorial material from which this representation emerges to the forces of temporalization. In other words: *Das Eismeer* and *Eis* display time, but they do not insert it on the pictorial level.[31] Both Friedrich's canvas and Richter's book even make a point of markedly negating the time factor as an operative force. Friedrich excludes the categories of event and occurrence in favor of depicting a static scenario. Richter creates the impression of a narrative—i.e., the representation of events in the course of time—but ultimately stalls it, as if even the flow of potential stories had been frozen in those regions of the globe where "day" and "night" no longer alternate at the rhythm at which they structure our lives.

Eis, then, is ruled by a program of generating still images. Action, plot, spatial traversals, and passages of time are all suspended—all development is momentarily stalled—placing the viewer/reader at a distance from which she or he may focus on the now disengaged image/text components that are held in a moment of tension. In this respect, *Eis* is comparable to Kluge's creation of "still images" through textual/pictorial montage. The resulting constellations rely on setting their components into a relation of suspension, rather than harnessing them into the facilitation of flows of action, history, plot, or images. Just as Kluge does not equate the constructive and disruptive moment of the cut with the category of the event, Richter also disassociates his combinations of discrete image units from the depiction of developments.[32] (On the Klugean dissociation of cut from event, see chapters 2 above and 8 below.)

SHOWING TIME THROUGH ICE AND SNOW: *DEZEMBER*

Richter's photographs in *Dezember* are similarly removed from the representation of processes in time, although they do not engender this removal by "arresting" a journey in images, negating the visual narrative,

or first provoking and then stilling the sense of a passage in time. Rather, here the effects of the image are situated on an even more basic level, and they respond to the title *Dezember*, which indicates a span of time, a moment in the year, and also the passing of one year into another. Not only is there not a single indication of such a passage in Richter's photos; there is also hardly any sense of space that could be visually and physically traversed (figures 7.16–7.17).

The panorama that can be assembled through these pictures is visually dense and without voids. Richter's photographs appear strangely clogged. Almost nowhere does depth, let alone vastness, extend into a spatial expanse.[33] In most of the pictures a dense crisscross of twigs, branches, dried leaves, and snow assembles into a visual hedge, beyond which the photograph holds nothing in reserve. The appeal is textured, but this is not a surface. We see flurries of snow, but nothing seems to be moving, falling, or drifting.

This visual condensation never achieves complete solidity, but neither does it allow for an unfolding of space. Instead, the areas in these images that are not suffused with matter form an irregular system of throughways intertwined with the materially articulated veins and arteries, the capillary system of branches and snow. The result is an impression of irregular porosity, a spongelike mass. In these pictures, any indication of a plausible viewer's standpoint has been avoided, making it practically impossible to visually situate oneself *vis-à-vis* the image as spatial representation. There is no horizon to accommodate such visual measurement. In all likelihood, the view offered by these pictures is one onto the upward slope of a mountain, perhaps down into a gorge or a valley (figures 7.18–7.19). But wherever the image permits a view, it is filled with trees. There is no clearing here through which the viewer could imagine entering the image, nor are there isolated structures that could function as stand-ins, as visual representatives of his or her situatedness in this wintry world.[34] These images neither make room for a beholder, nor cede her or him the right of being in the image by proxy.

7.16–7.17 Gerhard Richter, photographs from *Dezember*. © Gerhard Richter 2017.

24. **Dezember 1943:** UNÜBERSICHTLICHE LAGE ZU HEI-LIGABEND. Er war gerufen worden; andere Ärzte standen wegen der späten Stunde des Feiertages nicht zur Verfügung. Im Kreiskrankenhaus eine Notbesetzung, Abweisung des Falles. DAS KIND LAG MIT KOPF UND GESICHT OBER-HALB DES BECKENEINGANGS. Die Wehen verstärkten den Druck, nichts orientierte das Lebewesen nach unten, zu unserer Wirklichkeit hin. Der Kopf des Kindes preßte sich gegen die Knochenstruktur der Mutter. In solchem Fall hilft nur die HOHE ZANGE. Die war (nicht mehr heute, wo generell Kaiserschnitt gilt, sondern zur Zeit jenes Geburtshelfers und Arztes) eine Eisenkonstruktion, die das empfindliche Kopfende des Kindes von beiden Seiten umfaßt, also »schient«, und unter Beachtung der Empfindlichkeit dieses Köpfchens einen »sanften, jedoch eisernen Zwang« ausübt, die aussichtslose Position in eine aussichtsreiche umzuwandeln. »Ohne Gewalt«, d. h. der Arzt muß den Drehpunkt finden. Der Winzling, der nichts davon weiß, wie er geboren werden soll, braucht Führung. Derweilen darf er nicht ersticken. 7000 Teile hat ein solches »Ich« des regierenden Arztes; fast horcht er, während er fühlt, und dies mit Hilfe des Eisenstücks. In den Vorstunden zum Heiligabend hat er vier Schnäpse konsumiert; das machte manche seiner Nerven träge. Dann aber hat die Alarmierung seine Kräfte enerviert.

Die Gefährlichkeit des Eingriffs, von der er weiß, ist eine Droge. Während er das »junge Ding«, eine Eiweißmasse von Milliarden Jahre alter Struktur, aber empfindlich gegen jede

77

7.18–7.19 Alexander Kluge and Gerhard Richter, *Dezember* (page spreads).
© Gerhard Richter, Alexander Kluge.

22. Dezember 1943: Ein Schlitten steht im Wohnzimmer. Probesitzen auf dem Geschenk. Die auf dem Schlitten sitzen, sind Geschwister. Die Dämmerstunde kommt. Kerzen. Wir sind beieinander. »Wir sind immer noch sehr lebendig / Und wir freuen uns unbändig / Diese Zeiten durchzuhalten.« Der Vater, ein Soldat, ist auf Urlaub heimgekommen. Die Mutter ist untreu gewesen. Das wissen die Kinder. Sie singen: »Doch zwei, die sich lieben / Die bleiben sich treu!« Die Mutter erschrickt. War das eine Anspielung? Die Kinder aber haben nichts verraten, nur die Wahrheit haben sie gesagt.

Jetzt singen alle das Lied. Es hat die letzten Kriegsjahre begleitet. Es geht um einen Soldaten, der bewaffnet in die Fremde marschiert, den aber die Sehnsucht nach Hause zieht. Solche Menschen sind zum Siegen nicht geeignet. Auch die Frauen in der Heimat singen das Lied: »Es geht alles vorüber, es geht alles vorbei / Auf jeden Dezember folgt wieder ein Mai!« Auf den Mai war jetzt der Dezember gefolgt. Draußen ist es dunkel. DOCH ZWEI, DIE SICH LIEBEN / DIE BLEIBEN SICH TREU.

70

And just as depth is difficult to visually fathom in these images, so are time and space. It would be misleading to call this assemblage of pictures a "series," for, in distinct contrast to the serial structure of photographic registration, these images do not form chronological successions that would make it possible to reconstruct the temporal order in which they were taken or, by implication, the path through space that the artist, equipped with a camera, would have needed to travel in order to take them. It is this refusal to even mimic a succession of moments that marks Richter's images, which also stands in stark contrast to the associations conjured up by the title of the book in which they appear—*Dezember*. There is literally no passage here: space is so densely overlapping with matter that it seems impenetrable, or untraversable, and neither a traversal of territory nor a flow of time is registered. "December" thus loses any possible interpretation as a month within a calendar cycle, and even more so as the month which ends the Western year, and ushers in the Christian festival of Christmas. All these moments of passage—or, more precisely, all these interpretations of month and moment *as* passage—seem to lose their significance here, where *Dezember* refers to a block of time.[35]

THE COMBINATION AND DIVISION OF IMAGES ACCORDING TO GERHARD RICHTER

With *Eisberg, Eis*, and his photographs in *Dezember* Richter, then, produces three different examples of image "arrest." Evidently, none of these works presents a literal case of halting the image, since none of them is based in a temporalized medium. In other words, Richter does not press a pause button to bring a previously moving image to a halt. Instead, the artist generates this effect by arranging individual images (and text) into combinations, and through this operation of combining he creates moments of suspension (of time). In *Dezember*, Richter's photographs form an opaque visual block that precludes the emergence of a sense of temporal transition; he also prevents the formation of a representation

of space from which the camera's/spectator's passage through that space could be deduced. In *Eis*, the impression of a journey to the Arctic is first conjured up, only to be subsequently neutralized. And in *Eisberg im Nebel* the visual exploration of the pictorial space of representation itself is stalled as the depicted motif (the iceberg drifting in the foggy sea) enters into an osmosis with the level of image poiesis where painterly representation itself is caught up in the artist's technique of the blur. Here, the viewer's experience of progressing toward a fuller "understanding," or simply a more complete visual account of what Richter gives her or him to see, is progressively frustrated. (A comparable stalling takes place on the pages of *Eis* as the book's photos hover between depicting the space of the ocean and flattening out into a shimmering opalescent surface.) In all of these cases, the effect of suspension receives a semantic charge from the reservoir of polar imagery, with its associations of a hypothermic arrest, and of the solidification of the fluid element of water into the aggregates of ice and snow, which set the thematic baseline for an understanding of these works *as* suspensive. Although they are executed in a technique that seems to have little in common with Friedrich's method of "displaying" the image of the sublime in *Das Eismeer*, these works are comparable with this romantic painting in terms of their overall effect. Each evokes a dynamic element, only to preclude it from unfolding. As the textual and pictorial components refuse to be subjected to the imperative of temporalization, the passage of time takes the form of an image. In other words: just like *Das Eismeer*, *Eisberg im Nebel*, *Eis*, and *Dezember* all produce images *of* time, precisely because they do not turn time into an operative factor on the level of figuration, image combination, or representation. Both temporality's representation and its suspension are interdependent.

The technique that Richter employs in these cases could be counted among the "strategies of the hiatus," on whose centrality to the artist's work and beyond Buchloh has recently insisted.[36] Such a strategy could possibly find its predecessor in a work like *Seestück* (*See—See*) (*Seascape*

(*Sea—Sea*)) (1970), which deserves to be called metapoetic, because it openly displays the rules according to which the artist produces his combinations of images (figure 7.20).[37]

This square, large-format canvas (200 × 200 cm) depicts a seascape at first sight not dissimilar to those in Richter's Arctic paintings or in the *Eis* photographs. The viewer confronts the vast extent of the ocean's agitated surface as it stretches out toward the horizon. The sky above seems heavy with an unbroken mass of low-hanging clouds. Only the horizon line figures as a sliver of light, a paling of the image's otherwise opaque tones of dark gray into a cold white tinged with a hint of blue. The impression is one of fog emerging from a leaden sea. The viewer, of course, also sees the barely concealed pictorial origins of *Seestück*. One is quick to recognize that Richter has not simply painted this canvas after a single photograph. Rather, he has taken two such images, cropped each of them by the section depicting the sky, and finally turned one of them 180 degrees, so that it now meets the lower image exactly on the horizon line (figure 7.21).[38]

The inverted rippling ocean waves in the upper section of the image suggest massing clouds. The horizon line affords the viewer an impression of perspectival depth, while also marking the fissure between two assembled photos. It looks as if a fine layer of mist evaporated from this interstice between two repainted images; or as if a zone of faint light formed a dividing line between two media reproductions. One work, one picture, emerges as the result of a conjoining of two separate images. Although it emerges from this encounter, this image also openly displays the non-identity of its constituents. This constitutive interstice is at the same time softened out, as it is subjected to a soft-focus quasi-*sfumato* treatment and integrated into the content of the image (it functions as the horizon line), and it is the negating mark at the origin of this work. In fact, Richter's title *Seascape (Sea—Sea)* says it all: *Seascape* names the overall image that emerges through a reduplication or repetition of its pictorial constituents *Sea* and *Sea*. The dash "—" that stands between *Sea*

7.20 Gerhard Richter, *Seestück (See—See)/Seascape (Sea—Sea)*, 1970, oil on canvas, 200 × 200 cm. Nationalgalerie, Staatliche Museen Berlin (Cat. Rais. 244). © Gerhard Richter 2017 (0195).

7.21 Gerhard Richter, maquette for *Seestück (See—See)*, 1970, detail from *Atlas-Tafel 194 (Photocollagen)/Atlas-Plate 194 (Photo Collages)*, 1970. © Gerhard Richter 2017.

and *Sea* literally and functionally reiterates the horizontal bisection of the very image that springs from it.

Within the parameters of the present Klugean reading, Richter's generative joining of separate, iterating elements, which also reads as a constitutive split within the work, could appear as a veritable trope of production. It is by no means limited to photographic work or photo-based painting. Named paradigmatically in the motto for Richter's 2011 artist's book *Patterns*—"Divided, Mirrored, Repeated"—in which one of his *Abstract Paintings* is subjected to the visual operations of vertical division, mirroring, and repetition to create 221 patterns, it can already be observed at earlier points in his *œuvre*, for example, in a piece like *Zwei grau übereinander* (*Two Greys, One upon the Other*) (1966) in which two rectangular fields in different tones of gray are placed on top of one another, the darker field occupying the upper position, while both float on a white ground (figure 7.22).[39] The distribution of color fields, horizontally split as they are, also replicates the schematic layout of a printed newspaper page, where two tones of gray denote a photograph and an accompanying column of text on a white ground—the very newspaper format that Richter used as a source for a number of his initial photo-paintings.

Doppelglasscheibe (*Double Pane of Glass*) (1977) provides another example where the principle of constitutive splitting and joining is developed into a quasi-formalist exercise in space. Set up on a supporting black iron frame, the work juxtaposes two identical planes (figure 7.23). One side of each of these windowpanes is thickly painted in matte gray, while the other side maintains the characteristic reflective surface of glass. The reflective and the matte sides of the panes face in the same direction. This joining of iterating separates makes for a veritable engine of artistic signification. There is, first, the succession of both panes, as if to form the nucleus for a potentially open-ended series of iterations to each side of the work. Secondly, there is the quite literal quasi-sculptural pun on the structure of a double glass window. And thirdly, there is, on a more

7.22 Gerhard Richter, *Zwei grau übereinander/Two Greys, One upon the Other*, 1966, enamel paint on canvas, 200 × 130 cm. Olbricht Collection (Cat. Rais. 143-2). © Gerhard Richter 2017 (0195).

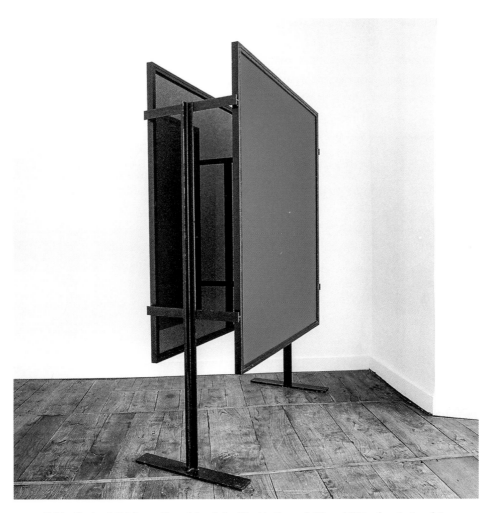

7.23 Gerhard Richter, *Doppelglasscheibe/Double Pane of Glass*, 1977, glass (painted in gray on one side) and iron, 200 × 150 × 50 cm. Musée départemental d'art contemporain, Rochechouart, France (Cat. Rais. 416). © Gerhard Richter 2017 (0195).

complex level, the analysis of the structure of the painted image. The latter's representational capacities had over centuries been conceptualized by figuring the painting-as-window, and artists relied on the viscosity and delicate layering of paint—i.e., a practice of mixing—to create a diaphanous continuum of color that appeared to display spatial extension, i.e., depth.[40] In *Doppelglasscheibe*, Richter has split this representational apparatus into a set of components that no longer fit together. Out of painting-as-window he has generated a literal double glass window, a couple of two-sided planes, each featuring an opaque and a reflective surface, each in its own way shutting the viewer out rather than providing visual access. In between them now exists a strange literal space that replaces the space of pictorial representation, and is characterized by the encounter of glass and thickly applied paint. Richter has split painting in two, and constructed a sculptural combination of its components that adds up to something like an image of painting, but one that no longer performs the (traditional) functions of the painted image. A third example among many more would be the stark case of *Spiegel* (1981), in which Richter simply replaces the painted image with a mirror that is sometimes exhibited directly facing an identically formatted counterpiece of the same title.

Dividing, iterating, reflecting, and mirroring are also the structuring principles for *Eis*, in which each page is split into an upper and a lower half, a layout choice that in turn repeats the structure of many of the horizontally divided photographs on its pages, which set the reflective surface of the "sea of ice" against the northern sky shown in the image's upper section (figures 7.24–7.25).

In the form of the bisected page, the book distributes its images and the accompanying text either in parallel between upper and lower register, or in a reverse order whereby the upper and lower text/image unit's top edges touch one another. This parallel distribution follows the principle of the horizon, while the inverted presentation along an imagined axis, bisecting the book, is organized according to the principle of

reflection, where a surface mirrors an adjacent space. Sometimes, also, an image or a unit of text is set against a blank section.

The principle of inversion also applies along the book's vertical axis. Each of its outer jacket pages displays the title in capital letters, and the artist's name, along with one photograph. Inside each cover is an identical set of publisher's information, and the volume's spine arranges the title *Eis* twice in opposite directions, while its midsection is occupied by the book's barcode (figure 7.26). The photographs and text sections inside are intermittently but regularly arranged in such a manner that the shorter edges of the pages can serve as both headers and footers. As a result, none of the volume's outer pages unequivocally reads as first or last, and the book can be begun in both directions. As a result, the left-to-right order of reading is no longer unilaterally implemented here. Instead, it is doubled. In effect, *Eis* has two reading/looking directions, neither taking precedence over the other, because both appear to be valid front-to-back movements.[41] In addition to turning pages, the reader can now also flip and turn the entire volume, because top and bottom are not unequivocally defined. The impression of storytelling, of showing a passage in time, is hence even more fully revealed as the effect of a strategy that relies *de facto* on the mirroring, splitting, and iteration of images, and conjures out of these image combinations and distributions a virtual image of time.

Richter's technique of image combination and division can in fact be traced back to the very early beginnings of his work as an artist. In 2009 the Richter archive published an edition of linotypes which the artist produced in 1957, retrospectively titled *Elbe*, the river that crosses Dresden, which Friedrich had sketched when he was working on *Das Eismeer*.[42]

About a third of the 31 sheets which the artist had entrusted to a friend upon leaving East Germany divide the surface of the paper into an upper and a lower section, marked by a contrast between lighter and darker shadings of black or gray, or through the difference between a

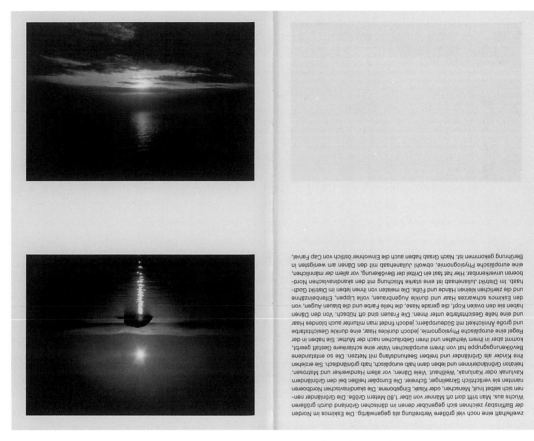

7.24–7.25 Gerhard Richter, *Eis*, 2011, page spreads. © Gerhard Richter 2017.

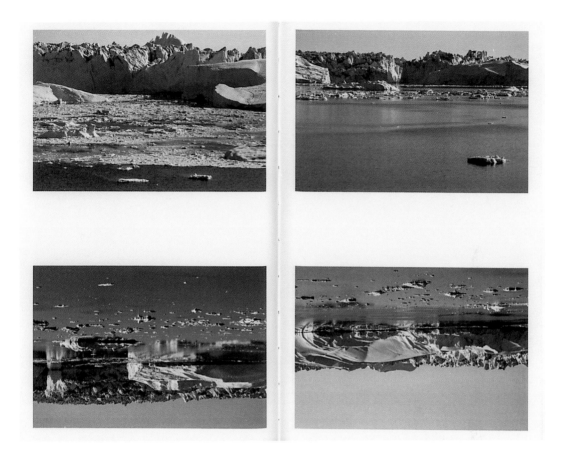

7.26 Gerhard Richter, *Eis*, 2011, book jacket. © Gerhard Richter 2017.

more solid or more watery density of color (figures 7.27–7.28).[43] Two leaves display a circular shape in their upper sections. Intentionally blocked out in the process of printing, the light-cream color of the paper here stands out starkly against the surrounding darkness, hence carving out the image of a moon hovering over a plane of water. One image directly inverts this arrangement, thereby creating the impression that the moon is being reflected in the river. Two others show a less geometrically circumscribed lightening-up of sections of the lower field—as if an undefined source of luminosity shone upon moving waters, or upon a stream veiled by a haze of fog.

Considered by themselves, these sheets from *Elbe* seem primarily to offer an exploration of the theme of the night sky over dark waters. The distinction between the tones of black and gray that one can observe on single pages could be read as an intrapictorial reintroduction of the serial differences in tones that characterize the entire sequence of leaves; or they might be elaborating on the uneven heterogeneity of monochrome fields which is typical of the linotype process. However, if one connects *Elbe* to works like *Seestück* (*See—See*), or *Eis*, it becomes clear that in this very early work may lie the beginnings of a wide-reaching strategy of segmentation and (re)combination from which Richter generates assemblages of images. Considered as elements within this trajectory, the horizontal difference of darkness describing a view of river and sky at night; the interstice between two repainted photographs from which emerges a seascape; and the horizontal bisection of the photographs of the Arctic Ocean in *Eis* and their elaboration into a layout of reduplicating and mirroring text/image arrangements on the book's pages, all form part of one artistic strategy: a procedure that now even more clearly deserves to be called, in Buchloh's terms, a strategy "of the hiatus."[44] In the present context, this method can be described as a technique of coordinating image segments into combinations that include and articulate the very segmentation between their constituents. The difference between the two (repainted) photographs that form *Seestück* (*See—See*), the intervals

7.27 Gerhard Richter, *Elbe 5*, 1957/2009, reprint of 1957 monotype, 29.5 × 21 cm, in artist's publication 2009. © Gerhard Richter 2017.

7.28 Gerhard Richter, *Elbe 18*, 1957/2009, reprint of 1957 monotype, 29.5 × 21 cm, in artist's publication 2009. © Gerhard Richter 2017.

between images and text sections in *Eis*, and the horizon lines between river or ocean and sky (*Elbe*, *Eis*) are all activated as constitutive moments of segmentation within an overarching project of producing image combinations. What is crucial here, and also quite astonishing, is the fact that a purely intrapictorial, thematic element, or a threshold in the gradation of darkness, can perform the same function as the combination of two completely distinct images (two photos in *Seestück*, but also the difference between these original photo(s) and the paintings that were executed "after" them), or a stream of individual images interwoven with segments of text, spread over the pages of a book. Hence the segmentation lines along which Richter builds his image combinations pass all the way through theme, quantity of light, sign type (image/text), to medial support. In fact, all of these seem to function as categories within the encompassing activity of joining and differentiating images, of dividing and (re)assembling the pictorial.

In this sense, Richter's works operate in a similar way to Friedrich's images. Friedrich's (bi-)sectional treatment of the picture in *Mönch am Meer* (*Monk by the Sea*) is part of a formal economy that produces an image which depicts the undepictable (here: infinity) through integrating the structure of a determinate judgment (*ein bestimmtes Urteil*), that is, a moment of discernment, into its composition (see chapter 6 above). Another potential parallel to Friedrich's work opens up at this point—and another perspective onto Richter's division of images: Discussing Richter's *Doppelgrau* (*Double Gray*) (2014)—two adjacent lacquered fields of slightly varying gray tones under glass—in relation to the legacy of Barnett Newman's work, Buchloh situates "Richter's new strategies of rupturing the pictorial field" in a "formal trajectory" and in their "historical specificity." The "spatial and material hiatus in Newman's painterly surfaces (what he somewhat disrespectfully called 'the zip') appears in Richter's *Double Gray* now as an actual material discontinuity, i.e., as the rupture of the pigment's surface and cohesion by the insertion of a linear, vertical negative space resulting from the division of supporting panels."[45]

Although the (art-)historical vantage point here is a different, more recent one—Newman and abstract expressionism, not Friedrich and German romanticism—the central question is absolutely pertinent: "whether any of the once heroically celebrated strategies of critical negativity are actually still accessible to pictorial or sculptural means or whether they have already been decisively lost or can only operate in and according to fundamentally different media strategies."[46] With regard to Newman's work, this is the "question of whether the sublime as an integrally necessary condition of aesthetic experience could still be upheld."[47] And it is here that Richter's "strategies of the hiatus" matter.[48] In connection with the history of (modernist) painting, Buchloh argues, Richter operates a shift from "the actual intervention on the pictorial surface … that demarcates the hiatus of gestural or monochrome expansion and cohesion" to "an actual spatial rupture …, an opposition between the muted picture plane and the barred architectural support surface."[49] If this amounts to a (painterly) negation of the possibility of negation, the disjunctive image operations we encounter in *Eis* might be described as an alternate route to and from (Friedrich's) sublime: a constellational probing, a disjunctive approximation that paradoxically also involves a distancing.[50]

In *Mönch am Meer* the technique of disjunctive assemblage also produced a distancing effect—a distancing to which Friedrich subjected the very image of the sublime in *Das Eismeer*, which he achieved through using the concrete picture, as embodied in his canvas, for conjuring up and at the same time blocking, cutting off, earlier instantiations of that pictorial and aesthetic topos. Richter's works *Eis* and *Dezember* produce a similar result, but in relation to temporality. They generate virtual images of time, without actualizing them. Both artists' operations are inseparable from a moment of distancing, and both produce this distancing through a technique of disjunctive assemblage. *Das Eismeer* affords the viewer a distant image of the sublime; *Dezember* or *Eis* presents the viewer/reader with a distant image of time in that she or he is experientially disengaged from the passage of time or the passage through space, hence varying

a principle that Stefan Germer once described in relation to Richter's renegotiation of the conditions of possibility of history painting in his cycle *18. Oktober 1977*, in which form is the result of a "painterly *distancing* from the photographically recorded."[51] The associations of a stalling of flux into the stillness of an arrested image are in part due to the semantics of Arctic imagery; but they are no less related to the form of disengagement with which Richter and Friedrich liberate the viewer from her or his entanglements with the image, so that she or he is given the time and space to contemplate, ponder, weigh—and judge, or distinguish while seeing. And perhaps this is what Gerhard Richter recognized in Friedrich's work when he—as Alexander Kluge writes in his story "Die gescheiterte Hoffnung"—saw *Das Eismeer* at the Hamburg Kunsthalle. Or what Kluge saw when he fictionally juxtaposed Richter and Friedrich in his own constellational assemblage.

KLUGE, ROMANTIC COMMENTARY, AND THE BERLIN SCHOOL: TOWARD A (TEMPORALLY) EXTENDED NOTION OF MONTAGE

Both Richter's and Friedrich's image poetics also correspond to Kluge's strategies for producing what he calls "still" images which allow the viewer and reader to exercise their faculty of distinction.[52] In Kluge's work, stalling—and stilling—the image offers more space for contemplation. This contemplative mode is critical in the ancient Greek sense of the term, when *krinein* meant drawing distinctions, or "to distinguish," in the sense of enabling the subject to exercise discernment. Kluge's story "Die gescheiterte Hoffnung," in turn, generates a context (*Zusammenhang*) in and through which his method is concretely constelled with Friedrich's and Richter's. That is to say: the comparison between Richter's, Friedrich's, and Kluge's methods developed in this chapter is more than an extraneous exercise of pulling together similar, but ultimately disconnected, techniques of producing still images. Rather, this comparison unfolds the rich constellational content embedded in Kluge's story.

What this constellation, and the resultant comparison, suggest is, not least, that the characteristic stilling of the image and the production of distance, as an activity that allows for the exercising of discernment, can be generated across the respective media in which they take place, and that the prime connecting element between all of them could be described as a general technique of montage, in the sense of an artistic, literary, and theoretical practice that relies on cutting and combining elements of the most varying nature.

There are further examples in Kluge's work—especially his collaborations—in which a comparable effect is achieved. German director Tom Tykwer's contribution to Kluge's DVD project *Nachrichten aus der ideologischen Antike* (*News from Ideological Antiquity*) represents one such case. As analyzed above (see chapter 4), in his short film *Der Mensch im Ding* (*The Human in the Thing*) Tykwer transforms what used to be a moving image into a space to be investigated. This space is also the realm for an analysis of the (image of) objects—here: products, and the investigation of their history of production—supplied by Tykwer's voice-over commentary. Stalling the image, investigating it, and combining it with the discrete element of the non-diegetically anchored audio recording of his commentary are the elements of this disjunctive assemblage that are designed to enable discernment.

A related trope in Kluge's work is the filming of still images (see chapters 4, 6, and 10), often accompanied by his voice-over commentaries. In *Früchte des Vertrauens* (*Fruits of Trust*), Kluge's second DVD project, two further German directors of Tykwer's generation pay homage to this practice. In their twenty-minute film *Rekonstruktion eines Polizeiverhörs in der Dauer einer Zigarettenlänge* (*Reconstruction of a Police Interrogation Lasting as Long as it Takes to Smoke a Cigarette*) Christoph Hochhäusler and Christian Petzold analyze a scene from Dominik Graf's television movie *Er sollte tot* (*He Should Dead* [*sic*]), which aired as part of *Polizeiruf 110* (*Police Call 110*), a popular crime series broadcast on Sunday evenings on the public television network ARD.

Hochhäusler and Petzold's camera simply shows the surface of a desk, upon which we see a stack of photographs. Each picture is a still from one scene in Graf's film, and at intervals a hand reaches into the camera's field of vision, lifts one of the photographs, and puts it aside, a little further up on the surface, hence gradually building a second stack (figures 7.29–7.32). Focusing on the picture on the top of the first stack, Hochhäusler and Petzold discuss the action of Graf's film, but also the psychological disposition of the characters, their interactions, as well as the information, and possible further plot developments and dialogue, that the viewer can deduce from each of these individual, halted frames. The sequence gradually adds up to a shot-by-shot analysis of a single scene. Film scholar Eric Rentschler has argued that the new independent German cinema that emerged in the 1990s after the fall of the Wall has learned its lessons from Neuer Deutscher Film (New German Film), and especially from the Oberhausen Manifesto, which Kluge drafted.[53] According to Rentschler, this so-called Berlin School of film, with Tykwer, Hochhäusler, and Petzold as three of its main protagonists, derives from 1970s Oberhausen countercinema "an aesthetics of reduction and restraint" along with "a penchant for image-focused rather than plot-driven constructions."[54] This account could just as well serve as an assessment of Tykwer's, Hochhäusler's, and Petzold's contributions to Kluge's DVD projects, especially if they are considered in conjunction with Kluge's own contributions. One would merely need to add Kluge's statement that for him, simplicity and sobriety—or, in Rentschler's terms, reduction and restraint—are not mere categories of style.[55] Rather, they function as the guiding principles of an ethics of production. In these types of filmic work, but also in Richter's and Friedrich's art, images are not defined as sites where sensory information blossoms into opulence. Rather, these images offer a wealth put on hold, a richness in reserve. In all of these historically and aesthetically vastly differing bodies of work, the road toward the image leads not through amplification, but through reduction. The image emerges when narrative and temporalization have

7.29–7.32 Christoph Hochhäusler and Christian Petzold, *Rekonstruktion eines Polizei-verhörs in der Dauer einer Zigarettanlänge/Reconstruction of a Police Interrogation Lasting as Long as it Takes to Smoke a Cigarette*, from Alexander Kluge, *Früchte des Vertrauens/Fruits of Trust*, 2009, DVD, color and b/w, 658 min). Christoph Hochhäusler / Christian Petzold / Alexander Kluge / Filmedition Suhrkamp.

all been stripped away, when development has been suspended, so that critical contemplation and distant wonder can be given free rein.

Kluge has compared Hochhäusler and Petzold's image-by-image analysis of Graf's *Polizeiruf* to the practice of art criticism in the German romantic tradition. What the two contemporary German directors are doing, he says, is "Schlegel at its best."[56] The Schlegel brothers propagated a theory and practice of criticism that rested on the assumption that the artwork comes into being only through the commentary of the critic who applies her or his faculty of discernment to it.[57] Hochhäusler and Petzold exercise a similar method, Kluge argues, and their critical commentary brings the images in Graf's film into being, while already contributing to the discerning analysis of the film. This is also the case, albeit adopting a slightly mocking tone, for the visitors in the 1810 Berlin exhibition who parade in front of Friedrich's *Mönch am Meer*, as imagined by Brentano and Arnim, and for the two visitors to the Hamburg Kunsthalle in Kluge's story "Der Untergang der Hoffnung" who exchange thoughts about Friedrich's *Das Eismeer* (see chapter 6 above); also for Arnim's, Brentano's, and Kleist's commentary on Friedrich's work. One could extend the analogy to the audio recordings in which Kluge's voice-over comments on still images in his films and clips. And this principle also sits at the heart of his practice of paraphrasing images and works across time.

In itself, this analogy between Klugean methods and the romantic concept of art criticism may be more of a paraphrase—i.e., a condensing and differentiating rendering of this concept—than a philological reconstruction: more of a constellation than the attempt to merely illustrate the Schlegels' theories. But it certainly helps Kluge's viewers and readers to conceptualize more clearly a central tenet of his work: that this work proposes a mode of production that aims at criticality, in that it integrates elements of discernment into its very own activity. And to generate images that are at once concrete and removed, rich and distant.

From early on in his career, Kluge has provided a definition of the method by which these distant types of images are generated; this is, of

course, the theory and practice of montage as an exercise of discernment. If we look at Friedrich, Richter, and the Berlin School directors—that is to say, when we study the image context (the *Zusammenhang*) established by the story "Die gescheiterte Hoffnung"—one of Kluge's more enigmatic statements on cinema and montage begins to become more accessible. In the brief *avant-propos* to *Geschichten vom Kino* (*Cinema Stories*), Kluge claimed that "das Prinzip Kino" is "älter als die Filmkunst [the principle of the cinema is older than the art of film]."[58] In a certain way, all the individual cases discussed here, along with their context-generating arrangement by Kluge, function very much as Kluge describes the working of his montage principle. Yet none of them belongs within the proper framework of film. They either predate it, or appear in non-cinematic media (the book, the journal, photography, digital video). That is to say: Kluge has established a suite of images and their variations which suggests that the combinatory production of "still" images predates and outlasts the age of classical film. Rather than being inherently tied to the cinematic *dispositif*, montage traverses it. In other words, what used to be called montage in the age of (analog) cinema—including filmic, but also literary and other artistic practices—has been released from its strict containment within the institutions, apparatuses, technologies, and styles of film, because it had a previous history, and has already entered its post-cinematic future, our present. The epoch of its medial territorialization may have been nothing but an interval. At least through the lens of Kluge's work, it seems difficult to maintain the hegemony of media technologies over the definition of montage.

At the risk of extending this expanded notion of montage to a state of near-unrecognizability, one would need to add that in Kluge's sense, even the practice of romantic commentary—or the practice of paraphrase—serves a comparable end, in that it transposes the principle of combination to the realm of work and commentary, in order to produce an effect of distancing distinction, of stilling the image. The Schlegels' practice of critique, the Berlin School directors adding their own spoken

commentaries to arrested image material, or Kluge adding his own voice to his filmic images, are all montage-related activities for Kluge.

Furthermore, Kluge's "paraphrasing," or commenting method, suggests that at least in his case, this distinguishing and reconstellating activity is inherent to, and perhaps even identical with, the act of production. Montage creates a context in which such side-by-side operations in diverse media and forms can take place. Creation and production are constellational in that they generate a connection between separate entities—images, texts, media, speakers, and the intervals between them.

In some ways this expanded notion of montage seems to resonate with a general theory of assemblage that has recently been put forward in the fields of the arts, social theory, and epistemology.[59] Kluge's (re-)constelled notion of montage is in line with these approaches insofar as both operate on the assumption that the activity of montage, the implementation of constitutive intervals, and the creation of contexts are coeval. None of them precedes the others. The classical montage approach would have positioned the destructive and constructive powers of montage *against* a preceding moment of (false) ontological stability. Montage used to be directed against "likeness," the mere duplication of the status quo through the shot, or a deceptively intact surface appearance. Hence its double coding as an anti-organicist mode of construction, and an aesthetics of rupture. Reconstelled montage, or montage *as* constellation or generative commentary, does not break up any preceding integral units. Instead, it generates by way of disjunct assemblage. Kluge diverges from these other approaches in that his work maintains the principle of critique.[60] He insists that, executed in the right manner, montage as constellation constitutes a practice that implements critical operations through the disjunctive arrangement of images and texts, in that it refocuses its constituents in a suspensive stillness, by placing them at a remove in which they can become the sites for exercising discernment.

TIME, DURATION, AND EXTENSION

Many Media Histories (Perspective of Time)

Intertitles, Masks, and Color: Chronopolitics of the Formed Filmic Image

Intertitles, reminiscent of the lettered panels familiar from cinema's silent era, are among the most recognizable formal features of Kluge's work in television and in film. These text fields figure in his earliest works, like *Abschied von Gestern* (*Yesterday Girl*) and *Artisten in der Zirkuskuppel—ratlos* (*Artists under the Big Top: Perplexed*), where they appear in those films' black-and-white palette. In the 1970s and early 1980s, when Kluge changes to colored stock, the ground for these intertitles is predominantly a warm blue, with white letters. Their content includes production credits, which are often presented in a manner that runs contrary to the conventions of cinema, as is the case, for example, in *Deutschland im Herbst* (*Germany in Autumn*), which begins with a panel that introduces the names of all participants with the words "Es wirkten mit: … [The following contributed: …]." Kluge's lettered panels also display the name of his production firm, *Kairos Film*, usually at the end. Throughout the film, and frequently in identical colors and fonts, they also serve as structuring instances. As such, they present section titles, thereby dividing

the film into chapters, like "Das Kraftwerk der Gefühle" (The Powerplant of Feelings), "Totensonntag" (Sunday of the Dead), or "Abbau eines Verbrechens durch Kooperation" (Dismantling of a Crime through Cooperation), which usually function as autonomous units.[1] Kluge also sometimes uses text fields to present quotations, like Karl Kraus's dictum "Je näher man ein Wort anschaut, desto ferner blickt es zurück [The closer one looks at a word, the greater the distance from which it looks back]," excerpts from Plato's *Apology* (in *Lehrer im Wandel* [*Teachers in a Time of Change*]), or his own gnomic comments, such as in *Deutschland im Herbst*: "An einem bestimmten Punkt der Grausamkeit angekommen, ist es schon gleich, wer sie begangen hat: sie soll nur aufhören [Once we reach a certain point of violence, it doesn't matter by whom it was committed: it just must stop]." Or, in *Der Angriff der Gegenwart* (*The Assault of the Present*), intertitles which spell out extracts from the libretto of Puccini's *Tosca* are inserted into a segment that documents a dress rehearsal for that opera in Frankfurt. A coherently designed stream of text thus weaves through the image track of a Klugean film. Although it is composed of varying textual genres (production credits, literary quotes, etc.), the variety in content is matched by a uniformity of appearance. If it were presented on a printed page, this visual homogeneity would hardly be noticed because there it is, in fact, a standard rule. In a book or magazine, most letters are designed to look alike. If they are transposed onto the cinema screen, however, the viewer/reader notices not only the presence of such letters in a medial environment where they do not normally appear; to her or him they also stand out for their visual homogeneity. On the screen Kluge thus both preserves the comparatively uniform look of the page, and transforms it into a visually noticeable quality.

As Kluge moves into the realm of television, the structuring function of the text fields changes. Here their function is often to punctuate contributions which extract "headings" and tangential summaries from the ongoing dialogic stream between Kluge and his respective interlocutors. It is also here, as well as in Kluge's work in digital media, that the quasi-literary

usages of the text field become more pronounced. The panels now display longer excerpts from texts like Eisenstein's notes for his planned film of Marx's *Das Kapital*, which are presented *en suite* over a number of fields. Occasionally, Kluge even inserts one of his own short literary stories in its entirety into the image sequence, thereby forcing his audience to switch from a perceptual mode of "viewing" into one of reading. In these cases he also manipulates the process of deciphering the letters by imposing a slow tempo on the succession of these text fields. Panels—which may only show several phrases—are kept up longer than necessary for the reader merely to process their meaning. As one's gaze lingers on them, the immutable screen forces the reader/viewer into a type of reception in which looking at a word and reading it begin to alternate.

One effect of this pronounced presence of the written word on the screen is that Kluge's films trigger associations with the aesthetics of silent cinema, which they could even be said to emulate. In fact, Kluge has repeatedly declared that this period in cinematic history is of special significance for his own project.[2] The lettering panels thus establish a historical relay that connects Kluge's work to the cinematic poetics and aesthetics of a period in which the possibility for simultaneously recording sound and image did not exist. Perhaps one could call these text fields deliberate anachronisms which, however, could not be further removed from nostalgically celebrating the appeal and appearance of the glory days of early film. While they turn anachronism into a form, they do not function anachronistically.[3] Rather, in their function as relays to the era of silent cinema, they establish a connection with that era while also articulating a distance from it. Through mimetically restaging the look of early cinema, they create an approximation to it, while also marking a difference. This is partly due to the divergent medial conditions under which Kluge sets words onto the screen, as compared to the technological and historical circumstances of the 1910s and 1920s. In the early years of film, in the absence of an audio track that bound visual to aural recording, intertitles often served as "bridges" between segments of acted scenes.

Where the image could not be brought to bear on the requirements of the plot, the letters on the screen—at least partly—fulfilled a quasi-literary function by simulating a narrative "voice." In contrast, employed by Kluge after decades of combined sound/visual recording, this operation now foregrounds the very *silence* of the resulting image.[4] Indeed, one of the most prominent aspects of watching text on the Klugean screen appear and disappear is the muteness conveyed by these letters, a quality which is reinforced through Kluge's otherwise rather frequent use of offscreen commentary to accompany montage sequences of filmed illustrations, paintings, and other static image material. This is not true in the case of the lettering panels, which Kluge never reads out loud. Here, the effect is almost reversed. The presence of letters on the screen marks the conspicuous absence of the director's otherwise prominently audible voice, turning the text on the screen into visual signposts whose visibility carves out a moment of pronounced silence, where the image is divested of its aural dimension.

Kluge's imitation of the visual codes of silent film, then, serves precisely *not* to restore its aural and visual effects. These letters never "bridge" two otherwise unconnected, or unintelligibly interconnected, segments of supposedly "narrative" stretches on the image track. Nor do they elicit a hallucinatory, simulated "voice" that would serve as an agent of "storytelling" through images. Instead, the letter image in Kluge's work imitates and rearticulates one of the general media conditions of early filmic imagery—its technological silence—and it does so today, a century later. And, reciprocally, this "muting" also affects the perception of the letters, which have now been stripped of their phono-representational function. They have been isolated, and now stand on the screen, in complete stillness, since their phantasmatic aurality has been silenced. Through Kluge's text panels, today's audiences are put in a position where they "see" early cinema's silence—a position that would have gone unnoticed at the time. Kluge's strategy here thus aims at creating moments in which the general (medial) conditions of archaic film are conjured.

A similar effect is achieved through Kluge's frequent use of "masks" which black out large segments of the image, showing views sometimes through a single oculus, sometimes through a binocular cut-out onto a zone that appears to lie "behind" them.[5] These takes frequently show historical footage, anonymous illustrations, or occasionally eyes, in pairs or single, peeking toward the camera. In a few cases Kluge also captures entire faces and other body parts in this mode. As in the case of intertitles, this intervention produces a stylistic *rapprochement* with the epoch of nascent cinema, in which lozenge-shaped or round black masks were frequently used to either open or close a filmic sequence (before the invention of the dissolve). This historical approximation is also signaled by the resemblance between such "masked" images and what could be described as a telescopic formatting of vision. The single central binocular cut-out on an otherwise black screen simulates the view through a telescope—a view which, in Kluge's films, frequently displays historic filmic material. Another formal reference point is the peephole structure of proto-cinematic devices such as the nickelodeon, through which the medium's early viewers were provided with restricted views at the first films.[6] One particularly marked example of such a reference occurs in one of Kluge's short films from the 1960s, *Feuerlöscher e.a. Winterstein* (*Volunteer Firefighter Winterstein*), in which the camera captures a single eye, peeping directly toward it through a hole, wandering slightly from side to side, while the rest of the visual field is steeped in black (figures 8.1–8.6).

Whereas the loose montage structure of that film also allows for potentially classifying this image as the representation of some anonymous Peeping Tom, the general gist of Kluge's historicotemporal recourse to the early days of cinema makes it clear that here he is also establishing the fiction of filming from within the otherwise shut-off projection box of the nickelodeon, outward through the peephole, while some anonymous cinemagoer is watching a show.

Like the intertitles, the image of spatially confined vision, then, triggers a temporal reach toward the technological and historical beginnings

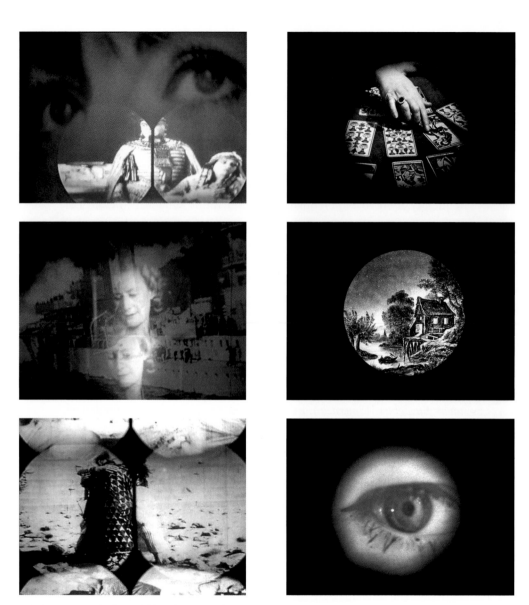

8.1–8.5 *Die Macht der Gefühle/The Power of Feelings* (1983, 35 mm, color and b/w, 113 min). Alexander Kluge / Kairos Film.

8.6 *Feuerlöscher e.a. Winterstein/Volunteer Firefighter Winterstein* (1968, 35 mm, b/w, 11 min). Alexander Kluge / Kairos Film.

of the filmic medium. Through alluding to the masks of silent film, the box of the nickelodeon projection apparatus, and also—not least—to the spatial container that is the camera itself, the partial obfuscation of the screen opens trajectories in time that connect Kluge's present with the archaic strata of the medium in which he works. And yet, through this formally marked type of telescoping, Kluge's films and TV features also insist that no approximation, including his own operations within the history of moving pictures, bridges the distance that separates point of view and the object to be (visually) approached. Instead, the images of early cinema are set into a temporal perspective that shows them as past. As if presented through the perspective of time, they are displayed through the lens of their pastness.

The third formal device that instigates this temporal politics of the filmic image results from Kluge's specific use of color filters. The historic cinematic material, as well as refilmed still images such as children's drawings, newspaper illustrations, prints, etc., that appear as elements of his montages are frequently marked by a peculiar method of additional color treatment. Soft spots and slight hazes of red, blue, yellow, or purple are placed over this historical imagery, glazing it with diagonal fields, while chromatic halos hover over other segments of the image. Kluge also occasionally provides his own takes with added chromatic shades, his protagonists moving through zones of deep red, or dark shades of purple. Through this practice certain individual images, although they already exist in color (i.e., not black and white), stand out as specifically colorful. While other pictures merely display chromatic tones, in these images color begins to *signify*.

With this decision to amplify and reinforce the image's autonomous palette, Kluge still realizes his media-historical politics of the image. For the colored image—again—begins to resemble the visual appearance of early cinema, in which entire segments of films were frequently suffused with color through tinting, i.e., dyeing of the negative. Yet Kluge's color strategy is not a mere gesture of historical reference, nor do the nonrepresentational shades of his palette simply restore an autonomous visual

quality to the filmic image.[7] The color of the Klugean image results from a procedure that is different from the historical techniques of tinting. It is the product of a simple yet ingenious do-it-yourself technique invented by Kluge and his team, who refilmed historic footage at the editing table with color foils attached either to the camera or to the monitor (see chapter 4 above). This technique, which is a result of a bricolage approach to manipulating the apparatus of visual recording, creates a strange chromatic form that conjures up the appearance of early film, but is not identical with it. Color is restored to the image by shooting through foils and filters, re-creating the hazes over the historic material. In conjunction with this technique of color filtering, and with an understanding of color *as* a diaphanous filter, the image begins to imitate the appearance of early silent film. At the same time, Kluge's goal is not to achieve a perfect historical simulation. The hues and tints are too infrequent, too incomplete, to generate a simulacrum of silent cinema. Instead, they function as visual estrangement, a highlighted filtering effect that signifies the temporal and medial distance of the historical image stock as much as it mimics its original appearance. The color filter thus performs the function of a mimetic or representational veil, which approximates the imagery of the past as much as it restores its temporal distance. Just like the fine, subtly mismatched hazes of color with which Kluge "tints" historical imagery, be it fictional or documentary, there is a veil of mediation in his films and features: a veil which brings the object (in this case, historical film) closer, while at the same time locating it at an infinitely remote, because constitutively removed, place.

In/Visibility of the Letter: Kinship with Writing and the Disappearance into the Media Environment

Kluge's work thus positions itself as the emitting and receiving point for a plumbing of the temporal distance that both separates and connects his own production to the period of early cinema. This distant

approximation is situated on the level of content (as a "treatment" of early cinema), and on the level of form (as a restaging and reappropriation of its technological devices and formal characteristics). While the lettering panels play a central role in this diachronic positioning, this is not their only function. They are also operative within the synchronous economy of text and image. One particularly intriguing example for such a use of text fields is a brief sequence from *Die Patriotin* (*The Patriot*) in which Kluge first simply presents a panel with the already mentioned quote from Karl Kraus, "Je näher man ein Wort anschaut, desto ferner sieht es zurück [The closer one looks at a word, the greater the distance from which it looks back]."[8] The image, which remains onscreen for only a couple of seconds, generates an intricate play of references, functioning like the visual equivalent of a pun that engages not only with Kraus's sentence, but also with its subtext. By association, the Krausian aphorism elicits Benjamin's definition of the auratic phenomenon, for which it served as a template. Benjamin defined the aura as the "Erfahrung einer Ferne, so nah sie auch sein mag [apparition of a distance, however near it may be]" and as a state in which things return the gaze.[9] Kluge literalizes this conceptualization when he presents Kraus's words on a cinema screen, i.e., lifted from their original context: the printed page. The text is therefore presented as something that is to be "viewed" much more than "read."[10] In the process of deciphering, the reading eye necessarily needs to cancel the material appearance of the letter in order to comprehend the word. One cannot both read and look at a word's letters at the same time. Yet the cinema screen relies on the visual appearance of the image (and here of the letters-cum-image). In this specific realization of the word-image, Kluge thus also strategically bears out Adorno's dictum—originally formulated with Kluge's work in mind—that montage "arranges things in a constellation akin to that of writing."[11] In the same text—"Filmtransparente" (Transparencies on Film)—Adorno described writing (*Schrift*) as "moving before our eyes while fixed [*ein Stillgestelltes*] in its discrete [*einzelnen*] signs." That is to say: writing is described as

analogous to film, and letters or words as analogs to fixed frames. He also declared that film realized its potential as art only if it achieved an "objectifying re-creation [*Wiederherstellung*] of this type of experience," i.e., an objectification of reading.[12] Kluge responds to this by literally putting the letters on the screen. He also turns it around, because for Adorno, the objectifying character of film consists in capturing the things of the world (film renders them decipherable through montage). But Kluge does not show "things" here, he shows words (intertitles), and these are entities which, although they are read, are not seen.

Kluge has said that he sees a categorical difference between the status of this onscreen lettering and the status of letters on the printed page.[13] He has developed two different strategies that respond to this particular visibility of onscreen writing. Each corresponds to a different stage in the recent history of technology: one to film; the other to electronic images (television, digital media). In the vast majority of his analog films, produced from the early 1960s to the mid-1980s, he chose the unadorned sans serif Akzidenz Grotesk as the single font for the lettering panels (figures 8.7–8.10).[14]

As soon as Kluge switched to electronic images, and especially to digital media, this restrained presentation was replaced by a plethora of forms, colors, and graphic arrangements. In contrast to his earlier regime of neutrality, the letters begin to vary in size and shape, sometimes even within a single panel. They are rotated diagonally, or stretched into curves, and on several occasions their design even begins to mimic, or set a counterpoint to, their textual content. For example, short literary anecdotes about the character of light are set in letters that seem to be illuminated: sometimes even taking on the character of flames, sometimes surrounded by graphic representations of emanating rays (figures 8.11–8.14). In other cases, a particularly gruesome story—for example, a narrative about a Wehrmacht soldier who suffers a brain injury and is considered "unworthy of life" by his compatriots, and executed—is presented in a particularly colorful and cheery typeface.

8.7 *Die Macht der Gefühle*. Alexander Kluge / Kairos Film.

8.8 *Die Patriotin / The Patriot* (1979, 35 mm, color and b/w, 121 min). Alexander Kluge / Kairos Film.

8.9 *Abschied von gestern / Yesterday Girl* (1966, 35 mm, b/w, 88 min). Alexander Kluge / Kairos Film.

8.10 *Nachrichten von den Staufern I und II / News from the Staufers* (1977, 35 mm, b/w, part I: 13 min, part II: 11 min). Alexander Kluge / Kairos Film.

8.11–8.14 *Früchten des Vertrauens/Fruits of Trust* (2009, DVD, color and b/w, 65 min). Alexander Kluge / Filmedition Suhrkamp.

The reduction of the letters' appearance to stark sobriety, and its explosion into a wildly incongruous panorama, correspond to the two different medial milieus in which they appear. The enclosed spatial *dispositif* of the cinema, its wide screen, and its bundling of light into the confines of the projection area are matched with a late-modernist reduction of the typeface. By contrast, the abundant, incongruous fonts respond to the conditions of television, where the screen is integrated into each viewer's different private dwelling, and where Kluge's television features coexist and appear within the usual hodgepodge of network programming. This visual diversity is intensified even further as soon as Kluge begins to work with digital media. Here the transmitted image may appear on screens of increasingly varying size, from a cell phone to a computer, and his clips now exist within the incalculable variety of appearances and visual phenomena to be found on the internet. Stripped down to neutral under the focused conditions of the cinema, and proliferating in appearances when dipped into the protean bath of television and the internet, the Klugean visual policy of lettering thus proceeds by adapting to the formal conditions of each medium. The focused design of the letter replicates the focusing of attention through filmic projection; its irregular diversification reiterates the formal heterogeneity of the medial environments of television and the internet.[15] Kluge uses a camouflage strategy by which the appearance of the text imitates the overall formal configuration of each medium. By replicating, even depicting, the conditions of its medium, the letter disappears into the structure of its milieu.

Literarization of the Screen

Film scholar Miriam Hansen has indicated an important historical reference point for Kluge's practice of onscreen lettering: the title projections of the Brechtian *V-Effekt* (alienation effect). Brecht developed his method of onstage titles and projections of slogans onto screens lowered

into the space of the stage in collaboration with his set designer, Caspar Neher.[16] Forming part of a more encompassing aesthetics of estrangement, these projections were instrumental in implementing a critique of representation on the stage.[17] Using a term coined by Benjamin, Hansen also calls this a *Literarisierung*, a making literary of otherwise unliterary art forms (theater, film).[18] Benjamin defined "literarization" as follows: "'Die Literarisierung bedeutet das Durchsetzen des 'Gestalteten' mit 'Formuliertem', gibt dem Theater die Möglichkeit, den Anschluß an andere Institute für geistige Tätigkeit herzustellen.' Zu Instituten, ja zuletzt zum Buche selbst. [Literarization amounts to interspersing the formed with the formulated. It allows theater to connect with other institutions of intellectual activity. With other institutions, and ultimately with the book itself.]"[19] In addition to engineering a historical connection with the period of early cinema, and negotiating a strategic adaptation to the formal features of the medial environment, the Klugean policy of onscreen lettering would hence also generate a relation between the image media of the screen and the letter-based print media of the page, such as the book. Film no longer "just" renders objects "readable" by turning the image through montage into an entity that can be deciphered "akin" to the way in which writing is read. Neither does it confine itself to altering and adjusting the look of the letter in response to the visual conditions of film and television. Rather, Kluge here also opens film directly to the realm of the printed book: for example, by incorporating quotes like the one from Kraus, and turning them into images.[20] It is important to note that this integration of the literary into the filmic does not amount to producing some sort of literal cinematic version of a book, in the sense in which, for example, a Merchant/Ivory production would attempt to "turn" a novel by Henry James "into" a film. Even those of Kluge's films that correspond closely to one of his literary works, like *Abschied von gestern* and the short story "Anita G.," never attempt such direct "translations."[21] The basic narrative outline for text and film may be the same, but Kluge's montage technique never creates more than a rudimentary

match between the plot structures of cinema and literary text, nor does it generate parallel structures by which, for example, the chapters of the story would find their equivalents in "chapters" of the film.

In the context of the quotation from Kraus, this operation of literarization is particularly salient, because the Benjaminian subtext includes the diagnosis that the book, in its displacement through the emergence of cinema, has entered a stage of auratic fading. Moreover, this quotation regarding the "greater the distance" from which a word "looks back" anticipates, in a punning manner, Kluge's later real engagement with the medium of *Fern-Sehen*, namely tele-vision, which in the original German literally describes the act of seeing or looking across a great distance (*Ferne*).[22] As if this complication were not enough, Kluge links Kraus back to one of the main themes of *Die Patriotin*: the negotiation of state power, German history, and the Reich. The subsequent image—after "The closer one looks at a word, the greater the distance from which it looks back"—allows its historical implications to implode into the contemporary concerns of Red Army Faction terrorist Germany by adding the additional word "Deutschland" (the latter distinguished from the preceding sentence by capital letters, italics, a serif typeface, and the absence of quotation marks) (figures 8.15–8.16).

What took place before this historicization and political actualization constitutes an important function of Kluge's intertitles: they are one element within his project of strategically determined media displacements whereby a film becomes the repository of a media relation that typifies another medium—the book, or the printed page—whose assumed historical dominance has supposedly been declining for almost a century: the period during which the printed book has become an auratic object.

8.15–8.16 *Die Patriotin*. Alexander Kluge / Kairos Film.

Perspective of Time: Can There Be a Klugean Media Historiography?

There is a further approach to analyzing the specific media relationality and media temporality laid out in Kluge's work, and it could start out from an illustration in his book *Der Angriff der Gegenwart auf die übrige Zeit. Abendfüllender Spielfilm, 35 mm, Farbe mit s/w-Teilen, Format: 1: 1,37. Drehbuch* (The Assault of the Present on the Rest of Time. Feature-Length Film, 35 mm, Color with b/w Segments, Format 1:1.37, Script). This slim volume accompanied the release of the film *Der Angriff der Gegenwart auf die übrige Zeit*, and on its last page Kluge reproduces Brunelleschi's prospectus for an ideal city, namely Florence. This schema for a mathematical—i.e., calculable—organization of spatial representation through Euclidean geometry depicts the first urban center of the European Renaissance, including a recognizable *campanile* in the Palazzo Vecchio (figure 8.17), which Kluge juxtaposes with the following comment: "Perspectives of Florence after Brunelleschi. The present film deals with the perspective of time. [*Im vorliegenden Film geht es um die Perspektive der Zeit.*]"[23]

Film, book, perspective—three foundational media of the Western representational system are alluded to in this text/image montage. A possible reading from the vantage point of media archaeology would point out the privileged historical link between two of these media systems: central perspective and the printed book. McLuhan argued in *The Gutenberg Galaxy* that both media ensembles effectuate a linearization of representation.[24] If film, as a medium based on recorded time, is usually situated after this age of the book and central perspective, it is only logical, if not tautological, for Kluge to declare that the "vorliegende Film [the present film]" deals with the perspective of time, because this is to a large extent what film does: its images are temporally perspectivized—an insight as old as film practice and theory. Béla Balázs, one of the pioneers of film theory, had already employed the term "Zeitperspektive"

Perspektiven von Florenz nach Brunelleschi. Im vorliegenden Film geht es um die Perspektive der *Zeit*.

8.17 Illustration from *Der Angriff der Gegenwart auf die übrige Zeit/ The Assault of the Present on the Rest of Time* (book version). Alexander Kluge.

(temporal perspective, or perspective of time) in his 1924 study *Der sicht-bare Mensch* (*Visible Man*), one of the founding documents of film aesthetics, to account for the cinematic medium's essentially temporalizing mode of presentation.[25]

In a certain way, *Der Angriff der Gegenwart auf die übrige Zeit* could therefore indeed be seen as a film about "film." Understood as an ensemble of technologies and modes of representation that unravel the book and central perspective as governing media, this film deals with the displacement of these older media: "der Film *Der Angriff der Gegenwart auf die übrige Zeit* (handelt) vom Kino [the film *The Assault of the Present on the Rest of Time* deals with cinema]."[26]

In fact, one of the most fertile readings of the Klugean project offered in recent years proceeds from a paradigm intrinsically related to writing genealogies of media and technology. In the context of his interpretation of Kluge's text *Schlachtbeschreibung* (*The Battle*), Burkhardt Wolf has suggested that Kluge's work displays certain parallels to Foucault's conceptualization of history, as developed in works such as *The Archaeology of Knowledge*, which also served as one of the epistemological points of departure for the project of media archaeology, whose proponents transposed the framework of discourse analysis to the field of the history of media technologies.

A text like *Schlachtbeschreibung*—with its motto "Stalingrad ist keine Nachricht [Stalingrad is not news]"—does not develop a compact account of the historical event "Stalingrad," i.e., the occupation of the city by the German Wehrmacht, its siege and subsequent total defeat by the Soviet Army. Rather, it splinters its representation into multiple layers of miniature occurrences, descriptions of administrative procedures and chains of command, decision processes, including errors of judgment and the charting of possible developments, as well as accounts of technological and industrial, even biological, processes. The asubjective, non-anthropocentric character of this type of representation, as well as the dissolution of the historical "point" or milestone "Stalingrad" into a network of

superimposed processes and exchanges, leads Wolf to recognize a parallel to a Foucauldian charting of the visible and the enunciable.[27] In this view, Kluge—not unlike Foucault—does not treat the historical event as a monument in the context of an all-encompassing historiographic panorama. Instead, he insists on its character as a structural break or discontinuity.[28] There is ample evidence in favor of this argument: a section in Kluge's *Chronik der Gefühle* (*Chronicle of Feelings*) that investigates the question "Gibt es eine Trennlinie zwischen den Zeitaltern? [Is there a dividing line between the ages?]"; a programmatic statement, phrased as a question, that seems strikingly close to a Foucauldian history of discontinuities. This emphasis on rupture, in combination with an analysis of the interplay of micro and macro temporalities far beyond and below the subject's historical perception—an approach that Foucault inherited from the École des Annales—might well be compared with the version of history that is constructed, for example, in the opening sequence of *Die Macht der Gefühle*: a sunrise over the city, World War I, the epoch of silent film, the medieval epos of the Nibelungs, the Viking mythos of Valhalla, nineteenth-century Germany with the Paulskirchen assembly (i.e., the failure of the 1848–1849 revolution) and the Wagnerian project, a 1981 anarchist murder, and the backdrop of the German autumn, i.e., the violent aftermath of 1968. One could even recognize a parallel between Foucault's method of discourse analysis, which traces different sets of *énoncés* that correspond to different historical moments, and what could be called a Klugean method of "staging discourse." Examples of the latter would include the registration of the various ways of speaking in front of Kluge's TV camera, but also—more specifically, and perhaps more overtly—the documentation of the expert's discourse, or the discourse *of* expertise, in segments of his films, and especially in the interview features.

However, there are also limits to this analogy, and they are perhaps nowhere more evident than when we set the paradigms of media archaeology—as developed, for example, by Friedrich Kittler and his

students—against the historicotemporal aspects that characterize media in Kluge's work.[29] One of the fundamental operations that allowed for the development of media-archaeological studies was the introduction of the question of media into the Foucauldian framework. Kittler went to the heart of the matter when he connected the filmic cut, understood technologically, to Foucault's historiography of discontinuities, thereby introducing the concept of the technological a priori. The principle of film, Kittler declares, is "cutting [vom Prinzip her Schnitt]," and he extends this definition to the realm of history. Film is

the chopping up of continuous motion, or history, before the lens [vor dem Sucher]. "Discourse," Foucault wrote, "is snatched from the law of development and established in a discontinuous atemporality: ... several eternities succeeding one another, a play of fixed images disappearing in turn, do not constitute either movement, time, or history." As if contemporary theories, such as discourse analysis, were defined by the technological apriori of its media.[30]

For Kittler, this analogy enabled a rewriting of discourse history as a history of consecutive media *dispositifs*, with each being understood as a specific technohistorical arrangement that establishes the framework for all possible articulations at a given point in time. While this is not entirely foreign to Kluge's project, their positions diverge on at least two points: first, the interpretation of the cut in relation to the category of history; second, the question of periods in (the history of) media.

Kluge's use of the cut differs from its media-archaeological conceptualization, where it figures primarily as the temporal rupture that initiates a history of discontinuities. In Kluge's work, it is the discontinuity between elements of montage that gives rise to temporal relations in the first place. Foucault saw the history of *dispositifs* as a series of historical ruptures between, for example, techniques of power, of governing, of

gathering knowledge, and of generating the conditions of possibility for what can be said. The key historiographical operation lay in emphasizing the discontinuity, not the continuity, between such subsequent historical regimes. Whereas Foucault's own practice certainly allows for a much greater degree of superimposition and perpetuation of discursive elements from one period to another than the usual account of "grand" historical ruptures suggests, the basic structure is one of a discontinuous series of historical periods—a stance that is adopted in the media-archaeological model. This perspective is ultimately incompatible with Kluge's work. To put it simply: in Kluge's work, there is no "age" of the book, for example, with a beginning and an end, because the structuring model of temporality is not one of subsequent "regimes" or periods. Or: for Kluge, discontinuity does not figure as historical rupture but, rather, is significant primarily for its involvement in the image trope which is montage. Series of images or textual elements are always arranged in such a way as to generate very far-reaching historical, even prehistorical, trajectories, but also very short-term temporal references. Points in time are connected through association: one event calls up another, varying developmental tempi are played out against each other. But the goal is never to make a synchronous cut that would "ground" the description of a given historical moment, or even the present. In other words: Kluge does not share the Saussurean legacy that enabled the structuralist project and Foucault's discourse history, and still makes media archaeology possible. (This non-affiliation also constitutes one crucial dividing factor between Kluge's work and, for example, the semiotic school of film theory and criticism (e.g., Christian Metz's *Film Language*, the *Cahiers du Cinéma*), but also of film-making (e.g., the play with film as a multilayered sign in Godard's *2 ou 3 choses que je sais d'elle* [*2 or 3 Things I Know about Her*]).[31] In a similar vein, Kluge has distanced himself from Eisenstein's linguistic ambitions, which he criticizes for merely "appointing" images to the status of a language.[32] *If* there is a Klugean version of advancing the film–language analogy, or of theorizing the filmic image

as a sign, it is not shaped by the analogy between cinematic signification and linguistic structures. Neither is it structured, like Eisenstein's theory and practice, around rhetorical models, or the comparison of montage to concept formation and poetic intensification.

Especially when it comes to the media–related aspects of his work, Kluge seems to systematically counter a (historical) "grounding" of a medium in its own conditions or the period of its historical dominance: television thus becomes "bookish" or "operatic"; film becomes "essayistic" and integrates literary components in their specificity (i.e., not by treating them as material for a film plot); and even literature appropriates aspects of the television interview feature, begins to produce "interview books," and delivers proper *Geschichten vom Kino* (*Cinema Stories*) (which Godard produced for TV). In this manner, Kluge's work constantly attacks the very concept of the media epoch, at least in its periodizing sense (this does not prevent him from authoring a *Chronik der Gefühle—Chronicle of Feelings*).[33]

This aperiodical or anepochal approach is the antichronological correlate to Kluge's appropriation and development of the Brechtian literarization of theater, understood, with Hansen and Benjamin, as an opening of the stage toward the book. Kluge systematizes this strategy in his work (TV becoming bookish and cinematic, film becoming literary, and the book becoming TV-esque and filmlike), and his predicament is that the supposed "critical" potential of such estrangement(s) does not reside in the properties of the targeted medium toward which the base medium is displaced. Estrangement, then, is not a critical strategy, because, for example, film or the book offer inherent qualities that would make them more suitable for critical articulation, and hence designate them as target media for the displacement of television in the interest of criticality. Rather—if it exists—critical potential here lies in the displacement, the shift, the alteration itself. How could such a practice, which is based on each medium becoming (an)other, stabilize a periodic categorization? If one were to look for a correlate in Foucault's work, the strongest

approximation would probably be the concept of a transversal, or vertical, displacement which was identified by Gilles Deleuze: "The history of forms, the archive, is doubled by a becoming of forces, a diagram."[34] With this formulation, Deleuze read Foucault as not just delivering a description of discontinuous historical stages of discourse (the archive of possible enunciations; or the *dispositif* of materializations of power). Foucault, Deleuze suggests, also addressed the transformative forces by which these discontinuous stages engender new stages. They are "inseparable from temporal vectors of derivation": "One must ... travel along the different levels ... instead of simply displaying phenomena or statements in their vertical or horizontal dimensions, one must form a transversal or mobile diagonal line."[35]

Yet this comparison too soon reaches its limits, at least if one follows Deleuze's interpretation of Foucauldian transversality as a realization of becoming. The difference between Foucault's diagonal trajectories and Kluge's development of one given medium into another is the difference between a type of becoming that is non-determined (Foucault as read by Deleuze) and one that is strategically determined (Kluge). Although the Klugean transformation of one medium into another is never perfect (if it were, it would lose its significance), the start and end points of this movement are always discernible: the book moves toward TV or film; film toward book and TV; TV toward film and book. That is to say, Kluge's media are never "deterritorialized" in a Deleuzian sense.

The second aspect that separates Kluge's project from a post-Foucauldian media history is that for Kluge, the medium does not have an a priori status—either in historical terms, or in terms of his own production. Or: in Kluge's work, questions of mediality are always second to the continuation of production. This is already evident in the fact that Kluge almost seamlessly declinates his themes and topics through all the media he works in. The case of *Der Angriff* in its twofold media articulation, as both a book and a film, is characteristic of his media politics in this respect. It must be regarded as a signature of his work that Kluge has

developed a method of artistic and theoretical production that allows him freely to treat a set of identical, or at least very closely related, topics in any of these different media environments without making clearly recognizable concessions to their specific conditions of production. For example: the city of Halberstadt, Kluge's hometown, and its almost complete destruction by the British Royal Air Force on April 8, 1945, one month before Nazi Germany's capitulation, figures first in one of Kluge's oldest and best-known literary texts, "Der Luftangriff auf Halberstadt" (The Air Raid on Halberstadt); it subsequently also appears as an unseen urban and political backdrop to the 1970 short film *Ein Arzt aus Halberstadt* (*A Doctor from Halberstadt*); and, through—perhaps documentary?— footage of a Royal Air Force squadron in attack, it is integrated into *Die Patriotin*. The prerequisite for this type of production, this transmediatic procedure, is closely related to a central aesthetic and political stance of Kluge's work: the commitment to minor forms (see chapter 9 below).[36]

CODA: CUT TO HISTORY: BEYOND PERIODS

Although one important function of the cut and montage in Kluge's texts and films is to create historical relations, or the temporality of history (see chapter 1 above), this relationality is not submitted to the paradigm of historiography, at least not in the sense in which it governs the archaeologies of discourse and media. Klugean montage is inherently linked to the negotiation of temporal relations by way of the image (and also text), just as Godard decreed when he stated that in montage the filmmaker holds "the present, the past, and the future" in her or his hands.[37] Kluge's negotiation of time also falls fully under the conditions mapped out by Deleuze in his description of the "time-image," from which, as he writes, montage "extracts ... the relations of time."[38] Deleuze's general account of the function of cutting and (re)combining under the auspices of the time-image—that here, "montage itself works and lives in time"—also accurately covers Kluge's specific program of

establishing temporal relationality by way of the cut.[39] A similar analogy could be constructed regarding the interrelation between montage and history, as a specific subset of temporality. Godard once found the following example for this interrelation: "when Cocteau says: if Rimbaud had lived on, he would have died the same year as Marshal Pétain," and, further: "So you see the portrait of the young Rimbaud, you see the portrait of Pétain in 1948, you put the two together, and there you have a story, you have 'history.'"[40] In its generality, this formulation—"tu as 'de' l'histoire," "there you have history" or "there is history"—also serves to describe the way in which this category emerges in Klugean montage. While certain images and text elements set specific reference points within the historical realm, they are never contained around those instances. Although Klugean works in texts, and images traverse historical moments, they also always serve to evoke historical temporality as such.

In this sense, Klugean (image) work is never limited to furnishing the "representation" of a concrete historical moment, a period, let alone an "event." Instead, history emerges as a dimension, almost as the quality of "historicity." Rather than attempting a description of a distinct historical moment or period—or a media epoch, for that matter—these data are starting points for further temporal probings, and for the opening of relations in time between the most divergent dimensions. "Der Luftangriff auf Halberstadt" focuses as much on that specific date in German history (and implicitly in Kluge's biography) as on relating it to a multitude of preceding moments in history (the impersonal narrative voice in that story famously speculates that, in order to prevent the catastrophe(s) of 1945, in which the children of the Halberstadt high-school teacher Gerda Baethe perished, it would have taken "since 1918, 70,000 determined teachers, all like her" who "would have had to teach hard for 20 years in each of the countries involved in the First World War").[41] The text also describes the events that led to the city's destruction as a superimposition and mismatch of processes of multiple temporal dimensions (e.g., the many individuals' survival strategies, referred to as "strategy

from below," and the temporal regimes structuring the deployment of the air squadron that would bomb the town to ashes—"Strategie von oben [strategy from above]").[42] In other words, although Kluge's story has a concrete date and the naming of an event in its title, these temporal and linguistic specifications stand in provocative contrast with the dispersion and heterogeneity of the temporal relations which they help to establish.

The other way in which Kluge's work articulates the dimension of history through images consists in presenting and combining these images in such a manner that their own historical weight begins to register. This he achieves in four distinct modes: first, through the incorporation of older visual material. This is the case, for example, in *Brutalität in Stein* (*Brutality in Stone*), which incorporates documentary footage from the 1936 National Socialist Party convention that took place on the very grounds which Kluge's and Schamoni's film documents about a quarter-century later. Second, through the visual rerecording of historical image material, static or moving. Illustrations, photographs, and paintings are all captured by Kluge's camera, and so is historical footage, overwhelmingly from the age of silent cinema, which Kluge does not integrate through copy and cut, but through a procedure of refilming. These segments of refilmed films, as well as the markedly still imagery sometimes caught in static takes, sometimes explored through minimal pans and tilts, mark the historical dimension as reimaged images (see above). The third mode consists in a recombination of historical imaging technologies with current equipment that could be described as a palimpsest of technohistorical layers. Kluge is especially fond of the Debrie camera, whose masks and lenses he combines with up-to-date electronic cameras. The resultant image, then, carries the traces of two technohistorical strata in its informational and formal structure. And there is, finally, the fourth mode of amplifying the historical dimension of the image which is achieved through a mimesis of the image's older modes of appearance, as is the case with the restaged colors of tinting (see above). Except for the last

technique, all modes are products of a procedure that could be regarded as an expanded notion of montage that extends far beyond the mere linear combination of time-based image material. (See chapter 4 above for an analysis of Kluge's constellational method.) Through all of these methods, Kluge articulates an implicit criticism of an understanding of images as merely transparent media for the "representation" of historical subject matter. Instead, his practice foregrounds the image's historical—and, by consequence, temporal—substance. History emerges, in turn, as the dimension in which images exist. The image and its recombinatory montage are, then, not just a medium for depicting history. Rather, in Kluge's work, history is marked out as the (temporal) medium of the image itself.

One of the preconditions for this "historicization" of the image is that it is freed from the boundaries of a narrative apparatus. In this sense, Kluge's entire project parallels the Godardian enterprise in *Histoire(s) du Cinéma*, as interpreted by Jacques Rancière, who saw in it a rectification of cinema's (self-)misunderstood "historicity."[43] Following Rancière, one of the central failures that Godard's montage politics in *Histoire(s)* seeks to correct is that "cinema misunderstood the power of its images, its inheritance from the pictorial tradition, which it agreed to subject to scripted 'stories,' heirs of the literary tradition of plot and character."[44] Certainly Kluge nowhere unleashes a flood of (art-)historical imagery that could rival the picture streams and superimpositions of Godard's video project. His work does not tap into the pictorial treasures that have accumulated over centuries of Western image history. Instead, he strategically isolates and autonomizes limited and often obscure sets of images. Through the procedures described above, these become the stock from which the image as a genuinely historical entity, and history as the temporal dimension of images, become discernible (figures 8.18–8.21).

8.18–8.21 *Nachrichten aus der ideologischen Antike/News from Ideological Antiquity*, transcript of Eisenstein's notes for a film of *Capital*. Alexander Kluge / Filmedition Suhrkamp.

Short Forms, Small Units

Brevity and Form

In *Ulmer Dramaturgien* (*Ulm Dramaturgies*, 1980), a collection of film-the-oretical writings and programmatic texts that emerged from the work of the film institute which he co-founded at the Ulm Hochschule für Gestaltung (School of Design), Kluge formulates a plea for brevity—or, more precisely: he sketches a general program that relies on short, minimal components as basic formal units: "Dramaturgy of brevity [*Drama-turgie der Kürze*]. How does one produce concentrates, … a shorthand suitable for montage, … so-called miniatures. It is possible to narrate entire films in this microstructural form of narrative."[1] This statement, further broken down to "shortness, suitability for montage, associability [*Kürze, Montierbarkeit, Assoziierbarkeit*]," relates immediately to the way in which Kluge structures his films, at least since the 1968 *Artisten in der Zirkuskuppel: ratlos* (*Artists under the Big Top: Perplexed*). Klugean cinema typically consists of a collection of miniature components, documentary and fictional; filmed "scenes," printed pages, and illustrations; appropriated found footage (from the realms of fiction and documentation); and textual elements. Kluge's literary texts and story collections

are produced in a similar way: one "text" consists of a collection of short elements; brief stories, but also textual documents (such as actual Wehrmacht orders in *Schlachtbeschreibung* [*The Battle*]); they also encompass found visual material such as photographs, illustrations, diagrams, maps, etc. These elements are then necessarily assembled in a linear order, given the medial conditions of the filmic image track and the textual mode of the book. Kluge's earlier feature films and stories still tend to impose a narrative order, although a supposed plotline never dominates an entire movie or book. (Exemplary cases are *Abschied von gestern* (*Yesterday Girl*), a film which, on the surface, "tells the story" of its main protagonist, Anita G., who is gradually slipping into petty delinquency; or "Der Luftangriff auf Halberstadt" (The Air Raid on Halberstadt)—a text that gives an account of the British air raid that demolished Kluge's hometown to the point of near-annihilation.) Over the course of his artistic development, Kluge abandons the paradigm of an organizational metanarrative, and the montage components become more prominent. They are thematically related but formally disjunct, and acquire the status of paratactically coexisting elements. The opening sequence of *Die Macht der Gefühle* (*The Power of Feelings*), for example, features all these various elements. After this introduction, the film stages a fictional courtroom drama; an episode about a woman caring for a foster child; a mini-narrative about another woman who is first left by her lover, then raped by another man; the story of the prostitute Knautsch-Betty, who is "bought for her own sake" by the procurer Schleich; the murder of Ante Allewisch, and the subsequent nursing of Allewisch back to life in a fairytale-like ending in which the constant labor of feelings ("care") actually triumphs over death. The film also includes a substantial amount of documentary footage shot at the Frankfurt opera during a production of Wagner's *Tannhäuser*, starring Anja Silja and directed by Michael Giehlen, in addition to passages devoted to quick-motion takes of the stage's lighting system; and others that chart the building's architecture.

In conversation with Heide Schlüpmann and Gertrud Koch, Kluge has called this "Miniaturtechnik … eine Nummerndramaturgie [technique of miniatures … a dramaturgy of vaudeville numbers]."[2] He thus provides a vivid description of the formal organization of his works as cinematic or textual revues by comparing their structure to those of stage musicals or the sequence of "acts" at the circus. This analogy echoes Bloch's description of Benjamin's *Einbahnstrasse* (*One-Way Street*) as a philosophical revue (*Revueform der Philosophie*). Kluge's comparison has two further implications. First, it ties the technique of miniatures to the period of archaic cinema, the age of attractions, when film figured as one entertainment feature among many other "acts" on fairgrounds.[3] Second, it implies that Kluge's 1968 film *Artisten in der Zirkuskuppel: ratlos*, with its central institutional analogy between circus and television, also articulates a meta-statement about his formal practice. (One of its central themes—the elephant—returns at several other points in his work; its source document is a relic from cinema's archaic age of attractions: Edwin S. Porter's single take of an elephant being electrocuted.)[4] The film's—still perceivable, but interrupted—plot—in which a circus director, played by Hannelore Hoger, attempts to found a "reformed" circus in the spirit of the critique of ideology, fails, and then joins a television station with the same intention (and outcome)—can be read as an allegory for Kluge's own tendency to approach medial concerns by way of vaudeville "numbers." For the primacy of the short form, or the small unit, also prevails beyond the level of a cinematic or literary poetics in the Klugean conception of the medium. This is most obvious in his books, whose organizational principle, with its characteristic mix of images, documentary elements, and fictional texts, eludes categorization in classic literary terms. Situated on a level beyond—or below—"story," "short story," or "novel," the Klugean book confronts the reader in its character *as* a medium (i.e., emphatically as a *book*), just as the Klugean film negotiates its media aspects beyond or beneath questions of "plot" or genre classifications of fiction versus documentary. In both cases, canonical formal

definitions are bypassed in favor of a direct encounter with the medium, and this path leads through the realm of revues.

Short forms and small units are, finally, also the constitutive components of Kluge's TV features. This relates most obviously to the textual and graphic intermissions that punctuate the conversation segments: generally they are of short duration. It relates, moreover, to the length of each feature program, which varies from fifteen to twenty-five minutes (with the exception of a few forty-minute examples). While the conversation sections, due to the absence of cuts, give the impression of temporal extension, the overall duration of each feature is actually quite short compared both to other programs and to Kluge's feature films.

Moreover, Kluge's "minute" films (*Minutenfilme*), as short as clips, further isolate the animated illustration format. Snippets of documentary footage and animation generate image combinations, such as *Neonröhren des Himmels* (*Neon Lights in the Sky*), where a static take of a log cabin in a Nordic landscape, set against the sky, is briefly replaced by an illustration of two mammoths walking in the snow (60,000 years ago, the Klugean lettering informs the viewer), only for the cabin image to return. The filmed sky is animated in such a manner as to produce the effect of a wavering turquoise aurora borealis. In the last third of this minute-long clip, the cabin's windows flash up intermittently: Kluge's signature combination of static architecture, temporalization, and light effects, executed in about two minutes. Clips like this have been shown at film festivals, but also in the context of exhibitions; for example, in 2007 at the Haus der Kunst in Munich, or in 2009 at the Serpentine Gallery in London. Kluge has made a particularly extensive use of these short forms in the context of his online work. On his website, the audience finds not only *minute films* and television features. These are also now combined with montage fragments from his cinematic *œuvre* (see chapter 4 above).

Small-Unit Production

For Kluge, the formal category of brevity is to be understood as an actually unfolding *brève durée*—that is to say: for him, formal shortness is not a metaphorical category. It translates into an amount of real time that is consumed by the actualization of the short form. In his conversation with Koch and Schlüpmann, he extends this understanding of shortness beyond the level of the formal characteristics associated with a given work to the actual circumstances of making a work, i.e., to the realm of production. Talking about the—then very recent—beginnings of his television work, Kluge explains how dctp formed a strategic alliance with the Japanese advertising agency Denzo when negotiations with two very established prospective partners, the large *Westdeutsche Allgemeine Zeitung* and the Nordrhein-Westfalen state TV program *WDR*, had reached a dead end. Denzo's intention, says Kluge, was to enter the Western (German) television market—which was for them uncharted terrain and was, due to the recent introduction of commercial stations, in a process of transition. Thus, for a brief period of exploration, Kluge, Denzo, and dctp shared a common interest: "Then, there is the possibility of a common interest for a short stretch of time in which they do not yet know how the consumer's desires and needs are arranged here. They need to explore and we need to explore."[5] Instead of continuing negotiations with established institutions, Kluge opted for a collaboration with the newcomer to the field on the basis of a perceived brief period of shared interest, to successfully launch his television work.

This story would be of purely anecdotal value, were there not a number of further parallels between the Klugean plea for short forms and other aspects of his mode of production. In fact, Kluge once explicitly stated in reference to his film production company Kairos Film that his method depended on "staying small": "This is the method with which one stays a small unit [*eine kleine Einheit*]—just like my company; you would be surprised how small it is, I do not have a single employee."[6]

Smallness and shortness are thus defined not just as formal categories, but also as categories of production. In this way they designate, for example, the reduction of larger and more complex contexts of production (such as a crew, a film studio, etc.) to a comparatively fast-acting minimal unit. Kluge's exhortation "the small must join to form a coral reef" sketches a minimal political perspective for a collaboration of such small units, and the general advice to "downsize" is perhaps best exemplified by his decision to abandon the "bigger," more complex structures of film production in favor of making TV features which, in addition to himself as interviewer, require only an assistant, one cameraman, and an editor. (Kluge has subsequently also used the image of the coral reef to envision possible collaborations between a multitude of artistic producers through online platforms, such as YouTube.)[7] Klugean programs have occasionally been described as "auteur TV" (*Fernsehen der Autoren*).[8] This description is compelling not so much because of the suggested analogy between an independent *cinéma des auteurs* and a specific "independent" way of making television features, but rather because Kluge, with his mini-production company, has found a way of transforming the conditions of working within the (image) medium of television in such a manner that they approach the perhaps smallest imaginable production unit: the literary author. By downsizing in this manner, Kluge has found a way of producing broadcasts with the same versatility with which a writer can produce a text.

POETICS OF SMALLNESS

Given the double meaning of the term "small unit" in Kluge's system—designating both a minimal (i.e., short) formal element and a minimal production entity—it seems appropriate to speak of a genuine *poetics* of smallness that generates his work. Poetics is understood here in the sense of an explicit or implicit set of rules which structure the making of a work of art, i.e., the formal features of the resulting work, but also

the process of production. (In the latter sense, the present use of the term exceeds its classical interpretation as relating "just" to the features of the work; it is an extended concept of poetics, relating to and generalizing the Greek meaning of the term *poiein*—to make.) Kluge's poetics encompasses both of these levels (form/product and production), and the imperative of segmentation and smallness applies to both. It also has a number of further implications.

First, as already sketched above, small poetics allows Kluge to bypass the laws of genre which regulate artistic production by upholding classifications such as "novel," "first-person narrative," "plot," "documentary film," "fictional film," etc. By supplying many miniature versions of these formats, and organizing them all into one film or book, Kluge's work passes from a level structured by narrative or documentary economies to a plane where he works directly in the realm of the medium (hence the possibility to work with/on "cinema history" without classifying film as "narrative" or "documentary"; hence the impression that in Kluge's work one encounters *the* "film" or *the* "book" directly, as such).

Yet the poetics of small units also leads beyond the negotiation of singular media and their specificity. It enables a type of production that passes from one medium to another, and thus outmaneuvers questions of mediality in favor of more supple and amplified productive capacities. For example, Kluge's reliance on anecdotal—i.e., small narrative—components allows for a smooth passage of these elements from literature to film; from film to film—the scenes of Gabi Teichert digging which originally featured in *Deutschland im Herbst* (*Germany in Autumn*) can be identically reemployed in *Die Patriotin* (*The Patriot*); or from film to book—as is the case with most "dramatic" fictional scenes in *Die Patriotin* and *Die Macht der Gefühle* which are "retold" as brief episodes in the identically titled books that accompany the films; or the re-narrated filming of the opening images of *Die Macht der Gefühle* in the single-paragraph encompassing story "Zeitrafferaufnahme eines Sonnenaufgangs" (Time-Lapse Take of a Sunrise) in *Geschichten vom Kino* (*Cinema Stories*). In each of

these cases, the reduction of length and internal complexity allows for a higher degree of transposability.[9]

The transmediatic velocity of small units is not limited to their definition as mini-episodes. A small unit can also be formed by one recurring material image, such as the illustration of the blind driver who is assisted by a boy in the passenger seat. This image appears in various contexts, including TV conversations with Dirk Baecker, and in print in the corresponding volume of interview transcripts. It is presented to Jean-Luc Godard in an interview feature, which begins with an appropriated and "refilmed" sequence from the French director's 1965 *Pierrot le fou*: a visually "altered" short clip of Jean-Paul Belmondo driving, with Anna Karina in the passenger seat, both seen frontally through the windshield—clearly a corresponding theme. In this feature there is also a full-screen shot of the blind driver, which lasts for about half a minute; and the image reappears in the footnote section to *Geschichten vom Kino* where the interview transcript was published (figures 9.1–9.4).

A small unit's function can even be fulfilled by a mere signifier, such as a proper name. This is, for example, the case with the name "Pichota." In *Die Macht der Gefühle*, Alexandra Kluge—who played Anita G. in *Abschied von gestern*—appears as a reporter—named Pichota—who interviews an opera singer; in a television feature, Peter Berling plays Manfred Pichota, former bodyguard of Adolf Hitler; and the name is used in several corresponding Kluge stories, such as "Anita G." (Perhaps a small unit can even be an actor, or an actress—the recurring members of Kluge's film "family," or even his recurrent conversation partners: Alexandra Kluge, Hannelore Hoger, Alfred Edel, Peter Berling, Christoph Schlingensief, Heiner Müller, Dirk Baecker, Joseph Vogl, etc.)

These examples do not demonstrate only how the principle of small units allows Klugean production to slip from medium to medium. They also demonstrate that the small unit, following the procedures of recontextualization and slight rescription or variation, stands behind Kluge's breathtaking productivity. Over the course of approximately fifty

9.1–9.4 dctp television feature *Blinde Liebe/Blind Love* with Jean-Luc Godard (2001). Alexander Kluge / dctp.

years, Kluge has published an immense number of literary texts; he has directed twenty-six films; he has produced over 3,000 television features; he has established a website on which he reedits his films and features into approximately sixty loops, each comprising a number of clips; and he has issued four DVD films.[10] This enormous output is partially enabled by the fact that a small unit, in Kluge's sense, can be assembled quickly (here again, the principle of shortness applies). This is illustrated in an often-retold Klugean anecdote: Eager to explore work beyond the field of law, in which he had just obtained his doctorate, Kluge became an intern on the set of Fritz Lang's last film through Adorno's recommendation. Contrary to his high expectations, the experience proved frustrating:

> By the third day Fritz Lang practically stopped directing and confined himself to surveying the production, because Arthur Brauner [the producer] categorically took the side of the lower-ranking workers and the architect. He failed to see Lang's qualities. In the meantime I wrote stories in the canteen which became the *Case Histories* [*Lebensläufe*].[11]

If the larger project fails, retreat behind the sidelines and draft a collection of short stories in its shadow. Another example would be the format of the TV interview. This takes only a couple of hours to produce on site: the camera work and the sound recording's strategically reduced level of complexity, the programs' deliberate technical "low finish" (generating the "noisy" character of the features) are the flip side of a production mode that allows for fast output.

Yet it would be wrong to assume that sheer numerical maximization is Kluge's goal. Rather, this exponential growth must be considered an inevitable correlate to the technique of recontextualization and rescription that coincides with his method of small-unit production: if, for example, one short form travels from context to context, it is also assigned a new, slightly or strongly varied signification (for example, the Gabi Teichert episode in

Deutschland im Herbst figures as one element in a collective filmic response to the German autumn versus the fuller description of her character, as well as the broadening of the historical panorama in *Die Patriotin*). Such transformations can also take place on the level of the format, as exemplified in the development of the Klugean "interview" (as such a small form, "merely" a recorded conversation). The first instances of it in Kluge's work can be found in films such as *Der Angriff der Gegenwart* (*The Assault of the Present*), where actors play both parts, interviewer and interviewee. In *Die Patriotin*, Hannelore Hoger—as Gabi Teichert—visits the Social Democrat Party convention and interviews "real" delegates. And only a few years later, Kluge begins the production of television conversations where he interviews "real" experts, but also actors playing the role of experts.

In each case, the introduction of a new short form or the transposition of one that has already been presented elsewhere also produces a variation within the context it enters.[12] The most impressive example is perhaps the project of the *Chronik der Gefühle* (*Chronicle of Feelings*). Issued in 2000, the two-volume text contains almost every piece of literary writing that Kluge had published up to that point, plus an indeterminable number of miniature interventions, small additions or alterations to older stories, extensions of existing plots or historical trajectories, etc. In this rather grand gesture one recognizes the approach of a television producer who has learned to put out a hundred features per year. The day-to-day vernacular of televisual communication has reentered the realm of book production, and altered the understanding of the printed medium in a way that would have been inconceivable through its encounter with film alone. In any case, it becomes clear that a production method that relies on short forms and small units as the basis for recontextualization and variation escapes classical conceptions of "invention" or "œuvre": thousands of miniature components contribute to permanent modifications, continually reshaping one evolving landscape that extends over various media; a terrain that is not "leveled" but, rather, accommodates continual alterations, changes, and distinctions. It also makes it difficult

to maintain the description of an artist's or an author's lifetime work as the sum of her or his (individual) works. Instead, one confronts "work," in the sense of a permanently increasing internally modifying stream of production. In this sense, the use of small units is also a prerequisite for Kluge's critique of finalized forms: the small units'/short forms' velocity, their internal modulability, but also their potential for context alteration, prevent his production from crystallizing into a limited number of set, i.e., "final," products or works. In their place, there is "work."

There is one axiom which safeguards small-unit production. The short form can enter into as many contexualizations as possible, but it must never be fully "absorbed." Its distinction from the other short forms which it joins, and also from the shared context which it establishes with the other units, must not vanish. The principle of a dramaturgy of "acts" applies on many levels, from a single image and signifier to entire narrative episodes or stretches of cinematic footage; it is upheld through this double distinction, i.e., by neither letting the acts collapse into each other, nor letting the entire revue become identical with its individual acts. "Small" and "short" are, in other words, determined by a variable scaling that measures them against their coexisting counterparts and against their sum total. As long as this distinction is guaranteed, the small-units method functions as an organizational principle that describes a specific relation of elements both among themselves and *vis-à-vis* their entirety. This entirety of elements, this context of short forms, this modulating terrain of small units, designates another aspect of the Klugean concept of *Zusammenhang* (context).

ZUSAMMENHANG OF SMALL UNITS, MONTAGE OF SHORT FORMS

It is, in other words, necessary to further specify the Klugean nexus of montage and *Zusammenhang*, first by defining Klugean montage *as* a montage of short forms or small units; and by extending the concept of montage from the level of form to the plane of production: a context of many small

production units produces a formal context which is, in turn, constituted by many short forms. This also entails a further definition of what Kluge understands by *Zusammenhang: Zusammenhang* can be a formal context, it can relate to a single work (one book, one film), it can refer to the context of "the" work (an artist's *œuvre*, the interrelation of her or his works); finally, it can refer to the conditions of production in general (in the sense of the term *Produktionszusammenhang*, as the specific context formed by the circumstances and results of production). Kluge's dramaturgy of short acts (i.e., small units) cannot be separated from its orientation toward *Zusammenhang*, reaching from the smallest contextualizations to the largest extensions: "The counterpart to these small units would be films of eighteen hours in length that realize a context."[13] The type of *Zusammenhang* to be achieved in Kluge's work is, then, "the counterpart to the miniature, and at the same time built with miniature building blocks."[14]

Negt's and Kluge's definition of the "Gewalt des Zusammenhangs [violence of context]" is, correspondingly, tied to a diagnosis of its largeness: "Alle Menschen, die Mächte, die Tiere, die Maschinerien sind als Zusammenhang schrecklich und unheilvoll. Es wird alles zu groß und ist schon gefangen, ehe einer sich äußern könnte. [Once they form a context, humans, powers, animals, machineries are all terrible, and bode ill. Everything becomes too large and is already blocked, before any individual could speak up.]"[15] It is only logical that Kluge's critique of *Zusammenhang* through montage is thus also specified as proceeding through the employment of small units and short forms:

> One needs to develop forms that are able to persist in this impossible context which extinguishes expression. These will probably be short forms, which, however, can build so many series [*Reihen*] with one another and have so much trust in the form of variation [*Variationsform*], which is also a form of difference [*Differenzform*], that they provide the possibility of renarrating very simple and very extensive topics.[16]

———

Montage in Kluge's work, then, is not just the technique for the construction of *Zusammenhang per se*. For Kluge, montage needs to rely on short forms in order to keep the constructed context variable. Many short forms can combine into more and more varied series, are easier to transpose, and thus easier to employ for the purposes of alteration and rescription, than large forms. By inventing many short forms (filmed scenes, animations, literary episodes), but also by defining actors, interlocutors, found images, signifiers, etc., *as* small units, Kluge generates an immense reservoir of potential alterations (Pichota as a reporter in a film, Pichota as a dialogic counterpart; Alexandra Kluge as Anita G., Alexandra Kluge as the reporter Pichota; Miriam Hansen as a conversation partner, Miriam Hansen as a fictional expert, etc.). Kluge also keeps the context of production nonfinite. The short form and the small unit are, in other words, the key elements for producing form *as* a form of variation, i.e., as a form of difference.

Ausweg / Escape

Heeding Negt and Kluge's dictum from *Geschichte und Eigensinn* (*History and Obstinacy*)—"Der Ausweg wird ein Zufall sein. In der Evolution sind es immer die Kleinformen, die die Zufälle für ihre Entwicklung aufzugreifen vermögen [Escape will come by chance. In evolution it is always the small forms that seize the opportunity for development]"—one finally arrives at a further description of the function which the poetics of the small holds for Kluge's project.[17] Kluge offers his contribution to a strand of political practice, recognized by Deleuze and Guattari as formulated in Kafka's work, which treats the question of finding "a line of escape or, rather, … a simple way out" (as opposed to an abstract and general state of "liberty").[18] He makes films, television features, and texts as permanently recombinable and rescriptable assemblages (or, perhaps, films, television features, texts, as one assemblage) from small or short elements, because it is only through this procedure that (a) the *Zusammenhang* which always exercises some sort of *Gewalt* (violence) is

prevented from completely forming as such: from crystallizing, as it were; and (b) the way out, the *Ausweg* (escape), which begins by and as chance, can be recognized, and begins to be traceable. Or, in Kluge's words: "im Zusammenhang gibt es immer einen Ausweg [there is always an escape in context]."[19] If it is contextualized, this quote not only serves as another motivation for Kluge's montage practice: "ein Grund für Montagetechnik … ist eben diese Suche nach Auswegen [one reason for the technique of montage … is this search for escape routes]." It also demonstrates, again, the essentially dialectic manner with which Kluge employs his concepts. If at other points he emphasizes the *Gewalt des Zusammenhangs* (violence of context), here he stresses that it is *Zusammenhang* as constructed by montage which allows for escape routes: "There are no escapes in the limited single circumstance [*im begrenzten Einzelverhältnis*]. Escape exists only, if at all, through cooperation, i.e., in contexts."[20]

Such a position must not be confused with an artistic or theoretical practice that promises the actualization of such a way out, let alone access to a state of "freedom." Rather, this way out is embodied, if at all, as a possibility through the permanent—albeit ever so slight—renegotiability, the looseness, of a *Zusammenhang* that is described by and realized through an ensemble of small elements. Just as Kluge's features and interviews systematically admit noise as a subject for future distinctions and as motivation for an ongoing appeal to the faculty of discernment (see chapter 3 above), the poetics of small units secures an option to react to chance and the possibility of unforeseen development, or at least strands of development that are unforeseeable at the level of large forms (*grosse Formen*). In this sense, Kluge's practice could be described as a strategy that seeks to prevent, or to escape from, the violent closure and actualization that goes hand in hand with the constitution of *Zusammenhang* by inserting intervals of time via small forms that open up the whole. That the temporal structure of this strategy resembles a perpetual displacement or postponement comes as no surprise. Kluge has formulated this goal himself; it is encoded in the term *Zeitgewinn*: if we have gained anything at all, we have gained some time.[21]

PERMANENT ACCUMULATION, PERPETUAL BEGINNINGS

ZEIT-ANSÄTZE / APPROACHING TIME

Kluge once criticized wasting time at the movies. Film as a pastime (*Zeit-vertreib*) is, in his opinion, "an annihilation of time."[1] His declared intention is, by contrast, to make films that will generate time, films "that add to one's lifetime [*die Mehr an Lebenszeit zurückgeben*]."[2] At first glance, this opposition of a film industry that caters to an "annihilation of time" on the one hand, and an independent, "critical" practice that "adds to one's lifetime" on the other, seems to rely on an overly stable juxtaposition of the terms "independent" and "mainstream," as well as a rather monolithic view of the culture industry. Kluge's comparison: "Hitchcock's enclosed space [*geschlossene Raum*] poses the same risk as a party convention at Nuremberg," i.e., his rejection of a suspense-oriented cinematographic style that obfuscates the viewer's experience of time passing while watching a film, seems to fall in line with such predicaments.[3] Kluge thus appears to present a dichotomy: on one side a wasteful, potentially regressive approach to time at the movies that goes together with an absorbed mode of viewing, in which the duration of the process of reception is obfuscated; on the other a mode of reception that partly

secures its critical validity and potential progressiveness by foregrounding the passage of time. It is certainly debatable if this juxtaposition in its strictest form is ultimately convincing. Yet the nature of Kluge's work indicates that something beyond this schematic opposition is actually at stake here.

Kluge's films and books pay close attention to temporality, and they realize temporal relations in a complex, varied, and internally diverse manner that can perhaps best be described as heterochronicity.[4] This quality, which is related to Kluge's rejection of a notion of time as unified and homogeneous in his categorical dictum "time is not *one* [*Es gibt nicht eine Zeit*]," results from a specific strategy of correlating the linear and temporally unfolding character of the filmic medium with manipulations of recording and reproduction speed, the treatment of temporality on the level of representation, and the interrelation between the segments of the Klugean work, i.e., the montage of short forms.[5] In this sense, Kluge calls his productions "temporal works of art [*Zeitkunstwerke*]," and positions them in relation to "a faculty of discerning time [*Unterscheidungsvermögen, was Zeit betrifft*]."[6]

In Kluge's films, the viewer encounters at least three different technical time/image relations. First, regular film footage, i.e., the filmic recording of temporally unfolding processes. Second, technically manipulated temporalities. These include time-lapse takes, such as the sunrise at the beginning of *Die Macht der Gefühle* (*The Power of Feelings*), referred to by Kluge as "temporal long shots [*Zeittotale*]."[7] Another example consists in refilmed old footage, such as the *Nibelungen* material, that is slowed down just enough to visualize the succession of still frames as a series of pulsating images.[8] A third is the filming of still images, i.e., of pro-filmic material pictures, a process in which the technical temporalization of the filmic image is pitted against the stillness of the filmed object. These still images include textual elements, like the printed page (for example, from *Dialektik der Aufklärung* [*Dialectic of Enlightenment*] in *Artisten in der Zirkuskuppel: ratlos* [*Artists under the Big Top: Perplexed*]), manuscript

elements (illuminated sheets in *Nachrichten von den Staufern* [*News from the Staufers*]), or illustrations, e.g., Caspar David Friedrich's 1804 pen-and-sepia drawing *Wallfahrt bei Sonnenaufgang* (*Procession at Sunrise*) in *Die Patriotin* (*The Patriot*). One could include architectural footage in this category, due to the formal stability of its subject, buildings, which translates into quasi-atemporality (figures 10.1–10.4).

Kluge's work opens an even wider spectrum on the level of the temporal processes and dimensions that it represents. It includes short literary or dramatic episodes which occasionally function as elements in the narration of a wider "story," as exemplified, for instance, in the scenes from the life of Gabi Teichert in *Die Patriotin*. (It would be difficult to identify a plot for this wider narrative, though; perhaps the only overarching development to be detected is the growing disorientation of the film's protagonist.)[9] For Kluge, the representation of temporal processes, however, is not necessarily bound to narrative structures. A passage like the sunrise over Frankfurt is completely free from narrative elements (or narration is reduced to a necessary minimum element within descriptive activity); this example also illustrates the highly varied temporal dimensions, from the longest to the shortest periods. The recorded transition from light to darkness occurs in the course of three hours, its filmic representation in less than one minute. The next sequence adds temporal dimensions of enormously diverging lengths: 1983's political reality in the form of the Karry murder, as presented in the filming of his memorial service; its connection to the German autumn (1977) and, implicitly, to the aftermath of 1968 (Karry having been killed by leftist-autonomist terrorists); the approximately forty years which had passed at that time since the end of the Second World War (thrown into relief by the implicit conflict between the generation of '68 and their National Socialist parents, but also as evoked implicitly by images of the collapsing court of the Huns in the historic *Nibelungen* footage); the history of cinema, through a reference to Lang—that is to say, about sixty years; the tradition of failed German revolutions since 1848 (again evoked through the Paulskirchen

10.1–10.4 *Die Patriotin / The Patriot* (1979, 35 mm, color and b/w, 121 min), works by Caspar David Friedrich, filmed: *Arbor in Moonlight* (*Gartenlaube im Mondschein, c.* 1820s) (10.1); *Winter Landscape* (*Winterlandschaft*, 1811) (10.2); *Procession at Sunrise* (*Wallfahrt bei Sonnenaufgang*, 1805) (10.3); *Morning* (*Der Morgen, c.* 1821–1822) (10.4). Alexander Kluge / Kairos Film.

imagery); the history of opera and the Wagnerian project (late nineteenth century); German literary history dating back to the Middle Ages and the *Nibelungenlied* (circa 1200); the even older historical references to Germanic mythology (the Ragnarök motif in Lang and Wagner, but also the Middle High German recourse [around 1200] to this older material). One could transpose this bundle of temporal distances into qualitatively differing temporalities, such as the history of cinema, which here would include the history of German film from the 1920s to New German Cinema; and the negotiation of Kluge's individual history as a filmmaker who began his career as an intern on the set of Lang's last film. To which could be added German political history, as manifest in the relation of a West German subject to the returned immigrant director who had to flee the country under the National Socialists. These categories could be complemented by the history of opera; the time of myth; the time, or history of art (film, literature, opera) relating to the time of myth (Wagner's *Ring*, Lang's *Nibelungen*); etc. Kluge's film opens these diverse temporal trajectories without organizing them into a coordinated stream of events or processes. Rather, they coexist in their varying scale and volume like a bundle of partially superimposed, partially unrelated strands: a stream of sheer temporal complexity. Such a diversity is another effect of the Klugean approach to montage, a technique for the production of an internally heterogeneous, non-causal (i.e., nonlinear) time context. This general non-synchronized temporality has a pointed correlate in the temporal mismatches and missed encounters that recur in Kluge's stories. Scholars have commented on this "missed encounter of two or more temporal structures": "All these separations are temporal separations. Time is a recurrent theme in terms of not having enough time and missed time."[10] This is exemplified in the comment in "Der Luftangriff auf Halberstadt" (The Air Raid on Halberstadt) which points out that for high-school teacher Gerda Baethe, now buried in the burning ruins of her city, to have "a strategic perspective" would have necessitated that "since 1918, 70,000 determined teachers, all like her, would have had

to teach hard for 20 years in each of the countries involved in the First World War."[11] Or the explanation that the British Air Force squadron approaching Halberstadt—even if the pilots had seen the white flag of individual capitulation on the city's church tower—would not have had the chance to stop the attack and simply return to their base: a jet returning with bombs on board is a risk. Translated into temporal terms: the temporality of the technology and industry of the air attack, and the temporality of the city's inhabitants, are divided into two registers whose trajectories cannot meet. In Kluge's terms: *strategy from above* and *strategy from below* cannot be synchronized.

The Klugean combination of short elements into (image) series thus generates a temporal density and variation that resists formatting by immediate causality or linearity. *Die Macht der Gefühle* opens with the sunrise over Frankfurt, not with a reference to a historical or mythological "first" event; once such older layers are brought into play, they do not appear in the mode of a "flashback," or any kind of representational glance back into history or myth; moreover, the sunrise does not function as an introductory element for a subsequent film plot. It is a pure beginning. Furthermore, the (image) series is not governed by the promise of a realistic or documentary recordability of time through the instrument of the camera: "The series are the points of access to the flow of time. This is real, while the snapshot of the so-called present is unreal. There is no closure of time. [*Es gibt keinen Abschluß der Zeit.*]"[12]

This goal—*Zeitgewinn*—might count as another distinctive criterion that separates Kluge's from earlier montage projects. Eisenstein's temporal policy consisted in articulating the revolutionary moment (e.g., *October*) as the contrastive division of montage. As Annette Michelson has shown, the rhetorical effect of this operation consists in creating a momentous style that corresponds to a distention of time (see chapter 2 above). Klugean montage, it seems, does not claim a *prima facie* temporal validity for the negative moment of the cut. To put it differently: Kluge does not define montage as a (temporal) moment of negation. Its

constitutive operation is difference and distinction; its ideal is the still image that suspends temporal pressure.

This resistance to synchronization and temporal monofocality is also evident in Kluge's media politics of form. It is articulated, for example, in the way in which Kluge takes advantage of the enormous storage capacities of media like the DVD. As explained above, he makes strategic uses of the incongruity between the temporality of the act of individual reception on the one hand, and the temporality of stored clips and texts on the other (see chapter 4). Through extending stored time to a scale that exceeds by far the capacities of the time of reception, he creates a "mismatch" which results in the creation of latent temporalities in the work, and a constellating type of reception. The same holds for the acts of reading through which Kluge's growing compilations of reedited and readjusted literary works need to be deciphered. Another example for a Klugean poetics of heterochronicity would consist in his decidedly asynchronous treatment of image, sound, and lettering panels in his films and television features in which text fields, for example, suddenly supplant the camera image while the aural recording of the conversation continues; or Kluge's non-diegetic voice is clearly marked as belonging to a different temporal register than the filmic images, while also following a different rhythm than that of the unfolding visual stream.

The name of Kluge's film production company is Kairos Film. In ancient Greek, the word *kairos* indicated a temporal concept that was defined in opposition to its sister term, *chronos*. Whereas *chronos* referred to quantifiable time—i.e., a structuring of temporality that depended on scaling and measurement—*kairos* stood for the time of the moment, the time of opportunities and chances that needed to be seized. It is clear that the Klugean politics of time relates to the category of *chronos* only insofar as it combines multiplicities of temporal measurement into complex heterochronic assemblages. But the Klugean approach to kairological time also stands in contrast to the usual understanding of this concept. There is not a single instance in which Kluge would grant his audience the

experience of a "full present," the single moment. What he offers instead is an experience of time as a multilayered field of quasi-tectonic tensions.

ZEITGESTALTEN / TIME GESTALTS

The artistic production of a heterochronological panorama has an equivalent in the theory of *Zeitgestalten* that Negt and Kluge develop in *Geschichte und Eigensinn* (*History and Obstinacy*). They start from the observation

> that a learning and working being produces its temporal approaches at each moment anew with help from its environment, both phylogenetically and ontogenetically. Such "temporal approaches [*Zeitansätze*]" include "one's own time/autotemporality [*Eigenzeit*]," "children's time," "long pregnancies," "the time of the clock," "patience."[13]

The notion of the *Zeitansatz*—the approach to but also the beginning of time, perhaps even an attitude toward temporality—includes the concept of a multiplicity of varying temporal orders and regimes that coexist in a living and working being. It also refers to the perpetual restructuring of this heterochronological order. Both features, heterogeneity and permanent reorganization, characterize the *Zeitgestalten* which *Geschichte und Eigensinn* explores via fragmentary comments on the time designs of evolutionary biology, Freudian psychoanalysis (in both cases with a particular focus on the interrelation between ontogenesis and phylogenesis), and Marx's historical-materialist account of the development of capitalism.[14]

Negt and Kluge's comment on evolutionary biology targets a central epistemological trope in the work of biologist and philosopher Ernst Haeckel. Their "note on the biogenetic law [*Notiz zum biogenetischen Grundgesetz*]," which Haeckel formulated in his 1866 *General Morphology*,

begins with the curt remark "This law does not exist."[15] Negt and Kluge aim at Haeckel's assumption

> that in the development of the embryo, phylogenetic features generally precede individual features: as if the entire phylogenetic process were repeated individually by the embryo in the uterus. That is, as if the embryo reiterated all preliminary stages of human development, from ur-cell to fish, reptile, etc., only to become ever more specific toward and after birth, i.e., to put more and more distance between himself or herself and the forms of all other living beings.[16]

The accuracy of this critique (Negt's and Kluge's representation of Haeckel's theory, let alone the actual relation of ontogenesis to phylogenesis) cannot be verified here. It is, however, possible to describe the shift in temporal models with which Negt and Kluge operate. Haeckel's biogenetic law superimposes temporal processes of divergent fields, and hence generates an effect of representational stability. More precisely: a stability that is achieved through a posited homology between very large-scale and very small-scale developments. The development of the human embryo, from the appearance of very general to very specific features, reiterates the becoming of the human species. It also restages as a temporal *pars pro toto* the development of species as such, i.e., evolution, in that the first stages of embryonal development *qua* lack of specification still carry the potential features of all other species. Only in the course of the increasing specification toward, for example, the human form are these other potential features excluded. If Haeckel's law posits a decreasing resemblance between increasingly developed embryos of differing species, this is because the biogenetic law dictates that embryonal development reiterates evolutionary speciation. This homology of micro- and macro-development functions as a bilateral stabilization. First, it motivates the form of the microdevelopment by declaring it to be

one example, a formally determined miniature version of the overarching macrodevelopment. Second, it also makes the strictly unobservable macrodevelopment ("evolution") palpable by providing an observable model development for a temporal process that extends far beyond any observational scale. The development of one species and of all species has, thus, to a certain extent been rendered graspable.

Negt's and Kluge's model, by contrast, cuts this stabilizing link:

> There is no linear connection between the history of the species and history; the history of the species looms into historical processes [*ragt in geschichtliche Prozesse hinein*], but how it produces effects always depends on the specific historical and social conditions.[17]

In this model, a determination and motivation of the form of the microprocess by the macrodevelopment is impossible; so is the "representation" of macro through micro. The mutual stabilization is replaced by the possibility of an intervention of factors belonging to the temporal register of evolution in the order of individual time, but these interventions do not determine or motivate the shape of the micro-order. Instead, they break it, or differentiate it in a nonreciprocal process: "The history of the species breaks [*bricht*] individual history—but this proposition cannot be reversed."[18]

With this critique, Kluge and Negt offer a model of time that comes down on the side of differentiation rather than homogenization and stabilization. An approach like Haeckel's, which treats microtemporal and macrotemporal processes as structural homologs, does not allow for differentiation. In the biologist's model, short-term developments mirror long-term developments in a closed circuit in which the different processes neatly fold onto each other, because it is assumed that in the development of every new moment of life (the embryo), the development of all life (evolution) is reiterated. Negt and Kluge, by contrast,

posit an interaction of macrotemporal and microtemporal processes in a mode of interference, rather than reiteration and mutual stabilization. For them, the relation between these temporal strata is one of a "fractioning," of "interruptions," hence one of heterochronicity, not of homogeneous temporality. Microtemporality and macrotemporality differ not just in terms of scale, but qualitatively, and their interactions produce additional difference.

Negt and Kluge sketch another differentiation of temporal models in their Freud commentary. They emphasize, first, the Freudian notion of the *Überlebsel* (survival), i.e., of anachronistically surviving (psychological) elements that originate in older periods, but are not "rationalized" in the course of further development. Although strictly speaking they are no longer functional, they persist well after the time of their formation. Beyond this hint toward a theory of a non-synchronizing, anachronic development of the psyche, Negt and Kluge elaborate more fully on what they call Freud's "bi-temporal approach to human biographies [*zwei-zeitigen Ansatz der menschlichen Lebensläufe*]."[19] If the Freudian term *Überlebsel* is at first sight connected to a concept of an internally uneven, heterogeneous development, the concept of bi-temporality (*Zweizeitigkeit*) articulates an understanding of development not just as a nonlinear process, but even more specifically as a process that is divided into two separate temporal strata. Negt and Kluge find its central articulation in a passage from Freud's text *Der Mann Moses* (*The Man Moses*) which underlines

> that deferral and the bi-temporal approach … are intimately connected with the historical development of the human species [*Geschichte der Menschwerdung*]. Man seems to be the only animal characterized by such latency and a delayed sexuality. … This is in a certain sense a human privilege. From this perspective it appears to be a survival from prehistory, just like certain elements of the anatomy of our bodies.[20]

325

The Freudian notion of bi-temporality (as such, originally a sur-
vival) thus functions as a chronometric signature for more familiar phe-
nomena like delayed human sexuality, with its characteristic period of
latency (initially developed by Freud in the context of his theory of
sexuality, but later reemployed for his conceptualization of trauma). In
Freudian psychoanalysis, the period of latency is the result of a censoring
intervention—the initial repression of sexual or traumatic experience—
and splits psychic development into a first stage (primary sexuality, trau-
matic encounter) and a second stage (secondary sexual development,
reactivation of the trauma *qua* association). However, the second stage is
not a mere continuation of the initial process. Rather, in Freud's system,
the temporal interruption is bound to a qualitative change that is the
result of this split temporality which, accordingly, no longer constitutes
a linear development. Where repressed drives and wishes are concerned,
the blocking of the first development equals the emergence of culture,
understood as the product of sublimation and deferred desires; it is nec-
essarily bound to the acquisition of repressional conflicts, i.e., neuroses.
Where trauma is concerned, the blocking of a psychological processing
has a protective function: it deflects an otherwise overwhelmingly harm-
ful negative affective input. If it is called up later, through association, the
initially unregistered but unconsciously stored traumatic content is acti-
vated, and generates a conflict with the protective repressive mechanisms.
The results are traumatic symptoms (e.g., repetition compulsion, transfer
processes, etc.) which do not emerge linearly from an initial triggering
event, but through the separating encapsulation of the first traumatic
encounter and the later recourse to the blocked psychotemporal stratum.
As exemplified in *Der Mann Moses*, but also in *Das Unbehagen in der Kul-
tur* (*Civilization and Its Discontents*), Freud applies this model both to the
development of the individual psyche and to the development of human
culture in general. As summarized by Kluge and Negt:

Freud's remarks relate to an externally caused process of primary separation in the history of the species. To this on a subjective level responds the separation from the genital principle, and as a consequence the separation from nature. In turn, the subjective response reinterprets said rupture in terms of the history of the species as a "pause" that makes room for more subtle developments.[21]

In this sense, the constitutive hiatus structures temporal processes of acculturation both on the level of the individual and on the level of the entire cultural system; in each case, historical time—i.e., the time of culture—is identical with a separation from the temporal register of nature: "In this perspective, psychological time, the clocks of generations, the time of history are all not originary, continuous temporalities on the level of the history of the species."[22] (While Negt and Kluge put forward the concept of human time *as* interrupted, they do not mention that Freud's construction of the development of culture at large, and the acculturation of the subject, is structurally almost identical with the posited homology of ontogenesis and phylogenesis—which they criticize in Haeckel. For Freud, the development of the child receives its motivation from the development of culture on a metahistorical scale, and it performs the very same *Veranschaulichung* of this unobservable process as the development of the embryo does for Haeckel.)

Negt and Kluge present their most elaborate conceptualization of interrupted time, finally, in their commentary on Karl Marx, which hinges on "the secret of primitive accumulation"; that is, Marx's translation of and elaboration on Adam Smith's term "previous accumulation":[23]

In Marx's *Kapital*, so-called primitive accumulation ... is the hinge and break-out point for any type of modern production of labor power, and accordingly for the production of history. ... It is the first real precondition of the developmen-

tal history of capital, just as the commodity is the first real precondition of its principle.[24]

According to Negt and Kluge, the term primitive accumulation describes both a summation and the termination of pre-capitalist structures; in other words, it is not the result of but the precondition for capitalist accumulation.[25] In line with their credo that the "organizing moments in history" are "processes of separation" (*Trennungsprozesse*), they interpret the historical moment of previous accumulation as just one such "incisive historical process of separation [*einschneidenden geschichtlichen Trennungs-prozess*]."[26] Separation describes the question of previous accumulation, as indicated by the following quotation from Marx:

> The investigation of this question would amount to studying what economists call "previous or primitive accumulation," but what should actually be called primitive expropriation. We would find that the so-called originary accumulation designates nothing else but a series of historical processes which result in the dissolution of the originary unit between the working subject and the means of production.[27]

Previous or originary accumulation is, in other words, the positive term for a structural founding split between the subject and the means of production. Furthermore, separation is also the very structure of the historical, temporal process of originary accumulation in the sense of a beginning of capitalism: namely, a rupture between the pre-capitalist and capitalist phases of history: "This is why we start with a story [*Geschichte*] of separation processes that narrates the modern beginning [*Anfang*] of all qualities. All earlier preconditions of this beginning, i.e., entire chains of endings, enter into this story."[28] Negt and Kluge take this theory to its ultimate conclusion when they redefine the notion of "beginning" from being bound to temporal primacy, as for instance in the concept

of a prehistorical phase, to being a function of a constitutive separation embedded in processes of history and time:

> The beginning, i.e., the incisive separation, does not lie in the primary roots [*Urwurzeln*], but at a central point, for example in the first third of the middle of a historical process. The designation of this historical angle point is arbitrary: primitive accumulation and its divisions can be caused by something in the present, even by something in the future. In our narrative rendering [*Nacherzählung*] we quickly come across the fact that individual processes—which we merely covered up by using the unanalyzable concept of the "course of history"— do not display a linear development.[29]

In this manner, Negt and Kluge advance the concept of an *originary hiatus* (an *Ur-Sprung*), and ensure that this constitutive separation is not assigned the function of a beginning—i.e., that is not conceived in the manner of temporal primacy: "It would be wrong to posit this point of time, the middle of the process, retroactively as a beginning … : Without the non-capitalist prehistory, i.e., the sum of previous beginnings, there is no content to primitive accumulation."[30] They also insist that the "time gestalt [*Zeitgestalt*]" of originary accumulation—i.e., originary separation—is systematic, and thus not tied to an exact temporal or chronological location at all: "Primitive accumulation is a systematic category: the process must have somehow taken place. This might have occurred at an early stage, it can also still happen in the present."[31] There is no localizable date for the constitutive split (which, accordingly, does not separate historical periods or epochs).

This non-localizability of the originary hiatus is also the effect of the last fundamental quality that Negt and Kluge assign to originary accumulation/separation: "the permanence of this process."[32]

Lat. per = through, away; manere = to stay, to continue; permanent: "to stay throughout," "to continue for the entire duration." [*Lat. per = durch, weg; manere = bleiben, fortwähren; permanent: "durch die Bank bleibend", "die ganze Zeit über fortwährend."*] As far as primitive accumulation is concerned, permanence means that under the principle of separational energies nothing will stay as it is. The principle of social transformation becomes permanent once primitive accumulation has picked up [*aufgegriffen*] such a massively accumulated measure [*ein so massiv angehäuftes Maß*] of separation potentials [*Trennungspotentialen*] that it triggers a dialectics of regression and progress. The formations which precede primitive accumulation display an unequivocally conservative moment. Permanence before and after primary accumulation thus inverts its meaning.[33]

Permanent accumulation describes, in other words, not a stabilization but, rather, a perpetual continuation and restructuring of a system whose elements are subjected to permanent redistributions *qua* repeated separations:

> The word "permanence" implies that beginnings will from now on condense into a principle of permanently renewed radical transformations [*Umwälzungen*]. Thus capital does not come into being once (with an incredible mass of separation energy that would be able to fill one period and its decline). Rather, capital in its entire setup is generated at its base [*Sockel*] through perpetually reiterated primitive accumulation and its collective processing [*Verarbeitung*].[34]

The concept of an originary accumulation/separation thus describes a state—which is not a state, but dynamic—of beginning without end:

there is no ending to the constitutive splitting. The constitutive separation does not mark a start; rather, it embodies and exercises a permanent beginning to which everything is now subjected.

PERMANENT ACCUMULATION, PERPETUAL SEPARATION: POETICS OF THE ORIGINARY CUT

On the basis of these explanations in the field of temporal concepts, and on the basis of the described release of heterochronic streams in Kluge's artistic production, it is perhaps finally possible to suggest one last definition for the function of the cut in Kluge's work, where it has a distinctive function; where it is constitutive for the establishment of montage; where it establishes and interrupts contexts and relations; and where it is one element within a poetics of small units and short forms. In addition to all these, Kluge's cut also functions within a temporal economy of production. Here, the cut separates (and binds) elements (images, textual fragments, etc.) in such a manner as to generate nonlinear temporalities. It is also by way of the cut (and its organizing function) that the context of the Klugean work (the *Werkzusammenhang*) is perpetually enlarged, reorganized, amplified, and internally restructured and rewritten. For is there a better term than "permanent accumulation" to account for the immense summation of films, features and books, images and texts, recordings, etc., which Alexander Kluge has produced over the past decades? And yet, heeding Kluge's definition of the subtractive character of montage (to make fewer, not more, images), and keeping in mind the internal differentiation and distinction associated with the cut, it would be wrong to describe this development as a pure amassing of work in the sense of a numerical "more." It is, rather, the function of a permanent beginning through perpetual separation, an unending internal splitting that reopens the status quo for renegotiation, and makes a break with what is there. It is this wave of work, the result of a permanent accumulation and perpetual separation, which greets Kluge's audience.

Notes

Preface

1. See Jan Philipp Reemtsma, "Unvertrautheit und Urvertrauen—Die 'Gattung Kluge.' Laudatio auf Alexander Kluge," *Deutsche Akademie für Sprache und Dichtung. Jahrbuch* (2003), 169–176.

2. Rosalind Krauss develops an outstanding discussion of a reconfigured notion of medium specificity, as well as a strident critique of the concept's problematic origins in the texts of Clement Greenberg. See *The Originality of the Avant-Garde and Other Modernist Myths* (Cambridge, MA: MIT Press, 1986); *The Optical Unconscious* (Cambridge, MA: MIT Press, 1993); and *A Voyage on the North Sea. Art in the Age of the Post-Medium Condition* (London: Thames and Hudson, 1999). In *A Voyage on the North Sea*, Krauss refers to Stanley Cavell's notion of automatism as a parallel concept to the project of medium specificity. See Stanley Cavell, *The World Viewed* (Cambridge, MA: Harvard University Press, 1979). For a recent proposal to move beyond the paradigm of medium specificity in visual art, see David Joselit's *After Art* (Princeton: Princeton University Press, 2013); see also, for a specific case study, Irene V. Small, "Medium Aspecificity / Autopoetic Form," in Alexander Dumbadze and Suzanne Hudson, eds., *Contemporary Art: 1989 to the Present* (Chichester, UK: Wiley-Blackwell, 2013), 117–125. David Rodowick lays out the slightly different situation in film theory in which, as he writes from a distinctly post-Deleuzean perspective and with an eye to the linguistically informed work of Christian Metz, the notion of cinematographic specificity "can be defined only by the set of all possible films or filmic figures that could be derived from the cinematic 'language,' and this language is in a continual state of … change." David N. Rodowick, *The Virtual Life of Film* (Cambridge, MA: Harvard University Press,

2007), 18. From this perspective, which considers the cinematographic as a virtuality, no definition of the specificity of any medium can be grounded in criteria of ontological self-identification or substantial self-similarity. See ibid., 19, 31–41. On another occasion, Rodowick also remarks that the historical emergence of the digital constitutes one of the most significant challenges for all theories of medium specificity—a shift that also informs Joselit's reflections. See David N. Rodowick, *Reading the Figural, or, Philosophy after the New Media* (Durham: Duke University Press, 2001), 37. For an outright rejection of the concept of medium specificity in film studies, see section I, "Questioning Media," of Noël Carroll, *Theorizing the Moving Image* (Cambridge: Cambridge University Press, 1996), 1–74.

3. These ideas are formulated exemplarily in Friedrich Kittler, *Gramophone, Film, Typewriter*, trans. Geoffrey Winthrop-Young and Michael Wutz (Stanford: Stanford University Press, 1999), originally *Grammophon, Film, Typewriter* (Berlin: Brinkmann & Bose, 1986); in Friedrich A. Kittler, *Discourse Networks 1800/1900*, trans. Michael Metteer with Chris Cullens (Stanford: Stanford University Press, 1990), originally *Aufschreibesysteme 1800/1900* (Munich: Fink, 1985); in Bernhard Siegert, *Relays: Literature as an Epoch of the Postal System*, trans. Kevin Repp (Stanford: Stanford University Press, 1999), originally *Relais. Geschicke der Literatur als Epoche der Post, 1751–1913* (Berlin: Brinkmann & Bose, 1993); and in Cornelia Vismann, *Files: Law and Media Technology*, trans. Geoffrey Winthrop-Young (Stanford: Stanford University Press, 2008), originally *Akten: Medientechnik und Recht* (Frankfurt am Main: Fischer, 2000). For the most recent shift in this field, in which work is increasingly being done under the paradigm of "cultural techniques," see Bernhard Siegert, *Cultural Techniques: Grids, Filters, Doors, and Other Articulations of the Real* (New York: Fordham University Press, 2015).

4. This shift is echoed in the sustained investigation of the terms "labor," "labor capacity," "labor-power," and "production," which also takes place in *Geschichte und Eigensinn*. Devin Fore situates the many manifestations of the Negt/Klugean concept of "labor" in his introduction to the volume's English translation. Devin Fore, introduction to Alexander Kluge and Oskar Negt, *History and Obstinacy*, ed. Devin Fore (New York: Zone Books, 2014), 23–24.

5. This notion of surface realism refers to the term's development in the thought of Adorno, as well as to related notions in film theory. See chapter 2 for a more extensive analysis.

6. Alexander Kluge, *Cinema Stories*, trans. Martin Brady and Helen Hughes (New York: New Directions, 2007), xi. For the original German, see Kluge, *Geschichten vom Kino* (Frankfurt am Main: Suhrkamp, 2007), 7.

7. See chapter 2 for a detailed analysis of the Klugean concept of the third image.

8. See, for instance, Bruno Latour's anticritical stance in *Reassembling the Social: An Introduction to Actor-Network-Theory* (Oxford: Oxford University Press, 2007); also in Bruno

Latour, "Why Has Critique Run Out of Steam? From Matters of Facts to Matters of Concern," *Critical Inquiry* 30, no. 2 (Winter 2004), 15–20. See also Armen Avanessian, "The Speculative End of the Aesthetic Regime," *Texte zur Kunst* 93 (March 2014), 40–66, on the anticritical tendency of the theoretical movement of speculative realism; and, as an important countervoice, Hal Foster, "Post-Critical," *October* 139 (Winter 2012), 3–8.

9. In its complex engagement with temporality, Kluge's work anticipates and resonates with a number of positions that have emerged in criticism, theory, and philosophy over the past decades, such as Deleuze's theory of the time-image: Gilles Deleuze, *Cinema II: The Time-Image* (Minneapolis: University of Minnesota Press, 1989); various critiques of capitalist time, from Jacques Derrida, *Given Time I: Counterfeit Money* (Chicago: University of Chicago Press, 1992) to Moishe Postone, *Time, Labor, and Social Domination: A Reinterpretation of Marx's Critical Theory* (Cambridge: Cambridge University Press, 1995); and, more recently, Joseph Vogl, "Taming Time: Media of Financialization," *Grey Room* 46 (Winter 2012), 72–83, which addresses the role of electronic media, financial speculation, attempts at controlling time, and a futurization of the present. See also Joseph Vogl and Philipp Ekardt, "In the Pull of Time: A Conversation on Speculation," *Texte zur Kunst* 93 (March 2014), 96–126; and Joseph Vogl, *The Specter of Capital* (Stanford: Stanford University Press, 2014). This panorama would also include Georges Didi-Huberman's reflections on the temporality of images, *Devant le temps* (Paris: Minuit 2000), *L'Image survivante. Histoire de l'art et temps des fantômes selon Aby Warburg* (Paris: Minuit, 2002), and Peter Osborne's recent critique of the notion of the contemporary, *Anywhere or Not at All: Philosophy of Contemporary Art* (London: Verso, 2013). Bernard Stiegler's protracted philosophical investigation of the interconnection of futurity, possibility, and technics are also pertinent. See, e.g., his *Technics and Time 1: The Fault of Epimetheus* (Stanford: Stanford University Press, 1998). The panorama would also include more historically focused studies such as Pamela M. Lee, *Chronophobia: On Time in the Art of the 1960s* (Cambridge, MA: MIT Press, 2004); or Alexander Nagel and Christopher Wood, *Anachronic Renaissance* (Cambridge, MA: Zone Books, 2010); as well as studies of the effect of technological temporalization on the arts: Sven Lütticken, *History in Motion: Time in the Age of the Moving Image* (Berlin: Sternberg Press, 2013); or Thomas Y. Levin, "You Never Know the Whole Story: Ute Friedrike Jürss and the Aesthetics of the Heterochronic Image," in Tanya Leighton, ed., *Art and the Moving Image: A Critical Reader* (London: Tate Publishing/Afterall, 2008), 460–474, which focuses on the practice of multiple parallel projections of temporalized images. In film studies, David Rodowick's *Gilles Deleuze's Time Machine* (Durham: Duke University Press, 1997) would be a case in point. In the field of literary studies, one could turn to Martin Hägglund, *Dying for Time: Proust, Woolf, Nabokov* (Cambridge, MA: Harvard University Press, 2012), which discusses the centrality of the experience of time for a modernist literary aesthetics, with and after Freud and Derrida; or to Armen Avanessian

and Anke Hennig, *Present Tense: A Poetics* (London: Bloomsbury, 2015), which resonates with Quentin Meillassoux's speculative recuperation of deep, prehuman time, as laid out, for instance, in his "Metaphysics, Speculation, Correlation," *Pli: Warwick Journal of Philosophy* 22 (2011), 3–25.

10. See Fredric Jameson, "On Negt and Kluge," *October* 46 (Fall 1988), 151–177 (here 170).

11. See also Eric Rentschler's comments in "Remembering Not to Forget: A Retrospective Reading of Kluge's 'Brutality in Stone'," *New German Critique* 49 (Winter 1990), 29, on the difficulty of accurately translating this term.

CHAPTER 1

1. See Alexander Kluge, *Geschichten vom Kino* (Frankfurt am Main: Suhrkamp, 2007), translated as *Cinema Stories* by Martin Brady and Helen Hughes (New York: New Directions, 2007). Another possible translation of the title *Geschichten vom Kino* would be *Histories of the Cinema*; this version would have the advantage of transporting the homage which Kluge's project pays to Godard's *Histoire(s) du Cinéma*. Yet the common German-language designation for a history of cinema, as well as a history of film, a history of the book, or a history of painting, would be a construction that employs the genitive article *des*, as in: *Geschichte des Kinos*. It is my intention to demonstrate below, especially in chapters 8 and 10, that the Klugean project does not coincide with such a historiography of a single medium.

2. Kluge, *Geschichten vom Kino*, 20.

3. Andreas Huyssen has observed that Kluge's literary texts hardly ever offer sustained developments of plotlines. He also suggests that Kluge's authorial practice tends not only not to establish such classical narrative criteria as a plotline, but even to actively suspend their emergence. See Andreas Huyssen, "An Analytic Storyteller in the Course of Time," *October* 46 (Fall 1988), 118. The diagnosis is even more generally applicable to Kluge's feature films. While these regularly comprise acted sequences, nuclei for potential filmic plots, they often unfold these elements only in a fragmentary manner. To make this point is not to deny the validity of Kluge's repeated claim that he is a "storyteller." But his is a recalibrated narrative practice whose main organizational parameters are montage and what he calls "die Darstellung von Differenz" [the representation of difference]. See Alexander Kluge and Jochen Rack, "Erzählen ist die Darstellung von Differenz. Alexander Kluge im Gespräch mit Jochen Rack," *Neue Rundschau* 112, no. 1 (2001), 85. See also the preamble to Kluge's second lecture on poetics at the Goethe-Universität in Frankfurt, in which he states that individual sentences are linked to each other ("verbinden sich") through montage "durch Montage."

And further: "You can also call this an architecture of context, or of constellations." Alexander Kluge, *Theorie der Erzählung. Frankfurter Poetikvorlesungen* (Berlin: Suhrkamp, 2013). The quote is from pp. 20–21 of the booklet that accompanies two DVDs, which document Kluge's lectures. (On Kluge's notion of architecture, see the remainder of this chapter. Kluge's concept of context—*Zusammenhang*—is analyzed in chapter 2; chapter 4 presents an analysis of the concept of the constellation.) See also Kluge's occasional related rejection of a thematic definition of stories: "(As a genre) stories are not thematic. They are abbreviated images ('flashes')." Alexander Kluge, "Zeitenwechsel (rasch)," in Axel Honneth, Thomas McCarthy, Claus Offe, and Albrecht Wellmer, eds., *Zwischenbetrachtungen. Im Prozeß der Aufklärung. Jürgen Habermas zum 60. Geburtstag* (Frankfurt am Main: Suhrkamp, 1989), 813. For a detailed analysis of how a single Klugean cinema story relies on montage and/as the variation of different time-image perspectives, see Philipp Ekardt, "Film ohne Star. Alexander Kluges Präsensgeschichte über Asta Nielsen," in Armen Avanessian and Anke Hennig, eds., *Der Präsensroman* (Berlin: de Gruyter, 2013), 237–247.For a more extensive account of Kluge's montage technique see below, chapters 2, 4, and 9, *passim.*In his analysis of the constructional principle that underlies Kluge's literary texts, Fredric Jameson makes reference to the concept of collage, not montage, but comes to a similar conclusion: "Kluge distributes the building blocks of … what may be called nonexistential segments, which is to say nonnarrative units set side by side in a kind of collage." Jameson, "War and Representation," *PMLA* 124, no. 5 (October 2009), 1544.

4. Strictly speaking, this retelling includes a shift in perspective. Whereas the filmic image shows the sunrise over Frankfurt, Kluge's story combines a description of this sunrise with the act of recounting how that sunrise was filmed. In a section of notes at the end of the volume, a standard feature of Kluge's literary and theoretical books, he connects this story explicitly to the opening sequence of *Macht der Gefühle*. See Kluge, *Geschichten vom Kino*, 311.

5. Ibid., 16.

6. Ibid., 17.

7. See Philipp Ekardt and Alexander Kluge, "Returns of the Archaic, Reserves for the Future: A Conversation with Alexander Kluge," *October* 138 (Fall 2011), 123.

8. Helma Sanders-Brahms recounts how, in Kluge's Munich office, the *Gesang der Rheintöchter*—the overture to Wagner's *Ring*—was a recurring musical presence. See Helma Sanders-Brahms, "… desto ferner sieht es zurück. 'Die Patriotin' von Alexander Kluge," *Film und Fernsehen* 1 (1992), 11. Kluge's later story, "Die Götterdämmerung in Wien" (Twilight of the Gods in Vienna), fictionalizes the rehearsal and performance of the *Ring*'s last night, during World War II's final bombings in Vienna. When it was first published, this text was dedicated to Heiner Müller. See Alexander Kluge, "Die Götterdämmerung in Wien (für Heiner Müller)," in Christian Schulte, ed., *Die Schrift an der*

Wand. Alexander Kluge: Rohstoffe und Materialien (Osnabrück: Rasch, 2000), 23–29. Wagner's work forms one of the topics of a conversation between Müller and Kluge broadcast as a TV program under the title "Anti-Oper, Materialschlachten von 1914, Flug über Sibirien" (Anti-Opera, Battles of the Material in 1914, Flight over Siberia). The transcript was published in Alexander Kluge and Heiner Müller, *Ich bin ein Landvermesser. Gespräche. Neue Folge* (Hamburg: Rotbuch, 1996), 119–142. Bayreuth and other performances of Wagner's operas, among them Müller's stagings, stand at the center of a later conversation between Kluge and Pierre Boulez. See Alexander Kluge and Pierre Boulez, "Das Ruinengesetz in der Musik," in Schulte, *Die Schrift an der Wand*. For an analysis of Kluge's story and his conversation with Boulez, see chapter 2.

9. See Uwe Rada, "Revolution der Feierabendguerilla," *Die Tageszeitung*, November 12, 2013, retrieved at <http://www.taz.de/!5055119/>.

10. See Alexander Kluge, "The Air Raid on Halberstadt on 8 April 1945," in Kluge, *Air Raid*, trans. Martin Chalmers (London: Seagull Books, 2014), 1; translation modified. For the original German, see Kluge, "Der Luftangriff auf Halberstadt am 8. April 1945," in *Neue Geschichten. Hefte 1–18. Unheimlichkeit der Zeit* (Frankfurt am Main: Suhrkamp, 1977), 34–35.

11. Kluge, "The Air Raid on Halberstadt," 1, 3; "Der Luftangriff auf Halberstadt," 35 (translation modified).

12. See also Kluge's comment on the "Reichsruinengesetz [the law of ruins]," in conversation with Pierre Boulez: "There is a decree by Hitler, made in 1943, the so called 'Reichsruinengesetz.' —It ordered that all materials for National Socialist monuments were not to be used in a cost-saving manner, but in such a way that they would look impressive in 6,000 years. That's the law of ruins." Kluge and Boulez, "Das Ruinengesetz in der Musik," 15. For an analysis of the complex situatedness of *Brutalität in Stein* both within German political history and the history of German film, see Eric Rentschler, "Remembering Not to Forget: A Retrospective Reading of Kluge's 'Brutality in Stone'," *New German Critique* 49 (Winter 1990), 23–41.

13. See ibid., 33, for a juxtaposition of *Brutalität in Stein* and Riefenstahl's treatment of the party congress grounds.

14. The Aktion Barbarossa also figures in *Nachrichten von den Staufern* through filmed military maps, photographs, and images of pages from history books.

15. Alexander Kluge, *Der Angriff der Gegenwart auf die übrige Zeit. Abendfüllender Spielfilm, 35 mm, Farbe mit s/w-Teilen, Format: 1: 1,37. Drehbuch* (Frankfurt am Main: Syndikat, 1985), 8.

16. Ibid., 109–110. The translation of Kluge's term *umbauter Raum* is not unproblematic: literally, the German expression means "space enclosed by built elements." The customary English-language formulation "enclosed space" lacks the element of building. The

concept is, however, of a certain importance in Kluge's thinking, and especially in those parts of his work that deal with architecture. Its prime model is the tomb (see below). To accommodate these associations and implications, "walled-in space" here is a certainly inelegant, if not downright awkward, but perhaps tolerable compromise.

17. Kluge, *Der Angriff der Gegenwart auf die übrige Zeit. Drehbuch*, 109.

18. Alexander Kluge, *Die Macht der Gefühle* (Frankfurt am Main: Zweitausendeins, 1984), 214. In addition to providing a topological model for the nexus of cinema and affect, the image of being buried alive also encodes one of the central collective experiences negotiated in Kluge's *œuvre*: the huddling in shelters during the carpet bombings in 1945. On the processing of such experiences in Kluge's (and Negt's) writing, see Devin Fore, introduction to Alexander Kluge and Oskar Negt, *History and Obstinacy*, ed. Devin Fore (New York: Zone Books, 2014), 62.

19. Alexander Kluge and Florian Rötzer, "Kino und Grabkammer," in Schulte, *Die Schrift an der Wand*, 33.

20. See Jean-Louis Baudry, "Le dispositif: approches métapsychologiques de l'impression de réalité," *Communications* 73 (1975), 56–72; translated as "The Apparatus: Metapsychological Approaches to the Impression of Reality in Cinema," in Philip Rosen, ed., *Narrative, Apparatus, Ideology: A Film Theory Reader* (New York: Columbia University Press, 1986), 299–318. Foucault uses the term in the fourth chapter of his *La volonté de savoir*, titled "Le dispositif de la sexualité." See Michel Foucault, *Histoire de la sexualité*, vol. I, *La volonté de savoir* (Paris: Gallimard, 1976), 99–173. He explains it in a conversation published under the title "Le jeu de Michel Foucault" in the journal *Ornicar? Bulletin périodique du champ freudien* in 1977. See the reprint in Michel Foucault, *Dits et écrits*, vol. III *(1976–1979)* (Paris: Gallimard, 1994, 298–329). The partially abridged English translation gives a number of important passages where Foucault defines the *dispositif* very broadly as "a thoroughly heterogeneous ensemble consisting of discourses, institutions, architectural forms, regulatory decisions, laws, administrative measures, scientific statements, philosophical, moral and philanthropic propositions—in short the said as much as the unsaid. … The *dispositif* is precisely the system of relations that can be established between these elements … the *dispositif* in its general form is both discursive and non-discursive." Michel Foucault, *Power/Knowledge: Selected Interviews and Other Writings 1972–1977*, ed. Colin Gordon (Brighton: Harvester Press, 1980), 194–197. Translation is centrally modified in that the rendering of *dispositif* as "apparatus" has been changed to "*dispositif*."

21. Kluge, *Cinema Stories*, 3, translation modified; *Geschichten vom Kino*, 33. "This machine wasn't new. It consists of an entrance (a portal), a box office where the entrance money is paid, an exit, a projection hall (just like in a theater), and an audience" (translation modified).

22. Ibid. See the feature "Das Bild Europas. Eine Ausstellung von Rem Koolhaas im HAUS DER KUNST, München" [The Image of Europe. An exhibition by Rem Koolhaas at the Haus der Kunst in Munich], broadcast on RTL in the series *Prime Time* on February 6, 2005. Also another one on February 27 of the same year, an interview with Koolhaas, under the title "Das Ungebaute kritisiert das Gebaute" [The Unbuilt Criticizes the Built]—a variation of Kluge's own credo "Das Unverfilmte kritisiert das Verfilmte" [The unfilmed criticizes the filmed]. See the list compiled by Kluge's production assistant Beata Wiggen which appeared in a special issue, "Die Bauweise von Paradiesen. Für Alexander Kluge," of the journal *Maske und Kothurn* 53, no. 1 (2007), 182.

23. See the chapter "Coney Island: The Technology of the Fantastic," in Rem Koolhaas, *Delirious New York: A Retroactive Manifesto for Manhattan* (New York: Monacelli Press, 1994), 29–79. Koolhaas does not mention nickelodeons or penny arcades in this chapter. In Kluge's work, this interest in the minute architectural units of the *Kino-Automaten*, the small diameter of the peephole, and the brevity of archaic film, feeds into a poetics of short durations, small forms, and an aesthetics of the glimpse (see chapter 9). See also Kluge's statements in Ekardt and Kluge, "Returns of the Archaic, Reserves for the Future," 124–125, where he develops a dialectic between the brevity of the clip, and the smallness of a mobile phone's screen on one hand, and works of very extended duration, such as his DVDs and the very large format of public projections, on the other.

24. Kluge, *Geschichten vom Kino*, 34; *Cinema Stories*, 3, translation modified. Miriam Hansen points to a similar genealogy of cinema as an initially "illegitimate" art form that was developed by Kluge's teachers Adorno and Horkheimer in their *Dialektik der Aufklärung* (*Dialectic of Enlightenment*). See Miriam Hansen, "Introduction to Adorno, 'Transparencies on Film' (1966)," *New German Critique*, no. 24/25 (Autumn 1981–Winter 1982), 197. See also her article "Reinventing the Nickelodeon: Notes on Kluge and Early Cinema," *October* 46 (Fall 1988), 179–198.

25. Kluge, *Geschichten vom Kino*, 34; *Cinema Stories*, 3 (translation modified).

26. Kluge, *Geschichten vom Kino*, 38; *Cinema Stories*, 7 (translation modified).

27. Kluge, *Geschichten vom Kino*, 38; *Cinema Stories*, 7 (translation modified).

28. Alexander Kluge, *In Gefahr und größter Not bringt der Mittelweg den Tod. Texte zu Kino, Film, Politik*, ed. Christian Schulte (Berlin: Vorwerk 8, 1999), 158.

29. Kluge, *Geschichten vom Kino*, 39; *Cinema Stories*, 8.

30. Kluge, *Geschichten vom Kino*, 38; *Cinema Stories*, 8 (translation modified).

31. Or, as Kluge puts it elsewhere: "Das ist eine Architektur unserer Erfahrung, die ja auch ein Medium ist." [This is an architecture of our experience, which is also a medium.] Kluge and Rötzer, "Kino und Grabkammer," 33. He also discusses spaces

and time forms (*Räume und Zeitformen*) which are vessels (*Gefäße*) in which experience dwells, or lives, which it inhabits (*wohnen*). These, Kluge calls *nicht-endgültige Architekturen* (non-definite architectures). See ibid.

32. See Walter Benjamin, "The Work of Art in the Age of Its Technological Reproducibility," in Benjamin, *The Work of Art in the Age of Its Technological Reproducibility, and Other Writings on Media*, ed. Michael W. Jennings, Brigid Doherty, and Thomas Y. Levin (Cambridge, MA: Belknap Press, 2008), 19–66; originally "Das Kunstwerk im Zeitalter seiner technischen Reproduzierbarkeit. Zweite Fassung," in Benjamin, *Gesammelte Schriften*, vol. 7.1, ed. Rolf Tiedemann and Hermann Schweppenhäuser (Frankfurt am Main: Suhrkamp, 1989), 351–384. For Benjamin, the point of comparison between architecture and film lies in the fact that they both provoke a type of reception based on "Gewohnheit [habit]." See "Das Kunstwerk im Zeitalter seiner technischen Reproduzierbarkeit," 381; "The Work of Art in the Age of Its Technological Reproducibility," 39–40. The mode in which Kluge refers to Benjamin here can be described as an example of his characteristic paraphrases: i.e., abbreviated and condensed versions of preexisting texts, films, or images, into which Kluge usually instills moments of derivation from the factual, divergences into the realm of the possible. For a more encompassing analysis of this concept of the paraphrase in Kluge's work, see chapters 4 and 6 below.

33. Kluge and Rötzer, "Kino und Grabkammer," 31. See Baudry, "The Apparatus," *passim*.

34. Kluge and Rötzer, "Kino und Grabkammer," 32.

35. Kluge in conversation with Edgar Reitz. Edgar Reitz, *Bilder in Bewegung. Essays, Gespräche zum Kino* (Reinbek bei Hamburg: Rowohlt, 1995), 75.

36. Theodor W. Adorno, "Filmtransparente," in *Gesammelte Schriften*, vol. 10.1, ed. Rolf Tiedemann et al. (Frankfurt am Main: Suhrkamp, 2003), 354; translated as "Transparencies on Film," by Thomas Y. Levin, *New German Critique*, no. 24/25 (Autumn 1981–Winter 1982), 200. Miriam Hansen has made the strongest case for a parallel reading of Kluge's and Adorno's works. Regarding Adorno's "Filmtransparente" article which the philosopher wrote in support of the Oberhausen manifesto, see Hansen, "Introduction to Adorno." This suggestion is reinforced by a conversational remark on Adorno's part: "Herr Dr. Kluge and I have been friends for many years, and in this friendship conversations on the problematics of film have time and again played a very important role." See Scriptum Podiumsgespräch mit der "Gruppe junger deutscher Film" zum Thema "Forderungen an den Film" während der "Internationalen Filmwoche Mannheim 1962." The script is kept at the Adorno-Archiv at the Akademie der Künste, Berlin, where its call number is Adorno-Archiv Ge 142/1–24. Numbers after the slash indicate the respective pages of the typescript: here Ge 142/2. The other discussants were Joseph Rovan and, as representatives of the Oberhausen group, Kluge, Strobel, Reitz, and Senft.

CHAPTER 2

1. In their joint 1974 work *In Gefahr und größter Not bringt der Mittelweg den Tod* (*In Danger and Dire Distress the Middle of the Road Leads to Death*), Kluge and his fellow director and cameraman Edgar Reitz assembled an array of filmic shots that perform a similar task. The film documents the forceful eviction by the police of the inhabitants of squatted houses in Frankfurt am Main, as well as the subsequent demolition of these buildings to erect commercial architecture in their place. Cinematically captured through takes of mirroring office towers under construction, it is film, not a map, that gives us an image of architecture's past futurities—impending absence and coming presence are juxtaposed.

2. Alexander Kluge and Gertrud Koch, "Die Funktion des Zerrwinkels in zertrümmernder Absicht. Ein Gespräch," in Rainer Erd, Dietrich Hoß, Otto Jacobi et al., eds., *Kritische Theorie und Kultur* (Frankfurt am Main: Suhrkamp, 1989), 116.

3. Alexander Kluge, *In Gefahr und größter Not bringt der Mittelweg den Tod. Texte zu Kino, Film, Politik*, ed. Christian Schulte (Berlin: Vorwerk 8, 1999), 204. The base for this Klugean variation is the Godardian dictum—from his 1960 feature film *Le petit soldat*—that cinema is truth 24 times/second. Miriam Hansen relates this film-theoretical concept to apparatus theory and to the work of Marker, Mangold, and others in her posthumously published *Cinema and Experience: Siegfried Kracauer, Walter Benjamin, and Theodor W. Adorno* (Berkeley: University of California Press, 2012), 237. For a general account of filmic procedures as "subtraction," and a concomitant understanding of film as "forming reality's negative imprint," see Dudley Andrew, "A Film Aesthetic to Discover," *Cinémas. Revue d'études cinématographiques / Journal of Film Studies* 17, no. 2–3 (Spring 2007), 59. Andrew connects this negative film aesthetic to a conception of cinema as an "art of absence" (ibid.) as proposed by Godard (see below). See, finally, Alexander Kluge, "Die Macht der Bewußtseinsindustrien und das Schicksal unserer Öffentlichkeit," in Klaus von Bismarck, Günter Gaus, Alexander Kluge, and Ferdinand Sieger, eds., *Industrialisierung des Bewußtseins: Eine kritische Auseinandersetzung mit den "neuen" Medien* (Munich: Piper, 1985), 105–106, where Kluge contrasts this technological feature of film with electronic image media, such as television. For an analysis of Kluge's strategies for reinstating these moments of interruption and suspension, which he also calls "Zeitorte" (time sites), see chapter 4 below.

4. Alexander Kluge, *Cinema Stories*, trans. Martin Brady and Helen Hughes (New York: New Directions, 2007), 12. For the original German, see Kluge, *Geschichten vom Kino* (Frankfurt am Main: Suhrkamp, 2007), 43. (The capitals are Kluge's.)

5. Kluge, *Cinema Stories*, 107; *Geschichten vom Kino*, 329.

6. Kluge, *Cinema Stories*, 105–106; *Geschichten vom Kino*, 327–328.

7. Jean-Luc Godard, *Histoire(s) du Cinéma* (Paris: Gallimard/Gaumont, 2006), 140, 143, 145.

8. Alexander Kluge and Florian Rötzer, "Kino und Grabkammer," in Christian Schulte, ed., *Die Schrift an der Wand. Alexander Kluge: Rohstoffe und Materialien* (Osnabrück: Rasch, 2000), 35.

9. Ibid. See also Kluge and Koch, "Die Funktion des Zerrwinkels in zertrümmernder Absicht," 115.

10. Edgar Reitz, Alexander Kluge, and Wilfried Reinke, "Wort und Film," in Alexander Kluge, *In Gefahr und größter Not bringt der Mittelweg den Tod. Texte zu Kino, Film, Politik*, ed. Christian Schulte, 3rd, altered edn. (Berlin: Vorwerk 8, 2011), 25–26.

11. Peter C. Lutze identifies image clusters organized according to thematic similarity as basic building blocks for Kluge's films. See his monograph *Alexander Kluge: The Last Modernist* (Detroit: Wayne State University Press, 1998), 126. One could connect such thematic similarity to the abovementioned formation of themes and motifs, keeping in mind, however, that for Kluge their internal differentiation is at least as important as their agglomeration along vectors of likeness (see also the discussion of "complex themes" in Kluge's television programs in chapter 3 below).

12. Alexander Kluge, "Die Götterdämmerung in Wien," in *Geschichten vom Kino*, 155. Alexander Kluge: "The Twilight of the Gods in Vienna," trans. Deborah Holmes, in: *Vienna Tales*, ed. Helen Constantine (Oxford: Oxford University Press, 2014), 45–59 (here p. 50).

13. Kluge, *Geschichten vom Kino*, 157. Kluge, "The Twilight of the Gods in Vienna," 52–53.

14. Kluge, *Geschichten vom Kino*, 157–158. Kluge, "The Twilight of the Gods in Vienna," 53.

15. Alexander Kluge and Pierre Boulez, "Das Ruinengesetz in der Musik," in Schulte, *Die Schrift an der Wand*, 17. See ibid., 16–17.

16. Ibid., 16.

17. Ibid., 17.

18. Kluge and Rötzer, "Kino und Grabkammer," 42; Kluge and Koch, "Die Funktion des Zerrwinkels in zertrümmernder Absicht," 115.

19. Kluge and Rötzer, "Kino und Grabkammer," 35.

20. Ibid.; Alexander Kluge et al., "'In Gefahr und größter Not bringt der Mittelweg den Tod': Ulmer Dramaturgien," in Klaus Eder and Alexander Kluge, eds., *Ulmer Dramaturgien. Reibungsverluste. Stichwort: Bestandsaufnahme* (Munich: Hanser, 1980), 98.

21. Maciej Sliwowski's, Jay Leyda's, and Annette Michelson's translation of Eisenstein's "Notes for a Film of *Capital*" appeared in *October* 2 (Summer 1976), 3–26. See Annette Michelson, "Reading Eisenstein Reading *Capital*," *October* 2 (Summer 1976), 27–38, for her pioneering essay on Eisenstein's project. A short entry in *Geschichten vom Kino* also mentions Eisenstein's project. See Kluge, *Cinema Stories*, 45–46; *Geschichten vom Kino*, 148–149.

22. Philipp Ekardt and Alexander Kluge, "Returns of the Archaic, Reserves for the Future: A Conversation with Alexander Kluge," *October* 138 (Fall 2011), 131.

23. Ibid., 130.

24. Noël Carroll, "For God and Country," *Artforum* 11, no. 5 (January 1973), 56.

25. See Jacques Aumont, *Montage Eisenstein* (London: BFI Publishing; Bloomington: Indiana University Press, 1987), 163. For an account of the historical context of dialectical materialism in the Soviet Union when Eisenstein developed his project, see ibid., 65–66.

26. Gilles Deleuze, *Cinema I: The Movement-Image* (Minneapolis: University of Minnesota Press, 1986), 180.

27. Michelson, "Reading Eisenstein Reading *Capital*," 29.

28. Ibid.

29. See Sergei Eisenstein, "A Dialectical Approach to Film Form," in Jay Leyda, ed., *Film Form: Essays in Film Theory* (New York: Harcourt, Brace, 1949), 45–63. For Eisenstein's discussion of the sequence that Kluge picks up in *Artisten in der Zirkuskuppel*, which for the Soviet director exemplifies the artificial production of motion, see ibid., 55.

30. Kluge et al., "'In Gefahr und größter Not bringt der Mittelweg den Tod'," 38. One exemplary case of this gesture which identifies Eisenstein's work as a touchstone for understanding Kluge's practice is Christina Scherer, "Alexander Kluge und Jean-Luc Godard: Ein Vergleich anhand einiger filmtheoretischer "Grundannahmen," in Schulte, *Die Schrift an der Wand*, 90, 91, 97.

31. The following paragraphs are not intended to give a complete reconstruction of Eisenstein's montage theory and practice, both of which undergo a number of transformations throughout Eisenstein's career as a filmmaker. Rather, the subsequent argument merely presents a highly selective probing of a few interconnections between Kluge's and Eisenstein's works, as suggested through references in Kluge's texts and films. For a general account of Eisensteinian montage, see Aumont, *Montage Eisenstein*, especially the chapter "Montage in Question," 145–199.

32. Miriam Hansen, "Alexander Kluge: Crossings between Film, Literature, Critical Theory," in Sigrid Bauschinger, Susan L. Cocalis, and Henry A. Lea, eds., *Film und Literatur: Literarische Texte und der neue deutsche Film* (Berne: Francke, 1984), 169–196. See also Stuart Liebmann, "Why Kluge?," *October* 46 (Fall 1988), 18–22.

33. According to Aumont, the general Eisensteinian equation of cinema with montage is even located on a level that precedes actual editing: it is articulated in "the idea that there is something 'of the order' of montage even at the most elementary level, such as the movement from one frame to the next" (Aumont, *Montage Eisenstein*, 155; see also ibid., 156). However, Hansen's argument seems perfectly reconcilable with the *stylistic* analysis proposed by Annette Michelson, who points out that after the making of *October*, Eisenstein's cinema increasingly becomes "identified with the *fixed* shot as the dominant component of the montage style." Michelson, "Reading Eisenstein Reading *Capital*," 35–36.

34. Sergei Eisenstein, "The Cinematographic Principle and the Ideogram," in Leyda, *Film Form*, 36.

35. Ibid., 37. See also Deleuze's definition of dialectical montage as a process in which "the one divides itself"; Deleuze, *Cinema I: The Movement-Image*, 34. On the fundamentality of the notion of conflict for Eisenstein's understanding of the dialectic and film aesthetics in general, see Aumont, *Montage Eisenstein*, 67–68. Aumont further explains that Eisenstein's later concept of montage, which he developed in his writings of the late 1930s, can be regarded as a successor to the formerly central term "conflict" (ibid., 155). This is the case, for example, in the text "Laocoön," where Eisenstein claims that "montage pervades all 'levels of film-making, beginning with the basic cinematic phenomenon, through 'montage proper' and up to the compositional totality of the film as a whole." Sergei Eisenstein, "Laocoön," in *Selected Works*, vol. 2, ed. Michael Glenny and Richard Taylor (London: BFI Publishing, 1994), 109. On conflict and the related idea of a collision of shots, see Michelson, "Reading Eisenstein Reading *Capital*," 30.

36. Eisenstein, "Laocoön," 128.

37. Deleuze, *Cinema I: The Movement-Image*, 33–34.

38. Ibid., 33.

39. Annette Michelson, "Camera Lucida/Camera Obscura," *Artforum* 11, no. 5 (January 1973), 34.

40. Ibid., 34–35. The second quote is from Michelson, "Reading Eisenstein Reading *Capital*," 30.

41. *Abschied von gestern* (*Yesterday Girl*), for example, reads as the story of a young woman, the child of Holocaust survivors and an immigrant from East to West Germany, who gradually slips into a state of a petty delinquency and an existence as a social outcast.

42. The introduction to *Macht der Gefühle*, with its juxtapositions of historic footage, documentary takes, varying themes, multiple registers of rendering history, etc., is a good example here (see chapter 1 above).

43. Kluge's montage sequences *do* work toward the construction of contexts (*Zusammenhänge*). However, his understanding of context has nothing to do with a given profilmic or pre-narratively existing stratum of "reality" that merely awaits depiction (see below, section on *Zusammenhang*/"context").

44. See also Kluge's statement: "Bilder sind konkret und dann sind sie autonom [images are concrete, and furthermore, they are autonomous]"; in Alexander Kluge and Gertrud Koch, "Grundströme des Kapitals. Ein Interview mit Alexander Kluge von Gertrud Koch," *Texte zur Kunst 73* (March 2009), 93.

45. See Eisenstein, "The Cinematographic Principle and the Ideogram," 30.

46. For a contextualization of Eisenstein's ideas on the ideogram and montage within a more general theory of writing, see the chapter "Cinema and Writing" in Christian Metz, *Language and Cinema* (The Hague: Mouton, 1974), especially 271–284.

47. Alexander Kluge, Frieda Grafe, and Enno Patalas, "Interview mit dem Regisseur von *Die Artisten in der Zirkuskuppel: ratlos*," *Filmkritik* 9 (1966), 491.

48. See also Kluge's critique that Eisenstein "ernennt die Bilder zu Sprache [simply takes images for a language]": Kluge and Koch, "Grundströme des Kapitals," 93.

49. See Eisenstein, "The Cinematographic Principle and the Ideogram," 30–32.

50. See Sergei Eisenstein, "On the Structure of Things," in *Nonindifferent Nature* (Cambridge: Cambridge University Press, 1987), 3–37.

51. Ibid., 14, 35.

52. Sergei Eisenstein, "Word and Image," in Jay Leyda, ed., *The Film Sense* (New York: Harcourt, Brace, 1947), 9.

53. Eisenstein, "Laocoön," 128.

54. Ibid., 129.

55. Kluge, *Cinema Stories*, 45–49; *Geschichten vom Kino*, 146–150.

56. See also the interview with Kaufman in *October* 11 (Winter 1979), 54–76.

57. See Kluge, *Cinema Stories*, 45; *Geschichten vom Kino*, 146.

58. Kluge, *Cinema Stories*, 45; *Geschichten vom Kino*, 146.

59. Miriam Hansen, "Cooperative Auteur Cinema and Oppositional Public Sphere: Alexander Kluge's Contribution to *Germany in Autumn*," *New German Critique* 24/25 (Autumn 1981–Winter 1982), 48; Kluge and Koch, "Grundströme des Kapitals," 91.

60. Jacques Aumont, *Les théories des cinéastes* (Paris: Armand Colin, 2005), 14.

61. Dziga Vertov, *Kino-Eye: The Writings of Dziga Vertov*, ed. Annette Michelson (Berkeley: University of California Press, 1984), 41.

62. Ibid., 91.

63. Ibid., 90.

64. The interval, writes Vertov, "consists of the sum of various correlations," such as the correlation of planes (close-up, long shot, etc.); the correlation of foreshortenings; the correlation of movements within the frame; the correlation of light and shadow; the correlation of recording speed. Ibid.

65. Jonathan Beller's account of the interval as "negative space between the montage fragments" is convincing to the extent that it emphasizes its negative character. The interval's supposed spatiality, however, would seem to require a more extensive argument. See Jonathan Beller, "Dziga Vertov and the Film of Money," *boundary 2* 26, no. 3 (Autumn 1999), 160. See also Aumont, *Les théories des cinéastes*, 14: "The term 'interval' refers to … what separates two fragments of the same film."

66. Vertov, *Kino-Eye*, 90. For Michelson's statement, see her "'The Man with the Movie Camera': From Magician to Epistemologist," *Artforum* 10, no. 7 (March 1972), 65.

67. Vertov, *Kino-Eye*, 20. In a different text, Michelson emphasizes that Vertov's concept of the interval exceeds the mere editing of visual parameters and figures ultimately as the "operative compositional principle invoked at every level of the labor process." See Annette Michelson, "The Wings of Hypothesis: On Montage and the Theory of the Interval," in Matthew Teitelbaum, ed., *Montage and Modern Life, 1919–1942* (Cambridge, MA: MIT Press; Boston: Institute of Contemporary Art, 1992), 72.

68. Deleuze, *Cinema I: The Movement-Image*, 82.

69. Ekardt and Kluge, "Returns of the Archaic, Reserves for the Future," 125.

70. Rainer Lewandowski, *Die Filme von Alexander Kluge* (Hildesheim: Olms, 1980), 7. See also Scherer, "Alexander Kluge und Jean-Luc Godard," 79–81.

71. See, for instance, Kluge's statements in an interview with Rainer Lewandowski in Lewandowski, *Die Filme von Alexander Kluge*, 53. On Godard's initial admiration for Eisenstein, his later orientation toward Vertov, and his subsequent reappraisal of Eisensteinian montage, see Peter Wollen, "Perhaps …," *October* 88 (Spring 1999), 44; and Michael Witt, "Montage, My Beautiful Care, or Histories of the Cinematograph," in Michael Temple and James S. Williams, eds., *The Cinema Alone: Essays on the Work of Jean-Luc Godard 1985–2000* (Amsterdam: Amsterdam University Press, 2000), 36–37.

72. Witt, "Montage, My Beautiful Care," 37.

73. Ekardt and Kluge, "Returns of the Archaic, Reserves for the Future," 127.

74. Witt, "Montage, My Beautiful Care," 37.

75. Jean-Luc Godard, "Propos rompus en Avignon," in *Jean-Luc Godard par Jean-Luc Godard*, ed. Alain Bergala (Paris: Cahiers du Cinéma/Éditions de l'Étoile, 1985), 458, 460.

76. As quoted in Aumont, *Les théories des cinéastes*, 47. See also Aumont's diagnosis that Godard's work signifies the passage toward a "cinéma de l'image" (ibid., 44).

77. Jean-Luc Godard, *Introduction à une véritable histoire du cinéma*, vol. 1 (Paris: Éditions Albatros, 1980), 22.

78. Ibid.

79. As quoted in Witt, "Montage, My Beautiful Care," 47. See also Godard, *Introduction à une véritable histoire du cinéma*, vol. 1, 175.

80. Gilles Deleuze, *Cinema II: The Time-Image* (Minneapolis: University of Minnesota Press, 1989), 179. See also, for further clarification, Deleuze's text "Three Questions Regarding Six Fois Deux (Godard)," in which he explicitly contrasts this model of differentiation with Eisenstein's paradigm of the dialectic. (In *Jean-Luc Godard: Son + Image 1974–1991*, ed. Raymond Bellour [New York: Harry N. Abrams/MoMA, 1992]).

81. Deleuze, *Cinema II: The Time-Image*, 181.

82. Ibid., 179.

83. Jean-Luc Godard, "Le montage, la solitude, la liberté," in *Jean-Luc Godard par Jean-Luc Godard,* vol. 2, ed. Alain Bergala (Paris: Cahiers du Cinéma, 1998), 242.

84. Ibid.

85. Ekardt and Kluge, "Returns of the Archaic, Reserves for the Future," 132. Godard expresses a similar preference for the silent era, and even advances the idea that cinema's montage potential was stunted with the emergence of sound film: "The cinema never found montage. Something has gone missing in the period of sound film." Jean-Luc Godard, "Godard fait des histoires. Entretien avec Serge Daney," in *Jean-Luc Godard par Jean-Luc Godard*, vol. 2, 164.

86. Again translation proves difficult. For a comment regarding the English rendering of Kluge's concept of *Zusammenhang* as "context" in this book, see the section 'A Note on Translation' in the preface. Another German term that requires a few explanatory words is *Abbildlichkeit*, which indicates a semiotic relation by which an image/sign designates a signified by way of visualization. Strongly associated with religious or magic contexts, *Abbildlichkeit* underwent both a theological critique in German Protestantism, and again a philosophical critique in German idealism and romantic philosophy. The ancestral text for these negotiations is, obviously, Plato's *Republic*. Kluge's connection to this strand

runs primarily through the intellectual enterprise of his teacher Adorno. I will translate *Abbildlichkeit* as "likeness," fully accepting the theological baggage that comes with the term. Gertrud Koch analyzes Adorno's theories of mimesis and *Bilderverbot* (the ban on graven images) in relation both to the latter term's genealogy in Jewish theological thinking and to Adorno's film-theoretical predicaments in "Filmtransparente" (Transparencies on Film), in her essay "Mimesis and the Ban on Graven Images," in Hent de Vries and Samuel Weber, eds., *Religion and Media* (Stanford: Stanford University Press, 2001), 151–162. She also connects Kluge's filmic practice to the resultant "Critical Theorists' ambivalence toward images" (ibid., 161). Another important concept in the German philosophical tradition with which Adorno and Kluge here engage is that of *Anschauung* and *Anschaulichkeit*. Since the time of Goethe and Weimar classicism, *Anschaulichkeit* has referred to an immediate embeddness of cognitive and conceptual content in sensorial perception (see below). In Eisenstein's terms, the issue would be one of *obraz* vs. *izobrazhenie*, i.e., image versus depiction (see above).

87. Kluge et al., "'In Gefahr und größter Not bringt der Mittelweg den Tod'," 48.

88. Kluge and Koch, "Die Funktion des Zerrwinkels in zertrümmernder Absicht," 116.

89. Reitz, Kluge, and Reinke, "Wort und Film," 24. In this case, the German term *Anschauung*, not *Abbildlichkeit*, has been rendered as "likeness." *Anschauung*, which is not a quantitative noun—i.e., for which strictly speaking there exists neither 'too much' nor 'too little'—here conveys the object's part within the construction of *Anschaulichkeit*. It is what a perceiving and cognitive subject sees and understands about the object in the act of seeing and understanding: how the object presents itself in and through vision and cognition. In a transposition to the system of film, the authors use it to refer to an exaggerated claim of resemblance associated with the recording powers of the camera, and what it shows about, and not just of the world. See, for example, Adorno's reading of Hölderlin's poetics and his poetry of the caesura: "Geschichte durchschneidet das Band, welches nach klassizisitscher Ästhetik Idee und Anschauung im sogenannten Symbol verknüpft. [History cuts the ribbon which, according to classicist aesthetics, binds idea and *Anschauung* in the so-called symbol.]" Theodor W. Adorno, "Parataxis," in *Noten zur Literatur* (Frankfurt am Main: Suhrkamp, 1981), 465. Miriam Hansen first underlined the importance of Adorno's negative aesthetic for Kluge's practice. See Hansen, "Alexander Kluge: Crossings between Film, Literature, Critical Theory," 180.

90. Theodor W. Adorno, "Transparencies on Film," trans. Thomas Y. Levin, *New German Critique*, no. 24/25 (Autumn 1981–Winter 1982), 200; originally "Filmtransparente," in *Gesammelte Schriften*, vol. 10.1, ed. Rolf Tiedemann et al. (Frankfurt am Main: Suhrkamp, 2003), 354.

91. Adorno, "Transparencies on Film," 202 (translation modified); "Filmtransparente," 357.

92. Adorno, "Transparencies on Film," 202 (translation modified); "Filmtransparente," 357. Beyond the possible translation of Adorno's formulation "erscheinende Ober-fläche" as "phenomenal surface," i.e., as pertaining to the realm of phenomena, his wording also carries a reference to the problem of *Erscheinung* (appearance) and *Schein* (semblance). Both are integral to Adorno's (and, arguably, Benjamin's) reflections on camera-based media technologies. They are also, mostly via Adorno's influence, impor-tant for Kluge's image theory and practice. In the tradition of Critical Theory they connect the philosophical and poetological question of mimesis to the Judeo(-Christian) theological strand of a ban on images (see note 86), as well as to the aesthetic question of the sublime and the beautiful.

93. Adorno, "Transparencies on Film," 203; "Filmtransparente," 357–358. For an analysis of how this understanding of montage as a "constellation akin to writing" relates to the use of fields of lettering in Kluge's films and clips, see chapter 8 below.

94. Adorno, "Transparencies on Film," 200 (translation modified); "Filmtransparente," 354.

95. Alexander Kluge and Oskar Negt, *History and Obstinacy*, trans. Richard Langston et al. (New York: Zone Books, 2014), 236 (translation modified). For the original German, see Negt and Kluge, *Geschichte und Eigensinn* (Frankfurt am Main: Suhrkamp, 1993), 510. See also Anton Kaes, "Über den nomadischen Umgang mit Geschichte: Aspekte zu Alexander Kluges Film 'Die Patriotin'," *Text + Kritik* 85/86 (1985), 143–144; Bertolt Brecht, "Der Dreigroschenprozess. Ein soziologisches Experiment," in *Schriften*, vol. I (Frankfurt am Main: Suhrkamp/Aufbau, 1992), 469.

96. Kluge, *In Gefahr und größter Not bringt der Mittelweg den Tod* (1999 edn.), 101.

97. Alexander Kluge et al., "Reibungsverluste," in Eder and Kluge, *Ulmer Dramaturgien*, 97. See also Alexander Kluge, *Die Patriotin. Texte. Bilder 1–6* (Frankfurt am Main: Zweitausendeins, 1979), 41.

98. Carl Schmitt's work on Hobbes's *Leviathan* is of crucial importance for Negt and Kluge's argument here. See, for example: "Carl Schmitt legt dar, daß zum Zeitpunkt der ersten englischen Ausgabe des *Leviathan* von Hobbes (1651) die Magie der Bilder sich von den Grunderfahrungen bereits getrennt hat. [Carl Schmitt demonstrates that at the time of the first English edition of Hobbes's *Leviathan* (1651), image magic had already been separated from basic experiences.]" Negt and Kluge, *Geschichte und Eigen-sinn*, 1023.

99. Ibid., 1022.

100. Ibid., 1024.

101. Ibid.

102. Max Horkheimer and Theodor W. Adorno, *Dialectic of Enlightenment*, trans. John Cumming (London: Verso, 1979), 57; originally *Dialektik der Aufklärung* (Frankurt am Main: Fischer, 1988), 64.

103. "Since the end of the sixteenth century there is merely allegorical expression—if any—for the basic experiences which are expressed in these two terrible and fascinating monsters. This does not mean that these two basic experiences—terror and fascination—do not exist any longer. After this point, they merely exist without a bundling expression, they express themselves in dispersal; as fear and attraction, related to all sorts of manifestations." Negt and Kluge, *Geschichte und Eigensinn*, 1024. See also Negt and Kluge's basic definition of the human labor capacity (*Arbeitseigenschaften*): "Die Grundform der meisten mechanischen Arbeitseigenschaften, die die menschlichen Körper auszuführen vermögen … beruht auf der Anwendung unmittelbarer Gewalt. [The basic form of most mechanical labor characteristics that humans perform … relies on the use of direct violence.]" Negt and Kluge, *Geschichte und Eigensinn*, 14; Kluge and Negt, *History and Obstinacy*, 88.

104. Ibid., 1023.

105. Kluge and Koch, "Die Funktion des Zerrwinkels in zertrümmernder Absicht," 119.

CHAPTER 3

1. Alexander Kluge, Astrid Deuber-Mankowsky, and Giaco Schiesser, "In der Echtzeit der Gefühle. Gespräch mit Alexander Kluge," in Christian Schulte, ed., *Die Schrift an der Wand. Alexander Kluge: Rohstoffe und Materialien* (Osnabrück: Rasch, 2000), 363. Kluge's formulation for this last phrase is "ein überprüfbarer Tonfall."

2. Ibid., 361.

3. The story of how Kluge successfully claimed a weekly amount of broadcast time on these commercial channels has entered the annals of recent German media history. After the German conservative party, the Christian Democratic Union, won the 1983 federal elections, plans were put in place to open the—up to that point—exclusively publicly, i.e., state-administered, distribution of television programs to commercial providers. Under these conditions Kluge initially planned to found independent, "third" stations (the *unabhängigen Dritten*) which would broadcast neither "state-administered" nor commercially driven material, and for which the independent New York broadcaster *Papertiger Television* would serve as a possible model. The plan did not materialize. Instead, Kluge developed a tactics of strategic compromise and niche-occupation. Together with Stefan Aust, then editor in chief of *Der Spiegel* magazine, and the Japanese advertising agency Denzo, he formed dctp—the "development company for television programs."

Dctp began providing material for the so-called *Kulturfenster* (cultural windows), a designated amount of broadcast time that each newly founded commercial TV station in Germany was legally obliged to reserve for "culturally relevant" topics. Aust joined Kluge in order to expand the *Spiegel* print format to the broadcast medium. Denzo, who wanted to break into the European market, were interested in the time slots reserved for commercials that were inserted into the *Kulturfenster*. There seem to be two major reasons why this construction has proved as stable as it did for Kluge, for three decades now: first, the fact that the Social Democratic regional government of Nordrhein-Westfalen at the time consented to the introduction of commercial channels (which, Germany being a federal state, was a matter of negotiation between the *Länder* and the federal government, i.e., between *Bundesrat* and *Bundestag*) only on condition that the *Kulturfenster* would be guaranteed by the very same law that opened up the market to commercial providers. One of the main legal advisors to the government of Nordrhein-Westfalen in this matter was none other than Kluge himself, a lawyer by training. The second reason is that such commercial providers, in order to receive a broadcasting license, must already, in their application, have proved their intention to actually cover the cultural slots. At the time, RTL did so by applying for the frequency in collaboration with dctp. The permission was granted as such, making it effectively impossible for RTL to disengage from Kluge's production company, because this would entail the loss of their license. In the overall process Kluge was, in other words, involved as (1) a legal advisor to one of the major legislating parties, (2) a co-applicant for a broadcasting frequency, and (3) a provider and producer of programs. At a later point he was even able to realize his initial idea: to found an independent station whose program was distributed for a few years via metropolitan cable networks (XXP). The above account paraphrases Kluge's comments in Kluge, Deuber-Mankowsky, and Schiesser, "In der Echtzeit der Gefühle. Gespräch mit Alexander Kluge"; and in Alexander Kluge, Gertrud Koch, and Heide Schlüpmann, "'Nur Trümmern trau ich …'. Ein Gespräch mit Alexander Kluge," in Hans Ulrich Reck, ed., *Kanalarbeit. Medienstrategien im Kulturwandel* (1987; Frankfurt am Main: Stroemfeld/Roter Stern, 1988), 13–28. See also the extensive historical analysis in Matthias Uecker, *Anti-Fernsehen? Alexander Kluges Fernsehproduktionen* (Marburg: Schüren, 2000), 48–63; also Kluge's programmatic analysis of the institutional, economic, and political conditions of television production in Alexander Kluge, "Die Macht der Bewußtseinsindustrien und das Schicksal unserer Öffentlichkeit," in Klaus von Bismarck, Günter Gaus, Alexander Kluge, and Ferdinand Sieger, eds., *Industrialisierung des Bewußtseins: Eine kritische Auseinandersetzung mit den "neuen" Medien* (Munich: Piper, 1985), 108–111. On the production of Kluge's earliest TV features, see Peter C. Lutze, *Alexander Kluge: The Last Modernist* (Detroit: Wayne State University Press, 1998), 180–184. What is ultimately perhaps even more striking than the legal wit and strategic ingenuity that led to this successful partial occupation of the television sphere is the fact that almost twenty years prior to the realization of the project, Kluge already anticipated this move into the media institution fictionally, in his film

Die Artisten in der Zirkuskuppel: ratlos (*Artists under the Big Top: Perplexed*), where the circus director Leni Peickert, played by actress Hannelore Hoger, joins a broadcasting network, together with a group of friends, to produce "critical" programs. For an analysis of *Artisten* as a metafilm thematizing the problems German independent filmmakers were facing at the time, see Eric Rentschler, *West German Film in the Course of Time: Reflections on the Twenty Years since Oberhausen* (Bedford Hills, NY: Redgrave Publishing, 1984), 45–46.

4. There are two "inventories" that list Kluge's television output from its beginning in 1988 up to 2007. The first list covers the decade from 1988 to 1999, and was included in *Die Schrift an der Wand*, 403–438. The other, covering the years 1999–2007, was compiled by Kluge's production assistant Beata Wiggen, and appeared in the journal *Maske und Kothurn*. See *Maske und Kothurn* 53, no. 1 (2007), 137–192.

5. Kluge has filmed work by directors such as Peter Konwitschny, Hans Neuenfels, Frank Castorf, and Werner Schroeter.

6. For example, in interviews with the Detroit/Chicago techno DJs Jeff Mills and Paul Johnson, or in a conversation with film director Romuald Karmakar about his documentary on German DJ Hell. Techno tracks are also sometimes used as acoustic openers for features, and a photo of the Berlin *Loveparade* illustrates the cover of the second volume of *Chronik der Gefühle /Chronicle of Feelings*.

7. Among the actors Kluge has interviewed are Irm Hermann, another member of the former Fassbinder clan; and, prominently, Sophie Rois, star of the Berlin Volksbühne am Rosa Luxemburg theater under the direction of Frank Castorf. For a transcript of the conversation between Kluge and Müller, see Alexander Kluge and Heiner Müller, *Ich bin ein Landvermesser. Gespräche. Neue Folge* (Hamburg: Rotbuch, 1996), 119–142.

8. For instance, director of photography Michael Ballhaus, with whom Kluge collaborated on a project for the Venice film festival, talked about his work with Fassbinder and Scorsese, but also about technical details of camera work, such as the light-sensitivities of various film stocks, or the degrees of refraction and light-bundling enabled through different types of lens.

9. See Philipp Ekardt and Alexander Kluge, "Returns of the Archaic, Reserves for the Future: A Conversation with Alexander Kluge," *October* 138 (Fall 2011), 130.

10. On Kluge's notion of coarseness, see ibid., 126–127.

11. There is only a very small percentage of interview features in which Kluge's role is taken by an assistant or, even more rarely, by a third party. See, for example, the program "Total Glücklich" (Totally happy), aired on January 19, 1998, in the context of *News & Stories*, in which the photographer Digne Möller Marcovicz interviews the Russian chansonnière Adriana Lubowa. See the inventory in *Maske und Kothurn* 53, no. 1 (2007), 431. The list also includes the publicist Günter Gaus's TV conversations *Zur*

Person. Although they are produced by dctp, and mirror the basic conversational setup of Kluge's features (the interviewer Gaus is never visible), they lack the visual and conversational interstices and additions which characterize Kluge's TV work.

12. Kluge, Deuber-Mankowsky, and Schiesser, "In der Echtzeit der Gefühle. Gespräch mit Alexander Kluge," 365. This stance echoes Kluge's critique of invisible cutting.

13. In this specific distribution of the aural and the visual, Kluge's cinema functions in a similar way to Godard's, as analyzed by Gilles Deleuze: "the sound itself becomes the object of a specific framing which *imposes an interstice* with the visual framing. The notion of voice-off tends to disappear in favor of a difference between what is seen and what is heard, and this difference is constitutive of the image. There is no more out-of-field. The outside of the image is replaced by the interstice between the two frames in the image." Gilles Deleuze, *Cinema I: The Movement-Image* (Minneapolis: University of Minnesota Press, 1986), 180–181. In this case, these "two frames" would be of an aural and visual nature. In other cases—for example, in Kluge's constellational composites—there are multiple visual layers correlated across a constitutive hiatus, as well as multiple temporalities (see chapter 4 below). In these cases, the interstice runs intravisually and intratemporally.

14. See also, in comparison to the usage of the director's voice in Godard, Christa Blümlinger, "Rededispositiv und Filmbegriff in Kluges Kulturmagazinen," in Christian Schulte and Winfried Siebers, eds., *Kluges Fernsehen. Alexander Kluges Kulturmagazine* (Frankfurt am Main: Suhrkamp, 2002), 105.

15. See Joseph Vogl, "Kluges Fragen," *Maske und Kothurn* 53, no 1 (2007), 126. Vogl's term is *Haftbarmachung*.

16. Ibid., 125.

17. Blümlingler employs Michel Chion's term *acousmatic voice* to account for this constellation. See Blümlinger, "Rededispositiv und Filmbegriff in Kluges Kulturmagazinen," 105. See also the section "The Acousmatic" in Michel Chion, *Audio-Vision: Sound on Screen*, trans. Claudia Gorbman (New York: Columbia University Press, 1994), 71–73: "Acousmatic, a word of Greek origin … describes 'sounds one hears without seeing their originating cause,' or 'producing sounds for hearing, without giving the sight of their origin.'" (Ibid., 71; translation modified.) Chion also connects the category of the *acousmatique* directly to the role of the *hors-champ* (offscreen): "The opposition between visualized and acousmatic provides a basis for the fundamental audiovisual notion of offscreen space." (Ibid., 73.)

18. This specific arrangement of voice/the aural dimension and image/the visual dimension forms a countermodel to the constitutive difference between sound and sight, and the replacement of the "outside" of the image by an interstice between the aural and the visual within the image that Deleuze diagnosed *à propos* the work of

Godard (see note 13 above). In the case of Klugean TV, the disjunctive arrangement is the result of an immobilization of the image, its insistent refusal to display the source of the voice, which is, through the steadfast visual index of the interlocutor's gaze and orientation, permanently implied, but never shown. The Klugean way of staging the acousmatic voice resonates, further, with the subject of Kluge's conversation with Pierre Boulez, and also the story "Die Götterdämmerung in Wien" (see chapter 2 above). Both dialogue and narrative develop a *ruinous* approach to the Wagnerian project—that is to say, a reading that runs against its tendencies to render the orchestra invisible by covering the pit. Again, the issue would be one of distinction between two types of *acousmatism*: one that produces a saturated, seemingly self-sufficient image which mirrors the musical score (Wagner); the other a type that truncates the image in the manner described above.

19. Vogl, "Kluges Fragen," 121–122.

20. That expertise in Kluge's system can be "actual" and "imaginary," "real" and "fictional," on *both* sides of the conversation—i.e., on the side of interrogation and that of response—is highlighted by Miriam Hansen's account: "A few weeks ago I received an inquiry from a writer reviewing *The Devil's Blind Spot*. … The question was where I had written on Murnau's Mephistopheles with reference to a passage in Marx 'which points out that Mephistopheles is to be counted among the soothsayers, the interpreters of the future.' Well, I had to pass. Unfortunately, I've never written anything on either Murnau, nor Mephistopheles, nor Marx. Nonetheless, Kluge's story *The Devil as Entertainer* invokes me, or someone with the same name, as an 'expert' on recently discovered unused footage of Murnau's *Faust*." Miriam Hansen, "Fictional Experts: Roleplay and Authority in Kluge's Work," *Maske und Kothurn* 53, no. 1 (2007), 69. Hansen's text also compares the role of Kluge's televisual experts to the figure of the expert in his films. On the encounter with the expert—not just in the professional sense, but also as a source of a type of knowledge that relates to everyday life—see Diedrich Diederichsen, "Betroffene, Exemplifizierende und Human Interfaces," in Miriam Dreysse and Florian Malzacher, eds., *Experten des Alltags. Das Theater von Rimini Protokoll* (Berlin: Alexander Verlag, 2007), 159.

21. Vogl, "Kluges Fragen," 122.

22. Ibid., 124.

23. Georg Stanitzek, "Massenmedium Kluge," in Schulte, *Die Schrift an der Wand*, 246.

24. Ibid.

25. Jacques Attali, *Noise: The Political Economy of Music* (Minneapolis: University of Minnesota Press, 1985), 26–27.

26. Ibid., 33.

27. Ibid.

28. A similar observation may be made regarding Kluge's filmic and literary characters. Figures like Anita G. or Gabi Teichert are marked by an absence of development, i.e., by their stubborn, obstinate character continuity, a complete absence of transformation.

29. Michel Serres, *The Parasite*, trans. Lawrence R. Schehr (Baltimore: Johns Hopkins University Press, 1982), 71–72.

30. Samuel Weber's theoretical account of television as splitting the correlation of one viewing body to exactly one distinct and localizable place operates—tellingly—under the explicit exemption of one example: "two bodies cannot take or share the same place at the same time. (The case of the *parasite* may be cited here as the exception that proves the rule.)" This observation is footnoted as follows: "In French, radio or television interference—'static'—is called *parasite*." Samuel Weber, *Mass Mediauras: Form, Technics, Media*, ed. Alan Cholodenko (Stanford: Stanford University Press, 1996), 115.

31. Alexander Kluge and Oskar Negt, *History and Obstinacy*, trans. Richard Langston et al. (New York: Zone Books, 2014), 113 (translation modified). For the original German, see Oskar Negt and Alexander Kluge, *Geschichte und Eigensinn* (Frankfurt am Main: Suhrkamp, 1993), 64.

32. Negt and Kluge, *Geschichte und Eigensinn*, 51.

33. For an in-depth analysis of Kluge's concept of "feeling" see below, chapter 5.

34. Kluge and Negt, *History and Obstinacy*, 106; cf. Negt and Kluge, *Geschichte und Eigensinn*, 49.

35. Negt and Kluge, *Geschichte und Eigensinn*, 49.

36. Ibid., 53.

37. Ibid., 65. As Devin Fore points out, the category of self-regulation is also an important factor in Kluge and Negt's theory of capitalism in that it constitutes an important criterion that sets human capital—which has the capacity to self-regulate—apart from fixed capital, while also distinguishing living labor from machine capital. See Devin Fore, introduction to Kluge and Negt, *History and Obstinacy*, 23–24.

38. See Dirk Baecker, *Postheroisches Management. Ein Vademecum* (Berlin: Merve, 1994), 79–81.

39. Alexander Kluge and Dirk Baecker, *Vom Nutzen ungelöster Probleme* (Berlin: Merve, 2003), 19. The central reference would be Francisco J. Varela, Evan Thompson, and Eleanor Rosch, *The Embodied Mind: Cognitive Science and Human Experience* (Cambridge, MA: MIT Press, 1991), especially the section "Enaction: Embodied Cognition," 147–184.

40. Kluge and Baecker, *Vom Nutzen ungelöster Probleme*, 19–20.

41. Ibid., 17. A similar account of productive "noise" can be found in *Geschichte und Eigensinn*—predating the conversation between Baecker and Kluge by about fifteen years: "It is striking that human brains do not at all operate according to the forms of so-called rationality. According to either their nature or their constitution, they work neither logically nor teleologically (they are not goal-oriented). They are neither theological (myth-forming), nor do they really take the immense pauses they seem to be taking when they function in a disciplined fashion or follow operating-instructions. Rather, human brains achieve their highest operational level when they are 'doing nothing,' according to the criteria of entrepreneurial enterprise. Conversely, they become paralyzed when long-term coercion imposes inactivity on them. When someone 'thinks nothing at all,' encephalograms show 'white noise,' extreme activity." Kluge and Negt, *History and Obstinacy*, 104; cf. Negt and Kluge, *Geschichte und Eigensinn*, 45.

42. Baecker, *Postheroisches Management*, 80.

43. Kluge and Baecker, *Vom Nutzen ungelöster Probleme*, 6.

44. Further points of contact between Kluge's work and systems theory are his references to Luhmannian *Emergenztheorie*, the theory of emergent properties, which, as Devin Fore has shown, correlates with moments in Kluge and Negt's writing in which they display an "emergentist understanding of history." See Fore, introduction to Kluge and Negt, *History and Obstinacy*, 56.

45. Kluge's use of noise in his television work could also be connected to the generation of counterpublic spheres, a concept that he and Oskar Negt introduced in their first joint monograph, *Öffentlichkeit und Erfahrung* (*Public Sphere and Experience*). See Oskar Negt and Alexander Kluge, *Öffentlichkeit und Erfahrung. Zur Organisationsanalyse von bürgerlicher und proletarischer Öffentlichkeit* (Frankfurt am Main: Suhrkamp, 1972), 7. In her foreword to the book's English translation, Miriam Hansen has shown that the Negt/Klugean idea of a counterpublic, and its spheres, is closely connected to the effects of electronic media, their intervention in existing market structures, monopolies etc., but also to the potential for alternate aggregations, relations, and organizations of communication that emerges in this process as well. See Miriam Hansen, foreword to Oskar Negt and Alexander Kluge, *Public Sphere and Experience: Toward an Analysis of the Bourgeois and Proletarian Public Sphere* (Minneapolis: University of Minnesota Press, 1993), xiii–xiv, xxiii–xiv, xxix. Hansen pointedly remarks that Kluge must have come to the conclusion that "no local counterpublic can emerge today outside or independently of existing industrial-commercial, especially electronic publicity." (Ibid., xxxv.) If we consider Kluge's TV programs as elements of noise within that medium's overall panorama, we can easily think of them as instantiations of a counterpublic that exist within, rather than outside, that medium's framework. These programs' structuring as noise—i.e., as disturbance, suspension, jamming etc., of a given order—points to their categorically

"embedded" character. Although noise sabotages a channel's operations, it exists only within the transmissions enabled by that very channel. Hence Serres's insistence on its parasitical character. To which one would need to add Hansen's diagnosis that in the Klugean model such counterpublics cannot exist in a systemic "outside." See also Hansen's remarks on the concept of *Zusammenhang* (context) for the Negt/Klugean model of the counterpublic. (Ibid., xxxix.) On *Zusammenhang* in Kluge's practice and thinking, see above, chapter 2. For a programmatic statement by Kluge regarding the restructuring of the public sphere through the emergence of electronic media, their industries and public institutions, see Kluge, "Die Macht der Bewußtseinsindustrien und das Schicksal unserer Öffentlichkeit," in particular 55–56, 72–73.

46. Stanley Cavell, "The Fact of Television," in *Themes Out of School: Effects and Causes* (Chicago: University of Chicago Press, 1984), 234; see also 241.

47. Ibid., 247.

48. This is where Kluge's practice eludes a Cavellian analysis. Cavell contrasts the "genre-member principle" of cinema with the "serial-episode principle" according to which TV "works aesthetically." Cavell, "The Fact of Television," 242. Kluge does not operate in episodes.

49. David Joselit, *After Art* (Princeton: Princeton University Press, 2013), 55.

50. I am using the term medium here in the sense of technical media, or media for transmission, as established, for instance, in the field of media archaeology. In this I diverge from Joselit's argument, which also encompasses the question of artistic mediums.

51. Latour, the central voice of actor-network theory, would insist that such assemblages create mediation; i.e., that a medium is not the site for an assemblage, but rather that the very assemblage is the site in which processes of mediation occur. See Bruno Latour, *Reassembling the Social: An Introduction to Actor-Network-Theory* (Oxford: Oxford University Press, 2007), 1–17, 37–42.

52. This being one of the central points of divergence between Latour's approach and the critical sociology of, for example, Bourdieu or Boltanski. See ibid., 1–17.

53. The term "assemblage" also captures a central aspect of Kluge's (and Negt's) general theory of political and social systems, which relies on the idea of transindividual, collective *aggregations*: for example, affective elements, subjective components, various types of experience, etc. As such it also characterizes, for instance, Kluge and Negt's concept of human capital, which—as Devin Fore has pointed out—the authors view as an "unstable assemblage of dissimilar and often ill-fitting components." Fore, introduction to Kluge and Negt, *History and Obstinacy*, 23. Another pertinent concept would be Negt and Kluge's general notion of the political, as laid out in their 1992 collaboration *Maßverhältnisse des Politischen* (*The Political as a Relation of Measure*). Criticizing an under-

standing of the political as a *Substanzbegriff* (a concept of substance), they instead call it an aggregate of attitudes, energies, feelings, and social streams. See Alexander Kluge and Oskar Negt, "Maßverhältnisse des Politischen. Vorschläge zum Unterscheidungsvermögen," in *Der unterschätzte Mensch. Gemeinsame Philosophie in zwei Bänden*, vol. 1 (Frankfurt am Main: Zweitausendeins, 2001), 690–1005 (here pp. 720–721.)

54. Cavell, "The Fact of Television," 252.

55. Ibid., 257. I have extrapolated the terms of my contrastive account of Cavell's notion of "monitoring" from his argument. He does not explicitly set monitoring vs. examination; or un/eventfulness vs. singularity.

56. Ibid., 258.

57. All quotations ibid.

58. I am alluding to Walter Benjamin's notion of the image as dialectic at standstill. See Walter Benjamin, *Gesammelte Schriften*, vol. 5.2, ed. Rolf Tiedemann and Hermann Schweppenhäuser (Frankfurt am Main: Suhrkamp, 1982), 577; translated in Walter Benjamin, *The Arcades Project*, trans. Howard Eiland and Kevin McLaughlin (Cambridge, MA: Belknap Press, 1999), 462.

Chapter 4

1. In a short film linked at the top of the page, Kluge explains the criteria for grouping the theme loops under the two contexts of "Große Themen" and "Gärten der Neugierde." The clip associates the "broad themes" context with the gnomon "1000 Jahre wie ein Tag" (A Thousand Years Like a Day). "Gardens of Curiosity" is associated with the keywords "Wissen, Geschichte, Bildung, Kontinente & Länder [knowledge, history, education, continents, and countries]," and with the elliptic proposition "Als ob man in den Kellern eines Museums etwas findet [Like finding something in the basement of a museum]." The selection in the "Gardens of Curiosity" context seems to be characterized by a proximity to academic and scientific research. For instance, there are theme loops on "Darwin und kein Ende [Darwin without End]," "Die Stauferkaiser [The Staufer Emperors]", or "Viren und Bakterien [Viruses and Bacteria]." The selection in "Broad Themes" seems less academically "disciplined," comprising, for example, loops titled "Kapitalismus ist keine Einbahnstrasse [Capitalism Is Not a One-Way Street]," "Krieg ist das Ende aller Pläne [War Is the End of All Plans]," or "Der Anschlag auf die Twin Towers [The Attack on the Twin Towers]." The third context, "Partner & Events," is easier to pin down. Here Kluge assembles loops that mainly fit into one of three categories: collaborations between himself and cultural institutions like the Cinémathèque Française, the Serpentine Gallery, the Venice film festival, or the Wiener Stadtkino, for which he has curated programs from his vast selection of clips. These are

now partly (re-)accessible through his website. The second category comprises loops that were filmed at particular events, like the blogger conference *re:publica* (these clips are furnished by dctp.tv's journalistic partners at Spiegel-TV). A third section consists of loops in which collaborations with single individuals are archived. These are actors like Sophie Rois, Hannelore Hoger, or Martin Wuttke; director and performance artist Christoph Schlingensief; comedian Helge Schneider; or former Fassbinder producer Peter Berling. The fourth context, "Nachrichtenwerkstatt [News Workshop]," is defined as an arena in which to work on "die Aufhebung der Trennung zwischen Tatsachen, Musik, Vernunft und Emotion [lifting the barriers between facts, music, reason, and emotion]." This comprises loops that thematize various forms of news formats or factual reporting and their relation to fiction (*Werkstatt der Chroniken* [Workshop of Chronicles]; *Erlöst die Tatsachen von der menschlichen Gleichgültigkeit* [Redeem Facts from Human Indifference]), in combination with a selection of individual loops that also appear in other contexts.

2. Alexander Kluge, *Sämtliche Kinofilme* (Frankfurt am Main: Zweitausendeins, 2007); Alexander Kluge, *Seen sind für Fische Inseln. Fernseharbeiten 1987–2008* (Frankfurt am Main: Zweitausendeins, 2009).

3. Alexander Kluge, *Nachrichten aus der ideologischen Antike. Marx—Eisenstein—Das Kapital* (Frankfurt am Main: Filmedition Suhrkamp, 2008). Eisenstein's "Notes for a Film of *Capital*," translated by Maciej Sliwowski, Jay Leyda, and Annette Michelson, were published in *October* 2 (Summer 1976), 3–26.

4. See Philipp Ekardt and Alexander Kluge, "Returns of the Archaic, Reserves for the Future: A Conversation with Alexander Kluge," *October* 138 (Fall 2011), 121.

5. Alexander Kluge, *Früchte des Vertrauens* (Frankfurt am Main: Filmedition Suhrkamp, 2009); Alexander Kluge, *Wer sich traut, reißt die Kälte vom Pferd: Landschaften mit Eis und Schnee. Stroh im Eis* (Frankfurt am Main: Filmedition Suhrkamp, 2010).

6. See Ekardt and Kluge, "Returns of the Archaic, Reserves for the Future," 127.

7. The image of the constellation also visually alludes to the figure of the constellation in the opening seconds of *Die Macht der Gefühle* (see chapter 1 above).

8. Ekardt and Kluge, "Returns of the Archaic, Reserves for the Future," 129.

9. Miriam Hansen has emphasized that the "insistence on the mixed, conjunctural, rapidly forming and disintegrating character of contemporary public spheres," which already marks Negt and Kluge's earliest theorization of the structure of publics in *Öffentlichkeit und Erfahrung* (*Public Sphere and Experience*), anticipates "the transformations of publicness and experience in the digitally based media environment—and the implications of these developments for cinema, film theory, and film history." See Hansen, *Cinema and Experience: Siegfried Kracauer, Walter Benjamin, and Theodor W. Adorno*

(Berkeley: University of California Press, 2012), xiv. Kluge's statement quoted above, which dates from our digital present, expresses an almost identical diagnosis.

10. Ekardt and Kluge, "Returns of the Archaic, Reserves for the Future," 129.

11. For an analysis that situates this conversation within the broader context of Negt and Kluge's dialogues, and sets it apart from Habermasian theories of communication, see Richard Langston, "Toward an Ethics of Fantasy: The Kantian Dialogues of Oskar Negt and Alexander Kluge," *Germanic Review* 85, no. 4 (2010), 271–293, esp. 281–285.

12. For an attempt at a more detailed analysis of the dialectical image's constellational character, see the present author's: "Die Bestimmung der Aufnahme: Licht und Graphie bei Walter Benjamin," in Daniel Weidner and Sigrid Weigel, eds., *Benjamin-Studien 2* (Munich: Fink, 2011), 45–61.

13. Walter Benjamin, "On the Concept of History," in *Selected Writings*, vol. 4, ed. Howard Eiland and Michael W. Jennings (Cambridge, MA: Belknap Press, 2003), 389–400 (here p. 395); for the original German, see "Über den Begriff der Geschichte," in Benjamin, *Gesammelte Schriften*, vol. 1.2, ed. Rolf Tiedemann and Hermann Schweppenhäuser (Frankfurt am Main: Suhrkamp, 1974), 691–704 (here p. 701). See also Walter Benjamin, "Surrealism: The Last Snapshot of the European Intelligentsia," in *Selected Writings*, vol. 2, ed. Michael W. Jennings, Howard Eiland, and Gary Smith (Cambridge, MA: Belknap Press, 1999), 207–221; for the original German, see "Der Sürrealismus: Die letzte Momentaufnahme der europäischen Intelligenz," in *Gesammelte Schriften*, vol. 2.1, ed. Rolf Tiedemann and Hermann Schweppenhäuser (Frankfurt am Main: Suhrkamp, 1977), 295–310.

14. Ekardt and Kluge, "Returns of the Archaic, Reserves for the Future," 129.

15. Ibid., 132.

16. See Miriam Hansen, "Reinventing the Nickelodeon: Notes on Kluge and Early Cinema," *October* 46 (Fall 1988), 179–182.

17. In organizational terms, one major threshold divides the general possibilities for combination on Kluge's discs. The alternative between the selection menu for texts and the one for time-based visual works forms the DVD's highest structuring partition. To put it in more concrete terms: portions of writing may occur within a trajectory of clips as onscreen lettering, or as filmed or photographed printed pages, but there is no direct access from this essentially pictorial segment of the DVD to those sections where Kluge's literary stories are stored as text files in pdf format.

18. Ekardt and Kluge, "Returns of the Archaic, Reserves for the Future," 123.

19. Ibid., 121.

20. Ibid., 127.

21. Ibid.

22. Richard Langston has argued that through computerized postproduction technologies, Kluge's work in television can partly "enfold montage within the frame": "Although television does away with cinema's structural gaps ... television can be made to compensate for this loss through the radical juxtaposition of heterogeneous material." Richard Langston, *Visions of Violence: German Avant-Gardes after Fascism* (Evanston: Northwestern University Press, 2008), 197. My subsequent argument diverges from his point in that, through reconstructing the constellational logics of Kluge's work in electronic media, including television, I intend to point out that Kluge has indeed discovered *structural* capacities for the modified continuation of disjunctive practices. This does not contradict Langston's point regarding his harnessing of televisual/thematic material.

23. See Dudley Andrew, "A Film Aesthetic to Discover," *Cinémas. Revue d'études cinématographiques / Journal of Film Studies* 17, no. 2–3 (Spring 2007), 51. Stephen Prince makes the case for "digital imaging" as operating "according to a different ontology than do indexical photographs" in "True Lies: Perceptual Realism, Digital Images, and Film Theory," *Film Quarterly* 49, no. 3 (Spring 1996), 27–37 (quotation from p. 29). See also the chapter "Old and New: Image, Indexicality, and Historicity in the Digital Utopia," in Philip Rosen, *Change Mummified: Cinema, Historicity, Theory* (Minneapolis: University of Minnesota Press, 2001), 301–349.

24. See André Bazin, "The Ontology of the Photographic Image," in *What Is Cinema?*, ed. Hugh Gray (Berkeley: University of California Press, 1967), 9–16. Miriam Bratu Hansen, introduction to Siegfried Kracauer, *Theory of Film: The Redemption of Physical Reality* (Princeton: Princeton University Press, 1997), xlix: "film is essentially an extension of photography and therefore shares with this medium a marked affinity for the visible world around us. Films come into their own when they record and reveal physical reality." For Laura Mulvey, this complementarity is one of "dialectical relations" between "cinema's aesthetic polarities, debated throughout its critical history," which through the emergence of electronic and digital technologies now "seem to become less important in their differences" than in their mutual relatedness. See Laura Mulvey, *Death 24x a Second: Stillness and the Moving Image* (London: Reaktion Books, 2006), 12.

25. Robert P. Kolker, for example, argues that the controversy "over the structure and importance of the shot and the cut, of the shot versus the cut, forms the bedrock of film theory." See Kolker, "The Film Text and Film Form," in John Hill and Pamela Church Gibson, eds., *Oxford Guide to Film Studies* (Oxford: Oxford University Press, 1998), 15.

26. See Lev Manovich, *The Language of New Media* (Cambridge, MA: MIT Press, 2001), 144; quote from p. 143.

27. Ibid., 143.

28. Ibid., 139; see also 49.

29. See ibid., 136. These techniques, Manovich argues, are not fully co-emergent with digital technologies; for him they have a prehistory in electronic and even classical analog procedures such as keying, video switchers, the blue box, etc. (ibid., 150, 142). For a critique of this argument as an essentially teleological understanding of media history, see below.

30. Diverging from such a line of thought, film scholar Francesco Casetti has argued that this purported disappearance of suture under digital conditions is not a necessary development. While in the shift from analog to digital, which spells out the end of the photographic era, the image's "relationship with physical reality," and with it a photographically "grounded" realism, may indeed vanish, other elements of the filmic image may take on the function of indexical referentiality and its characteristic "traces." Here, the "cues are capable of functioning as sutures," for example. Francesco Casetti, "Sutured Reality: Film, from Photographic to Digital," *October* 138 (Fall 2011), 95–106. The first quote is from p. 95, the second from p. 96.

31. Kluge has talked about his early embrace of video in connection with the work of Godard. See Rainer Lewandowski, *Die Filme von Alexander Kluge* (Hildesheim: Olms, 1980), 50–51.

32. Manovich, *The Language of New Media*, 151.

33. Jacques Rancière, "Sentence, Image, History," in *The Future of the Image* (London: Verso, 2007), 33–67, esp. 48, 58, 63, 67.

34. Tom Conley, "Cinema and Its Discontents: Jacques Rancière and Film Theory," *SubStance* 34, no. 3 (2005), 100.

35. Ibid., 103–104, 100.

36. This delinearizing potential was already theorized by Marshall McLuhan, and has subsequently been invoked by film theorists Martin Lefebvre and Marc Furstenau. See Martin Lefebvre and Marc Furstenau, "Digital Editing and Montage: The Vanishing Celluloid and Beyond," *Cinémas. Revue d'études cinématographiques* 13, no. 1–2 (Fall 2002), 69–107 (here pp. 75–76). See Marshall McLuhan, *Understanding Media: The Extensions of Man* (Cambridge, MA: MIT Press, 1994), 11–14, 26; McLuhan, *The Gutenberg Galaxy: The Making of Typographic Man* (London: Routledge and Kegan Paul, 1962), 124–127.

37. See, for example, the chapter "The Perspective of Real Time" in Paul Virilio's book *Open Sky*, where he lays out his "dromological" position that the "regimes of temporality" put in place by information technologies lead to an exclusion of "temporal exteriority" in favor of a creation of the "instant of instantaneous telecommunications," an event that Virilio otherwise refers to as "the accident of the present." Paul Virilio, *Open Sky* (London: Verso, 2008), 22–34. The first two citations are on pp. 22 and 25; the third on p. 14. See also Armen Avanessian and Robin Mackay, eds., *#Accelerate. The Accelerationist Reader* (London: Urbanomic, 2014), *passim*.

———

38. See Ekardt and Kluge, "Returns of the Archaic, Reserves for the Future," 122–123.

39. See ibid., 128.

40. Ibid. With different implications, one could also refer here to the work of Alexander Galloway, who has called for an understanding of the computer not as "an object, or a creator of objects," but rather as "a process or active threshold mediating between two states." This is what Galloway calls "the interface effect," and in the present case it would pertain to the media-historical situatedness of analog *vis-à-vis* digital images. See Alexander R. Galloway, *The Interface Effect* (Cambridge: Polity Press, 2012), 23.

41. Not to mention the relation between that cinematic image and the actual physical space in which it was recorded, or the non-diegetic voice of the director (here Tykwer) that "comments" in a manner, and also a tone, that harks back to the voice interventions in *auteur* cinema, for example Godard's, or Kluge's, to which Tykwer pays homage here. Tykwer has explicitly called Kluge the "Godard of German cinema." See Matthias Matussek, "Alexander Kluge. Guerilla-Filme fürs Fernsehvolk," *Spiegel* online (May 1, 2008) (<http://www.spiegel.de/kultur/kino/alexander-kluge-guerilla-filme-fuers-fernsehvolk-a-550734.html>). Moreover, *Der Mensch im Ding* seems to be a perfect example of what Laura Mulvey has described as the new possibilities generated by "delayed cinema," which emerges ever more prominently in the passage from analog to digital technologies. See Mulvey, *Death 24x a Second*. Starting out from an account of "moments of narrative halt, hinting at the stillness of the single celluloid frame" (ibid., 7) in analog cinema, Mulvey expands this model to include the newly acquired digital means for generating such moments of stillness, but also the emerging media-historical temporality between the moments of analog and digital film: "Delayed cinema works on two levels: first of all it refers to the actual act of slowing down the flow of film. Secondly it refers to the delay in time during which some detail has lain dormant" (ibid., 8). This dormant detail can encompass the entirety of analog cinema, which is now available for a critical reexamination: "video and digital media have opened up new ways of seeing old movies. … A return to cinema's past constitutes a gesture towards a truncated history, to those aspects of modernist thought, politics, and aesthetics that seemed to end prematurely before their use or relevance could be internalized or exhausted. … Such a return to the past through cinema is paradoxically facilitated by the kind of spectatorship that has developed with the use of new technologies, with the possibility of returning to and repeating a specific filmic fragment." (Ibid.) And just as the example of *Der Mensch im Ding*, as well as Kluge's wider engagement with the digital, suggests, Mulvey accounts for this new "aesthetic of delay" as the result of a "dialectical relationship between old and new media" in which "the problem of time" is posed with new acuity. (Ibid., 22.) An important reference point for any such analysis—the present one included—is Raymond Bellour's theorization of the freeze-frame in his essay "The Film Stilled," *Camera Obscura* 8, no. 3 (September 1990), 98–124.

———

42. See Manovich, *The Language of New Media*, 144.

43. See Béla Balázs, *Der Geist des Films* (Frankfurt am Main: Suhrkamp, 2001), 11–12; translated in Béla Balázs, *Early Film Theory: Visible Man and The Spirit of Film*, ed. Erica Carter, trans. Rodney Livingstone (New York: Berghahn Books, 2010), 95–96.

44. Or, as Alexander Galloway succinctly puts it, from a slightly different angle: "Data have no necessary visual form." Galloway, *The Interface Effect*, 82.

45. On a related note, Galloway writes: "data, reduced to their purest form of mathematical values, exist first and foremost as number, and, as number, data's primary mode of existence is not a visual one. Thus … any visualization of data requires a contingent leap from the mode of the mathematical to the mode of the visual." (Ibid.) And he adds the important point that any "visualization" of data "first and foremost" amounts to a "visualization of the conversion rules" from which it derives. (Ibid., 83.)

46. See also David Rodowick's argument that "composited outputs appear "seamless" or perceptually real because all the elements … belong to the same ontological order— that of symbolization." See David N. Rodowick, *The Virtual Life of Film* (Cambridge, MA: Harvard University Press, 2007), 170. It is precisely the digital's derivation from a mode of encoding, or symbolization, that enables its appearance of seamlessness. But this derivation does not motivate the resulting appearances in the same way as discontinuous appearances could be grounded in the necessary discontinuity, or finitude, of the materiality of the film strip. Note also Rodowick's point that "there are no criteria by which the coding characteristic of "machine languages" can be even remotely characterized as a perception." (Ibid., 112.)

47. On the potential absence of a perceivable difference between digital and analog images, see Lefebvre and Furstenau, "Digital Editing and Montage," 71. Philip Rosen has coined the term "digital mimicry" to account for the digital's "capacity … to imitate such preexisting forms of imagery." See Rosen, *Change Mummified*, 309.

48. See Annette Michelson, "The Wings of Hypothesis: On Montage and the Theory of the Interval," in Matthew Teitelbaum, ed., *Montage and Modern Life, 1919–1942* (Cambridge, MA: MIT Press; Boston: Institute of Contemporary Art, 1992), 61–81. Michelson explains that Vertov extends the principle of montage from the editing of visual parameters to the "operative compositional principle invoked at every level of the labour process" (ibid., 72). On montage as a paradigm for the whole of production, see ibid. See also Jonathan Beller, "Dziga Vertov and the Film of Money," *boundary 2* 26, no. 3 (Autumn 1999), 153. Beller writes that for Vertov, "and for other Soviet filmmakers of his time, the consciousness characteristic of montage is the consciousness endemic to modernity's assemblage process, from the assembly line to constructivism."

49. This embrace of desynchronization could, then, be seen as one element of Kluge's response to a general development in our society's mode of production, which is

mapped by Ali Dur and McKenzie Wark when they argue that in response to the first industrial revolution, the "modern artist … felt compelled to either reject industry or embrace it. The first industrial revolution has given way to the second, a revolution in the use of information as a means of control." See Ali Dur and McKenzie Wark, "New New Babylon," *October* 138 (Fall 2011), 42. It is clear that, in contrast to Wark and Dur's battle cry "Let's have done with Benjamin, Vertov, and all that" (ibid.), Kluge's trajectory is firmly rooted within this legacy, while reconstellating such historical and theoretical bases toward our digital present.

50. See also David Rodowick's account of the sociosystemic implications of what he describes as a splintering of the "mass image": "This process of serialization has also effected a qualitative transformation of time. … The heyday of broadcast television was the last figuration of the collective as mass: the serialization of space into a million monads that were nonetheless united in a temporal whole. Time had a sort of spatial unity guaranteed both by the reach of broadcasting and by its unilateral force. This mass image has now been fragmented not only by the proliferation of channels and micro-markets through cable and satellite distribution but also by the cellular network model, which turns every monad into a transmitter and a receiver." David N. Rodowick, *Reading the Figural, or, Philosophy after the New Media* (Durham: Duke University Press, 2001), 223–224. At least after the events of the Arab Spring, one would tend to slightly modify this diagnosis, in order to allow for the possibility of spontaneous, temporary re-formations of the masses, which, however, never seem to attain the stability of their predigital manifestations.

51. This essential acknowledgment of (media-historical) loss and discontinuity is not only the precondition for the possibility of a Klugean reactualization of montage. It also precludes the establishment of problematic teleologies that recognize in cinematic and videographic techniques, such as the filming of actors in front of a rear-screen projection backdrop, or color key effects, mere anticipations of digital procedures. Referring to the writings of Mark B. Hansen, Alexander Galloway has criticized Manovich's work in this regard, stating that Manovich essentially—and falsely—treats cinema as the first example of "new media." See Galloway, *The Interface Effect*, 4–5. A related critique is formulated in the editorial introduction to *October*'s 100th issue, which formulates a fundamental concern regarding "theoreticians of the new digital media proclaim[ing] that cinema and photography … were merely preliminary steps on the path to their merging with the computer in the *über*-archive of the database." See introduction to *October* 100 (Spring 2002), 3.

52. See T. J. Clark, *Farewell to an Idea: Episodes from a History of Modernism* (New Haven: Yale University Press, 1999), 3. See also Mark Lewis, "Is Modernity Our Antiquity?," *Documenta Magazine No. 1* (Cologne: Taschen, 2007), 28–53. Within the realm of cinema, this transition into our (digital) present would coincide with a process that

David Rodowick has pinpointed in the simple sentence: "Film … is now also becoming 'history'." Rodowick, *The Virtual Life of Film*, 93.

53. Mark Lewis points to the example of how modernist architecture reappears as an aesthetic value in the work of various contemporary artists. Lewis, "Is Modernity Our Antiquity?," 29.

CHAPTER 5

1. See Herbert von Baeyer, *Der lebendige Arm* (Jena: Verlag Gustav Fischer, 1930), plates vii and viii. In von Baeyer's book, the illustrations run over one and a half pages, whereas Negt and Kluge organize them in one horizontal row, thereby considerably reducing their original format.

2. See Fritz Giese, *Psychologie der Arbeitshand* (Berlin and Vienna: Urban & Schwarzenberg, 1928), 32.

3. See Alexander Kluge and Oskar Negt, *History and Obstinacy*, trans. Richard Langston et al. (New York: Zone Books, 2014), 116. For the original German, see Oskar Negt and Alexander Kluge, *Geschichte und Eigensinn* (Frankfurt am Main: Suhrkamp, 1993), 69–70.

4. Kluge and Negt, *History and Obstinacy*, 89; Negt and Kluge, *Geschichte und Eigensinn*, 15.

5. *History and Obstinacy*, 116 (translation modified); *Geschichte und Eigensinn*, 69–70.

6. *Geschichte und Eigensinn*, 14; *History and Obstinacy*, 89.

7. *Geschichte und Eigensinn*, 14–15; *History and Obstinacy*, 89 (translation modified).

8. Alexander Kluge, *Die Macht der Gefühle* (*The Power of Feelings*) (Frankfurt am Main: Zweitausendeins, 1984), 180.

9. Ibid., 183. An Ur-text for this complex appears in Kluge's 1969 short film *Die unbezähmbare Leni Peickert* (*The Indomitable Leni Peickert*) in a shot in which the camera shows a page from Horkheimer and Adorno's *Dialektik der Aufklärung* (*Dialectic of Enlightenment*). In the filmed paragraph, the authors discuss the feeler organs of snails as a paradigm for sensorial sensitivity.

10. Kluge, *Die Macht der Gefühle*, 183.

11. Ibid., 201.

12. Ibid., 184.

13. Ibid.

14. Ibid. In this affirmative quality, (Negt's) and Kluge's theory treats "agglomerated" feelings as akin to the affirmative forces of the merely duplicating camera recording and the violence of context (see chapter 2).

15. Kluge, *Die Macht der Gefühle*, 214.

16. Ibid., 200.

17. Ibid.

18. A narrative version of this scene appeared under the title "Die Befähigung zum Richteramt" (Qualification for the Office of Judge), ibid., 34–44.

19. The historically accurate comparison would be the one between *Die Macht der Gefühle* and the courtroom movie. When Kluge produced his film, in the early 1980s, the courtroom drama did not exist on German television. Scenes set in courtrooms figured regularly, of course, in the context of crime series, for example, but juridical proceedings had not yet turned into an independent genre. To this day, they are also nearly completely absent from news programs or documentaries on the country's networks due to a general legal banning of cameras from all court sessions. On the juridical and philosophical argument behind this legislation, see Cornelia Vismann, "Tele-Tribunals: Anatomy of a Medium," *Grey Room* 10 (Winter 2003), 14–15.

20. An exemplary excerpt from the scene's transcript:

—When you continued the shift, and when you aimed the rifle at your husband's chest, what was your purpose [*was war der Zweck davon*]?

—That was not my intention [*bezweckte ich das nicht*] at that moment. My leg hurt.

—You were scared [*erschreckt*]?

—I don't know.

—What was your intention when you directed the rifle's barrel at your husband?

—That the pain should stop.

—What pain?

—The pain in my leg.

—Not also the pain of the recent years?

—I don't know.

　　　Kluge, *Die Macht der Gefühle, 34–37.*

21. See Jessica Silbey, "Patterns of Courtroom Justice," *Journal of Law and Society* 28, no. 1 (March 2001), 106–107.

22. See Stefan Machura and Stefan Ulbrich, "Law in Film: Globalizing the Hollywood Courtroom Drama," *Journal of Law and Society* 28, no. 1 (March 2001), 125.

23. On the "dramatization" of legal procedures through the presence of the camera, see Vismann, "Tele-Tribunals," 15.

24. See also the present author's remarks in Philipp Ekardt and Gertrud Koch, "Zwiespältige Gefühle," in Irene Albers, Isabel Dziobek, and Hannah Hurtzig, eds., *Fühlt weniger! Dialoge über Emotionen* (Berlin: Verlag Theater der Zeit, 2011), 151–158; here p. 155. See also Kluge's comments on his practice of the close-up in Philipp Ekardt and Alexander Kluge, "Returns of the Archaic, Reserves for the Future: A Conversation with Alexander Kluge," *October* 138 (Fall 2011), 124–125.

25. One could say that Kluge's strategy amounts to undoing the double equation with which Gilles Deleuze described the cinematic logic of the affection-image: "the affection-image is the close-up, and the close-up is the face." Gilles Deleuze, *Cinema I: The Movement-Image* (Minneapolis: University of Minnesota Press, 1986), 87. In Kluge's work, only the latter part of the definition tends to be true. The close-up shows the face, but neither the face, nor the close-up in general, amounts to an affection-image.

26. This refers to Deleuze's account of "modern," i.e., postwar cinema, in which, as he wrote, "the situation no longer extends into action through the intermediary of affections." Gilles Deleuze, *Cinema II: The Time-Image* (Minneapolis: University of Minnesota Press, 1989), 272.

27. Alexander Kluge and Gertrud Koch, "Die Funktion des Zerrwinkels in zertrümmernder Absicht. Ein Gespräch," in Rainer Erd, Dietrich Hoß, Otto Jacobi, et al., eds., *Kritische Theorie und Kultur* (Frankfurt am Main: Suhrkamp, 1989), 115.

28. See also Kluge's suggestion that we should understand critique as a "pausing" function. He also calls this a "lateralization" of the urge and pressure to react, and describes it as a breaking down of impulses into action potentialities (in Alexander Kluge and Joseph Vogl, *Soll und Haben. Fernsehgespräche* [Zurich and Berlin: Diaphanes, 2009], 8).

29. Alexander Kluge and Florian Rötzer, "Kino und Grabkammer," in Christian Schulte, ed., *Die Schrift an der Wand. Alexander Kluge: Rohstoffe und Materialien* (Osnabrück: Rasch, 2000), 36.

30. Johann Joachim Winckelmann, "Thoughts on the Imitation of Greek Works in Painting and the Art of Sculpture (1755–56)," in *Johann Joachim Winckelmann on Art, Architecture, and Archaeology*, trans. David Carter (Rochester, NY: Camden House, 2013), 44. For the original German, see Winckelmann, "Gedanken über die Nachahmung der griechischen Werke in der Malerei und Bildhauerkunst (2., vermehrte

Auflage 1756)," in *Kunsttheoretische Schriften*, vol. 1 (Baden-Baden and Strasbourg: Heitz, 1962), 21. See also Gotthold Ephraim Lessing, "Hamburgische Dramaturgie," in *Werke*, vol. 6, ed. Klaus Bohnen (Frankfurt am Main: Deutscher Klassiker Verlag, 1985), 551–560.

31. In a similar context, Kluge—tellingly—connects his program to the rejection of an understanding of critique as "Gerichtshof der Vernuft" (the court of reason). Kluge and Vogl, *Soll und Haben*, 10–11.

32. Deleuze, *Cinema II: The Time-Image*, 158. Peter Wollen has analyzed the prehistory of the concept of the shock in Eisenstein's early work, where it appears in the figure of "ecstasy." See Peter Wollen, "Perhaps …," *October* 88 (Spring 1999), 44.

33. Annette Michelson, "Camera Lucida/Camera Obscura," *Artforum* 11, no. 5 (January 1973), 34.

34. Ibid.

35. Michelson derives her concept of momentous style from the work of philologist Erich Auerbach. See ibid.

Chapter 6

1. Alexander Kluge, "Die gescheiterte Hoffnung," in *Wer sich traut, reißt die Kälte vom Pferd: Landschaften mit Eis und Schnee. Stroh im Eis* (Frankfurt am Main: Filmedition Suhrkamp, 2010). The story has since also appeared, along with the majority of the booklet's content, in Kluge's 2012 publication *Das fünfte Buch* (Frankfurt am Main, Suhrkamp). An English translation of the story by Richard Langston was published in *Grey Room* 53 (Fall 2013), 92–93.

2. For an analysis of Kluge's critical engagement with German national history in *Die Patriotin*, see Anton Kaes, "In Search of Germany: Alexander Kluge's 'The Patriot'," in Tara Forrest, ed., *Alexander Kluge: Raw Materials for the Imagination* (Amsterdam: Amsterdam University Press, 2012), 95–126.

3. This shift does not entail a "depoliticization" of Kluge's work. For instance, the very concept of the dialectical/constellational image, to which Kluge has recourse, was developed by Benjamin in order to provide a countermodel to the linear temporal narratives of progress that were employed by conservative historians and the teleologically minded left alike. For Benjamin, the thrust lay in developing a critical politics of time, which might also serve as a model for understanding Kluge's concerns. For an example of contemporary Marxist political theory that explicitly draws on reconfigured notions of temporality, see Moishe Postone, *Time, Labor, and Social Domination: A Reinterpretation of Marx's Critical Theory* (Cambridge: Cambridge University Press, 1995), especially

chapters 5 ("Abstract Time," pp. 186–267) and 8 ("The Dialectic of Labor and Time," pp. 286–306).

4. Friedrich did not have to rely on the imagery of ice and snow to produce such an effect of stasis. Compare his rendering of a *Schiff auf hoher See mit vollen Segeln* (*Ship under Full Sail*): the depicted subject's framed central position, its vertical extension that replicates the small canvas's outlines (45 × 32 cm); its superimpositions of lines so fine they almost seem drawn rather than applied with a brush; how the ship's body appears to be stacked into a meticulously painted field of waves, which in its detailed accuracy seems essentially fixed and solid—all of these features make it clear that for the artist, showing a vessel with fully blown sails did not entail having to visually "enact" movement in his picture.

5. On the compositional proximity between Friedrich's depictions of ice in *Das Eismeer*, and of rock formations on other canvases, see Johannes Grave, *Caspar David Friedrich und die Theorie des Erhabenen* (Weimar: Verlag und Datenbank für Geisteswissenschaften, 2001), 18.

6. Johann Georg Quandt, *Streifereien auf dem Gebiete der Kunst* (1819), vol. 2, 195–196; as quoted in Grave, *Caspar David Friedrich und die Theorie des Erhabenen*, 93. The German expression *Wonnemond*, literally meaning "month of joy," is a—by now outdated—synonym for the month of May.

7. See Hans Blumenberg's canonical study *Shipwreck with Spectator: Paradigm of a Metaphor for Existence* (Cambridge, MA: MIT Press, 1997), *passim*. Blumenberg remarks in particular that this topos "presents the uninvolved spectator as the type who, … aesthetically, takes note of this distance from the enormity (*das Ungemässe*) with satisfaction or even enjoyment." Ibid., 10. The German term *ungemäss* alludes to the question of measure, measurement, and its failure in cases that are classified as "sublime." See below. It is very likely that Friedrich was familiar with at least one contemporary literary version of this topos, Kosegarten's *Briefe eines Schiffbrüchigen* (*Letters of a Stranded Sailor*). (See Grave, *Caspar David Friedrich und die Theorie des Erhabenen*, 42.) Kosegarten was a member of the social circles of the Greifswald University drawing instructor Johann Gottfried Quistorp, from whom Friedrich received his earliest education in the arts. (See Joseph Leo Koerner, *Caspar David Friedrich and the Subject of Landscape* [London: Reaktion Books, 1990], 77–81.) Kosegarten was also a pastor on the island of Rügen, which the painter visited and painted repeatedly. (See Grave, *Caspar David Friedrich und die Theorie des Erhabenen*, 42.) In his treatise "Vom Erhabenen" (On the Sublime), Schiller gives the paradigmatic example of a storm at sea. Friedrich Schiller, "On the Sublime," in *Essays*, ed. Walter Hinderer and Daniel O. Dahlstrom (New York: Continuum, 1993), 25. "Vom Erhabenen," in *Sämtliche Werke*, vol. 8, ed. Hans-Günther Thalheim et al. (Berlin: Aufbau, 2005), 227. Kant termed this specific category of sublime experiences "the dynamically sublime [*das Dynamisch-Erhabene*]," in which the

force of nature is viewed in its capacity of inducing fear. See Immanuel Kant, *Critique of Judgment*, trans. Werner S. Pluhar (Indianapolis: Hackett, 1987), 119–123. For the original German, see Kant, *Kritik der Urteilskraft*, ed. Wilhelm Weischedel (Frankfurt am Main: Suhrkamp, 1996), 184–189.

8. The term sublime "event" here refers to a subcategory of the dynamic sublime, as explained above. It is not meant to evoke Jean-François Lyotard's general account of (artistic implementations of) the sublime as an event *tout court*, which he proposed in his text "The Sublime and the Avant-Garde," *Artforum* 22, no. 8 (April 1984), 37. In fact, as I argue below, the conception of the sublime that emerges from a Klugean framework even tends to be opposed to an understanding of the sublime as an "event."

9. See, for example, Grave, *Caspar David Friedrich und die Theorie des Erhabenen*, 23.

10. At this point my argument, which starts out from and derives from the Klugean model, coincides with recent positions in scholarship on Friedrich, such as Johannes Grave's; he has described the painter as a critic—i.e., not as a follower—of contemporary aesthetic discourses. See the chapter "Sublime Landscapes? Friedrich's Landscapes as a Critique of Contemporary Aesthetics," in Grave's monograph *Caspar David Friedrich* (Munich: Prestel, 2012), 184–199. The concept of "showing" an image of the sublime without producing a sublime image, which I am developing in the following paragraphs, corresponds to Kluge's practice of suspension as a means of discernment, which in turn is connected to the project of critique as an operation of distinction.

11. The quotation marks are part of Kluge's title.

12. Andreas Huyssen has observed that Kluge's stories generally tend to suspend classical narrative criteria, such as plot formation. See Huyssen, "An Analytic Storyteller in the Course of Time," *October* 46 (Fall 1988), 118. For an in-depth analysis of one case in which Kluge constructs a very short "story" through this non-plot-oriented mode of textual paraphrase, see Philipp Ekardt, "Film ohne Star. Alexander Kluges Präsensgeschichte über Asta Nielsen," in Armen Avanessian and Anke Hennig, eds., *Der Präsensroman* (Berlin: de Gruyter, 2013), 237–247.

13. Kluge, "Die gescheiterte Hoffnung," 9. Kluge, "The Wreck of the *Hope*," 92.

14. See Wolfgang Stechow, "Caspar David Friedrich und der 'Griper,'" in Gert von der Osten and Georg Kaufmann, eds., *Festschrift für Herbert von Einem* (Berlin: Mann, 1965), 241. For the identification of Friedrich's polar canvases, see ibid., *passim*. See also the relevant entries in Helmut Börsch-Supan and Karl Wilhelm Jähning, *Caspar David Friedrich. Gemälde, Druckgraphik und bildmäßige Zeichnungen* (Munich: Prestel, 1973); and Grave, *Caspar David Friedrich und die Theorie des Erhabenen*, 85 and 92–104.

15. Kluge, "Die gescheiterte Hoffnung," 9. Kluge, "The Wreck of the *Hope*," 92.

16. Ibid.

17. Kluge, "Die gescheiterte Hoffnung," 10. Kluge, "The Wreck of the *Hope*," 92.

18. "Dahinter lag die weite, feste Eisdecke, an vielen Stellen jedoch schon geborsten, in den Spalten oft aufgerichtete kleinere Schollen, bald Baumzweige einklemmend. [Beyond lay the wide, solid blanket of ice, which yet was already fractured at many places; wedged in its crevasses were smaller shoals that had turned upright, as well as branches of trees.]" Carl Gustav Carus, *Briefe über Landschaftsmalerei. Zuvor ein Brief von Goethe als Einleitung* (facsimile reprint of the 2nd enlarged edition, 1835), ed. Dorothea Kuhn (Heidelberg: Schneider, 1972), 206.

19. Grave, *Caspar David Friedrich und die Theorie des Erhabenen*, 21.

20. Kluge, "Die gescheiterte Hoffnung," 10. Kluge, "The Wreck of the *Hope*," 92.

21. Stechow, "Caspar David Friedrich und der 'Griper,'" 243. On the medium of the panorama, and the popularity of Arctic themes for its shows in connection with Friedrich's work, see Dirk Tölke, "Eislandschaften und Eisberge. Studien zur Motiv- und Bildgeschichte von Eisformationen und polaren Szenarien in Gemälden und Graphiken des 16.–20. Jahrhunderts" (Univ.-Diss., Rheinisch-Westfälisches Hochschule, Aachen, 1995), 97–100.

22. Obviously, this is not to diminish the historical paradigm shift that manifests itself in Friedrich's landscape painting. For an analysis of its import, see Koerner, *Caspar David Friedrich and the Subject of Landscape*, passim.

23. See Kluge's insistence on the category of (past) possible futures. Philipp Ekardt and Alexander Kluge, "Returns of the Archaic, Reserves for the Future: A Conversation with Alexander Kluge," *October* 138 (Fall 2011), 123–124.

24. As formulated in Kluge's 1968 film *Artisten unter der Zirkuskuppel* (*Artists in the Big Top*).

25. See Luc Boltanski and Eve Chiapello, *The New Spirit of Capitalism* (London: Verso, 2005), for an account of the so-called "project-based polis." See also "Under the Shadow of Projects: A Roundtable Discussion with Heike-Karin Föll, Juan Gaitán, Christoph Gurk and Florian Wüst, Moderated by Philipp Ekardt and Hanna Magauer," *Texte zur Kunst* 94 (June 2014), 62–87.

26. Kluge's work could thus also offer one possible answer to the question "What would it mean for left politics not to look forward?," posed by art historian T. J. Clark in his essay "For a Left with No Future," *New Left Review* 74 (March/April 2012), 57.

27. Kluge, "Die gescheiterte Hoffnung," 10. Kluge, "The Wreck of the *Hope*," 93 (translation modified).

28. Kluge, "Die gescheiterte Hoffnung," 10. Kluge, "The Wreck of the *Hope*," 93 (translation modified). The capitals are Kluge's.

29. Kant, *Critique of Judgment*, 114–117, 124–126; Kant, *Kritik der Urteilskraft*, 180–184, 189–191. At least with respect to the predominant view of Friedrich's era and culture, namely early-nineteenth-century Germany, Dr. Sturm's opinion—which is not Kluge's—misses a crucial point: Kant did *not* decree an abstention from judgment in the face of the sublime. On the contrary, the sublime constitutes one of the prime examples of (aesthetic) judgment. This chapter partly seeks to constellate the Klugean theory and practice of discernment and judgment in and through images with a related concern in Friedrich's work, for which—*qua* historical context, and for its general import—the Kantian theory of judgment is a prime reference. For an attempt at reconstructing a historical parallel between Kant's theorization of the sublime and certain themes in Friedrich's paintings, see Barbara Ränsch-Trill, "'Erwachen erhabener Empfindungen bei der Betrachtung neuerer Landschaftsbilder'. Kants Theorie des Erhabenen und die Malerei Caspar David Friedrichs," *Kant-Studien* 68 (1977), 90–99. See also Brad Prager, "Kant in Caspar David Friedrich's Frames," *Art History* 25, no. 1 (February 2002), 68–86. In his book chapter "Orientation in Painting: Caspar David Friedrich," Michael Fried has recently sought to establish a parallel trajectory to the one that connects Friedrich and the Kantian theory of judgment; namely, via the question of orientation, as articulated in Kant's 1786 essay "Was heisst sich im Denken orientieren?" (What Does It Mean to Orient Oneself in Thinking?), and the literal orientation of Friedrich's *Rückenfiguren*. See Michael Fried, *Another Light: Jacques-Louis David to Thomas Demand* (New Haven: Yale University Press, 2014), 111–149. See also, on a related note, the remarks on the relation between Kant's use of the term *Aussicht* (view) and Friedrich's deployment of landscapes, views, and perspective, in Hilmar Frank, *Aussichten ins Unermessliche. Perspektivität und Sinnoffenheit bei Caspar David Friedrich* (Berlin: Akademie Verlag, 2004). On Kant and *Aussicht*, see ibid., 45–55.

30. The *Abendblätter* contained a mixture of brief factual news items and reviews, interspersed with short pieces of literature whose fictional status remained undeclared. The publication's indebtedness to the form of the anecdote, along with its characteristic combination of what nowadays could be described as journalistic and literary forms of writing, qualify it as an important point of orientation for Kluge's work, and Kluge has indeed repeatedly acknowledged the importance of the *Abendblätter*. See, for example, the feature *Heinrich von Kleist und das Boulevard-Prinzip* at <http://dctp.tv/filmekleist-boulevardprinzip/#/filme/Kleist-boulevardprinzip/>. For a reading of Kluge's work in relation to the genre of the anecdote, including a reference to Kleist, see Joseph Vogl, "Kommentar zu 'Die Lücke, die der Teufel lässt,'" *Text + Kritik* 85/86 (Neufassung) (2011), 120–124.

31. For a meticulous reconstruction of this text's authorial and editorial genesis, see Christian Begemann, "Brentano und Kleist vor Friedrichs *Mönch am Meer*. Aspekte eines Umbruchs in der Geschichte der Wahrnehmung," *Deutsche Vierteljahrsschrift für Literaturwissenschaft und Geistesgeschichte* 64, no. 1 (March 1990), 54–95; see also Gerhard

Kurz, "Vor einem Bild: Zu Clemens Brentanos 'Verschiedene Empfindungen vor einer Seelandschaft von Friedrich, worauf ein Kapuziner'," *Jahrbuch des Freien Deutschen Hochstifts* (1988), 128–140; and Roswitha Burwick, "Verschiedene Empfindungen vor Friedrichs Seelandschaft. Arnim, Brentano, Kleist," *Zeitschrift für deutsche Philologie* 107 (1988, Sonderheft), 33–44.

32. Heinrich von Kleist, "Emotions before Friedrich's Seascape," in Charles Harrison, Paul Wood, and Jason Gaiger, eds., *Art in Theory 1648–1815: An Anthology of Changing Ideas* (Oxford: Blackwell, 2000), 1032; originally Kleist, "Empfindungen vor Friedrichs Seelandschaft (13.10.1810)," in Roland Reuß and Peter Staengle, eds., *Berliner Abendblätter I: Sämtliche Werke. Brandenburger Ausgabe* (Basel: Stroemfeld, 1997), 61. A more accurate translation of the title would be "Feelings before Friedrich's Seascape," which conveys the full spectrum of the German term *Empfindungen*, which encompasses sensory as well as affective reactions and inputs. In this way, the slightly outdated expression *Empfindung* coincides with Kluge's use of the term *Gefühl* (see chapter 5 above). See also Clemens Brentano [and Achim von Arnim], "Various Emotions before a Seascape by Friedrich," in Harrison, Wood, and Gaiger, *Art in Theory 1648–1815*, 1029; originally Achim von Arnim and Clemens Brentano, "Verschiedene Empfindungen vor einer Seelandschaft von Friedrich, worauf ein Kapuziner (1810)," in Clemens Brentano, *Werke*, vol. 2, ed. Friedhelm Kemp (Munich: Hanser, 1980), 1037. For an identification of the various philosophical and discursive positions that are alluded to in Arnim's and Brentano's dialogue (including, in addition to Young, the poet Kosegarten, and the romantic philosopher Gotthilf Heinrich Schubert), see Hartwig Schultz, "Drei Blicke auf Caspar David Friedrichs 'Mönch am Meer,'" in Lothar Jordan and Hartwig Schultz, eds., *Empfindungen vor Friedrichs Seelandschaft: Caspar David Friedrichs Gemälde "Der Mönch am Meer" betrachtet von Clemens Brentano, Achim von Arnim und Heinrich von Kleist* (Frankfurt an der Oder: Kleist-Museum, 2004), 25–33. For a possible connection between Brentano's and Arnim's text and the philosophies of Kant and Burke, see Kurz, "Vor einem Bild," 131.

33. Brentano and Arnim, "Verschiedene Empfindungen vor einer Seelandschaft von Friedrich," 1034. Brentano [and Arnim], "Various Emotions before a Seascape by Friedrich," 1028. For an analysis of Kleist's complex reactions to and transformations of the Kantian definition of the sublime in several of his works, including a detailed analysis of Kleist's processing of Kant's ideas in the "Empfindungen vor Friedrichs Seelandschaft," see Bernard Greiner, "Die Wende in der Kunst: Kleist mit Kant," *Deutsche Vierteljahrsschrift für Literaturwissenschaft und Geistesgeschichte* 64, no. 1 (March 1990), 98–117, esp. 106–109; and Greiner, "Die 'Stime des Lebens' und die Materialität der Kunst: Kleists Essay über Caspar David Friedrichs Bild 'Der Mönch am Meer,'" in Jordan and Schultz, *Empfindungen vor Friedrichs Seelandschaft*, 49–66, esp. 53–62.

34. Kleist, "Empfindungen vor Friedrichs Seelandschaft," 102 (this passage is omitted in the English translation). Helmut Börsch-Supan observes that Kleist's version, in contrast

to Arnim's and Brentano's, commits to a judgment of Friedrich's work. See Helmut Börsch-Supan, "Bemerkungen zu Caspar David Friedrichs 'Mönch am Meer,'" *Zeitschrift des deutschen Vereins für Kunstwissenschaft* 19 (1965), 71.

35. See, for example, Robert Rosenblum, *Modern Painting and the Northern Romantic Tradition: Friedrich to Rothko* (London: Thames and Hudson, 1975), 13; and, with reference to Burke's *Philosophical Enquiry into the Origins of Our Ideas of the Sublime and the Beautiful*, ibid., 17. And, crucially, including analyses of Friedrich's *Kreuz im Gebirge* (*Cross in the Mountains*), and remarks on his *Wanderer über dem Nebelmeer* (*Wanderer above a Sea of Fog*), Koerner, *Caspar David Friedrich and the Subject of Landscape*, 180–184.

36. Kleist, "Emotions before Friedrich's Seascape," 1031 (Kleist, "Empfindungen vor Friedrichs Seelandschaft," 61); Brentano [and Arnim], "Various Emotions before a Seascape by Friedrich," 1028 (Arnim and Brentano, "Verschiedene Empfindungen vor einer Seelandschaft von Friedrich," 1034) (translation modified).

37. Or, in the words of Friedrich's and Kleist's contemporary Johanna Schopenhauer, published in 1810 in the *Journal des Luxus und der Moden* (*Journal of Luxury and Fashions*): Friedrich paints "unfathomable expanses" (*unermessliche Weiten*); as quoted in Koerner, *Caspar David Friedrich and the Subject of Landscape*, 116. Koerner succinctly sums up the matter by pointing out that Friedrich's landscape here, and in other cases, invokes "an infinity that no system can arrange." Ibid., 113.

38. Kleist, "Emotions before Friedrich's Seascape," 1032 (Kleist, "Empfindungen vor Friedrichs Seelandschaft," 61).

39. Kleist, "Emotions before Friedrich's Seascape," 1031 (Kleist, "Empfindungen vor Friedrichs Seelandschaft," 61). The English translation renders *Abbruch* (detriment) slightly convolutedly as "a demand the painting makes on me, that it does not fulfill."

40. For a concise list of formal features that contribute to this experience of incompleteness, see Werner Busch, *Caspar David Friedrich. Ästhetik und Religion* (Munich: Beck, 2003), 73. According to Greiner, the Kleistian formulation of "Abbruch"—detriment—invokes the limitation and disruption—also: "Abbruch"—imposed on the viewing subject's desire for summation, or comprehension ("Zusammenfassung") when experiencing nature as infinite, which in the framework of the sublime evokes the idea of the universal, of God, or of the whole ("eines Allgemeinen, Göttlichen, Ganzen"). Greiner, "Die Wende in der Kunst," 105. See also Prager, "Kant in Caspar David Friedrich's Frames," 70, for another account of the Kantian notion of the sublime as a tension between apprehension (*Auffassung*) and comprehension (*Zusammenfassung*) in relation to Friedrich's art.

41. Johannes Grave very convincingly criticizes the widely held view that Friedrich's landscapes "represent" infinity. They don't—because, as Grave argues, in order to depict (*abbilden*) infinity, they would need to represent "Maß–Losigkeit," the absence of

limits, which would be beyond the powers of depiction. See Grave, *Caspar David Friedrich und die Theorie des Erhabenen*, 65. In my argument, which does not contradict Grave's, I am operating with a concept of figuring the sublime through making the *limits* of representation operative. In his more recent monograph *Caspar David Friedrich* (2012), Grave describes Friedrich's relevant paintings as probings of the "limitations of pictorial representation" (199), and connects these to theorizations of the sublime, such as Lyotard's and Jean-Luc Nancy's. This is where my argument falls into line with his, and, ultimately with Koerner's general account of "Friedrich's system … as the demonstration of the limits of the system." Koerner, *Caspar David Friedrich and the Subject of Landscape*, 121.

42. Kleist, "Emotions before Friedrich's Seascape," 1031 (Kleist, "Empfindungen vor Friedrichs Seelandschaft," 61).

43. Koerner points out that any potential identification between the viewer and the turned figure, and here more specifically of the subject of the Kleistian text and the monk, hinges on a shared "instance of separation," i.e., not an "erasure of the boundary between self and world, but the establishment of a boundary." Koerner, *Caspar David Friedrich and the Subject of Landscape*, 213. Any connection would hence be enabled and preceded by a prior division.

44. Or, as Koerner has argued, in *Das Grosse Gehege* Friedrich draws the viewer into the landscape. See ibid., 121. Börsch-Supan describes this ultimate discontinuity between beach and ocean as an abyss (*Abgrund*) separating the realms of land and sea. Börsch-Supan, "Bemerkungen," 64.

45. Jonathan Crary, *Techniques of the Observer: On Vision and Modernity in the Nineteenth Century* (Cambridge, MA: MIT Press, 1991). See in particular chapters 2, "The Camera Obscura and Its Subject" (pp. 25–66), and 4, "Techniques of the Observer" (pp. 97–136).

46. See Svetlana Alpers, *The Art of Describing: Dutch Art in the Seventeenth Century* (Chicago: University of Chicago Press, 1983), 26–71.

47. Koerner reminds us that this picture also presents the viewer with instances of separation, for example when he emphasizes that the image also partly stages a separation from the depicted landscape. Koerner, *Caspar David Friedrich and the Subject of Landscape*, 112.

48. On the removal of the rigging as a potential system of measurement, see Börsch-Supan, "Bemerkungen," 67–70; Koerner, *Caspar David Friedrich and the Subject of Landscape*, 119; Busch, *Caspar David Friedrich*, 59–60; Johannes Grave, *Caspar David Friedrich. Glaubensbild und Bildkritik* (Berlin and Zurich: Diaphanes, 2011), 70. The painter's refusal to employ any *repoussoir* elements in *Mönch am Meer* makes for a related rejection of a possible system for intrapictorial orientation. Such devices—for example, depictions

of objects rendered in perspectival recession—had been in use since the classical age of Dutch painting. It is, in part, this absence of structuring techniques that contributes to Kleist's impression that one's eyelids had been cut away. See Jörg Traeger, "'… As If One's Eyelids Had Been Cut Away': Imagination in Turner, Friedrich, and David," in Frederick Burwick and Jürgen Klein, eds., *The Romantic Imagination: Literature and Art in England and Germany* (Amsterdam: Rodopi, 1996), 414–415.

49. Börsch-Supan writes: "perception [begreifende Wahrnehmung] and the intellect are meant to fail in view of the picture's background, which is meant to appear as a zone withdrawn from all measuring types of viewing." Börsch-Supan, "Bemerkungen," 64. See also Koerner's account of Friedrich's landscape compositions as "invoking at the horizon an infinity that no system can arrange" through disorganizing an "achieved continuity of space." Koerner, *Caspar David Friedrich and the Subject of Landscape*, 113.

50. According to classical aesthetic philosophies, the subcategory of the sublime at stake here would be the so-called "mathematical" sublime (Kant), or "theoretically-sublime" (Schiller), in the sense that it indicates a magnitude that is cognitively accessible, i.e., "thinkable," while surpassing the limits of sensory processing and mental representation, or imagination (*Vorstellung*). See Kant, *Critique of Judgment*, 103–114 (*Kritik der Urteilskraft*, 169–184); Schiller, "Vom Erhabenen," 225–228. Schiller, "On the Sublime," 23–26. See Börsch-Supan, "Bemerkungen," 64: "The necessarily finite image is determined [bestimmt] as a fragment of infinity."

51. See ibid., 65: "Die Unendlichkeit des Hintergrundes ist nicht quantitativ bestimmt als die Unbegrenztheit des Raumes, die sich auch mit der Perspektive darstellen ließe, sondern als etwas, das nur negativ … bezeichnet werden kann. [The infinity of the background is not determined quantitatively as that type of limitlessness which could also be represented through the means of perspective; rather, this infinity is something that can only be designated negatively.]"

52. Koerner points out that *Mönch am Meer* also displays another moment of segmentation: the disruption of a set of perspectival diagonals that are carefully alluded to in the picture. See Koerner, *Caspar David Friedrich and the Subject of Landscape*, 119.

53. At this point my (Klugean) argument, again, squares with—and relies on—important arguments in the literature on Friedrich: crucially, that of Koerner, who in his work departs from a Kantian understanding of the sublime in art, which "occurs at the moment of representation's collapse." He also writes: "According to this model, our incapacity to find a place within Friedrich's scene, which is to say our loss of a determinate relation between ourselves and represented nature through the artist's deliberate disruption of the conventional 'system' of landscape, becomes a symbol of our relation to a transcendent order." Koerner, *Caspar David Friedrich and the Subject of Landscape*, 100. For my own purposes, I bracket the question of transcendence, but my notion of

the determination of the indeterminate is in perfect agreement with Koerner's account of a loss of a "determinate relation" effected by a deliberate disruption of representation. In a slight change of perspective, I would simply understand this very "deliberate disruption" as a moment of determination through negation, which in its result determines something *as* indeterminate. These features, which characterize implementations of the sublime in artworks, would correspond to the structure of "sublime feeling" as it occurs in the perceiving subject, as analyzed by Lyotard: "The relation of thinking to the object presented breaks down. ... Thinking grasped by the sublime feeling is faced ... with quantities capable only of suggesting a magnitude or a force that exceeds its power of presentation." Jean-François Lyotard, *Lessons on the Analytic of the Sublime* (Stanford: Stanford University Press, 1994), 52. It remains to be seen, or argued, to what extent my stance can be reconciled with, or actually contradicts, Lyotard's earlier view of the sublime, which relies on the premise that in "the determination of pictorial art the indeterminate ... is not expressible, and it is to this that it must bear witness." Lyotard, "The Sublime and the Avant-Garde," 37. While my argument could perfectly well accommodate Lyotard's Kantian definition of the sublime as a mode of "negative presentation," or "nonpresentation" (ibid., 40), the potential divergence would be linkd to the concepts of "expression" and/or "witnessing." See also Lyotard, *Lessons on the Analytic of the Sublime*, 150–153, where he describe negative presentation as follows: "In excluding itself from its own limits of presentation, the imagination suggests the presence of what it cannot present. It unbinds itself ..., but it does this by removing itself from its finality and thus annihilating itself according to this finality. It follows that the said 'presence' is not an object of the imagination; it is only felt subjectively by thought, as this gesture of retraction." Ibid., 152. For a connection between Lyotard's reading of Kant's theory of the sublime as negative representation of the infinite, and the art of Friedrich, see Jörg Zimmermann, "Bilder des Erhabenen: Zur Aktualität des Diskurses über Caspar David Friedrichs 'Mönch am Meer'," in Wolfgang Welsch and Christine Pries, eds., *Ästhetik im Widerstreit: Interventionen zum Werk von Jean-François Lyotard* (Weinheim: VHC Verlagsgesellschaft, 1991), 108; also Prager, "Kant in Caspar David Friedrich's Frames," 78. Finally, see also Greiner's reading of Kleist (on Friedrich), in which he points out that, for Kleist, the sublime presents a case in which no representation is adequate, but in which the inadequacy of all representation can be (sensorially) represented. Greiner, "Die Wende in der Kunst," 105.

54. Compare also Neil Hertz's psychoanalytic definition of the experience of the sublime as a "passage to the limit": Neil Hertz, *The End of the Line: Essays on Psychoanalysis and the Sublime* (New York: Columbia University Press, 1985), 53; as well as Koerner's account of Friedrich's art as articulating the position of "the Romantic subject at the limits of his world": Koerner, *Caspar David Friedrich and the Subject of Landscape*, 120. See also his already cited general account of "Friedrich's system" as "demonstration of the limits of the system" (ibid., 121).

CHAPTER 7

1. Alexander Kluge, "Die gescheiterte Hoffnung," in *Wer sich traut, reißt die Kälte vom Pferd: Landschaften mit Eis und Schnee. Stroh im Eis* (Frankfurt am Main: Filmedition Suhrkamp, 2010), 9. Alexander Kluge, "The Wreck of the *Hope*," *Grey Room* 53 (2013). For a situating introduction and a more extensive reading of that story, including its complex relations to the work of Friedrich, see chapter 6 above.

2. See Philipp Holstein, "Gerhard Richter zeigt den Winter: Interview mit Alexander Kluge," *Rheinische Post*, October 21, 2010, available at <http://www.kluge-alexander.de/aktuelles/details/artikel/gerhard-richter-zeigt-den-winter.html>.

3. See, for example, "Gerhard Richter. Interview mit Hans Ulrich Obrist (1993)," in Gerhard Richter, *Text. 1961 bis 2007. Schriften, Interviews, Briefe*, ed. Dietmar Elger and Hans Ulrich Obrist (Cologne: Walther König, 2008), 310. Richter's biographer Dietmar Elger reports that Richter saw *Das Eismeer* in the original for the first time in 1968, when he was visiting professor at the Hamburg art academy. See Dietmar Elger, *Gerhard Richter: Maler* (Cologne: Dumont, 2008), 227–228.

4. Richter had already used images from that region in his 1992 artist's book *Sils*. See the volume's second edition: Gerhard Richter, *Sils*, ed. Hans Ulrich Obrist (Cologne: Walther König, 2002). In one of several expansions of his *Atlas*, Richter also included a number of panels showing photos from the Sils region. See Helmut Friedel, "Gerhard Richter. Atlas. Continuation to 2013," in Gerhard Richter, *Atlas. Tafeln / Sheets 784–802* (Munich: Lenbachhaus; Cologne: Walther König, 2013), 9.

5. These stories are "1. Dezember 1941: Eissturm an der Front in Moskau" and "Die Abgrenzung nach Alt- und Neujahr nach Deutscher Industrienorm (DIN)," in Alexander Kluge and Gerhard Richter, *Dezember* (Berlin: Suhrkamp, 2010), 7, 123–124. In the English-language edition these are "1 December 1941: Ice Storm on the Front Line outside Moscow" and "The Demarcation of Old Year and New Year According to German Industrial Standards (DIN)." See Kluge and Richter, *December. 39 Stories. 39 Pictures*, trans. Martin Chalmers (London: Seagull, 2011), 1, 117.

6. See inner front sleeve of the German edition.

7. This dialogue appears only in the film version.

8. Letter from Theodor W. Adorno to Alexander Kluge, March 13, 1967, quoted in Kluge, *Wer sich traut, reißt die Kälte vom Pferd*, 4. Translated by Richard Langston as part of an excerpt from this volume in *Grey Room*. Alexander Kluge: Preface, in *Grey Room* 53 (2013), 91.

9. Letter from Theodor W. Adorno to Alexander Kluge, May 26, 1967, quoted in ibid.

10. Nora Alter, Lutz Koepnick, and Richard Langston contextualize this intended collaboration in the larger framework of Adorno's thought, where it resonates, for instance, with his 1966 radio lecture "Erziehung nach Auschwitz" (Education after Auschwitz). See their "Landscapes of Ice, Wind, and Snow: Alexander Kluge's Aesthetic of Coldness," *Grey Room* 53 (Fall 2013), 61. See ibid., particularly 63–76, for a close analysis of the DVD's chapter 3—"Das Ende eines Eiszapfens mit Himmelsgestirn" (The Demise of an Icicle with the Heavens in the Distance), as well as a discussion of possible connections and continuities with Adorno's theories of the mediation of nature.

11. See Hans Ulrich Obrist, "Interview mit Gerhard Richter," in *Gerhard Richter: Bücher*, ed. Hans Ulrich Obrist and Dieter Schwarz (Dresden: Gerhard Richter Archiv; Cologne: Walther König, 2013), 37, 42. Here Obrist and Richter discuss the artist's first book, the 1966 joint project with Sigmar Polke, *Polke/Richter, Richter/Polke*. To the author's knowledge, Richter himself refers explicitly to the terminology of film and its techniques only once: in the title of his 2004 artist's book *War Cut*. As Dieter Schwarz explains, that title was chosen to describe the juxtaposition of newspaper clippings and detail shots of one of Richter's paintings which structures the book, providing an interpretation of the montage ("zusammenmontiert") of these two levels "in the sense of a filmic cut [*im Sinne des Filmschnitts*]." Dieter Schwarz, "Künstlerbücher von Gerhard Richter?," in *Gerhard Richter: Bücher*, 20. This is not, of course, to say that thinking about Richter's work in the context of a media theory and media poetics of film is unproductive. In her essays on the artist's work, Gertrud Koch has demonstrated the contrary (see below).

12. Benjamin H. D. Buchloh, "Gerhard Richter's *Atlas*: The Anomic Archive," *October* 88 (Spring 1999), 131.

13. Ibid., 134, 131. For Buchloh's central discussion of the historical dialectic between these two poles of opposition during the 1920s, see Benjamin H. D. Buchloh, "From Faktura to Factography," *October* 30 (Fall 1984), 82–119.

14. That being said, both historical strands, and both variants of montage practice (photographic and filmic), are intertwined and develop in parallel, so to speak. Whereas, as Buchloh has shown, Heartfield, Höch, or the Soviet artists' works must be considered as historical precursors to Richter's *Atlas*, Kluge's montage practice develops in part through a historical engagement with the works of their contemporaries Eisenstein and Vertov (see chapter 2 above). One could also point to the preeminent role which Benjamin's and Kracauer's writings on photography and film have played in theorizing both of these strands.

15. As early as 1973, in conversation with Irmeline Lebeer, Richter set his work apart from that of his contemporaries by invoking the legacy of romanticism: "There is with me an authentic reference to Romanticism which differentiates me from the hyperreal-

ists who represent the whole world of the present day." Quoted in Jean-Philippe Antoine, "Photography, Painting and the Real: The Question of Landscape in the Painting of Gerhard Richter," in *Gerhard Richter* (Paris: Éditions Dis Voir, 1995), 78 See also, for instance, Richter's similar statement in a much later interview with Paolo Vagheggi, in which he says that some of his pictures are "an homage to Caspar David Friedrich." "Gespräch mit Paolo Vagheggi (1999)," in Richter, *Text. 1961 bis 2007*, 356. Interestingly, on the occasion of a conversation between Richter and Kluge for one of the director's TV features, Richter makes a slightly disapproving remark about Friedrich's paintings. He juxtaposes the romantic artist's almost imperceptibly subtle and smooth layering of color with his own handling of paint, which conceptually engages with the problem of *faktura*. Available at <http://magazin.dctp.tv/2015/02/09/der-bildermacher-gerhard-richter-zum-83-geburtstag-2/>.

16. Benjamin H. D. Buchloh, "Readymade, Photography, and Painting in the Painting of Gerhard Richter," in Buchloh, *Neo-Avantgarde and Culture Industry: Essays on European and American Art from 1955 to 1975* (Cambridge, MA: MIT Press, 2000), 384.

17. See, for instance, Hubertus Butin, "Gerhard Richter—ein deutscher Romantiker?," in Hubertus Butin, Claudia Heinrich, and Peter Friese, eds., *Gerhard Richter und die Romantik* (Essen: Kunstverein Ruhr, 1994), 7–28; Butin, "The Un-Romantic Romanticism of Gerhard Richter," in Keith Hartley, Henry Meyric Hughes, Peter-Klaus Schuster, and William Vaughan, eds., *The Romantic Spirit in German Art: 1790–1990* (London: Thames and Hudson, 1994), 461–463, esp. 463, where Butin, invoking the work of Stefan Germer, describes Richter's painting as *Trauerarbeit*, as a work of mourning in relation to the romantic tradition. See also Mark Godfrey, "Damaged Landscapes," in Mark Godfrey and Nicholas Serota, eds., *Gerhard Richter: Panorama* (London: Tate Publishing, 2011), 80.

18. Kluge and Richter, *Dezember*, inner front sleeve.

19. See also Godfrey, "Damaged Landscapes," 73–89, for a discussion of how Richter's *Städtebilder* (*City Pictures*), for which the artist had used aerial photographs of cities, were, on their first reception in Germany, immediately associated with the experience of air raids.

20. Benjamin H. D. Buchloh, "Abstraktion—Transzendenz. Fragmente eines Lexikons für / über Gerhard Richter," in *Gerhard Richter: Bilder 1996–2001* (New York: Marian Goodman Gallery; Düsseldorf: Richter Verlag, 2002), 13; my translation. The original German formulation is: "Eine mögliche Erklärung der scheinbar unendlichen, quantitativen Ausdehnung der abstrakten Bilder Richters wäre die Theorie einer Produktion, die es sich zur Aufgabe gemacht hat, die Realität eines in sich geschlossenen, individuellen Werkes ebenso aufzuheben, wie die Idee eines in sich geschlossenen Œuvres, das im Laufe eines Lebens geschaffen wurde und das in seinen einzelnen, aufeinanderfolgenden Phasen vom Frühwerk bis zum Altersstil erkennbar wäre."

21. See Schwarz, "Künstlerbücher von Gerhard Richter?," 32.

22. See also Stefan Germer's remarks on this peculiar displacement of to-ing and fro-ing in front of Richter's paintings in his essay "Ungebetene Erinnerungen," in *Gerhard Richter. 18. Oktober 1977* (Cologne: Walther König, 1989), 51.

23. It is also in this sense that Richter's blurred photo-paintings "capture … a sliding glance," as Gertrud Koch has written: they force the viewer into an ongoing shift of perceptual and epistemological concentration, thereby eliciting a sliding focus, or permanent refocalization. Gertrud Koch, "The Richter-Scale of Blur," *October* 62 (Fall 1992), 136.

24. For a discussion of Richter's complex engagement with the episteme of the window in the history of painting, in particular as it unfolds in the artist's glass works, see Benjamin H. D. Buchloh, "Eight Gray: Between Vorschein and Glanz," in Lynne Cooke and Stephen Hoban, eds., *Robert Lehmann Lectures on Contemporary Art*, vol. 5 (New York: DIA Art Foundation, 2014), 39–49.

25. Gerhard Richter, *Eis* (Cologne: Walther König, 2011), no pagination. This volume forms Richter's second attempt at assembling images from his 1972 voyage into a book. The first version was titled *Gerhard Richter: Eis, 1973–1981*, and was published in 1981 by Galleria Pieroni in Rome. Both versions contain different selections of pictures. See Armin Zweite, "Gerhard Richter's Album of Photographs, Collages and Sketches," in Iwona Blazwick and Janna Graham, eds., *Gerhard Richter, Atlas: The Reader* (London: Whitechapel, 2004), 55. See also Obrist, "Interview mit Gerhard Richter," 62–64. For the purposes of my argument, I have decided to focus on the 2011 version: first, for the simple reason that it is temporally closer to Richter and Kluge's collaboration on *Dezember*; secondly, because one important difference between the two versions—the fact that the 2011 edition comprises a textual component—also renders it structurally closer to *Dezember*, which combines stories and pictures. The 1981 edition is, evidently, more tightly related to Richter's Arctic canvases, discussed above, on which he worked at about the same time (1981–1982).

26. Richter has systematically addressed these issues of reflection *vis-à-vis* painting in his monochrome works with glass and mirrors, i.e., his "colored mirrors," the earliest examples of which are the *Four Panes of Glass* (1967). See Buchloh, "Eight Gray," 31. Or, to adopt the perspective of Dieter Schwarz: a number of Richter's recent glass works "go back not only to his own glass panels of 1967 and to the paintings of doors and windows but also … to the photo-expedition he made to Greenland in 1972. The inspiration for that trip had been Caspar David Friedrich's renowned painting *The Wreck of the Hope* (1823–24)." Dieter Schwarz, "Glass Strips Glass: New Works by Gerhard Richter 2010 to 2013," in *Gerhard Richter* (London: Marian Goodman Gallery, 2014), 19–20.

27. Hal Foster, "Semblance According to Gerhard Richter," in Benjamin H. D. Buchloh, ed., *Gerhard Richter*, October Files (Cambridge, MA: MIT Press, 2009), 125. The German original is from Richter, *Text. 1961 bis 2007*, 223.

28. Ibid., 126. From the vantage point of a history of painting, the genealogy unfolds as follows: "It is as though Richter wanted to run these diverse strands of practice together, to put the exalted pictorial formats of the 'Northern romantic tradition' from Friedrich to Newman through the anti-aesthetic paces of the Duchampian (neo) avant-garde, the found image above all—to test the ideal of 'beautiful semblance' foregrounded in the romantic line with the fact of commodification underscored by the (neo) avant-garde line." Ibid., 115. On the problem of semblance in the painting of Caspar David Friedrich, see ibid., 126.

29. Ibid., 125.

30. One could, finally, connect the appearance and disappearance of narrative on the pages of *Eis*, the semblance of a story, to the model of a "temporal inscription," which Buchloh has identified in Richter's glass works: "the mirror and the highly reflective monochromatic glass pane intensify the purging of all indexical mark-making processes and situate the production of inscription entirely within the range of the reader/spectator." Buchloh, "Eight Gray," 38. This would amount to a mode of inscription that always-already anticipates and communicates its future evanescence.

31. In this specific treatment of temporality, *Eis* would seem to coincide with a general tendency in Richter's photo-paintings, which Peter Osborne has identified as a marking of time: "Richter's paintings mark time, the historical time of their production, the time of the crisis of painting, and they mark time with paint." Peter Osborne, "Painting Negation: Gerhard Richter's Negatives," *October* 62 (Fall 1992), 110.

32. This rather peripheral reading of Richter's stalling or suspension of narrative on the pages of *Eis* echoes Hal Foster's much more far-reaching interpretation of the role of suspension where Richter's painting engages with the quality of arbitrariness. Foster argues that Richter's works perform, expose, and ultimately *suspend* the arbitrary. See Hal Foster, *The First Pop Age: Painting and Subjectivity in the Art of Hamilton, Lichtenstein, Warhol, Richter, and Ruscha* (Princeton: Princeton University Press, 2012), 184. Foster also refers to Roland Barthes's late theory of the neutral, which, as a strategy for outplaying and eventually *suspending* the powers of paradigms, forms a crucial reference point in this context. See ibid., 208.

33. There is a strange kinship here with Richter's blurred paintings in which what seem like nebula and clouds of paint—colored, but also black, white, and gray—generate a compact effect in which the photographic motif that preceded the painting is absorbed. Gertrud Koch situates this impenetrability of Richter's painterly blur philosophically when she writes: "This blurring is ... both subjective act and objective state at one and

the same time. In phenomenological terms, it can be conceived of as a mental state in which the relation to the world of objects blurs and the act of blurring causes that world to appear particularly threatening—to appear as an impenetrable presence." Koch, "The Richter-Scale of Blur," 136.

34. This is in reference, but also in contrast, to Koerner's analysis of the mode in which Caspar David Friedrich's *Bäume und Sträucher im Schnee* (*Trees and Bushes in the Snow*) (1828) and *Fichtendickicht im Schnee* (*Fir Trees in the Snow*) (1828) create structures which accommodate the beholder by structurally engulfing her or him, or by offering stand-in figurations for the viewer. See Joseph Leo Koerner, *Caspar David Friedrich and the Subject of Landscape* (London: Reaktion Books, 1990), 5–10.

35. Not all of Richter's work is oriented toward producing this type of virtual time image. As Gertrud Koch has discussed in a short essay, a number of the painter's canvases actually follow an almost classically filmic program in that they realize an aesthetic of the snapshot, of the cut, and even of quasi-cinematic narration. See Gertrud Koch, "Verlauf der Zeit/Passage of Time," *Parkett* 35 (1993), 73–75.

36. Benjamin H. D. Buchloh, "Gerhard Richter's Glass: Painting's Double," in *Gerhard Richter* (London: Marian Goodman Gallery, 2014), 91.

37. The German word *Seestück* is the technical term for genre painting with maritime subject matter, i.e., depictions of the sea.

38. With reference to Richter's maquettes, Gertrud Koch suggests an explicitly photo-filmic concept of montage: "It is the seascapes most of all that make use of the stock of montage and retouching techniques. … Thus in many of the seascapes it is not the sky that one finds above the water, but rather a montage of mirror images of masses of water that nonetheless echo the formal structure of the more customary cloud formations." Koch, "The Richter-Scale of Blur," 138–139.

39. See Gerhard Richter, *Patterns* (Cologne: Heni/Walther König, 2011), no pagination. With reference to Kracauer's concept of the mass ornament, Benjamin Buchloh has called these works by Richter, and the related Strip series, chance ornaments, in which painting is subjected to "cutting, doubling, and symmetrical reversal." Benjamin H. D. Buchloh, "The Chance Ornament: Aphorisms on Gerhard Richter's Abstractions," *Artforum* 50, no. 6 (February 2012), 178; see also 174, 177.

40. See Buchloh, "Eight Gray," on Richter's engagement with the trope of the window in modernist painting and beyond. Julia Gelshorn situates Richter's mirror and window works in the theoretical and historical discourses opened by Alberti's *De pictura*. See her monograph *Aneignung und Wiederholung: Bilddiskurse im Werk von Gerhard Richter und Sigmar Polke* (Munich: Fink, 2012), 101–104.

41. Dieter Schwarz explains that the first version of *Eis* offers an even fuller manifestation of such mirroring, i.e., reversibility and invertible readability, in that all the images

which Richter selected for the 1981 book displayed a near-uniform division of sea and sky by the horizon line. See Schwarz, "Künstlerbücher von Gerhard Richter?," 32. He also explains that this principle of mirroring, and a permutation of the placement and orientation of images along the pages, also structures other artist's books by Richter. See ibid., 21.

42. Gerhard Richter, *Elbe* (Cologne: Walther König, 2009). On the retrospective titling, see Dieter Schwarz's explanation (ibid., 73).

43. See ibid., 5.

44. Buchloh, "Gerhard Richter's Glass," 91.

45. Ibid., 90.

46. Ibid.

47. Ibid., 85.

48. Ibid., 91.

49. Ibid., 91–92.

50. Rachel Haidu offers yet another interpretation of Richter's engagement with the sublime. In her essay "Images of the World and the Inscription of History," she focuses on the important question of scale: "The issue of scale and its relation to the Romantic sublime … becomes more powerfully felt as Richter's work takes on larger and larger proportions." Rachel Haidu, "Images of the World and the Inscription of History," in Godfrey and Serota, *Gerhard Richter. Panorama*, 203. Located in the realm of what Kant called the mathematical sublime (see chapter 6 above), the issue of sublime scale ultimately also falls under the paradigm of discontinuity—it is the hiatus between the capacity of the perceiving, apprehending mind and the magnitude of the object of apprehension that generates sublime experiences.

51. Germer, "Ungebetene Erinnerungen," 51; emphasis added. Germer also calls this an "Annäherung aus Distanzierung"—an approach, or approximation, by way of distancing. See ibid.

52. Kluge and Richter's second book collaboration, the 2013 *Nachricht von ruhigen Momenten* (*News from Quiet Moments*), modifies this project of producing still images. It is based on photographs by Richter, encompassing still lives, family pictures, landscapes, city shots, etc., which the artist published in fall 2012 in an issue of the German daily newspaper *Die Welt*, where they took the place of the newspaper's usual illustrations. Kluge complements Richter's pictures with stories of a similarly broad range, including some which center on the medium of photography, as well as others that thematize historical and more recent events that would have been deemed "newsworthy." Here, the idea of implementing a moment of stilling, epitomized by the term "ruhig" (*quiet*)

in the book's title, relies on the removal of Richter's images and Kluge's stories from the sphere of "news," "events," and their reporting. This is clearly articulated in the oxymoronic structure of the title *Nachricht von ruhigen Momenten*. A quiet moment would seem unnewsworthy *per se*. See Alexander Kluge and Gerhard Richter, *Nachricht von ruhigen Momenten* (Berlin: Suhrkamp, 2013).

53. See Eric Rentschler, "Declaration of the Independents: On the 50th Anniversary of the Oberhausen Manifesto," *Artforum* 50, no. 10 (Summer 2012), 279.

54. Ibid.

55. See Kluge's comments on what he refers to as the "ars povera" character of his work. Philipp Ekardt and Alexander Kluge, "Returns of the Archaic, Reserves for the Future: A Conversation with Alexander Kluge," *October* 138 (Fall 2011), 127.

56. Alexander Kluge, interview with the author, unpublished section.

57. See, for instance, Friedrich Schlegel's dictum that "wahre Kritik" (true criticism) is "ein Autor in der 2t Potenz" (authorship squared). Friedrich Schlegel, *Kritische Ausgabe seiner Werke*, vol. 18, ed. Ernst Behler (Munich: Schöningh, 1962), 106. On the notion of reflection and self-reflexivity (as indicated by Schlegel's formulation of the "2t Potenz"), especially in early romanticism, see Winfried Menninghaus, *Unendliche Verdopplung. Die frühromantische Grundlegung der Kunsttheorie im Begriff absoluter Selbstreflexion* (Frankfurt am Main: Suhrkamp, 1987), 72–131.

58. Alexander Kluge, *Cinema Stories*, trans. Martin Brady and Helen Hughes (New York: New Directions, 2007), xi. For the original German, see Kluge, *Geschichten vom Kino* (Frankfurt am Main: Suhrkamp, 2007), 7.

59. See Bruno Latour, *Reassembling the Social: An Introduction to Actor-Network-Theory* (Oxford: Oxford University Press, 2007).

60. See Bruno Latour, "Why Has Critique Run Out of Steam? From Matters of Facts to Matters of Concern," *Critical Inquiry* 30, no. 2 (Winter 2004). One of the fundamental differences between a Klugean and a Latourian approach to assemblage and/or montage seems to lie in Latour's embrace of "mere description," which he explicitly posits against (his understanding of) critique. See, for instance, the section "Deployment not critique" in Latour, *Reassembling the Social*, 136–140. While shying away from an embrace of positivism, Latour prefers to merely point to difference on the ontological level by quoting Tarde's dictum "to exist is to differ." (Ibid., 137.) The Klugean predicament, by contrast, correlates the localization of difference and the activity of discernment with the construction of montage ensembles. As is clear from Kluge's critique of mere depiction and his theory of context (*Zusammenhang*), any exhortation to "merely describe"—a Latourian mantra—would sound deeply problematic from his perspective.

Chapter 8

1. These section titles are from *Die Macht der Gefühle* (*The Power of Feelings*) and *Die Patriotin* (*The Patriot*).

2. "I would not be making movies if it were not for the film history of the 1920s, for silent film. Ever since I started to make films, I have made them in reference to this classical tradition." Alexander Kluge, *Die Patriotin. Texte. Bilder 1–6* (Frankfurt am Main: Zweitausendeins, 1979), 40. See Philipp Ekardt and Alexander Kluge, "Returns of the Archaic, Reserves for the Future: A Conversation with Alexander Kluge," *October* 138 (Fall 2011), 132.

3. The particular temporal signature of Kluge's lettering panels seems to be related to what Alexander Nagel and Christopher Wood have defined as "anachronic" art, understood as works that make ex-centric temporalities operative: "The work of art when it is late, when it repeats, when it hesitates, when it remembers, but also when it projects a future or an ideal, is 'anachronic'." Alexander Nagel and Christopher Wood, *Anachronic Renaissance* (Cambridge, MA: Zone Books, 2010), 13. One might include Jacques Rancière's definition of *anachronies*, to which Nagel and Wood refer, within this panorama (ibid., 370). Jacques Rancière, "L'inactuel," *Psychanalyse & Culture* 6 (1996), 53–64.

4. See the observation on this point in Rainer Lewandowski, *Die Filme von Alexander Kluge* (Hildesheim: Olms, 1980), 17.

5. This effect translates the actual spatial conditions under which this type of image is produced: Kluge's cameraman refilms footage and illustrations at the editing desk, while placing a mask in front of the camera lens.

6. For Kluge's continued, but now medially displaced, use of the peephole structure in relation to digital small formats such as the miniature screen of the mobile phone, or even the thumbnail image, see Ekardt and Kluge, "Returns of the Archaic, Reserves for the Future," 124–125.

7. Ibid., 116.

8. See Karl Kraus, "Pro domo et mundo," *Die Fackel* 13, no. 326–328 (1911), 44.

9. See Walter Benjamin, "On Some Motifs in Baudelaire," in Benjamin, *Selected Writings*, vol. 4, ed. Howard Eiland and Michael W. Jennings (Cambridge, MA: Belknap Press, 2003), 338; originally "Über einige Motive bei Baudelaire," in Benjamin, *Gesammelte Schriften*, vol. 1.2, ed. Rolf Tiedemann and Hermann Schweppenhäuser (Frankfurt am Main: Suhrkamp, 1974), 647. It could be argued that the veil of historical mediation through which Kluge's films present early film, in its characteristic combination of approximation and distancing, is a refigured version of the Benjaminian aura.

10. See Miriam Hansen, "Alexander Kluge: Crossings between Film, Literature, Critical Theory," in Sigrid Bauschinger, Susan L. Cocalis, and Henry A. Lea, eds., *Film und Literatur: Literarische Texte und der neue deutsche Film* (Berne: Francke, 1984), 175, 192. See also Stefanie Carp, *Kriegsgeschichten: Zum Werk Alexander Kluges* (Munich: Fink, 1987), 61–62.

11. Theodor W. Adorno, "Transparencies on Film," trans. Thomas Y. Levin, *New German Critique*, no. 24/25 (Autumn 1981–Winter 1982), 203; originally "Filmtransparente," in Adorno, *Gesammelte Schriften*, vol. 10.1, ed. Rolf Tiedemann et al. (Frankfurt am Main: Suhrkamp, 2003), 358. On the general nexus between montage, image, and writing in Adorno's thought and Frankfurt School theory, see Miriam Hansen, *Cinema and Experience: Siegfried Kracauer, Walter Benjamin, and Theodor W. Adorno* (Berkeley: University of California Press, 2012), 224–225.

12. Adorno, "Transparencies on Film," 201; "Filmtransparente," 355.

13. See Ekardt and Kluge, "Returns of the Archaic, Reserves for the Future," 132.

14. Akzidenz Grotesk was developed by the designer Otl Aicher, a colleague of Kluge's on the faculty of the Ulm Hochschule für Gestaltung, who also used it in his layout for Kluge's first literary publication, the 1961 Goverts edition of *Lebensläufe* (*Case Histories*).

15. At least in Kluge's implicit analysis, the classical modernist account of cinema as the cardinal medium of distraction is hence displaced by a newly emergent dyad in which television and digital media take on the function of dispersed reception, whereas film now functions as a medium that focuses attention.

16. See Vana Greisenegger-Georgila, "Caspar Nehers dialektische Bühne für Brecht," in Michael Schwaiger, ed., *Bertolt Brecht und Erwin Piscator: Experimentelles Theater im Berlin der Zwanzigerjahre* (Vienna: Brandstätter, 2004), 73–95.

17. See Brecht's programmatic texts about onstage projections of writing, such as "Über die Literarisierung der Bühnen," "Über Titel," or "Das Projektionsverfahren," in Bertolt Brecht, *Schriften zum Theater*, vol. 3 (Frankfurt am Main: Suhrkamp, 1963), 253–257.

18. Hansen develops Brecht's notion of a literarization of the theater, as connected to the use of onstage titling, and transposes it to Kluge's cinema, in "Alexander Kluge: Crossings between Film, Literature, Critical Theory," 178; also with relation to *Verfremdung* (estrangement) and gesture in Brecht (p. 184).

19. Walter Benjamin, "Was ist das epische Theater? Eine Studie zu Brecht," in *Gesammelte Schriften*, vol. 2.2, ed. Rolf Tiedemann and Hermann Schweppenhäuser (Frankfurt am Main: Suhrkamp, 1974), 524–525.

20. Benjamin once speculated about literarization as a possible effect of technical reproducibility. See the notes for the artwork essay in Walter Benjamin, *Gesammelte Schriften*,

vol. 1.3, ed. Rolf Tiedemann and Hermann Schweppenhäuser (Frankfurt am Main: Suhrkamp, 1974), 1039. In the end, he preferred "Politisierung" (politicization) (ibid.).

21. For an analysis of the cultural background and the general debate surrounding the divergences between *Abschied von gestern* and "Anita G."—the so-called *Literaturverfilmungskrise*—see the chapter "Germany before Autumn: The Literature Adaptation Crisis," in Eric Rentschler, *West German Film in the Course of Time: Reflections on the Twenty Years since Oberhausen* (Bedford Hills, NY: Redgrave Publishing, 1984), 128–157.

22. See also Samuel Weber's reading of Benjamin's artwork essay, where he emphasizes that in Benjamin's writings not only does the aura never fully disappear, but it also always carries at least the potential for a return through its character as an "appearance or apparition of an irreducible separation," as "always constituted in a process of self-detachment." See Weber, *Mass Mediauras: Form, Technics, Media*, ed. Alan Cholodenko (Stanford: Stanford University Press, 1996), 87. See also p. 88: "The aura would then be something like an enabling limit, the emanation of an object from which it removes itself, a frame falling away from a picture and in its fall, in its *Verfall*, becoming light: a bright shadow." Weber links these reflections directly to the Heideggerian category of *Ent-fernung*, "an 'un-faring' that does not exclude distance," which he discusses in his analysis of television (ibid.).

23. Alexander Kluge, *Der Angriff der Gegenwart auf die übrige Zeit. Abendfüllender Spielfilm, 35 mm, Farbe mit s/w-Teilen, Format: 1: 1,37. Drehbuch* (Frankfurt am Main: Syndikat, 1985), 112.

24. See the sections "The invention of typography confirmed and extended the new visual stress of applied knowledge, providing the first uniformly repeatable commodity, the first assembly-line, and the first mass production"; and "A fixed point of view becomes possible with print and ends the image as a plastic organism," in Marshall McLuhan, *The Gutenberg Galaxy: The Making of Typographic Man* (London: Routledge and Kegan Paul, 1962), 124–127.

25. See Béla Balázs, *Der sichtbare Mensch oder die Kultur des Films* (Frankfurt am Main: Suhrkamp, 2001), 85. The English version of *Der sichtbare Mensch* translates *Zeitperspektive* as "experience of time." See Béla Balázs, *Early Film Theory: Visible Man and The Spirit of Film*, ed. Erica Carter, trans. Rodney Livingstone (New York: Berghahn Books, 2010), 68.

26. Kluge, *Der Angriff der Gegenwart auf die übrige Zeit. Drehbuch*, 111.

27. Burkhardt Wolf, "Sichtverhältnisse im Krieg. Zur historischen Dokumentation und Spurensicherung bei Alexander Kluge," *Weimarer Beiträge* 48, no. 1 (2002), 6. For a more extensive theoretical discussion of Foucault's notions of *positivity* and the *historical a priori* vis-à-vis Kluge's work, see Burkhardt Wolf, *Von der Kunst kleiner Ereignisse: Zur Theorie einer "minoritären" Literatur: Alexander Kluge und Gilles Deleuze* (Marburg:

Tectum, 1998), 14–30. His suggestion is even more convincing if one includes Kluge's thematization of the history of film's *dispositifs*, which parallels Foucault's use of Baudry's film-theoretical concept of *le dispositif* for the purposes of historiography (see chapter 1 above). See also Fredric Jameson's (non-Foucauldian) analysis of Kluge's depictions of war and terror, in particular in *Schlachtbeschreibung* (*The Battle*) and "Der Luftangriff auf Halberstadt" (The Air Raid on Halberstadt). Jameson, "War and Representation," *PMLA* 124, no. 5 (October 2009), 1532–1547.

28. Wolf, "Sichtverhältnisse im Krieg," 5.

29. Kittler, although of different political convictions and a frequent outspoken critic of Frankfurt School thinking, held Kluge's work in high esteem. For instance, he gave the honorary speech for Kluge on the occasion of the latter's reception of the Adorno Prize in 2009. See *Südwest-Presse* (September 11, 2009), online at <http://swp.de/swp_import/nachrichten/uberregional/boulevard/art664546,212952,A>.

30. Friedrich Kittler, *Grammophone, Film, Typewriter*, trans. Geoffrey Winthrop-Young and Michael Wutz (Stanford: Stanford University Press, 1999), 117, translation modified; originally *Grammophon, Film, Typewriter* (Berlin: Brinkmann & Bose, 1986), 180. Foucault explains the function of discontinuities for his historiographic project in the introduction to *The Archaeology of Knowledge*, trans. A. M. Sheridan Smith (New York: Pantheon, 1972), 8–10; he unfolds the concept of the historical a priori and the archive on pp. 126–131 (originally *L'archéologie du savoir* [Paris: Gallimard, 1969], 16–17 and 66–73 respectively). See also Gilles Deleuze on "How can we conceptualize the cut?" in Foucault's work: Deleuze, *Foucault*, trans. Seán Hand (Minneapolis: University of Minnesota Press, 1988), 20; originally *Foucault* (Paris: Éditions de Minuit, 1986), 29–30. For Kittler's later, more diversified and more classically historiographic account of the era of film, see Friedrich Kittler, *Optical Media: Berlin Lectures 1999* (Cambridge: Polity Press, 2010), 145–207; originally *Optische Medien: Berliner Vorlesung 1999* (Berlin: Merve, 2002), 195–289.

31. See Christian Metz, *Film Language: A Semiotics of Cinema* (Chicago: University of Chicago Press, 1991). See also the canonical collective semiotic reading of John Ford's *Young Mr. Lincoln* in *Cahiers du Cinéma* 223 (August 1970), 29–47. One issue earlier, the *Cahiers* published Roland Barthes's Eisenstein reading "Le troisième sens," two issues earlier a selection of writings on 1920s Soviet cinema, primarily original sources including texts by Vertov, Eisenstein, Tynianov, etc., which partially connected questions of film to Russian structural linguistics. Both these issues also appeared in 1970.

32. See above, chapter 2.

33. This also holds true in relation to Derrida's post-Husserlian interpretation of the term, as unfolded into a historical model by Bernhard Siegert. See Siegert, *Relays: Literature as an Epoch of the Postal System*, trans. Kevin Repp (Stanford: Stanford University Press, 1999), 4–19; originally *Relais. Geschicke der Literatur als Epoche der Post. 1751–1913*

(Berlin: Brinkmann & Bose, 1993), 9–25. Or p. 10 of the English edition for the following concise formulation: "It is the withdrawal that gives. Stated differently and more technically: the epoch is a relay, a halt, that is necessary so that something arrives and comes to be known. ... Epochs predate history as its postal apriori." In Kluge's work, there are no epochs in this sense of a constitutive halt that enables the sending of a message; there are no relays. *If* the act of sending did constitute an important element of Kluge's work, it would probably have to be located in the gesture of sending the viewer, reader, his own work, to another place—or time. This would amount to the construction of *Zusammenhang* as an escape route from closure.

34. Deleuze, *Foucault* (English), 43 (translation modified; see p. 51 of the French edition).

35. Ibid., 21–22 (English); 30 (French).

36. Matthias Uecker's article "Rohstoffe und Medialitäten" suggests that what Uecker calls "intermedial" production in Kluge is both enabled and canceled "da deren intendiertes Medium immer das gleiche ist: der Kopf des Autors und die Köpfe seines Publikums [because the intended medium is always the same: the author's head and the heads of his audience]." Such a position seems difficult to defend, as does Uecker's claim that for Kluge, the "einzige wirkliche Medium [only real medium]" are "Erfahrungen und Wünsche [experiences and wishes]." See Matthias Uecker, "Rohstoffe und Medialitäten. Überlegungen zu Alexander Kluges Fernsehpraxis," in Christian Schulte and Winfried Siebers, eds., *Kluges Fernsehen. Alexander Kluges Kulturmagazine* (Frankfurt am Main: Suhrkamp, 2002), 84–85. This and other attempts at analyzing Kluge's output under the perspective of a supposed "intermediality," preferably by invoking the omnipresent trope of *Dazwischen* (in-between) as a montage-related guarantor for "criticality," prove fruitless with striking regularity. One could speculate whether the reason for this lies, again, in Kluge's technique of small forms/short units that effectively outmaneuvers questions of mediality in favor of questions of production (and not, as Uecker claims, in a supposed "Versuch, die Leistungsfähigkeit aller Medien zu testen [attempt to test the capacities of all media]." Ibid., 87.

37. Jean-Luc Godard, "Le montage, la solitude, la liberté," in *Jean-Luc Godard par Jean-Luc Godard*, vol. 2, ed. Alain Bergala (Paris: Cahiers du Cinéma, 1998), 242. See ibid. for Godard's *manual* account of montage: "Au montage ... on a physiquement un moment, comme un objet."

38. Gilles Deleuze, *Cinema II: The Time-Image* (Minneapolis: University of Minnesota Press, 1989), 42.

39. Ibid.

40. Jean-Luc Godard, "Godard fait des histoires. Entretien avec Serge Daney," in *Jean-Luc Godard par Jean-Luc Godard*, vol. 2, 163.

41. Alexander Kluge, "The Air Raid on Halberstadt on 8 April 1945," in Kluge, *Air Raid*, trans. Martin Chalmers (London: Seagull Books, 2014), 32. For the original German, see Kluge, "Der Luftangriff auf Halberstadt am 8. April 1945," in *Neue Geschichten. Hefte 1–18. Unheimlichkeit der Zeit* (Frankfurt am Main: Suhrkamp, 1977), 46.

42. Kluge, "The Air Raid on Halberstadt," 28–35; "Der Luftangriff auf Halberstadt," 43–58.

43. Jacques Rancière, *Film Fables* (Oxford: Berg, 2006), 171.

44. Ibid.

Chapter 9

1. Alexander Kluge, "Ein Hauptansatz des Ulmer Instituts," in Klaus Eder and Alexander Kluge, eds., *Ulmer Dramaturgien. Reibungsverluste. Stichwort: Bestandsaufnahme* (Munich: Hanser, 1980), 5.

2. Alexander Kluge, Gertrud Koch, and Heide Schlüpmann, "'Nur Trümmern trau ich …'. Ein Gespräch mit Alexander Kluge," in Hans Ulrich Reck, ed., *Kanalarbeit. Medienstrategien im Kulturwandel* (1987; Frankfurt am Main: Stroemfeld/Roter Stern, 1988), 17.

3. See Miriam Hansen, "Reinventing the Nickelodeon: Notes on Kluge and Early Cinema," *October* 46 (Fall 1988), 179–198. See also Tom Gunning's foundational article "The Cinema of Attractions: Early Film, Its Spectator and the Avant-Garde," in Adam Barker and Thomas Elsaesser, eds., *Early Film: Space, Frame, Narrative* (London: British Film Institute, 1989); Philipp Ekardt and Alexander Kluge, "Returns of the Archaic, Reserves for the Future: A Conversation with Alexander Kluge," *October* 138 (Fall 2011), 120.

4. See the *Minutenfilm Hinrichtung eines Elefanten* (Execution of an Elephant); also in Alexander Kluge, *Geschichten vom Kino* (Frankfurt am Main: Suhrkamp, 2007), 53–55.

5. Kluge, Koch, and Schlüpmann, "'Nur Trümmern trau ich …'," 13.

6. Alexander Kluge, Astrid Deuber-Mankowsky, and Giaco Schiesser, "In der Echtzeit der Gefühle. Gespräch mit Alexander Kluge," in Christian Schulte, ed., *Die Schrift an der Wand. Alexander Kluge: Rohstoffe und Materialien* (Osnabrück: Rasch, 2000), 367. The organizational politics of smallness also applies to dctp which, at the time of the publication of this book, has only six employees.

7. Ekardt and Kluge, "Returns of the Archaic, Reserves for the Future," 120.

8. See Johannes von Moltke, "KlugeTube, or Auteur Television," *Germanic Review* 85, no. 4 (2010), 368–372.

9. For a first brief discussion of Kluge's writing in relation to the genre of the anecdote, a model case of (literary) brevity, see Joseph Vogl, "Kommentar zu 'Die Lücke, die der Teufel lässt,'" *Text + Kritik* 85/86 (Neufassung) (2011), 120–124.

10. For a complete list of Kluge's films, see Kluge, *Geschichten vom Kino*, 351.

11. Alexander Kluge, Frieda Grafe, and Enno Patalas, "Interview mit dem Regisseur von *Die Artisten in der Zirkuskuppel: ratlos*," *Filmkritik* 9 (1966), 491.

12. From the very beginning, Kluge realized that the transposition of the rules of brevity to working in larger contexts would have to entail altering the latter's formal conditions. Already in fall 1962—i.e., a few months after the Oberhausen manifesto—he said: "Die Grundidee unserer Gruppe war nun, daß eine Reihe von Leuten jetzt Spielfilme machen sollten, die sich im Kurzfilmbereich unserer Meinung nach bewährt haben. Jetzt müssen aber zunächst die Bedingungen geschaffen werden, um die Ideen in den Spielfilm umsetzen und damit aus dem Schema des jetzigen Spielfilms herauskommen zu können. [Our group's basic idea was that a number of people who, in our opinion, had proved themselves in the area of short films, should be making feature films now. But now we have to create the conditions to transpose these ideas into the feature film, and to escape its current schemas.]" Adorno-Archiv: Ge 142/3, Akademie der Künste, Berlin. At this point, the intended effect of a transposition of short forms into the long form was therefore not to monumentalize the small unit but, rather, to transform the context of the longer film.

13. Kluge, Koch, and Schlüpmann, "'Nur Trümmern trau ich …'," 17.

14. Ibid.

15. Oskar Negt and Alexander Kluge, *Geschichte und Eigensinn* (Frankfurt am Main: Suhrkamp, 1993), 1021.

16. Alexander Kluge and Florian Rötzer, "Kino und Grabkammer," in Schulte, *Die Schrift an der Wand*, 42.

17. Negt and Kluge, *Geschichte und Eigensinn*, 1047.

18. Gilles Deleuze and Félix Guattari, *Kafka: Toward a Minor Literature* (Minneapolis: University of Minnesota Press, 1986), 6; originally *Kafka: Pour une littérature mineure* (Paris: Minuit, 1975), 25.

19. Alexander Kluge, "Das Politische als Intensität der Gefühle," in Thomas Böhm-Christl, ed., *Alexander Kluge* (Frankfurt am Main: Suhrkamp, 1983), 314.

20. Ibid. For a study of "figures looking for escape"—that is to say, the way out as a theme in Kluge's stories—see Stefanie Harris, "Kluge's *Auswege*," *Germanic Review* 85, no. 4 (2010), 294–317; here p. 295.

21. Kluge and Rötzer, "Kino und Grabkammer," 43.

CHAPTER 10

1. Alexander Kluge, *Die Macht der Gefühle* (*The Power of Feelings*) (Frankfurt am Main: Zweitausendeins, 1984), 64.

2. Ibid.

3. Alexander Kluge and Florian Rötzer, "Kino und Grabkammer," in Christian Schulte, ed., *Die Schrift an der Wand. Alexander Kluge: Rohstoffe und Materialien* (Osnabrück: Rasch, 2000), 35. See also Kluge's critique of suspense-oriented dramaturgies and plots in Alexander Kluge, "Die Macht der Bewußtseinsindustrien und das Schicksal unserer Öffentlichkeit," in Klaus von Bismarck, Günter Gaus, Alexander Kluge, and Ferdinand Sieger, eds., *Industrialisierung des Bewußtseins: Eine kritische Auseinandersetzung mit den "neuen" Medien* (Munich: Piper, 1985), 115–118. See also ibid., 117, for a rejection of the dramaturgical concept of the "Schlag des Schicksals [blow of fate]," which echoes Kluge's critique of a "fatalist" understanding of feelings as forces that motivate action (see chapter 5 above).

4. To my knowledge, the first observation regarding Kluge's penchant for "multiple temporalities" is made in passing in Eric Rentschler, "Remembering Not to Forget: A Retrospective Reading of Kluge's 'Brutality in Stone'," *New German Critique* 49 (Winter 1990), 34.

5. Alexander Kluge, "Wächter der Differenz: Rede zur Verleihung des Kleist-Preises," *Kleist-Jahrbuch* (1986), 29.

6. Kluge, "Die Macht der Bewußtseinsindustrien und das Schicksal unserer Öffentlichkeit," 102–103.

7. Kluge, *Die Macht der Gefühle*, 74.

8. Thomas Elsaesser has suggested that we understand the use of time-lapse takes in Kluge's films as a reference to cinema's chronophotographic origins. This interpretation could be extended to the pulsing historic footage in his films. The returns to the beginnings of cinema in Kluge's work would, then, reenact the historic rupture generated by the advent of the filmic medium, the discontinuity inflicted by a technologically "real" temporalization of the recorded image, which it then unfolds into heterochronic ensembles. See Thomas Elsaesser, "Mélancolie et mimétisme: les énigmes d'Alexander Kluge," *Trafic* 31 (Fall 1999), 88.

9. For the study of an individual case in which Kluge sets heterochronia against a linear model of narrative—in his story "Verfallserscheinungen der Macht" (Symptoms of the Decay of Power)—see Stefanie Harris, "Kluge's *Auswege*," *Germanic Review* 85, no. 4 (2010), 310–316. Leslie Adelson connects Kluge's account of literary writers as "guardians of differential temporalities" to a number of his stories that engage with the genre of science fiction and the theme of time travel. See Adelson, "The Future of Futurity:

Alexander Kluge and Yoko Tawada," *Germanic Review* 86, no. 3 (2010), 153–184. The quote is on p. 172.

10. The first quote is from Winfried Menninghaus, "Geschichte und Eigensinn: Zur Hermeneutik-Kritik und Poetik Alexander Kluges," in Hartmut Eggert, Ulrich Profitlich, and Klaus Scherpe, eds., *Geschichte als Literatur* (Stuttgart: Metzler, 1990), 263. The second passage is from Stefanie Carp, "Wer Liebe Arbeit nennt hat Glück gehabt: Zu Alexander Kluges Liebesprosa," in Thomas Böhm-Christl, ed., *Alexander Kluge* (Frankfurt am Main: Suhrkamp, 1983), 203.

11. See ibid.; also Alexander Kluge, "The Air Raid on Halberstadt on 8 April 1945," in Kluge, *Air Raid*, trans. Martin Chalmers (London: Seagull Books, 2014), 32. For the original German, see Kluge, "Der Luftangriff auf Halberstadt am 8. April 1945," in *Neue Geschichten. Hefte 1–18. Unheimlichkeit der Zeit* (Frankfurt am Main: Suhrkamp, 1977), 46.

12. Alexander Kluge and Gertrud Koch, "Die Funktion des Zerrwinkels in zertrümmernder Absicht. Ein Gespräch," in Rainer Erd, Dietrich Hoß, Otto Jacobi et al., eds., *Kritische Theorie und Kultur* (Frankfurt am Main: Suhrkamp, 1989), 121.

13. Oskar Negt and Alexander Kluge, *Geschichte und Eigensinn* (Frankfurt am Main: Suhrkamp, 1993), 18.

14. N.B.: The following paragraphs focus exclusively on Negt and Kluge's observations on these subjects; they do *not* attempt a comparative reading or interpretation of evolutionary biology, Freud, Marx, *and* Negt and Kluge.

15. Negt and Kluge, *Geschichte und Eigensinn*, 18.

16. Ibid., 19. On Baer and Haeckel, see ibid., 18–19.

17. Ibid., 19.

18. Ibid., 20.

19. Ibid., 982.

20. Ibid., 983.

21. Ibid., 984.

22. Ibid., 985.

23. Alexander Kluge and Oskar Negt, *History and Obstinacy*, ed. Devin Fore (New York: Zone Books, 2014), 85; for the original German, see Negt and Kluge, *Geschichte und Eigensinn*, 24. See also Marx's definitions in *Das Kapital*: "Der Prozeß, der das Kapitalverhältnis schafft, kann also nichts anderes sein als der Scheidungsprozeß des Arbeiters vom Eigentum an seinen Arbeitsbedingungen, ein Prozeß der einerseits die gesellschaftlichen Lebens- und Produktionsmittel in Kapital verwandelt, andrerseits die

unmittelbaren Produzenten in Lohnarbeiter. Die sog. ursprüngliche Akkumulation ist also nichts als der historische Scheidungsprozeß von Produzent und Produktionsmittel. [The process, therefore, which creates the capital-relation can be nothing other than the process which divorces the worker from the ownership of the conditions of his own labour; it is a process which operates two transformations, whereby the social means of subsistence and production are turned into capital, and the immediate producers are turned into wage-labourers. So-called primitive accumulation, therefore, is nothing else than the historical process of divorcing the producer from the means of production.]" Karl Marx and Friedrich Engels, *Werke*, vol. 23 (Berlin: Dietz, 1968), 742. / Karl Marx: Capital. A Critique of Political Economy. vol. I. Trans. Ben Fowkes (London: Penguin, 1976) , 874.See also Marx's succinct note: "Der historische Scheidungsprozeß, der die Arbeitsbedingungen in Kapital und die Arbeit in Lohnarbeit verwandelt. Damit die Grundlage der kapitalistischen Produktion gegeben. [The historical process of separation that transforms the conditions of labor into capital, and labor into salaried labor. Providing the basis for capitalist production.]" Marx and Engels, *Werke*, vol. 26.3 (Berlin: Dietz, 1968), 308–309.

24. Negt and Kluge, *Geschichte und Eigensinn*, 31.

25. See ibid., 24.

26. Kluge and Negt, *History and Obstinacy*, 85; originally Negt and Kluge, *Geschichte und Eigensinn*, 25, 27. Jameson underlines the dialectical structure of the Negt/Klugean concept of separation when he points out that "the concept of *Trennung*" has the "effect of generating relationality [i.e., Jameson's translation of the term *Zusammenhang*] as such, the ceaseless establishment of new connections and relationships." Fredric Jameson, "On Negt and Kluge," *October* 46 (Fall 1988), 161. In other words, *Zusammenhang* and *Trennung*, context and split, are not only connected by the necessity for an ongoing, dialectical and analytical separation, or splitting of context as productive and repressive (see chapter 2 above). Even exceeding the *per se* generative capacities of separation and splitting, which Negt and Kluge mention in the passage quoted above, the productive potential of *Trennung* lies partly, and more specifically, in its capacities for generating *Zusammenhänge* (contexts, relationality).

27. Negt and Kluge, *Geschichte und Eigensinn*, 37.

28. Ibid., 28. Devin Fore comments on the coincidence between the Negt/Klugean project and a shift in the very history of capitalism which they theorize here. He points out that the basic stance of *Geschichte und Eigensinn*, with its focus on "the human side of political economy," correlates with the moment "when capitalism began to evolve out of its 'heroic' phase of violent imperialist expansionism and concentrate its energies on exploiting the inner resources of the living subject." Devin Fore, "An Introduction to Kluge and Negt," *October* 149 (Summer 2014), 3–8. The quotations are from pp. 3 and

5. Fore also identifies this "shift in the strategy of capital from exploitation to 'imploitation'" as one of the reasons that required a revision of *Öffentlichkeit und Erfahrung*, the predecessor volume to *Geschichte und Eigensinn*. See Devin Fore, introduction to Kluge and Negt, *History and Obstinacy*, 19.

29. Negt and Kluge, *Geschichte und Eigensinn*, 30–31.

30. Ibid., 31.

31. Ibid., 34.

32. Kluge and Negt, *History and Obstinacy*, 85; originally Negt and Kluge, *Geschichte und Eigensinn*, 27.

33. Negt and Kluge, *Geschichte und Eigensinn*, 31.

34. Ibid., 31–32.

Index

Acousmatism, 354n17, 355n18

Actor-network theory, 105, 358n51

Adelson, Leslie, 395n9

Adorno, Theodor W., xix, 34, 48, 72–74,
196, 216, 277–278, 308, 334n5,
340n24, 381n10
Dialectic of Enlightenment (*Dialektik
der Aufklärung*) (with Horkheimer),
76–79, 367n9
on mimesis, critique of likeness,
349n86, 349n89, 350n92
on montage as "constellation akin to
writing" (*schrifthafte Konstellation*),
73–74, 277–278
on semblance (*Schein*), 34, 73, 350n92
"Transparencies on Film" ("Filmtrans-
parente"), 73, 277, 341n36, 349n86

Affect (affectivity, affection), xix, xxiv–
xxv, 25, 31–32, 41, 60–61, 130, 155–
164, 182, 185, 210, 326, 339n18,
369n25, 375n32. *See also* Feeling

Aicher, Otl, 389n14

Alpers, Svetlana, 203

Anachronism, 271

Andrew, Dudley, 131, 342n3

Anecdote, literary form of, 126, 278,
308, 374n30, 394n9

Archaic cinema, 70, 272, 275, 301,
340n23. *See also* Cinema of
attractions

Architecture, theme and topic of, xxix,
7–23, 26–34, 39–40, 44, 46, 74–
76, 80, 175, 205, 302, 317, 337n3,
339n16, 340n23, 340n31, 341n32,
342n1

Arnim, Achim von, 170, 198–201, 209,
264, 296, 375n32, 376n34

Assemblage, xxiv, 28, 44, 105–106, 235,
242, 255, 259–261, 266, 312, 321,
358n51, 358n53, 365n48, 387n60

Attali, Jacques, 97

Aumont, Jacques, 49, 64, 345n33,
345n35

Autorenfilm (*auteur* film), 67